Nationalism and Ethnic Conflict

Nationalism and Ethnic Conflict

Philosophical Perspectives

Edited by Nenad Miscevic

OPEN COURT
Chicago and La Salle, Illinois

To order books from Open Court, call toll-free 1-800-815-2280.

Open Court Publishing Company is a division of Carus Publishing Company.

© 2000 by Carus Publishing Company

First printing 2000

Printed and bound in the United States of America.

Library of Congress Cataloging-in-Publication Data

Nationalism and ethnic conflict : philosophical perspectives / edited by Nenad Miscevic
 p. cm.
 Includes bibliographical references and index.
 ISBN 0-8126-9415-5
 1. Nationalism. 2. Ethnic relations. I. Miscevic, Nenad.
JC312.N37 2000
 320.54—dc21
 00-029856

Contents

Acknowledgments vii

Introduction: The (Im-)morality of Nationalism 1
Nenad Miscevic

PART I: NATION AND NATIONALISM 23

1. On Redefining the Nation 25
Michel Seymour

2. On National Belonging 57
Olli Lagerspetz

3. Zionism, Nationalism, and Morality 75
Elias Baumgarten

PART II: FOR AND AGAINST 99

4. Patriotism: Morally Allowed, Required, or Valuable? 101
Igor Primoratz

5. On Liberalism's Ambivalence Regarding Nationalism 115
Christopher Heath Wellman

6. National Partiality: Confronting the Intuitions 133
Daniel Weinstock

7. The New Nationalisms 157
Gillian Brock

 8. Nationalist Arguments, Ambivalent Conclusions 177
 Margaret Moore

 9. Liberal Egalitarianism and the Case for Supporting
 National Cultures 197
 Alan Patten

10. Does Membership in a Nation as Such Generate
 Any Special Duties? 219
 Friderik Klampfer

11. Is National Identity Essential for Personal Identity? 239
 Nenad Miscevic

PART III: THE COMPROMISE WITH LIBERALISM 259

12. Cosmopolitan Democracy and Liberal Nationalism 261
 Jocelyne Couture

13. Liberally Limited Nationalism 283
 Robert E. Goodin

14. Cosmopolitan Nationalism 299
 Kai Nielsen

Contributors 321

Index 323

Acknowledgments

We gratefully acknowledge permission to reproduce the following copy-righted material:

Chapter 1, Michel Seymour, "On Redefining the Nation." Copyright © 1999, *The Monist*, Peru, Illinois, U.S.A. 61354.

Chapter 6, Daniel Weinstock, "National Partiality: Confronting the Intuitions." Copyright © 1999, *The Monist*, Peru, Illinois, U.S.A. 61354.

Chapter 7, Gillian Brock, "The New Nationalisms." Copyright © 1999, *The Monist*, Peru, Illinois, U.S.A. 61354.

Chapter 8, Margaret Moore, "Nationalist Arguments, Ambivalent Conclusions." Copyright © 1999, *The Monist*, Peru, Illinois, U.S.A. 61354.

Chapter 9, Alan Patten, "Liberal Egalitarianism and the Case for Supporting National Cultures." Copyright © 1999, *The Monist*, Peru, Illinois, U.S.A. 61354.

Chapter 12, Jocelyne Couture, "Cosmopolitan Democracy and Liberal Nationalism." Copyright © 1999, *The Monist*, Peru, Illinois, U.S.A. 61354.

Chapter 14, Kai Nielsen, "Cosmopolitan Nationalism." Copyright © 1999, *The Monist*, Peru, Illinois, U.S.A. 61354.

Introduction: The (Im-)morality of Nationalism

NENAD MISCEVIC

Nationalism has been the driving force of political life in many countries around the globe in the last two decades, and has become and remains a hot topic in contemporary political and moral debate. The question debated by moral philosophers is the following: is any form of nationalism morally permissible or justified, and, if not, how bad are particular forms of it? The present volume addresses this issue. In this introduction, I will review the subissues that papers collected here deal with, starting with the definition of nationalism, then moving to the debate for and against it, and concluding by briefly commenting on the attempt to construct a mild and hybrid liberal-cosmopolitan nationalistic doctrine.

It is only to be expected that the most exciting work on the topic will come from countries in which intellectuals have some first-hand experience with nationalism. The exciting quality is not only the matter of one's being informed, but also of personally taking a moral and political stance: a cool analytical head has often to be jogged by a heart (preferably in the right place) in order to produce high quality work in moral philosophy. Among those who are able to write about nationalism from *within*, we have quite a few authors from Canada, some of them also active in the political Quebecker movement, two authors from the former Yugoslavia (now Slovenia and Croatia), a few from Israel, and one from Finland. The solutions to the problems of nationalism that they advocate are sufficiently diverse and representative of the main divisions in contemporary debate.

Let me now move to the introduction proper. Since this volume joins in with another round of professional debate, I shall in this introduction attempt to alleviate a little the troubles of the more general reader. I would like to introduce the moral philosophical debate in simple and clear terms. However, if it is true, as Russell once said, that it is impossible to be widely understandable and accurate at the same time, I will have to apologize to

the authors. First, a note of warning. We are concerned with theoretical, philosophical discussion of nationalist claims. The philosophical authors sympathetic to nationalism—in this volume, for instance, Jocelyne Couture, Michel Seymour, Olli Lagerspetz, and Kai Nielsen—differ quite a lot from the average nationalist-in-the-street, not only in their manner of presenting their ideas, but in their ideas themselves. Philosophical pro-nationalism is much more moderate; it is informed by the awareness of terrible evils that historical nationalism has produced, and its defenders are eager to distance themselves from them. They usually speak of "various accretions that have given nationalism a bad name" and are eager to "separate the idea of nationality itself from these excesses" (Miller, 1992: 87).

The view that this is not easy to do, and might even be impossible is defended here in Gillian Brock's essay in the section on good and bad nationalisms. Philosophical pro-nationalism insists on retaining the largely liberal democratic frame, supplementing it and minimally modifying it; it is typically concerned with proposing "liberal nationalist" or even "cosmopolitan nationalist" solutions, well documented in the essays by Couture, Goodin, and Nielsen. Such an attitude is rather exceptional among actual nationalist politicians. Further, philosophical pro-nationalists are mostly clear-eyed about the factual falsity of common nationalist beliefs whereas ordinary nationalists mostly believe nationalist myths. Finally, philosophical pro-nationalism *is strictly universalist* in its manner of arguing. The first level of universalism is implied simply in the claim that a nationalist solution is valid for *all and every* (ethno-)nation. Every human being ought to be loyal to *his or her* conationals, and this requires that every human being believe that his or her community is better than every other. Even at this rudimentary level there is a contrast with ordinary nationalism, which is strongly (group-)egocentric, that is, not caring about the rest of the world at best, and invidious to particular other groups at worst. The deeper level of universalism, often attained by philosophers, consists in appealing to strictly universal considerations in order to defend ethno-nationalism, for instance, praising the *values of diversity* in defending nationalism.

Definition and Claims

Although political nationalism typically encompasses political and other kinds of actions—from very banal ones, like mingling with one's own ethnic kin, to more dramatic and extreme ones, like struggling for political independence—it is more than just a pattern of individual and collective behavior. No behavior is nationalist as such, regardless of the motives and

attitudes by which it is guided. The attitude behind the behavior counts crucially. For instance, avoiding neighbors of foreign origin is a typical nationalist behavior, but if done only out of fear of police it is clearly not nationalist. Equally, a thoughtful and rational nationalist would tend to sacrifice short-term national interests to the long-term ones when the two clash, and in doing so might endorse rather cosmopolitan-looking policies for a nationalist and noncosmopolitan purpose. On the other hand, any purely "private" nationalistic sentiment which issues no practical directives is really not a political item and falls out of the discussion of nationalism as a political phenomenon. The right view is then that the relevant nationalism is a political attitude supported by a body of doctrine. When is a political movement or doctrine "nationalist"? A doctrine is nationalist when the central place in that doctrine is occupied by directives for action: claims about obligations, duties, and rights.

Nationalist claims are typically focused upon the community of language, tradition, and culture, and upon existing state structures when these are available. For the ethno-nationalist it is the ethnic belonging—which is basically unchosen, depending on accident of origin and early socializing—which determines membership in the community. I shall often use the term "ethno-nationalism" as a reminder of the intended sense. Some authors, notably Michel Seymour in his contribution to the present collection, distinguish another, strictly cultural, sense of "nationalism," which completely abstracts from the issues of common origin. In this brief introduction I have unfortunately to disregard the subtle differences, so I shall sometimes also use "ethno-cultural" as a common umbrella term, and kindly ask the reader to turn to Seymour's more refined proposals and discussion.

A nationalist political doctrine is typically practical and revolves around a cluster of claims and exhortations which we shall detail in the paragraphs to follow. These are often backed by corresponding theoretical (or quasi-theoretical) considerations both about socio-historical facts and about values. Since several papers in the volume deal specifically with the definition of "nationalism" and "nation," I shall be rather brief in characterizing the advice and the theory.

Let me reiterate the important distinction I mentioned above: while the naive and spontaneous nationalism of people of a given group is often concerned with the members of the group only, in its more refined and philosophical forms, nationalism can become more universalist, and dictate rules for *every* such group. The content of the rules has to do with creation of political community, creation, preservation and enlargement of a state, and preservation of culture in its "pure form." Lagerspetz proposes in this volume that nationalism "stresses the expression of national identity as a central concern in politics." One might strenghten it to "*the* central

concern." Political nationalism centers around the claim of an ethnic-cultural group to have its own state, which will centrally "belong" to the ethnic-cultural group, and actively protect and promulgate its traditions. More precisely, a people has a right and an obligation to form its state. (The nasty variants deny this right to some people, and admit it only for the chosen ones. The weaker than classical variants weaken the claim in two directions: instead of having a state they speak of having some kind of political autonomy and self-government, and instead of rights and obligations they speak of rights only.) The claim is taken to have the value of a trump, and to override considerations of both individual interest and of pragmatic collective utility.

Nationalism is not concerned with the creation of a state only, contrary to what has been implied by Gellner in his early and now classical writings. On the contrary, once the state is there, the nationalists are usually quite watchful about the kind of culture it protects and promotes, and about the kind of attitude people have to their nation-state. Given varieties of political circumstance, nationalism can be expansionist and push for the enlargement of the already available state territory. The slogan put forward by Serbian president Milosevic, *All Serbs in one state!*, nicely illustrates the way some nationalists want to make ethno-nation and state coincide. A more modest version is isolationism: keep your country protected from foreign influences. A slogan that nicely captures this nationalist line is *France, love it or leave it,* bandied about by the French *Front National.* The idea translates into emotional language the abstract moral claim that each member of the (ethno-)nation has a strong obligation to promote its culture, work for its maintenance, and watch over its purity. A particularly nasty aspect is obsession with demographic 'power', which typically results in an exhortation to women to beget more children to their homeland. Men should do their part and die for their fatherland if necessary.

Political nationalism is closely tied to nationalism in culture, which insists upon the preservation and transmission of a given culture, more accurately, of a recognizably ethno-national scaffolding of the culture (real or invented, either partly or wholly) in its pure form: artistic creation, education, and research should be dedicated to this goal. Many elements of a given culture which are universalist or simply are not recognizably national often fall prey to such nationalist enthusiasms. Again, the classical variant takes the relevant norm to have the status of obligation-cum-right, and the force of a trump. The weaker varieties limit themselves to the right without imposing obligation. (Of course, in practice many nationalist writers—especially nonphilosophers—freely and without warning oscillate between weak and strong varieties, which makes discussion more involved than it should be.)

Now, what is the ethno-cultural group that underlies "nation" supposed to be? Both at the level of political, unreflective nationalism, and at the level of the sophisticated philosophical defense of pro-national attitudes, the dominant conception is the mixed one of *a cultural group, possibly united by a common descent,* endowed with some kind of civic ties. (For more subtle distinctions see the essays in the first part of the present collection.) They are variously called "nations," "ethnic groups," or even "tribes." A great deal of debate concerns whether all such groups should be granted a right to a state. Michel Seymour's contribution to this volume is an excellent and long overdue analysis of various concepts of nation, and almost a third of Olli Lagerspetz's contribution is devoted to the same task.

Let me mention one of the central issues concerning the definition of a nation. Everybody agrees that various combinations of various underlying traits, such as common language, history, customs, values, and religious denomination make true for each separate group the claim that it forms a nation. Now, not even all (pro-)nationalists agree about the objectivity of even the most central traits in question; some demand the actual objective possession of a common descent and relatively pure culture, others rest content with a more subjective version. David Miller, one of the most brilliant and most moderate contemporary defenders of pro-nationalist attitudes, stresses that individuals' having "a common national identity" is "essentially not a matter of the objective characteristics that they possess, but of their shared beliefs" (Miller 1992, 87). This characterization—compatible with the absence of the objective basis of national identity—accords rather well with the views made prominent in social science by Benedict Anderson, encapsulated in his famous saying that *nation is an imagined community.* It also has the advantage of being proposed by many serious philosophical pro-nationalists, but raises an awkward question about the grounds of obligation a member has to its ethno-national community. Most pro-nationalists insist that both the belonging and obligations are objective, independent of the will of the member. Now, if nations are imaginary communities, how can they ground such obligations? (Normally, imagined relations do not engender actual obligations: for example, I don't have a filial obligation to a person whom I merely imagine to be my mother.) Of course, actual living together and interacting with each other does generate obligations, but most often one does not interact with one's whole (imagined) ethno-cultural group.

Let me now place the nationalist stance on the map of possible positions in political theory. It provides an answer to two crucial general questions: First, is there one kind of group (smaller than the whole of mankind) that is morally of central importance or not? The nationalist answer is,

There is just one, namely the nation. Second, what is the ground of oblig-
ation that the individual has to her community or communities, the vol-
untary choice or the involuntary belonging? The nationalist answers by
pointing to the latter. This also determines what kind of association is more
important, in this case, the involuntary ones. The nation is typically seen as
essentially a nonvoluntary community to which one belongs by birth and
early nurture. Benedict Anderson claims that the reason many people are
ready to die for their country is precisely the fact that national belonging
is unchosen. With respect to preferring involuntary belonging, national-
ism differs from the view that stresses the unique moral value of civic bonds
but grounds that value in voluntary belonging. This contrasting view is
sometimes called "republicanism," although the label is applied to differ-
ent positions.

Let me mention that a few atypical but important authors, classics like
E. Renan and M. Weber, and occasionally contemporaries like Walzer,
define nation in a voluntaristic way, as any community that strives for self-
government.)

Nationalist assumptions nicely fit with what in philosophical literature
is known as the "communitarian" stance in general (whatever the basic
community-kind is taken to be: some communitarians prefer nation, some
more encompassing communities, like, for example, those defined by
wide-ranging religious traditions). It thus contrasts with the individualist,
classical liberal stance, which stresses the freedom of choice and, conse-
quently, the plurality of chosen belongings as the most appropriate frame-
work of moral life. Daniel Weinstock's essay in the present collection
discusses this "plurality of different kinds of groups" to which individuals
are by their very natures affectively linked. (Compare Miller: "liberalism v.
nationalism may be a specific instance of what is frequently now regarded
as a more general contest between liberal and communitarians" [1995:
193].)

Let us represent these answers in a table. The columns stand for the
number of relevant kind of groups, whereas the rows determine the rela-
tive importance of voluntary vs. involuntary association.

Let us now detail the contrast between the nationalist stance and the
more cosmopolitan view. The latter stresses the fact that each individual
happens to belong—simultaneously—to groups and communities of vari-
ous sizes and kinds; there are *no privileged, natural units* of the kind the
nation-centered view envisages. There are individual persons on the one
hand, the basic carriers of moral worth and responsibility, and there is
humankind on the other. Our ultimate obligation is the one we have to
human beings as such, regardless of their narrower belonging. The belong-
ing is to particular groups, but it is described in a different way than in the
nation-centered perspective. Groups differ by the degree of voluntariness:

	One Group-Kind of Central Moral Importance	No Single Group-Kind of Central Moral Importance
The Ground of Obligation is nonvoluntary belonging	• classical nationalism	
The Ground of Obligation is one's voluntary choice	• atypical nationalists like Renan and Weber	• individualism • classical liberalism • cosmopolitanism

the membership in some of these is purely voluntary (clubs), in some it is mixed (social classes and strata, nation-states) and some are not chosen, at least not in initial stages (family). The cosmopolitan stresses that in the modern world the voluntary belonging is often more accentuated; the person herself chooses what the relevant group and community or communities are. She does not deny the central place of culture in the debate, but points out that the classification of culture(s) and cultural phenomena by ethno-national criteria has many competitors; once you stop viewing cultural achievements as basically national, you realize the weight of other possibilities (closeness of style across national borders, actual trans-national influences and the like). The circles one belongs to are diverse, and, to use a geometrical picture, nonconcentric: an English working-class woman might feel solidarity with an Eskimo woman along the lines of gender belonging, and with a German working-class male along the lines of class belonging. The possibility and opportunity to switch from one group to another that is associated with voluntary belonging is an important feature, one whose moral importance is most obvious in the freedom of the choice of profession and in social mobility in general. Now, the loyalty one owes to each of the groups is *in principle* determined by the choices one makes, and by the past history of interaction. In this sense there is *no privileged focus of loyalty* independent from an individual's decision. The diversity makes for balance in most normal circumstances: a Catholic and an Orthodox (or a Protestant) find themselves together as fans of the same football team.

Within the cosmopolitan perspective, the more narrow circles can lead one in an almost continuous fashion towards the wider ones. Micro-region, nation, macro-region are not separated by gulfs from each other. The continuity (or near continuity) between them makes possible an important kind of moral learning through extending one's powers to empathize; the route from individual to humankind is paved by intermediate communities.

Finally, the plurality of various potential belongings is an important asset for the individual and her ability and right to choose. We can regard the circles of belonging as natural stepping stones towards the most universal and encompassing community, that of humankind. The general perspective finds its political application, which we shall discuss in the last chapter.

To see the two perspectives, the nationalist and the cosmopolitan one, at work, consider the way each of them presents and interprets ethnic conflicts, for instance, those in Ulster, Bosnia, or Kosovo. From the more cosmopolitan perspective the atrocities of such conflicts is a crucial piece of evidence against nationalism pointing to its deep irrationality and inhumanity. From the nation-centered communitarian perspective ethnic conflicts are a direct testimony in favor of nationalism. First, they point to the special qualities—depth, centrality, and ineradicability—of national feeling. Second, they make obvious the crucial importance of nationalist claims themselves. Why has the war in Bosnia been so bloody? Well, because the normal, natural solution of forming ethno-national states has here been made difficult by contingent, tragic circumstances. Were the Moslems not so dispersed, the natural solution would be a Moslem state; were the Croats not so dispersed, the natural solution would be to annex the Croat territories to the existent Croatian national state.

Let me once more illustrate the main claims with a quotation, this one by Oldenquist, who starts from the assumption that national communities have a noninstrumental value:

> This talk about non-instrumental value is intended to characterize how a majority of thoughtful people already regard tribes and cultures, namely that they do not think of them solely in cost-benefit terms and prefer not to see their total assimilation. And thinking this way can lead one to see merit in independence when the people themselves want it. This is because independence is seen as both a safeguard and consequence of the flourishing of a culture; when a culture is politically independent its dilution and disappearance are less likely.
>
> Yet, many cultures endure as minorities inside larger countries. Must they have sovereignty? Of course not, unless they insist and a number of other conditions are met, and most groups do not insist. The great majority of the world's ethnic groups would not secede even if it were. (Oldenquist 1997, 325)

To recap, here are the claims—call them the "Fundamental Claims"—that our pro-nationalist is supposed to defend:

> The preservation of a given ethno-national culture—in a relatively pure state—is a good independent from the will of the members of the culture, which ought to be assured by adequate means.

The nationalist next introduces the statist thesis:

In order that such a community should preserve its own identity and support the identity of its members, it has to assume (always or at least in most cases) the political form of a state.

In order to reach the final conclusions:

The ethno-national community has the right in respect to any third party and to its own members to have an ethno-national state.

And:

The citizens of the state have the right and obligation to favor their own ethnic culture in relation to any other.

These last claims are taken by the pro-nationalist philosopher to have a universal domain: they are valid for each (ethno-)nation. Their force is close to that of a trump.

The debate for and against nationalism on the theoretical level is the debate about the validity of these claims. Is national partiality justified and to what extent? Are ethno-national state and institutionally protected (ethno-)national culture goods independent from the individual will of the members, and how far may one go in protecting them?

Nationalism: For and Against

The second part of the book is dedicated to criticisms of nationalism and to arguments in its defense. The defense continues in the last and third part, in the context of liberal and cosmopolitan nationalism, so that the second part contains more critical than supportive papers. Taken together, the papers in the collection are roughly equally balanced in the attitude to nationalism they express. To concentrate upon the second part, the critics are Gilllian Brock, Margaret Moore, Daniel Weinstock, Friderik Klampfer, and Nenad Miscevic. Other contributors, whom I have already mentioned, whom I have already mentioned defend it in part one. (Alan Patten defends not so much nationalism itself but certain minority rights that reside in the value of ethnic culture to its members.) Why do nationalist claims require a defense? Well, they appear to clash—some in principle, some under normal circumstances—with various values that people tend to accept. Some of these values are considered essential to liberal-democratic societies, others important for the flourishing of culture and creativity. The main values in the first group are self-determination or autonomy and

benevolent impartiality. Self-determination of individuals is discussed by Gillian Brock in a section of her paper on new nationalisms; she concludes that nationalism is more of a hindrance than a help in matters of self-determination. Indeed, special duties towards one's ethno-national culture can interfere, and often do interfere, with one's right to autonomy (if I want to become a Buddhist, the only one in my community where the preponderant religion is a completely different one, I should be granted a right to do so without being thought to violate some special duty to community). If these duties are construed very strictly they can interfere with other individual rights, for example, the right to privacy. In contrast, the contemporary moral sensibility favors individualism as the basis of morality and politics. Political liberalism bears testimony to this, but there is also a more palpable evidence in favor of it. In many areas of social life the freedom to choose one's identification and belonging is seen as a sacrosanct right. Not only the choice of partner, but also of profession, of confessional and political persuasion and belonging is in principle a matter of free decision. Moreover, some important areas of involuntary belonging, such as gender, are being brought in line with the liberty-promoting stance: the biological determinateness of sexuality is a model example. Roles and behaviors associated with sexuality are seen as being in need of a radical rearrangement in the interest of equality and the freedom of choice. The givens of sexual identity and the "almost givens" of gender identity are being questioned in the name of freely assumed roles and freely chosen belonging. But if such a general and heavily influential belonging as that of sexuality is being questioned in the name of individual rights, it seems that less general and influential memberships should be capable of remodeling in the light of individual needs and wishes. Moreover, to the extent that nations are "imagined" or "constructed" communities, the alleged obligations they would impose seem to be merely imagined or constructed as well.

To move on to impartiality, it demands an equal moral concern and respect—at least in morally central matters—for each human being. Of course, exceptions can be made, but the burden is on those who demand special treatment. Nationalism by definition demands partiality, and one of its prominent defenders, Andrew Oldenquist, appropriately describes it as a "group egoism," so it should defend its claims against impartiality. Daniel Weinstock's essay in the present book is dedicated to this issue, and in it he argues that the nationalist's attempts ultimately fail. Igor Primoratz describes patriotism in similar terms, and argues for its very limited value.

The values in the second group prominently include the value of unconstrained creativity, and they might conflict rather strongly with nationalist claims; for example, telling writers or musicians or philosophers that they have a special duty to promote national heritage does interfere

with the freedom of creation. (Of course, these intellectuals should have the right to promote their national heritage, but the issue here is whether they have a duty to do so.) Another value is diversity within the community, which can also be thwarted by the homogeneity of a central national culture.

In between these two groups are the values that seem to arise from ordinary needs of people living under ordinary circumstances. In many modern states citizens of different ethnic backgrounds live together, and very often value this kind of life. (If you need a vivid illustration, remember that the winning French soccer team at the 1998 World Championship was multicultural indeed, with the Arab Zidane as the main star; even President Chirac praised the team's ethnic pluralism!) Politically, the original ethnically centered model of ethno-national state has undergone severe changes. In the first stage, in most parts of the Western world it has been replaced by the so-called "national" state that is only weakly beholden to its ethnic origin, if at all. In a second, contemporary stage, it is being questioned by the realities of both international cooperation and of substate communities. This very fact of cohabitation seems to be a good that should be upheld, and a means of conflict prevention. Nationalism is not very good at that, judging by both theory and experience, as Christopher Wellman is at pains to point out in his contribution.

In short, the nationalist claims are demanding indeed. Notice that one cannot defend them just on the basis of mere attachment to one's community or nationalist (or patriotic) sentiment of love of one's people and country. If such a sentiment is not coupled with hatred toward others, it is morally in the clear. However, one's sentiment does not justify the demand that others should share it, that is, that it should be a norm for all members of the community ("Lavinia, love it or leave it!"; I shall in my essay use the imaginary name "Lavinia" as a stand-in for any particular ethno-national community). It certainly does not come even near to justifying the demand for a specific state-organization which should transform the mere attachment into a politically organized form of life. Note that nationalism is rather demanding, so that its defense requires a lot of argumentation.

The thoughtful pro-nationalist writers have put forward several lines of thought in defense of such a nationalism, and the whole second part of this volume is dedicated to the dialogue between the proponents and the opponents of the claim. In order to help readers find their course in a rather involved debate I shall briefly summarize the considerations which are open to the ethno-nationalist to defend her case. The considerations and lines of thought built upon them are used to defend very different varieties of nationalism, from radical to very moderate ones. The key assumptions and premises which figure within each of the lines of thought we are going to

summarize often live an independent life in the philosophical literature: some of them figure in the proposed defenses of various traditionalistic views (like, for instance, MacIntyre's defense of his views on tradition in general) which have little to do with nation in particular.

Remember that the arguments in favor of nationalism purport to establish its Fundamental Claims about state and culture that we summarized at the end of the last section. We can divide these lines of thought into two groups. The arguments in the first group appeal to (actual or alleged) circumstances which allegedly make nationalistic policies reasonable (or permissible or even mandatory), such as the fact that a large part of the world is organized in nation-states, so that each new aspiring nationalistic group just follows an established pattern, or, to take a more special case, the circumstances of group self-defense or of redress of past injustice which might justify nationalist policies. Let me give each a name, and present a brief summary. Here then is the first group:

(1) *The Argument from (the Right to) Group Self-Determination.* A group of people of a sufficient size has a prima facie right to govern oneself, and decide about the future membership, if the members of the group so wish. It is fundamentally the democratic will of members themselves that grounds the right to an ethno-national state and to ethno-centric cultural institutions and practices. The argument presents the justification of (ethno-) national claims as deriving from the will of the members of the nation. (It is therefore atypical for the nationalist, who normally sees the demands of the nation as being independent from choices of individuals, and prior to them).

(2) *The Argument from the Right to Self-Defense and to the Redress of Past Injustices.* If the Lavinians are oppressed by Tribals, so that every Lavinian is worse off than most Tribals simply by virtue of being Lavinian, then the Lavinian nationalist claims—directed to the preservation of Lavinian identity through acquisition of political autonomy or even sovereignty and creation of Lavinian-centered cultural life—are morally plausible, even compelling. M. Walzer in this context rightly insists upon the role of the state to offer security to its citizens, and point out that any imaginable successor to the national state will have to do the same. For all state-like entities

> must guarantee the physical and cultural survival of their members. It is not because of some historical misunderstanding that Jews, Armenians, Palestinians, Kurds, Estonians, and Tibetans lay claim to and even fight for sovereign statehood. And once any of these peoples (or others like them) join a state, its purposes are bound to be the same as those of the preceding national movement: to assure the survival of this group of men and women and to foster and reproduce its cultural life. (Walzer 1995, 247)

The examples he gives, Jews, Armenians, and the rest, are prime examples of groups of people whose members have been denied elementary human rights because of their ethnic belonging. Of course, every decent state "must guarantee the physical and cultural survival of its members" (if "cultural" means that the members will at least be left alone and not interfered with in their cultural pursuits). In the case of these unfortunate peoples, the struggle for a state coincides with the struggle for a minimally decent life. *Such groups that are on the defensive tend to have our moral sympathies.* Their claims, even when strongly partial in their form, are evaluated by us, the onlookers, in the context of the unmerited inequality, and thereby made acceptable.

(3) *The Argument from Success.* The nation-state has been successful in the past, promoting equality and democracy. The ethno-national solidarity is a powerful motive for a more egalitarian distribution (Miller). Montesquieau has famously identified the love of one's country with the love of its just laws; his insight has been prophetic, and is of utmost importance for contemporary politics. It also promises to be essential for the moral life of communities in the future since it is the only political form capable of protecting communities from the threats of globalization and of assimilationism. The argument is discussed in the collection by several authors. Olli Lagerspetz and Kai Nielsen point to the moral and political promise of nationalism, whereas Margaret Moore criticizes the claim that nationalism is in general morally successful. She points out the problems it has with its approach to nonmembers, including minorities, and sets up an interesting dilemma for the nationalist, forcing him to be either too discriminatory or too generous. Christopher Wellman in his contribution discusses the perils and promises of nationalism in matters of justice and the prospects for meaningful life for the citizens of a nation-state, and ends on an ambivalent note, with some wise recommendations about avoiding nationalist excesses.

Let me now move to the second group. The arguments in this group defend the assumption that national communities have a high value (often a value that is noninstrumental, that is, not a means for some independent, valuable end), independently from the wishes and choices of their individual members; and depict the community as the source of a unique transmission device that connects the members to the values. In particular, the nationalist tries to establish *that an ethno-national state and institutionally protected (ethno-)national culture is a good independent from the individual will of the members.* (In general philosophical terms, they all belong to the communitarian lore.) Let me illustrate the general tenor of the group with a quotation from Oldenquist (1997, 325):

This talk about non-instrumental value is intended to characterize how a majority of thoughtful people already regard tribes and cultures, namely that they do not think of them solely in cost-benefit terms and prefer not to see their total assimilation. And thinking this way can lead one to see merit in independence when the people themselves want it. This is because independence is seen as both a safeguard and consequence of the flourishing of a culture; when a culture is politically independent its dilution and disappearance are less likely.

The nationalist ascribes a high value especially to the "national culture"; more precisely, he takes culture(s) to be essentially determined by their ethno-national belonging. His arguments thus center around the value of the national community and its culture, and are organized around its various aspects. For instance, he ascribes intrinsic value to each particular national community as such on grounds of general value of culture and in particular of moral value it can have as a transmitter of morality. Further, a value is being ascribed to the fact that members of a cultural community are particularly close to each other. Finally, an original value can be ascribed to the totality of "ethno-national" cultures, and a particular national community receives a standing from the contribution it makes to the overall diversity of the achievements of mankind. Once the high value of community is established, the line of thought leads to duties the members have to their community precisely because it is so valuable. In short, the nationalist tries to establish *that an ethno-national state and institutionally protected (ethno-)national culture is a good independent from the individual will of the members.* The arguments are summarized below.

(4) *The Argument from Intrinsic Value and Cultural Proximity.* Each ethno-national community is valuable in itself since it is the natural encompassing framework of various cultural traditions which produce and transmit important meanings and values. It also provides for a special cultural proximity between its members. Now, persons that are closer to the agent in this cultural sense are also closer to *her* morally: the agent has special obligations to them. The underlying traits of ethno-nation make for a very close proximity, and thus their carriers constitute a network of mutually very close agents, also in the moral sense. The network is therefore a moral community, with special, very strong ties of obligation. A prominent obligation of each individual concerns the underlying traits of the ethnic community, above all language and customs: they ought to be cherished, protected, preserved, and reinforced. From this obligation the nationalist finally derives community's right to have its state dictate political and cultural duties of its citizens. The argument from intrinsic value is thoroughly discussed by Margaret Moore, who notes that a nation faces competition from other kinds of communities as the provider of important value(s). Gillian Brock stresses that (what we have called) networks of proximity are

often entered out of prudential, egoistical reasons and pressure to conform, which obviously diminishes their alleged intrinsic moral value.

(5) *The Argument from Flourishing.* The ethno-national community is essential for the flourishing of each of its members. In particular, only within such a community can an individual acquire concepts and values crucial for understanding the cultural life and one's own life in particular. In particular, our nationalist assumes that an individual's choices essentially depend upon the framework of values which is itself not chosen. Most authors in the second part of the collection question this assumption, in particular Brock and Moore.

(6) *The Argument from Moral Understanding.* A particularly important variety of value is moral value. The rich, "thick" moral values are discernible only within particular traditions, to those who have wholeheartedly endorsed the norms and standards of the given tradition. As Charles Taylor puts it, "The language we have come to accept articulates the issues of the good for us." And, "We first learn our languages of moral and spiritual discernment by being brought into an ongoing conversation of those that bring us up" (Taylor 1989, p. 35). The nation offers the natural framework for moral traditions, and thereby for moral understanding; it is the primary school of morals.

(7) *The Argument from Identity.* The very identity of persons depends on their participation in the communal life. The communal enterprise is a process whose root is involvement with others: other generations, other sorts of persons whose differences are significant because they contribute to the whole upon which our particular sense of self depends. Thus mutual interdependency is the foundational floor of citizenship . . . outside a linguistic community of shared practices, there would be biological *Homo sapiens* as logical abstraction, but there could not be human beings. We are the persons we come to be in the social settings and contexts in which we come to be those persons, claims the pro-nationalist. The argument is set out with great forcefulness by Kai Nielsen in his paper in the third part of this volume, but also by Olli Lagerspetz in the first part. Given that identity is a precondition of morality and of flourishing, prior to the individual will (which, in contrast, depends upon a mature and stable identity), the communal conditions of identity have to be preserved and developed. The argument is criticized by several contributors, in particular by Brock (and Miscevic, who also offers a proposal for describing cultural and social identities so as to distinguish them from simple identity of individual).

(8) *The Argument from Diversity.* Each national culture gives its contribution to the diversity of human cultures in general. "The 'physiognomies' of cultures are unique: each presents a wonderful exfoliation of human potentialities in its own time and place and environment. We are forbidden to make judgments of comparative value, for that is measuring

the incommensurable," writes the most famous contemporary proponent of the idea, the philosopher Isaiah Berlin (interpreting Herder, who apparently first thought about it) (Vico and Herder 1976, 206). The carrier of basic value is thus the totality of cultures, from which each national culture that contributes to the totality derives its own value. Here is a further quote, this one from Berlin's disciple Avishai Margalit: "The idea is that people make use of different styles to express their humanity. The styles are generally determined by the form of life to which they belong. There are people who express themselves 'Frenchly,' while others have forms of life that are expressed 'Koreanly' or . . . 'Icelandicly,'" (Margalit 1997, 80). The plurality of styles can be preserved and enhanced by tying the styles to ethno-national "form of life." The argument ascribes a value—either general or particularly moral, or both—to each particular culture from a pluralistic viewpoint of the totality of cultures available. Assuming that the (ethno-)nation is the natural unit of culture, the preservation of cultural diversity amounts to institutionally protecting the (ethno-)national culture.

The lines of thought in the second group form a whole; they all start from the value of culture, moral and general, then focus upon ethno-national culture, in order to derive the centrality claim; finally, they pass from the alleged centrality of ethno-national culture to the need of a statist institutional structure to protect it. Since their main points are all linked to the primacy of community life in relation to the individual, they all belong in the communitarian tradition whose magic words are *community* and *identity* and a recurrent theme is the importance placed on non-chosen involuntary belonging. In each a general communitarian premise (Unchosen community is crucial for one's identity, or for flourishing or for some other important good) is coupled with the more narrow nation-centered claim that the ethno-nation is precisely the kind of nonchosen community ideally suited for the task.

Criticism of nationalist claims can focus either upon each general communitarian assumption, or upon particular claims on behalf of nation. The critical papers in this volume mainly take the first line; for instance, the paper by Weinstock focuses upon the first target (my own paper also focuses upon the alleged general value of community for the identity of its members). Let me therefore just point to the alternative line and mention a way to problematize the particular claims. I will choose the argument from success, in particular the premise that the ethno-national solidarity has a moral force, since it is a powerful motive for a more egalitarian distribution.

Does the love of one's people and country lead to social solidarity and encourage a more egalitarian distribution, as Miller, MacCormick and Nielsen would have it? Here is a rough test: if nationalism leads to egali-

tarianism, then the more radically nationalist a political system is, the more egalitarian it should be, and the more solidarity it should produce. Take then the extreme right, and the radically nationalist fascist regimes: were they egalitarian and did they foster genuine social solidarity? Not at all; they offer the disgusting show of rich and all-powerful führer-elites, wallowing in wealth, while millions of people suffer utmost deprivation. Not only this: such regimes have been destroying the very tissue of social solidarity wherever they have come to power. Next test: in communist countries egalitarianism was preached, if not practiced, so people have been well acquainted with its principles. Now, are the newly formed post-socialist states in which nationalists have gained power conspicuous for the solidarity, equality, and social justice? On the contrary: in these countries nationalism just provides a smoke screen for a very unjust redistribution of wealth. Take again the example of extreme nationalism in former Yugoslav countries: it was accompanied by extreme social injustice.

Why is it so? There is no direct link between nationalism and greed for money, so whence the correlation? Here is a proposal: By overstressing just one narrow set of goals having to do with ethno-national independence, and by legitimizing rather extreme means, nationalism, once enthusiastically accepted, makes the general public *dramatically insensitive to most other social issues.* In some post-socialist countries large minorities have been routinely deprived of their citizen's rights in order to secure the space for nationalist policies accepted by the majority. I would expect that such massive injustice on nationalistic grounds numbs the sense of justice and of social solidarity: if you can expel all Serbs from a school, or deny all Russians in the town the right to vote, or deny Albanian women in Kosovo the right to healthcare, why bother about small-looking infringements of civil rights within the ethnic community? Once social solidarity goes by the board, the space is clear for introducing dramatic inequalities and for plundering the country—as apparently has been happening in Albania, Serbia, and some ex-Soviet republics—under the aegis of national unity and pride.

Let me end on a more practical note. Although philosophical pro-nationalist arguments are subtle, their quick-and-dirty—that is, simplified, inflated, and enthymematic—versions appear in the actual nationalistic discourse, which sometimes feeds upon the ideas formulated in the philosopher's study. In this context, *the philosophical generality of formulations presents a direct political danger.* For instance, some philosophers love to talk about the "centrality of national culture," without bothering to separate its various aspects. Taken literally, such talk encourages the idea that in each big or small ethno-national country one should concentrate upon the local historical achievements in high culture. In practice, this can lead to the exclusion of standard internationally recognized curriculums from

university programs and works of art and literature. In my own country, Croatia, we have a four-year study program in Croatian philosophy that includes exams in "Croatian psychological identity"; in France, as well as in some Central European countries, analytic philosophy is partly suspect on the grounds of its being "Anglo-American," and the examples of narrow-minded, downright disastrous attempts at inventing a specifically ethno-national high culture can be multiplied at will. The same overgeneral idea of centrality of national culture often in practice encourages a disastrous linguistic purism. A related worry concerns the tolerant attitude towards nationalist mythology, which is often assumed, probably rightly, to be essential for constructing and maintaining cultural identity. Pro-nationalists assume that national mythologies are benign falsehoods, to be easily integrated into a civilized framework. They are factually wrong: mythologies come down from a savage and cruel past and bear its imprint; normally, they are far from benign in what they suggest or command. Our authors are also imprudent: the false mythologies show their bite in many actual situations, for example, when historians begin to discover their falsehood. Since national identity counts higher than mere factual truth, such historians are then silenced by the nationalist governments. The theoretical problem for the pro-nationalist philosopher is then to formulate principles that would condemn such practice, at the same time allowing for the moral centrality of the community values (which include appeal to the constitutive myths). I don't see how this could be done.

Of course, these practical liabilities are not fatal to a philosophical defense of nationalism, since many decent-sounding political theories have turned out to engender practical monsters, but they command certain caution. This brings us naturally to the last part of the volume, dedicated to compromises between nationalism and its opponents.

The Cosmopolitan-Nationalist Compromise

Even if one does not accept classical nationalistic claims, the lines of thought in favor of nationalism suggest that there is some value in national self-defense, in preservation of cultural traditions, in feelings of belonging to a common nation, and so on. This may not be the central value of political life, not even a central value, but a value nevertheless. On the other hand, pure individualism and cosmopolitanism do seem arid and abstract, requiring a supplementation of more homely and heart-warming motivation. Confronted with these opposite pulls, some authors in the volume opt for a mixture of cosmopolitanism and patriotism-nationalism. This reflects the actual status of the debate rather well, since mixed doctrines which call themselves "liberal nationalism" or "cosmopolitan patriotism"

tend to occupy the center stage. (A glance at the recent Cohen and Nussbaum book on cosmopolitanism confirms this impression: there B. Barber glorifies "a remarkable mixture of cosmopolitanism and parochialism" which in his view characterizes American national identity [p. 31]; Charles Taylor claims that "we have no choice but to be cosmopolitan and patriots" [p. 121]; and Hilary Putnam proposes loyalty to what is best in the multiple traditions that each of us participates in, apparently a midpoint between a narrow-minded patriotism and a too abstract cosmopolitanism.) Here are some main theses linked to liberal, liberally limited, and cosmopolitan nationalism: first, ethno-national claims have only prima facie strength, and cannot trump individual rights. Second, legitimate ethno-national claims do not in themselves automatically amount to the right to have a state; they mostly reach the level of cultural autonomy. Third, ethno-national patriotism is often subordinate to civic patriotism, that has little or nothing to do with ethnic criteria. (This is the view of Tamir, but it is not shared by Nielsen and Couture as documented by their essays in the present volume.) Fourth, ethno-national mythologies and similar "important falsehoods" are to be tolerated only if benign and inoffensive, being thereby morally permissible in spite of their falsity. Finally, any legitimacy that ethno-national claims actually have is derivative from the choice of individuals concerned. (In Tamir's version, the only relevant right that is explicitly guaranteed is the individual's right to take some permissible ethno-nationalist obligation upon oneself, and any obligation thus generated will be a freely assumed one). Couture in this argues that such a liberal nationalism is compatible with a moderate cosmopolitan stance, and offers protection for democracy in the face of the challenges of globalization.

The stance depicted is mild and civil, and there is a lot to be said in favor of it. However, as far as actual nationalism is concerned, such mixed proposals pay too high a price for their decency and civility. First of all, the kind of love of country they suggest is tempered by all kinds of universalist considerations, quite foreign to the patriotic spirit which makes people "march together, work together, fight together, live and die for each other," to quote a nineteenth-century French nationalist historian, Fustel de Coulanges. Second, and more importantly, the patriotism recommended is a selective one: the fatherland is to be loved for its actual qualities, for the universal values it happens to incarnate, rather than for being just what it is, one's fatherland. But if love is to be dictated by the qualities rather than by their bearer, why not sidestep the particular country, contingent mediator between us and the universal?

These contrasts with classical nationalism raise the following question: is the very idea of liberal or cosmopolitan nationalism—the compromise vie—coherent at all? Well, the first weakening—downgrading nationalist

claims from the status of trumps to prima facie duties only—deprives the compromise view of clear-cut answers to burning political questions. Whereas classical nationalism dictated where people should put their hearts, the compromise view claims only that ethno-nationalist interest is one legitimate interest among many. No clear guide to action is thereby given. Further, the compromiser who gives up the right to a sovereign ethnic state certainly falls out of the prototype of a nationalist. If she also proposes to purge national mythologies from elements offensive to liberal tastes—to minorities, members of neighboring ethnic groups, possibly to women, to mention just the most salient recipients—she will be left with little to substantiate her allegiance to a specific ethno-national tradition (not to mention that the whole idea of condoning false beliefs for their identity-building function is problematic.) Further, concerning the last thesis, that is, the permission the compromiser grants to one to take upon oneself some ethnically oriented obligation, is not in itself nationalist. It is like permission the tolerant lawgiver gives to members of some religious group; if they want to take special burdens upon themselves they are free to do it. The compromiser herself is thereby as little committed to nationalism as the tolerant lawgiver himself is committed to endorsing the religion he tolerates.

Now, add together all these features—deriving from the proposed weakenings of classical nationalism—and consult your intuition: is there anything left worthy of being considered nationalist? My intuition is more inclined to answer in the negative. Nielsen's and Couture's essays in this volume go some way towards alleviating these doubts, and the reader will be able to judge for herself.

The title of this collection mentions "ethnic conflict" and the reader might expect more dramatic pronouncements about it than are in fact encountered in the essays. It should be held in mind, however, that it is the situation of ethnic conflict that offers a major motivation for the nationalism debate, and provides the serious and often urgent political backdrop to it. We have chosen our title partly in order to stress this backdrop and the serious political motivation behind the academic and abstract-sounding exchange of points and arguments. After all, many of the authors in the volume themselves have been living through acute or chronic ethno-nationalist conflicts and their philosophical perspective has been to significant extent formed through their experience.

REFERENCES

Anderson, B. 1991. *Imagined Communities.* London: Verso.

Avineri, Shlomo, and Avner de-Shalit, eds. 1992. *Communitarianism and Individualism.* Oxford: Oxford University Press.

Berlin, I. 1976. *Vico and Herder.* Oxford: Oxford University Press.

Cohen, J., ed. 1996. With Martha Nussbaum and respondents. *For Love of Country: Debating the Limits of Patriotism.* Boston: Beacon Press.

Couture, J., K. Nielsen, and M. Seymour, eds. 1998. *Rethinking Nationalism. Canadian Journal of Philosophy,* supplemental volume 22.

Gellner, E. 1983. *Nations and Nationalism.* Oxford: Blackwell.

MacCormick, N. 1982. "Nation and Nationalism." *Legal Right and Social Democracy.* Oxford: Oxford University Press.

McKim, R., and J. McMahan, eds. 1997. *The Morality of Nationalism.* Oxford: Oxford University Press.

Miller, D. 1992. "Community and Citizenship." In Avineri and de Shalit.

———. 1995. *On Nationality.* Oxford: Oxford University Press.

Oldenquist, A. 1997. "Who are the Rightful Owners of the State?" In Koller and Puhl, eds., *Current Issues in Political Philosophy.* Vienna: Holder, Pichler and Tempsky.

Tamir, Yael. 1993. *Liberal Nationalism.* Princeton: Princeton University Press.

Taylor, Charles. 1989. *Sources of the Self.* Cambridge: Cambridge University Press.

Walzer, M. 1995. "Response to Veit Bader." *Political Theory* 23, no. 2, 247–49.

PART I

Nation and Nationalism

1

On Redefining the Nation

MICHEL SEYMOUR

1. Introduction

I submit what I believe is a new definition of the nation.[1] This essay is intended in part as a piece of conceptual analysis. Of course, in the attempt to be as clear as possible, I run the risk of becoming fairly abstract, and there are those who feel that abstraction in these matters is inappropriate. But I wish to face this challenge because disagreements over the nature of nationalism very often rest upon misunderstandings which are partly due to different uses of the same words, or to an unclear understanding of the notions involved. I believe that the philosopher may modestly contribute to some clarification even if the hope of reaching "clear and distinct ideas" is most probably not going to be fulfilled. Intolerance and political differences are perhaps sometimes not totally unrelated to the difficulty of conceptualizing complex notions. Our inability in this regard stems from an inability to reflect upon a complex reality. This is why a philosophical account may be useful.

2. Beyond the Ethnic/Civic Dichotomy

The task of developing a new conception of the nation is motivated by the desire to overcome the distinction between the ethnic and the exclusively civic conceptions of the nation. This dichotomy prevails in most contemporary works on nationalism.[2] I wish to develop a conception which departs from both views. Although my own account is also a civic one, I would criticize the traditional exclusively civic approach in many important aspects. In this section, I explain why there is an urgent need to develop a concept that goes beyond the dichotomy.

The exclusively civic definition of the nation is associated with the name of Ernest Renan.[3] According to that view, the nation is a sovereign state founded upon the will of the people. This conception manifested itself during the French Revolution, and it is based on the idea that a nation is a free association of individuals. It is, as Renan puts it, a daily plebiscite. Individuals give themselves a state and the state makes up the nation. This view emphasizes the subjective component of the nation since it underlines the importance of willing individuals, and it is very often interpreted within the framework of an individualistic political philosophy, because it very often gives an absolute priority to the individuals over the group.[4]

The ethnic definition is (perhaps misleadingly) associated with the name of Johann Herder.[5] It finds its full expression in German nationalism. The nation is, according to that view, founded upon language, history, and culture. Consequently, it appeals to more or less objective features. In order to belong to the same ethnic nation, one must share the same language, history, and culture. But even more importantly, the people must share the same ancestry or believe that they share the same ancestry. According to that view, the nation precedes the state, and it is very often interpreted as some kind of collective entity that transcends each and every individual. It is thus usually associated with a certain form of collectivism.[6]

Why should we want to abandon the ethnic/civic dichotomy? Without engaging in a detailed answer to this question,[7] let us say, first, that both views are usually associated with a certain conceptual monism. According to this approach, the nation must be either civic or ethnic. The two accounts mutually exclude each other and each presupposes that there is only one good account of the nation. But we could very well be forced to accept an irreducible conceptual diversity in these matters. Perhaps we must make use of many different concepts of the nation if we want to have a grasp on such a complex phenomenon. In short, we must endorse a conceptual pluralism.

A second difficulty relates to the dichotomy itself. We wrongly assume that we only have a choice between two options and nothing more. But there are many other concepts of the nation. There is the cultural account that must not be confused with the ethnic account, and there is also the diaspora nation which is similar to other sorts of nations but which has its own specific features. And in addition to all these concepts, I shall want to introduce a sociopolitical concept. So by accepting only two options, we unduly simplify things.

Moreover, the two conceptions lead to nationalist movements which, in different ways, induce a certain form of exclusion. The suggestion that ethnic nationalism often leads to exclusion is by no means a controversial

one. We are all familiar with many tragic examples of this in the twentieth century. But what about a purely civic nationalism? Isn't it an inclusive approach? Civic nationalism indeed initially presents itself as inclusive, but it is generally associated with a refusal to recognize cultural diversity. Even if it offers a way to cope in a nondiscriminatory fashion with cultural diversity, it does so by avoiding explicitly recognizing the existence of collective rights to those cultural communities. The main problem here is that civic nationalists adopt this strategy even toward national communities. That is, they choose to ignore cultural diversity within societies which are intuitively multinational. However, there are nowadays many "nations" without a state who want to gain political recognition, and it becomes increasingly illusory to think that they could accept being included in a multinational state without getting in return a minimal recognition of their specificity. And it has now become impossible to discard all these national movements as instances of ethnic nationalism. As movements of population become the norm throughout the world, all societies become more and more pluri-ethnic, and this applies also to nations without a state. It is simply wrong to suggest that they all fit the mold of the ethnic nation.

The political, cultural, and social patterns that can be noticed in the Western world at the end of the twentieth century call for a new approach that would not be caught in the dichotomy between ethnic and civic nationalism. Those who are willing to recognize the existence of nations without a state are not necessarily defending ethnic nationalism, and yet such nations have nothing to do with the traditional purely civic nation. Conversely, by recognizing these nations, we are at the same time recognizing the existence of multination states, and this means that we are moving away from the nationality principle which has very often been promoted by ethnic nationalists, that is, the principle that each ethnic nation should have its own state.

Actually, the traditional ethnic and civic views of the nation are just like two sides of the same coin, because both give rise to nationalisms which favor the nation-state as the only adequate political arrangement. An unconstrained ethnic nationalism presupposes that each ethnic nation should have its own state, while civic nationalism tends to exclude minorities by maintaining a policy of benevolent state neutrality. By ignoring all differences that arise within the political community, it favors in the long run a homogeneity within the state. So in that sense, it also promotes, albeit in an indirect way, the political model of the nation-state.

Our call for an account that would go beyond the ethnic/civic dichotomy is thus also motivated in part by a desire to challenge the traditional nation-state. We want to keep our distance from the traditional ethnic approach while recognizing at the same time that there are often many nations within a single sovereign state. And by recognizing them, we

simultaneously keep our distance from a purely civic account which usually tends to refuse such a recognition.[8]

If the only available options for a nationalist were the traditional ethnic and civic conceptions of the nation, it would then be very difficult to make a case for nationalism itself, and we should accept the conclusions drawn by all those who are against it. Conversely, I suppose that all of those who are naturally inclined to denounce all forms of nationalism will be satisfied with the dichotomy, because it confirms their prejudice against the nation. But the proliferation of liberal nationalist movements such as those in Scotland, Catalonia, and Quebec forces us to reconsider these hasty judgments, and reveals the simplistic character of an antinationalistic rhetoric.

These, then, are the fundamental reasons why we wish to go beyond the ethnic/civic dichotomy. It is true that the purely cultural account of the nation already constitutes a third option, but it resembles the ethnic conception too much to be entirely satisfactory. The purely cultural nation is the ethnic nation that has enriched itself by the assimilation of many immigrants.[9] I do not wish to dwell on the difficulties of the cultural account,[10] nor do I want to discard it altogether. But I wish to achieve a more radical departure from the traditional dichotomy. It is on this task that I now concentrate my efforts.

3. An Argument for Tolerance

I defend a certain conceptual pluralism regarding the nation. There is, first, the ethnic nation which involves only individuals having the same ancestry or who believe they have the same ancestry. There is also the exclusively civic account of the nation. In this case, the nation is equated with a sovereign state, a "country." Then there is the purely cultural account according to which being part of the nation requires sharing only the same language, culture, and attachment to the same history. Individuals who belong to the same cultural nation might have very different ancestral roots, but they are individuals who are assimilated to a definite linguistic, cultural, and historical community, Then there is the *diaspora* nation which supposes the existence of many groups having roughly the same culture, which are spread on many discontinuous territories, and which never constitute a majority on any of those territories.

Finally, there is the sociopolitical concept of the nation. According to that account, a nation is, as in the civic definition, a certain sort of political community. But unlike the civic account, this political community may or may not be a sovereign state. Another difference with the civic definition is that the account is not strictly political. It is also partly sociological. According to that account, the political community must contain

at least a *majority* of individuals that share the same language, culture, and history. This majority must also be the majority of the people who, around the world, are sharing these different features. If it were not for that group, the political community would not be a. nation in the sociopolitical sense. Thus, the sociopolitical nation is up to a certain point similar to the cultural nation. But, unlike the purely cultural account, it is not strictly sociological: it is also political. The sociopolitical nation is a political community, and it may even contain, in addition to the national majority, national minorities (that is, extensions of neighboring nations) and individuals of other national origins. So, contrary to the purely cultural account, the sociopolitical nation may be pluri-cultural.

This conception of the nation can all at once be civic and capture a certain sociological reality. According to it, the nation is some kind of inclusive political community, but it also involves what I call a national majority, that is, the largest sample in the world of a group of people sharing a specific language, history, and culture. I shall return below to a clarification of that new conception. For the moment, I wish to emphasize the fact that we must accept a conceptual pluralism. The sociopolitical account of the nation is not the only good account. All the above concepts are, in my view, perfectly legitimate and none of them should supersede the others. There are no such things as the essential features of the nation. The concept of the nation may vary from one community to the other, and so there might be variations from one community to the other on what is to count as a "national feature." Some concepts of the nation are problematic, mainly because those who advocate them do not accept other concepts.

The above concepts are not reducible one to the other, for they are all indispensable in order to account for the complex reality of nationalism. Many authors have admitted that nationalism is a multifarious phenomenon that cannot easily be apprehended, but few have gone so far as to acknowledge that the variety of national movements reflect also a wide variety of concepts of the nation. Even less numerous are those who have defended a conceptual pluralism. Most authors have admitted only one important dichotomy: it is the one that holds between the ethnic and the civic conceptions of the nation. Of course, some are also in a way opposed to the dichotomy, and they hate to have to choose between the ethnic or purely civic accounts, but it is most of the time because they wish to embrace a third account, a hybrid conception which would be a compound of ethnic and civic features. However, if I am right, the mistake is not to argue for this or that conception. It is, more importantly, to engage in a systematic defense of one particular view at the expense of all others. To repeat, the problem is the conceptual monism that accompanies most of the time these different views.

Moreover, the nation should not be understood as an entirely objective fact. There are two consequences that follow from rejecting a metaphysical realism about nations. We have to admit, first, a concept which involves subjective features such as national consciousness, nationalist sentiments, and the will to live together. A population cannot constitute a nation unless it has a certain national consciousness. It must perceive itself as a nation in order to become one.

The second and most important consequence is that our "definition" must be understood as a conception in John Rawls's sense. Rawls talks about a conception of the person, and by this he means a self-representation, as opposed to a description of the essential traits involved in personal identity.[11] Similarly, we should try to develop a conception of the nation which spells out nothing more than the representation that a whole population entertains about itself. It would thus be wrong to think that there is a particular account of the nation, one involving a certain equilibrium between objective and subjective features, which would be the correct account. Saying that nations are to a large extent dependent upon the self-representations of whole populations has far-reaching consequences that must be acknowledged. It is not enough to underline the subjective components involved in the nation, for this is compatible with a univocal account. Since there are many concepts of the nation, and since a nation is partly dependent upon the self-representation of the population as a whole, we have to admit that there could be within different populations different self-representations involving different concepts.

On the basis of those premises, we could formulate an argument for accepting a principle of tolerance toward different nationalisms. The argument requires that we accept, in addition, and as a matter of principle, the intrinsic or instrumental value of cultural diversity. It is intuitively clear that cultural diversity is something that should be cherished. So I shall not try to justify this additional premise within the confines of the present paper. For the purpose of the present argument, it is interesting to notice that if it were accepted, then it would be possible to formulate an argument whose conclusion is that we must adopt a principle of tolerance between different nationalisms. The argument rests upon the following fundamental principles:

1. There are many different concepts of the nation.
2. We should accept a conceptual pluralism in these matters.
3. Self-representations play a crucial role in the construction of a national identity.
4. It is possible for national communities to have different self-representations involving different concepts of the nation.

5. We should accept the principle of the intrinsic (or instrumental) value of cultural diversity.

6. The existence of different national self-representation is an instance of cultural diversity.

7. *Ergo*, we should adopt a principle of tolerance regarding the different self-representations of different national communities.

If I am right, nationalist tensions are often generated by an intolerance which is in part to be explained by a failure to accept a conceptual pluralism regarding the nation. If it appears important to reject the simplistic and dangerous ethnic conception of the nation, it is because, in general, this concept generates exclusion, racism, and xenophobia. But xenophobia begins as soon as one is unwilling to accept a different self-representation held by a different national community. Most of those who promote an ethnic concept reject ways of thinking about the nation which are different from their own.

Of course, this is not always clearly the case. An ethnic nation could also become intolerant toward a different ethnic nation, and thus not directed against a different sort of self-representation. In this case, the clash is not clearly to be explained by the inability to recognize a conceptual pluralism. So I am not claiming that intolerance is always to be explained by a violation of the above principles. There might be all sorts of causes for nationalist tensions, and my claim is only that I have captured one of these causes. If I'm right, the ethnic conception is not to be condemned in itself. Ethnic nations may be peaceful as long as they remain tolerant toward other groups. Tolerance is the key notion for the development of an ethics of nationalism.

It is also important to criticize a purely civic account which would simply identify nations with sovereign countries, if such an account were to go hand in hand with an intolerance toward different conceptions. As we saw, this account also very often generates a certain form of exclusion. Paradoxically, it achieves this exclusion by being too inclusive, that is, by ignoring differences among citizens of the same country, even if these differences include those that relate to language, culture, history, and political community. Intuitively, if you have, for instance, two political communities within the same sovereign state, each one composed of different linguistic, cultural, and historical groups, then chances are that the individuals belonging to those two groups will represent themselves as different national communities, even if these communities are situated on the territory of the same sovereign state. But the defenders of an exclusively civic account of the nation are very often unable or unwilling to recognize that. Once again, the problem lies not in the purely civic account of the

nation as such but rather in the inability of those who promote such a concept to allow for other concepts.

The principle of tolerance that I have just defended as a central idea in the ethics of nationalism inspires my own account of the nation. Of course, we can and indeed we must apply this principle in the context of the relations between different nations, but we should also use it for developing a new account of the nation. Tolerance is required not only for the treatment of the external relations between nations but also for the development of a new sort of national identity, one in which tolerance would become an accepted norm in the internal relations between different cultural groups within the nation. I believe that this is what a sociopolitical conception can do. Tolerance is built in such a view of the nation. It is, as it were, constitutive of the sociopolitical national identity.

Before we look at this new conception, we should, however, spell out a list of different constraints that should be accepted. It is fairly easy to produce a new concept of the nation, but it is much harder to develop one that could satisfy important and intuitive desiderata. This is what I shall now set myself to do.

4. Constraints on a New Definition

There are many constraints that, I believe, should be imposed on any new definition of the word 'nation'. Traditional views do not satisfy many of those requirements. This is perhaps not a reason for rejecting them, but it is a reason for introducing a new conception that would satisfy those constraints.

(i) We should, first, try to avoid as much as possible the traditional dichotomy between the exclusively civic and the ethnic account. These two opposing views describe two extreme positions: particularism and abstract universalism. We should try to avoid having to choose only between these two options. We need not condemn them as such, but we must produce a new conception of the nation that goes beyond them. Contemporary pluralist societies require a government and a constitutional law that can transcend particular views about the good life, and thus one that can transcend particularism. But, on the other hand, within actual multination states there is a need for "cultural protection." So even if a liberal state must follow a certain justificational neutrality, it cannot simply base its policies on abstract universal principles, and governments must do more than promote mere "constitutional patriotism."

(ii) The second constraint is that we should not have any prejudice in favor of or against the nation-state. We should adopt instead a pragmatic approach to the problem of determining whether nations must become

states. There are some cases where the only option for the nation is to remain within an encompassing state. Other nations should secede from the encompassing state. And there are still other examples of nations which could remain within the larger state if their collective rights were recognized. Without such a recognition, however, the rational option for them would be to secede. So we must in a sense depoliticize the definition of the nation. Adopting a particular definition must not be the consequence of adopting a particular political model. Nations can form nation-states or enter in larger political units such as multinational federations. There are also many other options beside these two options. Nations may enter into an economic and political union with others. In Europe for instance, people talk about creating a "federation of sovereign states." Multination states can also allow for a certain amount of political autonomy, a special status, or an asymmetry in the distribution of powers. Too often, those who discuss nationalism have already made up their mind about a particular model of political authority, but we should perhaps be as flexible as possible in this regard. We have to reach a delicate balance between theory and practice. In many multination states, there is no a priori answer to the question whether the component nation must secede or not. It all depends on the capacity of the encompassing state to recognize its multinational character.

In section 2, I have argued that among the reasons for rejecting the classical dichotomy between the ethnic and the purely civic accounts of the nation, there was the fact that each view presupposes that the best political arrangement is that of the nation-state. Now, I am saying that we should reject any account which has a prejudice for or against any particular political arrangement. Nations may or may not have their own state. This is not something that must be decided at the outset, in the very definition of the nation.

(iii) Let us now consider a third constraint. It concerns the equilibrium between individual and collective rights. Too often we interpret nationalism as involving the primacy of collective rights over individual rights. The right to self-determination, for instance, is often interpreted as superseding all other rights. But our conception must avoid ethical collectivism as well as ethical individualism. The right of self-determination must not become a way to impose the tyranny of the majority over the minorities, and multination states must perhaps find accommodation for an equilibrium between the collective rights of its component nations and the fundamental individual rights and liberties of all the citizens.

This third desideratum is in a way a consequence of the second one. If we are to allow for the possibility of multination states, we must at the same time grant to the component nations a certain recognition in the public space. It makes no sense to argue in favor of multination states while

at the same time refusing them a certain amount of recognition. It should
be obvious that the viability of multination states rests to a very large
extent on their ability to recognize themselves as multinational, and this,
in turn, requires a recognition of the collective rights of the component
nations. The only way to accommodate pluralism within a contemporary
society is to adopt a policy that acknowledges its deep diversity. But at the
same time the account must not induce a proliferation of collective rights
for all sorts of groups. If we were to do so, we would go against the pro-
tection of civil rights and liberties of all citizens. So we must produce an
account which will all at once be favorable to the admission of collective
rights and which will avoid attributing such rights to all sorts of groups.
One reaches in this way a delicate balance between individual and collec-
tive rights.

(iv) A fourth important constraint is that we must, in our definition,
achieve an equilibrium between the subjective and the objective compo-
nents of the nation. Nations are not just "imagined communities,"[12] that
is, pure abstract constructs or products of our imagination, but they are
not entirely objective entities that transcend the self-representations of
individuals. Language, culture, and history are to a large extent phenom-
ena that go beyond the self-representations of individuals, but nations do
not exist without a certain amount of national consciousness, a sense of
shared identity, and an explicit will to maintain this shared identity.

Some feel inclined to say that there are as many concepts of the nation
as there are individuals. They feel that the nation is entirely a subjective
matter. Even worse, some are prepared to say that since nationhood
depends very deeply upon a sense of allegiance, it becomes impossible to
find within a given population a common sense of belonging to a particu-
lar nation. In these matters, we have to look for the individual's sense of
belonging in order to determine his or her affiliation. It is thought that we
have to take into consideration what they value the most for the pursuit of
their own happiness. And since these feelings vary systematically from one
individual to the other, we feel inclined to say that nationalities, and thus
nations themselves, are reducible to personal preferences, psychological
inclinations, and an undefinable sense of belonging. But this relativism is
grossly exaggerated. Even if we are far from having reached a consensus,
and even if different individuals rate differently their different allegiances,
they could still agree on the fact that they share the same national affilia-
tion. To put it differently, even if nations are to a very large extent subjec-
tive, we should not analyze nationhood in terms of the preferences that
individuals attach to their different particular affiliations. In order to reach
a balance between the subjective and objective features of the nation, we
must avoid defining it in terms of the preferences of the individuals. It does
not matter whether a national allegiance is a primary good for each and

everyone. Of course, we rate our affiliations to different groups very differently, and it might very well be that a large segment of the population does not give much importance to their national affiliation. Nevertheless, most people recognize that they do have a national affiliation, and they share an intuitive sense of nationhood. This is all that we must consider when we talk about the subjective character intrinsically involved in our conception of the nation.

(v) Our concept must have positive moral repercussions. It must not be a purely descriptive concept and must not be normatively inert. It must in some sense be useful as a guiding principle for our actions or useful for our theory of nationalism. No matter how we choose to define the concept, it must be possible for the nation to exercise self-determination. The nation must have certain rights that it can exercise under special circumstances and these induce obligations on the part of other nations. When these obligations are not fulfilled, our definition may play an important role in an argument which leads to a solution of the problem of political recognition. The definition must not entail that the nation is under no circumstances whatsoever going to be able to exercise its moral right of self-determination. But at the same time, our account must not be such that all nations could be entitled to exercise whenever it wants a full right to self-determination. From a moral point of view, there must be conditions under which it could be reasonable for the nation to secede, and our definition must not be such that it allows all sorts of groups to secede.

(vi) The conception must also be developed in accordance with a liberal political philosophy. This is a constraint that I wish to impose upon my definition because I wish to apply the concept mostly to Western societies. I wish to remain as neutral as possible concerning the possibility of exporting the concept to non-Western societies.

(vii) Our concept of the nation must have many applications within different societies. It must not have been made only to account for a single case. The conception must thus be available for a certain generalization.

(viii) Finally, our definition must meet the intuitions held by a large number of individuals within the population. It must coincide to a large extent with the implicit conception shared by a large number of individuals. This constraint could thus be understood as a material-adequacy condition imposed on the definition.

So we now have eight important constraints that must guide us in our formulation of a new definition of the nation. Such a definition must neither be ethnic nor exclusively civic in order to reach a delicate balance between particularism and abstract universalism. We must also avoid presupposing anything in favor or against the nation-state if we want a harmonious relationship between theory and practice. We must reach an equilibrium between individual and collective rights. We must also try to

formulate a balanced account between the subjective and objective components of the nation. The concept must have favorable practical consequences and must be compatible with a liberal political philosophy. The definition should not have applications just for the particular case of a specific political situation with no applications anywhere else in the world. It will not be useful if we are unable to reach a certain generality and a multiple applicability. Finally, it must corroborate as far as possible the intuitive definition shared by the population.

I shall not dwell any further on these issues and will avoid a detailed discussion of the motivations for introducing such a list of constraints. For the purpose of the present paper, I am happy just to state these different requirements without any additional argumentative support. I believe that they should be met by any new definition, but it is first and foremost on such a definition that I wish to concentrate my efforts.

5. A New Definition

There is a vast literature on the theory of nationalism, and we must be very humble when we attempt to be original on this matter.[13] I shall nevertheless try to define the concept of the nation in a new way. However, I do not claim to be able to formulate necessary and sufficient conditions for the existence of a nation. The best that we can do is perhaps to draw some vague boundaries for some of the uses of the term. We are attempting at best to describe a particular stereotype. If a definition provides only a stereotype, it means that the concept is not defined in the absolute. It is not defined once and for all and it is not meant to be exclusive. Saying that we want to produce a stereotype means that our definition is at least in part community-relative, and by this I mean that it is the product of a certain political culture. Definitions can vary from time to time and from one political culture to another. As we saw in the previous sections, the word 'nation' may be used in all sorts of ways, and each of these uses may also be subjected to modifications from time to time.

It is often said that to appeal to the concept of the nation in a political debate is divisive, that it cannot create a consensus, and that we should be pragmatic and avoid it as much as possible. But we must not ignore the fact that we use the concept, and that many take for granted the ethnic/civic dichotomy in political debates. As we saw, this dichotomy is operative in most normative appreciations of national movements. It justifies a certain standard attitude toward nationalism in general, and it serves the political purpose of those who want to denounce all nationalist movements in actual sovereign states. So this already provides a good

motivation for producing a new definition. Moreover, the reason why nationalism seems to escape all attempts at a definition is perhaps because we have so far been reluctant to accept many different concepts, and have been fairly unsuccessful in our attempts to create new concepts which would be sophisticated enough to capture complex realities. So perhaps the problem is not of trying to define the nation but rather of being unable to accept a conceptual pluralism and to be creative enough. Those who criticize any attempt at a new definition do not realize that, by so doing, they could very rapidly find themselves siding with those who have a simplistic account of the nation, and thus also a simplistic understanding of nationalism.

So let us look now at the definition. Under that definition, the nation is seen as some particular kind of political community. It is a political community that has certain sociological properties. Therefore, I endorse a sociopolitical conception of the nation. It is only one concept of the nation among many. Another very important one is the nation conceived as a diaspora. It is important to bear in mind that this other sort of nation also exists. As a matter of fact, my own definition provides indirectly a criterion for the notion of a diaspora nation.

According to the sociopolitical conception, the nation is a political community containing a "national majority," that is, a group which is a majority on a given territory which also happens to be the majority of a group of individuals sharing the same language, culture, and history around the world.[14] The political community also very often contains "national minorities" (that is, extensions of neighboring national majorities) and individuals with various other national origins. In addition, a critical mass of individuals within this political community must perceive themselves as part of a nation and must be willing to continue to live as such. Finally, the political community must have its own particular territory.

The political community, as a whole, must be defined in terms of a "common public culture," that is, a common language and a common structure of culture in a common context of choice.[15] By a "language," I mean essentially a set of social conventions, such as a dictionary and a grammar, which are essentially the product of the community. The notion of a language must not be cast in a holistic account which would inextricably link it to a complete world view. By the "structure of the culture," I mean a set of basic political, social, and specifically cultural institutions. The features of the common public culture happen to be those of the national majority, and we describe them as "common" because these must be compatible with the existence of specific linguistic and cultural institutions held by minorities within the nation. Finally, by a "context of

choice," I mean a network of cultural, moral, and political influences. These external influences are mainly caused by countries which are in a certain geographical proximity, or by countries that have historical or linguistic similarities.

This account of the nation is political in the sense that a nation is a political community. According to this view, nationality is understood as citizenship just as in the traditional civic account. But if citizenship must be defined as membership in a political community, there still can be within a single sovereign state many different political communities. This is a first difference with the traditional civic account. It allows the political community to be less than a sovereign state. But there is a second and most important difference. Unlike the exclusively civic approach, it is not defined only in terms of a political community. It is a political community that contains a national majority and—if there are any—national minorities and individuals of different origins. If we were to define a nation as a political community that can be less than a sovereign state without entering into the sociological fabric of the population involved, we would unfortunately be unable to distinguish between the citizens of a city and those of a nation or a country. We thus would run the risk of allowing for national self-determination to very small populations on very small territories. My own account appeals to the notion of a political community, but it does not appeal to that only. A final and crucial difference with the traditional exclusively civic model is that the sociopolitical nation *recognizes* its pluricultural character. It seeks to harmonize the rights of the majority with the collective and individual rights of its national minorities.

By "national majority," I said that I mean the majority of a group of people sharing the same language, culture, and history. Notice, first, that I am not defining the national majority in terms of language only, but also in terms of culture and history. If we were to consider language only, there would be just one English-speaking nation, namely the United States, and only one French-speaking nation, namely France. But two communities sharing the same language can have different cultural influences and different historical roots, and for that reason, can form different nations. Notice also that the national majority is not just a majority on a given territory. It is, world wide, the majority of individuals with such a specific language, culture, and history. Being a majority on a given territory is not by itself sufficient to form a national majority. If we were to see it as sufficient, we would not be able to prevent the proliferation of nations. It is indeed always possible to multiply "majorities" in this way. You only need constantly to reduce the territory. This is why I say that the national majority is located where we find the majority of a population having the above specific features around the world.

This concept of a national majority is also useful for defining the diaspora nation.[16] Let us suppose, first, that a given population sharing the same language, culture, and history is scattered on many distinct discontinuous territories. Let us suppose also that there is no concentration of such individuals which constitutes an absolute majority. Let us suppose, finally, that all the samples of such individuals form minorities on their respective territories. If so, we would then be dealing with a diaspora nation, not with a sociopolitical nation. A diaspora nation is a nation that lacks a national majority.

The concept of a diaspora nation is thus derivable from the one that I am trying to define. But if we are speaking about sociopolitical nations as such and not just about diaspora nations, then the sample is a majority on the territory and it is also the majority of a group of people having the same features.

6. Four Key Notions

The above definition could be expressed in a few words. A sociopolitical nation is a political community composed of a national majority, and very often of national minorities and ethnic communities. All share a certain national consciousness on the same territory. There are at least four key notions involved here: political community, national majority, national consciousness, and territory.

(a) Political Communities

According to this definition, countries like Israel, Estonia, Latvia, Lithuania, Slovakia, the Czech Republic, Bosnia, and Croatia provide examples of political communities which could eventually form sociopolitical nations. Israel contains a Jewish majority and a Palestinian minority. Estonia, Latvia, and Lithuania contain respectively Estonian, Latvian, and Lithuanian majorities and Russian minorities. Slovakia contains a majority of Slovaks along with a Hungarian minority. The Czech Republic contains a Czech majority and a German minority of Sudetens. Bosnia contains a Muslim majority with Serbian and Croatian minorities, and Croatia contains a Croatian majority and a Serb minority. Serbia contains an Albanian national minority in the province of Kosovo.

These would all be examples of sociopolitical nations which have their own state. These political communities are always involved in a tension between the classic purely civic account and a more progressive sociopolitical conception. When a country contains national minorities, it is not well

suited for a purely civic account of the nation, and most of the above countries will sooner or later have to recognize their irreducible pluralist character. So I am not suggesting that all of them have already become sociopolitical nations. I am simply suggesting that they are inescapably leaning in that direction.

Sociopolitical nations are also sometimes political communities which are less than sovereign states. For instance, Catalonia, which has had its own political community since 1979, contains a Catalan majority and a Castillian national minority. In that sense, it has all the ingredients for becoming a true sociopolitical nation. To give a second example, now that Belgium has become a federal state, we can say that if the Flemish majority living in the five provinces of Flanders were formally to recognize the collective rights of the French minority living in Brussels, the Flemish nation would become a true sociopolitical nation. Within Canada, Quebec also forms a sociopolitical nation containing a majority of French Quebecers and a national minority of English Quebecers. Finally, because of the positive result of a referendum on a devolution of powers to a local government, Scotland is transforming itself from a purely cultural nation into a sociopolitical nation. In other words, Spain, Belgium, Canada, and the United Kingdom are all examples of multination states that contain nations which are or could eventually be good candidates for sociopolitical nations.

Of course, the process by which a group becomes a particular sort of nation is a never-ending process, and so our account must be a dynamic one. Within each of those political communities, there are individuals who have different representations of their nation. And even when a group represents itself as a sociopolitical nation, it can as a matter of fact behave more like a purely civic nation. But the above examples are clear cases of groups that are increasingly becoming sociopolitical nations.

(b) National Majorities

The originality of the concept lies partly in the requirement that the linguistic majority has to be the majority of a group of people with a specific language, culture, and history. It must always be possible to find on a certain territory a group of people constituting a majority, and this does not turn the group into a national majority. It won't if the majority of the people with the same language, culture, and history is to be found elsewhere.

The originality of the concept lies also in the fact that it is compatible with admitting "national minorities" as integral parts of the nation. As we have seen, national minorities are minority extensions of closely related national majorities existing on different territories, with their members

perceiving themselves in that way. According to this concept of a "national minority," the Russians in the Baltic states, the Hungarians in Romania or Slovakia, the Palestinians in Israel, the Sudeten Germans in the Czech Republic, the French Belgians of Brussels within the Belgian Flemish territories, and the Anglophones within Quebec are all examples of national minorities.

(c) National Consciousness

I have already said that national consciousness, the will to live together and the sense of belonging to a nation, are essential ingredients in the definition. National consciousness relates to the self-representation of the group as a whole. This subjective component not only involves a description of what the nation is, but also an expression of what it wants to be. It is with this self-representation that we are able to determine whether the group sees itself as an ethnic, cultural, civic, or sociopolitical nation.

The will to live together suggests that we can choose to be part of the nation. This is surely an obvious requirement if we are to allow immigrants to be part of the group. However, there is still a crucial difference between a nation and an association. The sociopolitical nation is a certain kind of political society and, as Rawls has emphasized, there are important differences between associations and political societies. We can always freely disengage ourselves from associations, but we have no such option when we choose to settle down on the territory of a particular political society. The only way to remove oneself from the authority of a particular political society is to move outside of the territory.[17]

The sense of belonging relates to the subjective involvement of the individuals in the nation, and it need not be shared equally by everyone. Many individuals may value more some of their other allegiances, whether to their family, their friends, their fellow workers, their city, or those that share the same sexual orientations. Indeed, we have to admit that individuals may give different priorities to their different social affiliations, but most individuals also have a sense of belonging to a particular nation. If it is so special, it is not because it is the most important allegiance. It is rather because it is the most common one.

(d) Territories

The territory also plays a role in the determination of the population that composes the nation. Less numerous communities that share the same language, culture, and history, but that are outside the territory, do not

belong to the nation, while minorities with a different language, culture, and history that we find on the same territory may be part of the nation. Very often the territory will have been determined by legislative regulation. These may coincide in some cases with actual frontiers between countries, but it may also coincide with internal frontiers such as those imposed by cantons, states, republics, provinces, or *Länder*. For example, Belgium is a multinational country containing essentially two different nations, the sociopolitical Flemish nation and the purely cultural Walloon nation. I ignore the Germanophone community which is more like a national minority. There is, of course, also a very large number of French Belgians (perhaps a majority?) who still represent themselves only as part of an exclusively civic Belgian nation. Indeed, there is no univocal self-representation within the French Belgian community. And since there is a large number of French Belgians in Flanders, there is perhaps a majority of French Belgians who would be reluctant to approve of a partly territorial characterization of their own nation, within the boundaries of five provinces out of the ten that we find in Belgium. But this is not true of the Flemish nation, since it does indeed represent itself as occupying the five other provinces of the country.

Sometimes, territorial divisions do not determine a unique nation, since there are other nations on the same territory. The territorial boundaries of the Baltic states coincide in each case with a unique nation containing Russian national minorities. But on some other occasions, even if the boundaries serve to determine the location of one nation, it can cohabit with many other nations. This is actually the case with Russia. The Russian population is spread out on many different territories, but it is on the Russian territory that we find the Russian nation. So the territory is an important criterion that determines the extension of that nation. But at the same time, there are many other nations on the Russian territory, like the Chechens for instance.

The same remarks apply in the case of Quebec. It is in that province that we find a Quebec sociopolitical nation, containing an English national minority and individuals of other national origins. But this does not mean that the territory serves to determine the existence of a single nation. There are also eleven aboriginal peoples living partly or totally on the same territory. So Quebec is a multinational state and it would remain multinational even if it were to become sovereign.

As we have just seen, even if the sociopolitical nation is not strictly defined in territorial terms, the territory plays a role in its determination. But sometimes territories may overlap. There might be different territorial boundaries that conflict with each other, and it is especially the case with aboriginal nations. These nations occupy a piece of land in ways that have

nothing to do with the traditional "European" views about the nature, extension, or significance of territorial delimitations. In North America, for instance, they have historically occupied territories that have nothing to do with Canada's division into provinces or with the U.S. division into states. Nevertheless, these nations have territories even in the judicial sense. In the 1982 Canadian constitution, for example, their ancestral rights were recognized and these entail at the very least a right of territorial occupation, even if it is not clearly delineated. And as these nations progressively move toward public governments on specific territories, they consolidate their territorial presence. Saying that the territory serves to define the nation does not mean that the same kind of boundaries should be invoked for all nations, nor that boundaries cannot in some sense overlap.

It is true that almost 45 percent of the aboriginal population living in Canada are in cities and do not clearly occupy distinct territories. These cases are akin to the case of diaspora nations, even if there are important differences between the two. I shall not try to dwell on these difficult problems though. I shall be happy to say simply that the concept of sociopolitical nation makes use of the notion of a territory, but that it is not so for cultural nations, diaspora nations, or those aboriginal nations which are dispersed into cities, as it is so often the case with those who live in North America.

To sum up on the notion of the territory: We often speak about the territorial definition of the nation. This means that any individual living on the territory of a state is part of the nation. This account won't do for the purpose of characterizing sociopolitical nations because, according to my account, there can be many different nations living on the same territory. As such, the purely territorial definition is just a variant of the exclusively civic account. And so, even if we use the notion of a territory as one of the main criteria, we cannot rely exclusively on the territorial criterion in order to determine who the members of the nation understood in the sociopolitical sense are.

So this is the definition that I wish to introduce in addition to the ones that are already available in the literature. In addition to the exclusively civic nation, the ethnic nation, the cultural nation, and the diaspora nation, we must accept also the sociopolitical conception of the nation.

7. Meeting the Constraints

In what follows, I consider different motivations for adopting this particular concept. The arguments I will put forward concern the constraints previously mentioned. I shall try to show that the above definition satisfies these different conditions.

1. Our concept can be distinguished from the ethnic and purely civic conceptions. These views very often negate the fundamentally pluralistic character of contemporary societies. Ethnic nationalism very often leads to violence and racism while the purely civic forms of nationalism lead to exclusion and forced assimilation. According to the traditional civic conception, nations are nothing more than sovereign states. But with that concept, we are unfortunately unable to say that Catalans, the Flemish, the Scots, Quebecers, Acadians, and Aboriginals have their own nations. My account does not necessarily treat these traditional views as illegitimate, but those who would like to endorse them must apply a principle of tolerance and recognize that there are different sorts of nations. And as soon as we allow for new accounts such as the cultural, the diaspora, and the sociopolitical conceptions of the nation, we begin to see that this variety of concepts is irreducible and that all of them can enhance our understanding of nationalism.

2. The account does not involve any prejudice in favor of or against treating nation-states as the best political arrangements. Nations may enter into political communities with other nations. Nothing in what I said prevents us from considering this possibility. As a matter of fact, I gave examples of sociopolitical nations which were sovereign states and examples which were not sovereign states. So there is no a priori bias involved in the account in favor of or against any particular model. Nothing prevents us from admitting multination states. There is no difficulty in allowing for many ethnic, cultural, or sociopolitical nations into the same political community or within a purely civic nation. When the encompassing entity is a purely civic nation, the component nations are nations within a nation, and there is surely nothing wrong with that.

Conversely, we are not committed to the claim that the nation-state is bound to disappear. It is now customary to hear talk about the end of the nation-state. We are being told that we must transcend the old model and adopt instead the idea of multination states. We are told that we should believe in multicultural citizenship. But actually, all forms of cultural pluralism must be implemented and these might begin "at home," that is, within the nation itself. The very concept of the nation must be understood so that it can become pluricultural. It would be pluricultural if national majorities were to coexist with minorities in the context of a single political community. Now my concept is precisely of that sort. It is one that can accommodate cultural pluralism within a nation-state as such. We should perhaps talk about the end of the traditional nation-state which was understood only in terms of common allegiances and which did not recognize the existence of many different cultures within the nation. But sociopolitical nations are all at once polyethnic and multicultural, and

when the concept of the nation is so understood, we should have nothing against nation-states.

3. Another aspect of the proposed definition is that it allows us to reach an appropriate balance between individual and collective rights. Many authors refuse to recognize any collective rights at all, and it is in part because they fear that all sorts of groups would want to be granted such rights. We would have to allow such rights to an endless variety of groups. But this is not a consequence of the present account. It must be remembered, first, that collective rights must not be reduced to the external protections of a minority from a majority, for they must also involve internal restrictions of the community as a whole over its individual members. Now when it is understood in this way, it appears that a collective right can only be enjoyed by a societal culture, for it is only in that case that the right can irreducibly be interpreted as a restriction imposed by the group and not as an external protection for a collection of individuals. Now this severely limits the number of groups entitled to collective rights. If we correctly understand collective rights as rights that can reasonably constrain the behavior of individuals within the group, then the only "true" collective rights are those that could be entertained by a societal culture, and the only groups that can meet this condition are pervasive linguistic communities.[18] If collective rights were not understood as imposing internal constraints on the liberties of citizens, they could always be analyzed in terms of special individual rights, and we would have then no reason for limiting the number of admissible groups.

Now under my account, the only groups that could be entitled to such rights are nations, national minorities, and some lasting immigrant communities that have themselves become societal cultures. These are all pervasive linguistic communities and thus irreducible collective bodies that can be characterized as societal cultures. I am therefore not committed to a proliferation of collective rights. By restricting the recognition of collective rights only to those groups, I am able to avoid a slippery slope that would force us to recognize collective rights to all kinds of groups.

4. My definition also incorporates an appropriate balance between the subjective and objective features of the nation. According to my account, a nation is to a large extent a self-representation. But the main characteristics of a nation are not those that are simply *valuable* for the individuals. We should not consider individual preferences as part of the self-representation. Individuals may assign different values to different features, but these preferences do not serve as criteria for determining among all their features the ones that are to count as "national." It would also be wrong to think of the nation as something entirely reducible to one's sense of belonging. Nations are more than that, as suggested by the different com-

ponents I have been describing. The concepts of national majority, national minority, and political community involve objective features.

But I have also argued that there is no nation if a critical mass of individuals within this political community do not represent themselves as belonging to a nation. Nations exist only if the individuals within the group tend to describe themselves as being part of a nation. The same kind of remarks apply to the members of national minorities. In order to be part of a national minority, it is not sufficient to be as a matter of fact an extension of a neighboring national majority within a political community. One also has to represent oneself as being part of that political community, and represent oneself as part of a national minority.

5. One of the most important motivations for accepting the definition is that it guarantees considerable political stability for those countries or political communities which contain national majorities, national minorities, and immigrant communities, and which would be ready to recognize the collective rights of these minorities. It is a pluricultural conception which, for that reason, intrinsically incorporates a principle of tolerance between cultural groups. It allows the inclusion of national minorities and immigrant communities within the nation. So we are, in effect, developing a conception which prevents a complete reshuffling of international borders. This is something which, I am afraid, cannot be achieved by the purely cultural account of the nation.

Moreover, those sociopolitical nations which are less than politically sovereign can, under special circumstances, be good candidates for the exercise of a full right to self-determination. They are already political communities, they already have a determinate territory and they already form a pluricultural society. So the fact that they would achieve independence would not create as much instability as would, for instance, an ethnic nation. Ethnic nations very often do not have political communities, and thus do not occupy a determinate territory, and they do not allow for cultural diversity. So it is hard to see how they could easily achieve independence without creating an enormous turmoil. I am not suggesting that there are no circumstances under which they could be justified in doing so, but they present additional difficulties. Furthermore, there is a very large number of ethnic nations all over the globe and this creates an additional difficulty for those who would like to grant them an equal moral right to secede. The situation is even worse for diaspora nations. But I want to argue that in the case of sociopolitical nations like Scotland, Catalonia, or Quebec, the situation is different. They could, under very special circumstances, have a morai justification to secede.

Some think that the cultural definition is the one to be favored, but I doubt it very much. The cultural view can be criticized (assuming that it is understood as the only adequate account) because it tends to make it

almost impossible for a nation to exercise its right to self-determination. Most cultural nations are spread on different territories. It is hard to imagine the conditions under which they could secede without violating the *uti possidetis* principle, that is, the principle according to which the seceding state retains its original frontiers after secession. Indeed the secession of a cultural nation would also be divisive for its own territory, if a cultural minority occupies the same territory. With a cultural concept of the nation, one is also unable to distinguish between national minorities and nations. One thus multiplies the number of candidates for nationhood and turns the suggestion that each one of them could enjoy a full right to self determination into an absurdity.[19]

Since the constraint that I am now discussing is the most important one, let me dwell on it a little more. There are other positive moral repercussions to be mentioned. The sociopolitical conception may also be useful in distinguishing between secession and partition. The first can only be performed by a nation, while the other is an act that can be performed by a subgroup within the nation, such as a national minority. It is sometimes the result of an ethnic nationalism, if not of plain "ethnic cleansing." It is most of the time illegitimate.[20]

Our definition goes beyond an exclusively civic conception and allows us to recognize subgroups within the state as nations, but we are not forced to treat national minorities as nations. On the contrary, our definition enables us to distinguish national minorities and nations. In so doing, we are able to prevent an escalation in the attribution of a full right to self-determination. With our definition we are able to recognize the existence of many different nations within a sovereign state without granting such a recognition to all the cultural groups within that state. Our definition thus satisfies our fifth requirement for a further reason. We are not in danger of having to recognize a right to secede to all sorts of groups. We could eventually be able to restrict the moral right to secede only to a very small fraction of cultural groups. Many accounts fail to give a plausible justification for exercising such a right. According to many different accounts, it is a right that many groups can claim for themselves, whether they are nations or not. But this kind of disastrous result shows why it is important to propose a sociopolitical definition. It is prescribed for moral reasons. We must arrive at a definition which implies that only some groups can, under special circumstances, be morally justified in making full use of a right of self-determination, and we must also arrive at a definition which usually prevents subgroups within a nation from doing so.

There are, under my account, many differences between national minorities and nations. There are, first, sociological differences. A national minority is an extension of a neighboring national majority, while a sociopolitical nation contains national majorities. But we can also distinguish the

ways in which both of them would exercise a full right to self-determination. In the case of national minorities, it would be through partition, while in the case of the sociopolitical nation, it would be through secession. So this is a second difference between the two groups. These two acts, secession and partition, are quite different because they are performed in two different contexts. A secessionist movement takes place when a component nation wants to achieve independence from an encompassing state. But a partitionist movement is one that occurs when a subgroup inside a population involved in a seceding process refuses to be part of that process. It always occurs simultaneously with a seceding process, and it always occurs because of the intervention of a third party. So partition and secession are two very different kinds of processes, and this is a second difference between national minorities and nations. The first exercise their full self-determination through partition, while the second exercise their full self-determination through secession. Finally, national minorities have different sorts of motivations for wanting to violate the territorial integrity of the encompassing state. Their motivations are very often irredentist or loyalist. Their goal is very often to remain part of the old state. This is, for instance, what happened in the cases of Bosnian Serbs or the Protestants in Northern Ireland.

So there are clear differences between national minorities and nations.[21] The two groups are sociologically very different, and when they violate the territorial integrity of an encompassing group, they do it in two different ways: through partition or secession. And finally, they do it for very different reasons. Of course, not all partitions are performed by national minorities. In the cases of Pakistan and Palestine, the groups involved were ethno-religious nations. So for that reason it could be thought that there are no clear difference between partitionist movements and seceding movements. But I want to claim that a huge difference subsists between ethnic groups and national minorities on the one side, and sociopolitical nations on the other. In the latter case, we are confronted with a full societal culture, an encompassing political community which occupies a determinate territory. The exercise of a full right to self-determination, in this case, has nothing much in common with "ethnic cleansing," irredentism, or partition. I am not saying that there are no contexts in which a national minority could be justified in partitioning the territory of a nation, but it must be granted that it is most of the time an illegitimate process. And I am not saying that all sociopolitical nations have the moral legitimacy to secede. I am just saying that the determination of the moral justifications is easier in this case, and that the process is in general much less morally suspect. If I am right, the political legitimacy of secession for sociopolitical nations is in general much less controversial than for other kinds of national or ethnic groups.

I have discussed the differences between ethnic or cultural nations and sociopolitical nations. I have argued that secession becomes more and more problematic when the nation ceases to be a sociopolitical nation. One can also make a clear distinction between national minorities and sociopolitical nations, and it can be claimed that the political legitimacy for violating the territorial integrity of an encompassing state decreases when the subgroup is a national minority and not a sociopolitical nation, and the reason is that national minorities are just parts of nations. Indeed, it should be clear that if we begin to allow for a complete self-determination even to those groups which are parts of nations, then we shall be unable to prevent an escalation in the process of secession.

By distinguishing ethnic, cultural, and diaspora nations from sociopolitical nations, and then distinguishing the latter from national minorities and immigrant communities, I am thus able to move away from a simplistic evaluation of the exercise of a full right to self-determination. These different groups exercise self-determination in different ways and for different reasons. By making all these distinctions, we are able to reflect upon the complex set of moral justifications that should be considered in order to adjudicate different nationalist movements.[22] It is in this sense that our definition has positive moral repercussions.

6. The definition that I am proposing is perfectly compatible with a liberal political philosophy. I said that, according to the account, nations can remain within larger multination states as long as they are in some sense "recognized." But this recognition does not entail endorsing a specific set of illiberal values and it does not mean that the collective rights of nations have an absolute priority over the individual rights of citizens. Let us look at these two claims successively.

The protection that is required is that of a language, a structure of culture, and a context of choice. These are structural features of the sociopolitical nation. The protection and promotion of these features have nothing to do with the protection and promotion of a particular view about the good life. It should not be interpreted as a communitarian requirement. It is perfectly coherent for a liberal philosopher to require the protection, promotion, and recognition of the existence of many distinct national communities within a multination state. By doing so, the state does not violate a justificational benevolent neutrality. As I have characterized them, sociopolitical nations are just political communities understood as involving a *lingua franca*, a common structure of culture and a common context of choice. By protecting these structural features of the nation, we are not advocating some kind of dubious national partiality or going against the preservation of cultural pluralism, for we are, on the contrary, precisely preserving cultural pluralism. Indeed, it could be claimed that, by implementing policies that seek to protect different

national political communities, we are, in effect, fighting for cultural pluralism. Different structures of culture have different contexts of choice and each one opens up new possibilities. By protecting them, we preserve different sets of moral, cultural, and political options.

There is a second confusion that can arise and that can partly explain why some mistakenly believe that our account goes against political liberalism. Those who think that the constitutional recognition of national diversity within a multination state is incompatible with liberalism very often make a wrong equation between liberalism and ethical individualism. Liberalism is committed to the protection and promotion of liberal values, and these are to a large extent individual liberties and freedoms, but it is also perfectly compatible with an equal promotion and protection of nations understood in my sense. In order to be a liberal, one need not be an ethical individualist.

Rawls himself acknowledges the existence of collective rights for peoples.[23] Nowhere does he suggest that those rights should always be subordinated to the fundamental rights and liberties of individual citizens. He has elaborated his two principles of justice in the simplified context of a closed society, and his *Law of Peoples* is developed in the simplified context of an international arena in which all peoples would have their own state. So he does not consider the particular case of a multination state in which the two principles of justice would be implemented next to those concerning peoples. This is why we cannot claim that he is committed to the view that fundamental individual rights have an absolute priority over collective rights of peoples. And so it is false to suggest that Rawls endorses an individualistic political philosophy.

There is a third and final consideration to bear in mind when considering whether my view of the nation is incompatible with political liberalism. Some have suggested that liberalism is implicitly linked to nationalism. Liah Greenfeld, for instance, argues that, contrary to what has been taken for granted by modernists who wish to explain nationalism as a byproduct of modernization, it is nationalism that gave rise to modernity.[24] In the same vein, Margaret Canovan has recently claimed that most liberal accounts have been formulated within the framework of the nation-state.[25] They take for granted the existence of nationhood, and presuppose its existence at the very core of their theoretical accounts. This is also true in the case of Rawls, who has argued that the two fundamental principles of justice must, at first, be implemented in the simplified context of what he calls a "closed society." Such a society looks very much like a nation-state. For all these reasons, it is quite problematic to suggest that nationalism is incompatible with liberalism. I could add that it is especially so for any account which is constrained by a principle of tolerance.

7. I believe that the sociopolitical definition has important implications for many countries. I previously mentioned that the definition could account for the multinational character of Belgium, Spain, Canada, and the United Kingdom. I also suggested that it could justify treating as an integral part of the nation, national minorities such as the Russians in the Baltic States, the Hungarians in Slovakia, or the Arabs in Israel. I can also add that, with such a concept, one can make sense of the existence of a single nation for the whole of Ireland, with one important national minority of British Protestants (whether or not the unification of Ireland is an available option for the present). It can also explain why it would be correct to treat Bosnia as containing a single Bosnian people, understood in terms of a political community between a Bosnian majority of Muslim faith, together with national minorities such as the Bosnian Serbs and the Bosnian Croats. The fact that the territorial integrity of Bosnia was almost not preserved by the Dayton Treaty is not an argument against my view of the nation as involving a national majority, national minorities, or immigrant communities. If anything, the Bosnian tragedy gives us a further reason for recognizing the moral fruitfulness of the sociopolitical conception.

The sociopolitical definition also has important applications to the Canadian case. Whether Quebec becomes sovereign or not, it is itself already a polyethnic, pluricultural, and multinational federated state. And if Quebec were to separate, Canada and Quebec would still remain polyethnic, pluricultural, and multinational. What is essential is that all of these states be able to acknowledge their deep diversity. My concept is intended as a contribution which is meant to deepen our understanding of this kind of diversity.

8. Finally, the sociopolitical definition coincides with an intuitive concept of the nation. Considering the case of Quebec, those citizens who are part of the Quebec political community are all members of the Quebec nation, while the aboriginal population constitutes eleven distinct nations on the same territory. My definition also conforms with formulations that have now become customary within the Quebec community. I think of such expressions as the 'national assembly', the 'national library', or the 'national holiday' that are now part of our vocabulary, in either French or English. These expressions reveal the existence of a certain national consciousness, but they also reveal the existence of an inclusive account of the nation. These expressions describe institutions enjoyed by all the people of Quebec, and not only by a sub-group within the political community. At the same time, Quebecers are perfectly aware of the needs of the Francophone majority and the rights of its Anglophone national minority. They believe that there would not be a Quebec nation if it were not for the existence of a majority of French Quebecers, but they are also aware that

they must protect the acquired rights of English Quebecers. All of this confirms that the definition satisfies the material constraint of capturing a concept intuitively accepted by a critical mass of the population within the community.

8. Conclusion

The previous discussion provides an argument for the rehabilitation of a certain form of nationalism. The word 'nationalism' should no longer be condemned, since it no longer involves a defense of the principle of nationality according to which each nation should have its own state. The word now refers only to the defense of the collective rights of nations, whether the word 'nation' is understood in the ethnic, civic, cultural, diaspora, or sociopolitical sense. As long as we endorse a fundamental principle of tolerance toward the self-representation of different populations, we can and should protect and promote the collective rights of nations. Many reject the word 'nationalism' and suggest instead replacing it with some other expression, for example, 'constitutional patriotism'. But by doing so, they show that they are, in effect, still under the spell of the dichotomy between the ethnic and civic conceptions of the nation. They see nationalism as some kind of xenophobic and resentful exaltation of race and ethnicity, and believe that the only acceptable attachments are to a civic state and to its constitution. But we have seen that there are many different concepts of the nation, and that the dichotomy is by itself not a satisfactory one. The ethnic/civic dichotomy cannot adequately account for many nationalist movements. Those movements which are constrained by the principle of tolerance cannot be described as racist or xenophobic, nor can they be reduced to a mere form of constitutional patriotism. For we have seen that even constitutional patriotism could be morally problematic if it were promoted in a manner which fails to apply a principle of tolerance.

This reassessment of nationalism can be made even more forcefully in the case of sociopolitical nations. Indeed, the defense and promotion of the collective rights of sociopolitical nations appear to be perfectly legitimate, because the principle of tolerance is constitutive of that kind of nation. A sociopolitical nation is much more than simply a multiethnic and pluricultural nation. It is one which acknowledges its deep diversity. In short, the principle of tolerance is built into the very concept of the sociopolitical nation. When nationalism is so understood, not only can it be tolerated, it can and indeed it must be described as perfectly legitimate.

MICHEL SEYMOUR

Université de Montréal

NOTES

1. I do not wish to make a radical distinction between 'people' and 'nation'. For many authors, the notion of a people refers to a sociological entity, while the nation is essentially described as political. This partly explains why I am reluctant to endorse such a distinction. As we shall see, I will try to develop a sociopolitical concept of the nation. Consequently, I do not wish to draw a sharp line between a sociological entity (the people) and a political entity (the nation). Moreover, those who make such a distinction usually subscribe to a univocal concept of the nation. Now, since I wish to defend a conceptual pluralism in these matters, this gives me another reason for not accepting a fixed dichotomy between the two concepts. In what follows, I shall indifferently use the terms 'people' and 'nation'. That being said, we could accept a minimal distinction between these two notions. Under any account, the concept of a people could refer to the sociological dimension of a nation, and thus to a certain kind of population, while the concept of the nation could be used to refer to the same group understood as the subject of certain rights. It is the people endowed with a certain political and juridical recognition. It is thus only when we talk about "peoples" which do not (or almost do not) have a judicial or political status (such as, for instance, the purely cultural or the diaspora "nations") that we feel strongly inclined to endorse the distinction and say that these are peoples and not nations. But if one is, like myself, willing to give a political recognition even to these sorts of nations and afford them a juridical status, this provides a further reason for not wanting to draw a radical distinction between the two notions. In any case, most conceptual distinctions can be made with the use of the word 'nation'. We are able to talk about the ethnic nation, the exclusively civic (or political) nation, the purely cultural nation, the diaspora nation, and the sociopolitical nation.

2. For a survey of the recent literature on the subject, see John Hutchinson and Anthony D. Smith, eds., *Nationalism* (Oxford: Oxford University Press, 1994); Gopal Balakrishnan, ed., *Mapping the Nation* (New York: Verso, 1996); Omar Dahbour and Micheline R. Ishay, eds., *The Nationalism Reader* (New Jersey: Humanities Press 1995); Gil Delannoi and Pierre-André Taguieff, eds., *Théories du nationalisme* (Paris: Éditions Kimé, 1991).

3. Ernest Renan, *Qu'est-ce qu'une nation?* (Paris: Calmann-Levy, 1882).

4. The exclusively civic conception is still nowadays defended by a large number of thinkers. For example, Jürgen Habermas, "Citizenship and National Identity: Some Reflections on the Future of Europe" *Praxis International* 12, no. 1 (1992): 1–19; Alain Finkielkraut, *The Defeat of the Mind* (New York: Columbia University Press, 1995); Liah Greenfeld, *Nationalism: Five Roads to Modernity* (Cambridge, MA: Harvard University Press, 1993); Pierre-André Taguieff, "Nationalisme et anti-nationalisme. Le débat sur l'identité française," in Serge Cordellier, ed., *Nations et nationalismes, Les dossiers de l'état du monde* (Paris: La découverte, 1995), 127–35; Dominique Schnapper, *La communauté des citoyens* (Paris: Gallimard, 1994); Claude Bariteau, "Pour une conception civique du Québec," *L'Action nationale* 86, no. 7 (1996): 105–68.

5. Johann G. Herder, Sämtliche Werke, Berlin (1877–1913).

6. Even if only very few thinkers subscribe to a purely ethnic conception of the nation, many believe that there is an irreducible ethnic component in any nation. For example, Anthony D. Smith, *The Ethnic Origins of Nations* (Oxford: Blackwell, 1986); see also his *National Identity* (London: Penguin Books, 1991); Clifford Geertz, "The Integrative Revolution: Primordial Sentiments and Civil Politics in the New States" in Clifford Geertz, ed., *Old Societies and New States: The Quest for Modernity in Asia and Africa* (New York: Free Press, 1963); Pierre Van Den Berghe, "Race and Ethnicity: A Sociobiological Perspective," *Ethnic and Racial Studies* 1, no. 4 (1978) and *The Ethnic Phenomenon* (New York: Elsevier, 1979); Walker Connor, *Ethnonationalism: The Quest for Understanding* (Princeton, NJ: Princeton University Press, 1994). For a survey of the literature on this question, see John Hutchinson and Anthony D. Smith, eds., *Ethnicity* (Oxford: Oxford University Press, 1997).

7. See my "Introduction: Questioning the Ethnic/Civic Dichotomy" in Jocelyne Couture, Kai Nielsen, and Michel Seymour, eds., *Rethinking Nationalism* (Calgary, Alberta: University of Calgary Press, 1998), 1–61.

8. For a passionate defense of multination states, see, for instance, Stéphane Pierré-Caps, *La multination* (Paris: Odile Jacob, 1995).

9. Good examples of cultural nationalism are to be found in Charles Taylor, *Reconciling Two Solitudes: Essays on Canadian Federalism and Nationalism* (Montreal: McGill-Queen's University Press, 1993); Fernand Dumont, *Raisons communes* (Montréal: Boréal, 1995); Will Kymlicka, *Multicultural Citizenship* (Oxford: Clarendon Press, 1995); John Hutchinson, *The Dynamics of Cultural Nationalism* (London: Allen and Unwin, 1987); Yael Tamir, *Liberal Nationalism* (Princeton, NJ: Princeton University Press, 1993); David Miller, *On Nationality* (Oxford: Oxford University Press, 1995).

10. See my Introduction, ibid., Section V, pp. 30–44.

11. See Rawls, "Kantian Constructivism in Moral Theory," *Journal of Philosophy* 77, no. 9 (1980): 515–72. See also *Political Liberalism* (New York: Columbia University Press, 1993 p. 31, n. 34.

12. For an account of the nation as an "imagined community," see Benedict Anderson, *Imagined Communities: Reflections on the Origin and Spread of Nationalism* (New York: Verso, 1983).

13. There are many recent and important contributions to the study of nationalism. See the bibliography at the end of *Rethinking Nationalism*.

14. The national majority is called a "majority" mainly because it is the majority of individuals in the world having the same features, and not only because it is a majority on its own territory. Of course, we must require it to form at least a majority on its own territory. But it could trivially fail to do so if there are no national minorities and no immigrants on the territory (for example, Iceland). The "essential" feature of a sociopolitical nation is that it *may* be pluricultural, but it need not actually contain any minorities on its territory.

15. The notions of "structure of culture" and "context of choice" are borrowed from Will Kymlicka. See his *Liberalism, Community and Culture* (Oxford: Clarendon Press, 1989).

16. For a recent study on the notion of a diaspora, see Robin Cohen, *Global Diasporas* (London: University College of London Press, 1995).

17. Rawls, *Political Liberalism*, p. 41.

18. Of course, this view of the linguistic community as an irreducible collective body presupposes a community view of language. For a definition of the societal culture, see Will Kymlicka, *Multicultural Citizenship* (Oxford: Clarendon Press, 1995), 76–79.

19. David Miller, for instance, is almost unable to grant a right to secede to any of the nations that he characterizes as cultural. See the criticisms raised by Margaret Moore in "Miller's Ode to National Homogeneity," *Nations and Nationalism* 2, part 3 (1996): 423–29; see also my "Introduction," 30–44.

20. For a critical evaluation of partition in the twentieth century, see Radha Kumar, "The Troubled History of Partition," *Foreign Affairs* 76, no. 1 (1994): 22–34.

21. Most authors fail to distinguish between national minorities and nations. In general, national minorities are described as a subclass of nations. They are defined as nations which happen to be outnumbered on the territory of a multination state. In other words, many authors tend to confuse national minorities and minority nations. See my introduction to *Rethinking Nationalism*, pp. 45–55.

22. For an examination of issues related to the morality of nationalism and seceding movements, see Allen Buchanan, *Secession, The Morality of Political Divorce: From Fort Sumter to Lithuania and Quebec* (Boulder, CO: Westview, 1991); Simon Caney, David George, and Peter Jones, eds., *National Rights, International Obligations* (Boulder, CO: Westview Press, 1996); Robert McKim and Jeff McMahan, eds., *The Morality of Nationalism* (Oxford: Oxford University Press, 1997); Percy B. Lehning, ed., *Theories of Secession* (London: Routledge, 1998).

23. See his "The Law of Peoples," in Stephen Shute and Susan Hurley, eds., *On Human Rights, The Oxford Amnesty Lectures, 1993* (New York: Basic Books, 1993).

24. Liah Greenfeld, *Nationalism: Five Roads to Modernity* (Cambridge, MA: Harvard University Press, 1992).

25. Margaret Canovan, *Nationhood and Political Theory* (Cheltenham, U.K.: Edward Elgar, 1996).

2

On National Belonging

OLLI LAGERSPETZ

1. Community and Representation

The idea of national belonging cuts across some important divisions within political philosophy. Unlike ethnicity, it is an inherently political notion. Unlike citizenship, its meaning is cultural rather than legal. I will look at the relations between these three forms of belonging. The idea of *political representation* must, I submit, furnish the starting point for discussions of what we today understand as nationality.

Modern ideas of political legitimacy involve the idea that a legitimate authority, whether elected or not, acts on the citizens' behalf. Even monarchs are framed as (good or bad) symbols for the nation rather than as rulers in their own right. If I recognize that a political body has legitimate authority over me I agree that the body is somehow representative of myself, of my will. The idea of a social contract is one philosophical expression of this modern view on legitimacy; it has more apt expressions. The notion of national belonging, I think, is one. If this is true, one should not be surprised at the close historical connection between nationalism and representative democracy. They are two aspects of a single approach to the question of legitimacy.

The idea of representative government runs into an apparent difficulty. How can *someone else's* decisions express *my* will? No conceivable political body can be guaranteed only to pass decisions to which I would willingly subscribe. And, in any case, if I only accepted a government's claim on my loyalty insofar as I agreed with its policies I would not be recognizing it as a legitimate authority. 'Legitimacy' implies that a political body has, to some extent, a claim on my loyalty independently of what I want.

In a modern democracy, of course, the government's claim on the citizens' allegiance is supposedly confirmed by a general election. But now suppose I have voted for the opposition. How can the fact that others vote

in a certain way commit me to abiding by *their* choice? The official answer is that by participating in an election I am, by that very fact, accepting the resulting régime as legitimate.

And in fact, I do. That is, I (who am now writing this) do—even if there will be limits to how far my loyalty will stretch. But I can only do so against an existing background of political thought and practice. I recognize that I am part of a 'common cause' from which I am not normally free to opt out. Thus what above all sets democracies apart from colonial administrations lies not in procedural matter—say the existence of an elected legislative assembly. Democracy, first and foremost, implies a political community to which the citizens regard themselves as actively committed. 'Representativity' here consists of the fact that the citizens see themselves as being called upon to agree *or disagree* with decisions concerning the State.

This has two aspects. First, it must be assumed that the citizens agree that there exists a certain kind of group of which they, as a matter of course, are members. Second, they must tend to address certain questions from the point of view of the good of the group.

In *The Social Contract*, Rousseau expresses the first point by stating that, in order for a people to be "fit for legislation" in the spirit of his Social Contract, they must be "bound by some union of origin, interest or convention."[1] This is a remark about the conditions in which Rousseau's social contract—indeed any social contract theory—is applicable. The remark is not just empirical. I can enter into valid contracts with strangers if a legal system is already in place; but a contract cannot create an intelligible basis for political life itself unless the relevant community is already held together by *some* ties. Arguably, this has been overlooked or smoothed over by most other social contract theories; possibly because they have largely been developed to address questions—say, of distribution of power—that arise within already existing political entities. As a result, contemporary political philosophy tends to treat nations as something they are not: as contract-based, Utopian communities *manqués*.

Thus we can say: there must be a community "before" there can be democratic legitimacy. However, this slightly clouds the issue which is not temporal. Many political communities (such as Canada, but to some degree even most of the 'old' nations) in fact owe their original existence to the previous establishment of a state structure and some form of popular representation. Nevertheless, a structure without a people remains an empty shell. There must be a fit, so to say, between the structure and a corresponding community. Northern Ireland is a case in point: any projected constitutional arrangement has the chance of earning democratic legitimacy just to the extent the electorate are prepared to see themselves as *one* community. Conversely, representative legitimacy is no longer applicable when citizens cease to see themselves as part of a meaningfully united

whole. If I see few significant ties between myself and farmers, or the unemployed, or a distant part of the country, then it will be difficult for me to see by what right the state can use 'my' tax money for their benefit.

My second point was that a democracy needs citizens; that is, people who pursue *causes* rather than just interests. Considerations of this kind made Rousseau distinguish between the will of the majority and the General Will.[2] The will of the majority can express the legitimate will of the people only if informed by a concern for the good of all, not by factional interests.[3] Here we have a major distinction between members of a national assembly and delegates assembled to negotiate a treaty. Of the former, each member is required to act in the interests of the whole community; of the latter, each is expected to work for a factional interest. The legitimacy of the treaty, once concluded, will in fact depend on the assumption that the delegates have done all they can to secure the interests of those, and only those, who sent them there.

If we go along with this view (as I think we should), questions of legitimacy cannot simply be treated as ones of legal validity. They cannot be divorced from substantial judgments about the spirit in which political decisions have been passed—for example, about acceptable ways of producing persuasion. On the other hand, how I judge this spirit will also in part reflect my views on the issues concerned.

2. Sharing Space

In order to have representative government you need a community. Political communities, I submit, are brought together and defined by *shared space* (or something analogous to it). What you share, with whom, and how you share it, defines your community with others.[4]

Geographical proximity as such is obviously not enough to constitute a community. Consider, for instance, those inside a department store at a given moment. Their physical proximity is uninteresting unless it is somehow thought to be of crucial importance to them all, say if a fire breaks out. But we would not, even in that case, say they are a community. Each, privately, rushes towards a door.

The thirty or so households inhabiting the property where I live are a geographically defined community. We all live in Gertrudsgatan 4, the city of Åbo. Of course, on a map, one could draw boundaries that split the property into any number of pieces, and the common address would no longer exist. What is important is the fact that there is a certain space for which we are jointly responsible: the courtyard, the dustbins, the sauna.

Sharing is not simply joint ownership, even if ownership, too, may come into it. The point is that we use and run the space together, discuss

its use, and share the responsibility for its being managed in the right way. Sharing does imply, however, that the positions of different individuals vis-à-vis the shared space are of the same general kind; that the views of some, for instance, are not systematically ignored.

This is not to say that what unites us is coinciding *interests*, even if it is fair to say that we all wish the shared space to be managed well. In any case, appealing to coinciding interests will be unhelpful as long as we disagree about what those are. Should the courtyard be paved? Should there be more, or fewer, parking lots? Conflicts on such issues are notorious. Our community is rather defined by the range of *possible conflicts*. While my brother, who lives elsewhere, may have opinions about paving courtyards, a disagreement between us would not constitute a conflict of interest.

In sum, 'community' and 'shared space' are two sides of a coin. We are united by shared space; vice versa, we share this space because there is a 'we' to share it.

Similar general points hold about citizenship. As Rousseau observes, the meaning of citizenship is conditioned by the range of issues that the citizens treat as shared.[5] In order to have citizens rather than subjects, you need a *Res publica*, or a jointly administered entity.

Rousseau himself may be accused of failing to clarify the relation between shared public space and unanimity; this made him say things that, according to some writers, contain the seeds of totalitarianism. A political community is constituted by the fact that the members more or less agree, tacitly perhaps, on two questions. First, who are the members? Second, what do they share; that is: what limits are there to issues that are to be settled collectively? Civil wars are fought over such questions (for instance, over the limits of legitimate state interference in matters of religion or property). Given some such basic agreement, the possibility of numerous conflicts arises. Thus the ties of citizenship do not consist of unanimity or even sympathy, but of the fact that a large number of issues, including disagreements and animosities, are to be resolved within a given public space.[6]

Summing up what I have said so far: there is an internal relation between the ideas of community, representative legitimacy, and shared space (or *Res publica*). A political question concerns something shared. In order for something to be shared there must be a community who shares it. Conversely, the community is what it is by virtue of what is being shared. And political decisions are made by bodies that are themselves political. That is, they are made by bodies seen as shared, as good or bad representatives of the community. This circle of concepts defines the sphere of political life.[7]

The modern view on legitimacy which I have outlined contrasts with two other approaches: (1) rule by a superior right; (2) attempts to assimilate questions of legitimacy to instrumental concerns. These views may be characterized as nonpolitical, indeed antipolitical.

The first view comprises, for instance, the divine right of monarchs. In colonial contexts, there was the analogous claim that white rulers represented a superior civilisation. Today, the ownership of capital may become the basis of immense power. The legitimacy of such power is conditional on its being perceived as essentially nonpolitical.

The second view is standardly—but mistakenly, I hope—construed as the Liberal creed *par excellence*.[8] The Liberal state is seen as the neutral meeting place of individual and factional interests, perhaps like a market where individual parties reconcile their conflicting wishes. Representative democracy may be singled out as the procedure most likely to produce a compromise palatable to all. Yet the assumption is that its value, by definition, will only be instrumental. This may be a fair description of how many people think about politics. However, it fails to acknowledge that there are those (including Liberal voters) who see democracy and the rule of law as objects of their genuine allegiance rather than as a palatable compromise.

3. The Nation

Representative legitimacy, then, presupposes a community, implying shared space. A sovereign state 'calls for' a corresponding community, that is, a *nation*. Conversely, to call a group of people a nation is to suggest that it has, or aspires or ought to aspire to having, a sovereign state, that is, a political space of its own.[9] The concept of a nation is thus inherently political. Unlike that of an ethnic group, it is also necessarily related to the idea of a territory—because a state is, by definition, anchored to a geographical area.

But more must obviously be said about what sets the nation apart from other types of community.

I may join some communities for a purpose; say, in order to promote a political cause, or to satisfy some need of my own. Conversely, I may give up my membership if my motives are frustrated or if my original views change. True, I may hang on out of sheer inertia; or perhaps I am, by then, connected to the group by ties of friendship. What is important is that I may, at any time, be intelligibly asked to give my reasons for being a member. By 'good reasons', we mean here reasons that might make someone else consider joining as well.

In the mainstream social contract tradition, my membership in a political community is modelled in these terms. Consequently, works within this tradition must include some reasoning about my needs or interests which, hypothetically, makes it plausible that I should *choose* to join a certain type of society were I presented with the choice.[10]

However, my membership in a nation is not subordinate to a purpose, just as I am not my parents' child for the sake of a purpose. This is a main difference between nations and Utopian communities. I cannot normally give you any good reasons for, for instance, being a Finn. This is not because there are only bad reasons; rather, there is normally no question about taking up a Finnish identity or giving it up. I can only answer the question, if at all, in terms of personal history: I am a Finn because I grew up in such-and-such a way.

This is not only to say what no one denies: that most people do not, as a matter of fact, think of their membership in a nation as a matter of choice. Rather, as I have already argued, the fact that there are communities of this kind cannot, even for theoretical purposes, be represented as the result of coinciding individual choices (even if individual members may give up their passports and acquire new ones; at any rate, my *wish* to belong to a nation presupposes that there are others who belong to it without having chosen to do so). A nation, as opposed to a charity or a Utopian community, has no purpose 'beyond itself'. That is: it has no purpose, period. Its 'purpose' is to cherish *its* shared space which is, circularly, defined in terms of the nation.[11]

An existing (ethnic or geographical) group can decide to become a nation, that is, to have political aspirations. However, the members' very determination to be a nation presupposes that they belong to a group that exists regardless of their will. Here nationalists would typically speak, not of a nation being created, but of a preexistent nation awakening to nationhood.

It follows from my argument (in section 1) that this conception of the nation is a necessary corollary to the idea of representative political authority. I can recognize decisions passed on behalf of a community as binding me only to the extent that I see my own membership as independent of specific purposes. Otherwise, I would feel free to opt out as soon as my purposes are better served by doing so. Thus the modern nation-state answers the question about the legitimacy of representative governments in terms of national belonging. I must go along with a collective decision because I 'belong with' those who made it. By refusing, I part company with my nation.

Then why should I *not* part company with my nation? I belong to other groups too, including those who part their hair on the left-hand side. There is no reason for me to feel a demand of loyalty towards my fellow members of that group. We see the original problem returning. The idea that was rejected—membership by consent—had been advanced as an answer to precisely this question: Why should the mere fact that I belong to a socially defined group imply anything about my moral rights or duties?

In the literature, a distinction is usually made between 'ethnic' and 'civic' criteria for national belonging.[12] According to the ethnic conception, I belong to a nation by virtue of shared ethnic characteristics such as a language. According to the civic conception, my membership rather depends on my loyalty to some institution such as the Monarchy or the Constitution. It seems to me, however, that *neither* of these conceptions of the nation could furnish good grounds for demands of loyalty.

First of all there is the difficulty of picking out the relevant group of people. If the 'civic' criteria of nationhood are collapsed into 'loyalty to a state', the demand turns circular: I ought to be loyal to whatever it is because, and just as long as, I am loyal. If, on the other hand, the civic criteria are identified as 'subscribing to a set of principles, as embodied, for example, in a (given) constitution', we have the definition of an international *charity*, not a nation. The constitutions of modern democracies resemble each other closely. Adherence to principles laid down in one of them is a political position but fails to explain why my solidarity should stop short at an international boundary.[13] Indeed, the demand that the country of my residence should partake of my patriotic sentiments at all now seems arbitrary. Adding a territorial criterion would resolve these difficulties but only by, circularly, making a reference to the concept of a nation.

Then how would one, on the other hand, define the extent of the *ethnos*? Again, in most cases at least, there only seem to be circular ways of doing so. Speakers of the 'same' language, say English, sometimes understand each other only by virtue of their common access to a 'nationally' imposed standard speech (say, 'BBC English'). Conversely, linguistic continua (such as Castilian-Catalan-Occitan-French) are chopped up in ethnic units in ways that already reflect assumed 'national' divisions rather than vice versa. Thus both civic and ethnic definitions in fact pick out the 'right' groups of people only by tacitly assuming that the nation has already been identified in some other way.

Another fundamental difficulty with both these views is that they do not explain why my solidarity should extend to those and only those who share the proposed defining features. In general, no *attribute* that I may have—be it language, descent, residence, opinions—can, on its own, motivate the demand that I should side with a particular group of people against others.

But it follows from my earlier argument that an individual's national belonging is not an attribute in this sense. Rather, it consists of her *exercise* of membership, that is, her practice of treating certain questions as something she shares with a particular group of others.[14] For instance, it would be misleading to see a citizen's allegiance to the U.S. Constitution simply as commitment to certain political principles, opinions that she incidentally shares with her fellow citizens. The significance of the

Constitution in U.S. national consciousness is closely tied to its *historical* role in the nation's formative events.[15] These events brought together the community identified as 'the Americans' and are today a point of reference against which its members relate political issues. In general, the relative weight attributed to civic vs. ethnic conceptions of national belonging among a given nation reflects its particular historical experience—the roles played by the state, by literature, religion, etc., in its development. Rather than legislating a priori, let us simply note the existence of such historically determined variations.

If we wish to examine whether a given group of people—say, members of an ethnic minority—'in fact' constitute a nation we must see what issues they do treat as shared; how they think and talk about their life together. We may have doubts about whether a group of people in fact generally think of themselves as a nation. However, no outsider has the power to decide whether they are *right* in thinking of their national belonging in the way they do.

4. Historicity

The bond of nationality is defined historically rather than in terms of a purpose. The idea of national belonging implies that the shared space of a nation, as it were, makes a demand on its members to continue sharing it. For instance, I may see it as a deceit if I fail to raise my children as Finns. This is an expression of the idea that history ethically constrains us; that the value or horror of what has happened before should prevent us from doing what would involve a denial of its significance.[16] We must go on *because* these fortunes were shared by a community before we were in existence. In this way, my actions are constrained by the significance of the past lives, achievements, and crimes of other Finns.

But in what sense, then, do these deeds by others constitute *my* past? This has to do with the way in which my ways of living and thinking—who I am—inevitably bear the stamp of historical contingency.

Remember that concepts like 'culture', 'society', and 'language' are abstractions. We never face those things as such, but only particular ways of doing things, particular people and places. In my childhood, nevertheless, some ways of doing things necessarily impressed themselves on me as *the* ways: I only later found out about alternatives. For instance, I did not, from my own point of view, learn 'a first language': I learned what, for me, counted as the ways in which one says things to others. I learned to live and to think; but this was necessarily to learn historically contingent ways of living and thinking. Nor did I find out about the features of 'the world in general', a world to be known independently of my own place in it.

'September', for instance, cannot be identified independently of a cultur-ally specific calendar. It is also associated with particular things that we expect to occur in September. It means, to me, the rustle of leaves on the streets, bright crisp mornings, berries and mushrooms, the end of vaca-tion—not a stretch of homogeneous time to be filled with different mean-ings depending on where one lives.

In this way, particular modes of thinking and living appear to me at once as contingent (because I know there are other ways) and necessary (because they are my ways). "God, [...] seeing that our narrow souls can-not grasp his wonderful world in its entirety, has set apart a piece of it to be called our country."[17] The nation, in the words of J. R. Jones, is a "microcosm," "a whole summary or crystallisation of the world, in one people."[18]

Any shared perspective on the world at once brings me together with others and sets 'us' apart from yet others. This is not accidental. Sharing experiences implies both union with others and the possibility of there being yet others foreign to those experiences. With some, for instance, I share an experience of particular localities. In a similar way, any use of sym-bols—for instance, language—implies a limited community. To speak is, paradigmatically, neither to speak to oneself nor to speak to everyone. It is to address and be addressed by a limited group of others. To overhear a remark is embarrassing because it is to encroach on those limits.

Furthermore, speech is directed towards other speakers of the same lan-guage. Local political discourses will, of course, always be conducted through the medium of a limited number of languages. In order to partic-ipate, I must be at least fluent in some relevant language. This certainly does not imply that I must be a *native speaker;* after all there are bilingual and multilingual communities. But what it does mean is that we must be able to find each other in a shared language of symbols that we see as important. Only through such encounters are we able to meaningfully join our fortunes with those of the nation. By means of culturally specific sym-bols—including sites, events, works of literature—we are connected to a specific past. In Benedict Anderson's words, we are forged into "an imag-ined community." Imagined—not because unreal or faked, but because our relation to symbols creates a link between ourselves and others with whom we are not directly connected.[19] At the same time, this is a com-munity not shared by those for whom the symbols carry a different mean-ing or no meaning at all.

My cultural belonging consists, in this way, in my communicative rela-tions with others: in the relative ease or difficulty with which I relate to them. It shows in the way that I can employ certain distinctions: for instance, telling good work from bad in the art, literature, or cookery of the culture to which I belong. I can also see where disagreement makes

sense. Or consider our relations to people from other cultures. To various degrees, I can recognize their individuality 'behind' their Russianness, Tibetanness, Swedishness, and the like. But where no such barriers exist, the other's particular language, gestures, sense of humor, dress, and so on, *help me discern* her individuality rather than blurring it for me.

In some circumstances, cultural contrasts will be articulated in terms of national or ethnic identity rather than, say, as differences of class or education.

No element of human culture is, in itself, ethnically neutral or ethnically loaded. Consider 'ethnic food', as, for instance, served at a Punjabi restaurant in London. An establishment advertised as 'Punjabi', *in Punjab*, is unconvincing. By 'ethnic', we mean what is not 'ethnic' where it comes from. The idea of ethnicity, then, involves being alive at once to the inescapability and to the historical contingency of one's own culture. My accustomed way of life is, at once, accidental since I, as a man, could have been born in another place, another time; and natural to me, as other ways of doing things strike me as strange, exotic, fascinating, or the like.

Whether or not two people 'belong to the same community' can only be determined in relation to specific issues. I am part of an academic community spanning many continents—while an immense gap separates me from the electrician living next door. The idea of national belonging, however, involves the assurance that my community with the electrician is, or ought to be, as real as it is with my fellow academics. There are ties between us independently of how well we personally get along. They would obtain even if we had never met, simply because we share the same historical space. Nationalism, whatever else it may be, is an exhortation to me to recognize my fellowship with him, fully to *become* his fellow. That was the explosive message of 1789 and 1848.

Finally a word of caution. My Finnishness is a fact about me; but acknowledging a fact is compatible with reflecting on it and drawing various conclusions from it. What I do about this fact will depend on its relation to other facts—for instance, my duties as a father, an academic, a privileged European. In *this* way it is true that the nation is, in Renan's words, a continuous plebiscite. The relevance of my national belonging for me depends on my own inclination to recognize it as a relevant concern. I must see for myself *whether* it makes a difference to how I think about politics, culture, career decisions, my children's upbringing, and so on.

5. Nationalism in Context

I would define nationalism as an approach that stresses the expression of national identity as a central concern in politics. As a nationalist, I believe

that my national belonging is an important aspect of who I am; and that I cannot fully express myself unless I have access to political institutions that reflect the particularity of the nation to which I belong.[20]

This highlights the importance of institutional context, above all the role of existing state structures.[21] In general, I do not think it fruitful at all to assess the different ideological manifestations of nationalism in abstraction from their context of application. There is a world of difference, for instance, between defending a nation's right to a life of its own and imposing a unitary national culture on 'its' minorities. Lenin was alive to this when he distinguished between the national strivings of the oppressed and those of the oppressor nations.[22] After the evil year of 1999, I hardly need to elaborate on the uses to which nationalism can be put in the specific context of totalitarian dictatorship.[23]

The ideal of an ethnically neutral, multicultural state (as currently discussed, in particular, in North America) is often contrasted with the resurgence of narrow ethnic nationalism in Eastern and Central Europe. Despite several alarming phenomena, however, I would still say this general approach betrays an American-cum-West European bias. More correctly, it is the bias characteristic of *nations whose survival is more or less secure.* Remember that almost all of the newly independent nations were destined for extinction by Hitler, Stalin, or both.

In this context, Michael Billig has coined the expression "banal nationalism." It refers to how the nation, in a large number of contexts, may become its members' obvious and therefore largely unacknowledged point of reference. For example, Nussbaum, in her plea for cosmopolitanism, refers to 'our' history, curricula, place in the contemporary world, and so on.[24] Her discussion assumes, as a matter of course, that 'we' are citizens of the United States—who, as a nation, are to take a stand in these issues. To quote Mikko Lagerspetz,

> [b]anal nationalism may be expressed in the 'flag-waving' routinely taking place at schools, athletic games, etc., but even more so in the fact that such flag-waving is absent. When a British subject hears the expressions, '*the* Prime Minister, *the* weather, *the* Meteorological Office', he will not be asking what country's Prime Minister, weather, or meteorological office is meant. At the same time, Estonians still need to speak of 'State' institutions of 'The Republic of Estonia'.[25]

This is not to suggest that everyone is a nationalist, let it be unselfconsciously. Just as nothing in itself is 'ethnic', the question of what counts as 'nationalism' is ultimately a function of where one stands. Members of large nations seldom face situations where they have to *think* of their national belonging or talk about it. Hence they may come to see

nationality as a nonissue and nationalism as a result of manipulation[26] chiefly applicable to nations other than their own.

A related bias is expressed in the usual, English-speaking academic consensus that nationalism, if acceptable at all, ought to be based on 'civic' rather than 'ethnic' conceptions of the nation.[27] The particularism implied in ethnic solidarity is contrasted with the assumed universalism of basing national solidarity on shared citizenship.[28] The bias is no doubt strengthened by the fact that most of the literature *sympathetic* to ethnic nationalism has, for natural reasons, been published in the relevant vernaculars rather than Philosophical English.

Politically, the academic consensus implies commitment to the status quo. Nationalism becomes a privilege for those nations who already have sovereign states of their own.[29] No legitimate form of nationalism will be available to peoples unable to identify with the institutions of 'their' state's core culture.[30]

Such discouraging conclusions might be acceptable to minorities if the existing institutions were ethnically neutral. The presumed universalism of 'civic' nationalism rests on this conception. However, what *is* ethnically neutral will itself be a central point of contention in debates about national self-determination.

R. S. Thomas observes that the postal code for Swansea is SA rather than, say, AT (as in Abertawe—Welsh for Swansea).[31] A matter of convenience . . . perhaps? But one may also, along with Thomas, recognize here a chauvinistic tendency to insist on English only. On the other hand, what shall we say about Thomas's own determination to use Welsh? Realistically, using Welsh at a post office in Wales will very often risk coming out as nationalism in someone's eyes while, say, the use of French in France will not. Yet of course the one language is not, *in itself*, more ethnically neutral or loaded than the other.

In particular, the implementation of bilingualism is likely to bring out the ambiguities of 'ethnic neutrality'. A bilingual society will need nurses, policemen, and other officials fluent in the language of the 'minority' which may, locally, constitute a strong majority. But language skills are not evenly distributed. Members of the 'majority' (local minority) are frequently not bilingual. Hence disqualified, such applicants will be likely to protest against discrimination. Whom should one listen to? Here it is more illuminating to frame the core questions as ones of *justice* rather than neutrality.

In other cases, the use of a national language is sufficiently entrenched as to appear ethnically neutral. That is, for example, a feature of the current multiculturalism debate in the U.S. Even the most radical advocates of an ethnically neutral state fall short of challenging the ascendancy of English. It is intelligible to see this as blindness to language issues—a form

of unconscious nationalism affordable to members of large nations. But again, there simply is no perspective-free way to decide exactly when a language issue *ought to* be raised.

The 'nationality question' does not exist independently of circumstances; not everyone feels pressed to address it. However, the imposition of unitary languages of state through administration, education, and business creates situations where the issue, for a particular group of people, is forced into the open. J. R. Jones writes:

> It is said of an experience that it is one of the most agonising possible [...] that is, of being forced to leave the soil of your country for good, to turn your back on your patrimony, to be torn by the root from your familiar land. [...] I have not had that experience, nor, I suppose, have you. But I know of another experience, equally agonizing and more irreversible (for you may return to your familiar surroundings), and that is the experience of knowing, not that you are leaving your country, but that your country is leaving you, passing out of existence under your very feet, being sucked away from you, as if by a consuming wind, to the hands and possession of another country and civilization.[32]

Minorities faced with *this* situation must make a choice. Perhaps they come to terms with the seemingly inevitable changes. They may submit to the received nationalism of the dominant culture as taught at schools and through the media. Alternatively, they may set up a shop of their own, decide to be a nation. Would that be a good thing? No one else can settle this question for them.

I have argued that 'the nation' is an indispensable element in the circle of concepts outlining the sphere of the political. It furnishes the basis of representative legitimacy by defining the group that is being represented: a historically defined community to which the individual is nonaccidentally related.

The reality that falls within this circle is historically contingent. What we now know as politics is the result of a late development concomitant with the emergence of modern nations. There is no reason to suppose that it may not one day give way to yet other ways of thinking and acting. At that point, the idea of a *nation* will change, too, even if the word itself may survive and take on new meanings. But those caring for democracy will have no reason to hope for its demise.[33]

OLLI LAGERSPETZ

The Department of Philosophy,
Åbo Academy and
The Academy of Finland

NOTES

Ackerman, Bruce. 1994. 'Political Liberalisms'. *Journal of Philosophy* 91: 364–86.
Anderson, Benedict. 1983. *Imagined Communities*. London: Verso.
Bauhn, Per. 1995. *Nationalism and Morality*. Lund: Lund University Press.
Billig, Michael. 1995. *Banal Nationalism*. London: SAGE.
Breuilly, John. 1995. *Nationalism and the State*. 2nd ed. Manchester: Manchester University Press.
Cockburn, David. 1998. "Past, Presence, and Place." Paper presented at the Past and Place Colloquium at Svidja Manor, Finland, 26–28 June 1998.
Dahlstedt, Sten, and Liedman, Sven-Eric. 1996. *Nationalismens logik*. Stockholm: Natur och Kultur.
Greenfeld, Liah. 1992. *Nationalism: Five Roads to Modernity*. Cambridge, Mass.: Harvard University Press.
Greenfeld, Liah, and Chirot, Daniel. 1994. "Nationalism and Aggression." *Theory and Society* 23, 79–130.
Häyry, Heta, and Häyry, Matti. 1993. "Reason or Nation?" *International Journal of Moral and Social Studies* 8: 143–54.
Hobbes, Thomas 1651/1985. *Leviathan*. London: Penguin.
Hobsbawm, Eric. 1992. *Nations and Nationalism since 1780*. 2nd ed.. Cambridge: Cambridge University Press.
Ignatieff, Michael. 1993. *Blood and Belonging*. London: BBC Books.
Järnefelt, Arvid. 1913. *Isänmaa*. Helsinki: Otava.
Jones, John Robert. 1970. *Gwaedd yng Nhgymru*. Lerpwl/Pontypridd: Cyhoeddiadau Modern Cymreig.
Lagerspetz, Mikko. 1997. "'Oleneb, millisesse paati satun . . . '; Noorte eestlaste mustat stsenaariumid" ["It depends on which boat I manage to catch . . . "; Black scenarios of young Estonians]. *Akadeemia* 1997: 2243–425.
Lagerspetz, Olli. 1998. *Trust: The Tacit Demand*. Dordrecht: Kluwer Academic Publishers.
Lenin, Vladimir Il'ič. 1965. "K voprosu o nacional'nostiah ili ob 'avtonomizacii'" [To the Question of Nationalities or of 'Autonomisation']. In V. I. Lenin, *Voprosy nacional'noj politiki i proletarskogo internacionalizma*. Moskva: Izdatel'stvo Politiceskoj literatury, 164–70. CEnglish translation included in: Lenin, V. I., 1970. *Questions of National Policy and Proletarian Internationalism*. Moscow: Progress Publishers.
Llywelyn, Dorian. 1998. "Brotherhood's Country, My Country, My Creed: Place in Welsh Spirituality." Paper presented at the Past and Place Colloquium at Svidja Manor, Finland, 26–28 June 1998.
Locke, John. 1689/1980. "Second Treatise on Government'." In J. Locke, *Two Treatises of Government*, ed. Peter Laslett. Cambridge: Cambridge University Press.
Mason, Andrew. 1999. "Political Community, Liberal-Nationalism, and the Ethics of Assimilation." *Ethics* 109: 261–86.
Miller, David. 1995. *On Nationality*. Oxford: Clarendon Press.

Nussbaum, Martha. 1996. "Patriotism and Cosmopolitanism." In M. Nussbaum with Respondents: *For Love of Country*. Ed. J. Cohen. Boston, Mass.: Beacon Press, 2–17.

Rawls, John. 1971. *A Theory of Justice*. Cambridge, Mass.: Harvard University Press.

———. 1992. "Justice as Fairness: Political Not Metaphysical." In Shlomo Avineri and Avner de-Shalit, eds., *Communitarianism and Individualism*. Oxford: Oxford University Press, 186–204.

———. 1993. *Political Liberalism*. New York: Columbia.

Rousseau, Jean-Jacques. 1987a. "Discourse on Political Economy." In J-J. Rousseau, *Basic Political Writings*. Indianapolis: Hackett, 111–38.

———. 1987b (SC). "On the Social Contract." In J-J. Rousseau, *Basic Political Writings*. Indianapolis: Hackett, 141–227.

Ruutsoo, Rein. 1995. "The Perception of Historical Identity and the Restoration of Estonian National Independence." *Nationalities Papers* 23 (1995): 167–79.

Thomas, R.S. 1992. *Cymru or Wales?* Llandysul: Gomer Press.

1. Rousseau, SC, Book II, ch. X, p. 169.
2. SC, Book II; Rousseau 1987a, 119–20.
3. However, what I *can* see as a concern for the good of all will in part depend on my views on what is morally acceptable.
4. There is the question of whether this is true of all communities. For the present purpose, it is enough to agree that it is a defining feature of political communities.
5. SC, Book I, ch. VI.
6. Thus the idea of 'world citizenship', as recently advocated, for example, by Martha Nussbaum, is problematic. She treats the idea as one of extending one's *sympathy*, even love, to all people of the globe (Nussbaum 1996: 9, 15, and passim).
7. Lars Hertzberg is acknowledged for helping me sum up my thoughts on this issue.
8. Rawls 1992; Rawls 1993, 11–15; 29-35; 145–46. Ackerman 1994, 365–75.
9. These are matters of some controversy. Some writers, to be discussed later, have questioned the legitimacy of distinguishing between nationality and citizenship. On the other hand, sometimes 'nationality' and 'ethnicity' are used interchangeably. This was the official Soviet usage.
10. For example, Hobbes 1651/1985, Book I, ch. 13; Locke 1689/1980, ch. IX; Rawls 1971, sections 15, 20.
11. U.S. national consciousness is a major exception to the rule that a first-generation immigrant cannot be fully nationalized. There is a strong tendency to emphasize the voluntary nature of American identity. The U.S.A. is also viewed as a nation with a 'purpose'. The individual American is assumed to pursue some form of 'the American Dream' (whereas no corresponding notion—say, of a Thai dream—exists elsewhere). These two features are connected. The more one's

membership in a group allegedly depends on choice the more imperative will it be
to find good reasons for the choice. However, this description of the U.S. simpli-
fies a great deal—see my argument later on.

12. A corresponding distinction is made between 'ethnic' and 'civic' forms of
nationalism. The former, it is argued, characterizes Germany and Central and
Eastern Europe, the latter Western Europe and North America. See, for example,
Bauhn 1995; Ignatieff 1993; Greenfeld and Chirot 1994; Häyry and Häyry 1993.
For a criticism see Dahlstedt and Liedman 1996, Miller 1995: 8–9.

13. Miller 1995, 163.

14. See, for example, Ruutsoo 1995, 170.

15. Miller 1995, 141.

16. The sense in which the past can be said to make demands on us is discussed
in Cockburn 1998.

17. Järnefelt 1913, 200. "Jumala[...] nähtyään ettei meidän ahtaat sielumme
ylety koko hänen ihanaa maailmaansa käsittämään, on siitä erottanut osan isän-
maaksemme." Trans. OL.

18. John Robert Jones, *Cristnogaeth a Chenedlaetholdeb*, 7. Quoted in
Llywelyn 1998.

19. Anderson 1983, passim. Thus, as Anderson demonstrates, the birth of
national consciousnesses was connected to the emergence of regionally distinct
newspaper-and-novel-reading publics.

20. This definition is, for instance, at variance with the journalistic practice of
speaking of 'nationalism' whenever a national government adopts assertive or
aggressive policies (Breuilly 1995, 8). It is also unrelated, in fact antithetical, to
colonialism (where the state's powers are extended outside the national territory).
Anderson (1983, 128–40) convincingly argues that colonialism and racism sprang
from sources unconnected or opposed to those of nationalism.

21. See Breuilly 1995, 13.

22. See, for example, Lenin 1965, 168.

23. Ethnic cleansing, as practiced by Serbia in Kosova, might seem conclu-
sively to discredit ethnic nationalism. But consider two points. (1) The Serbian
general public are agreed to be thoroughly nationalistic, yet it seems they were by
and large *kept in the dark* about the facts. This invites the suspicion that they would
not agree with what was done in their name. (2) Ethnically targeted genocide has
been justified by various causes, including civic nationalism (Turkey), religion
(Palestine), Communism (the U.S.S.R.), Liberalism (Guatemala), progress (North
America), civilization (colonial Africa). Obvious questions remain about the rela-
tion between particular policies and their ostensible motives.

24. Nussbaum 1996, 11–15.

25. Lagerspetz 1997, 2245. Trans. OL. See Billig 1995, 106–8.

26. As, perhaps, maintained by Hobsbawm (1992).

27. For example, Bauhn 1995, passim; Greenfeld 1992, 11; Greenfeld and
Chirot 1994, passim; Ignatieff 1993, 5; cf. Dahlstedt and Liedman 1996, passim;
Häyry and Häyry 1993; Miller 1995, 163.

28. For example, Bauhn 1995, 17. I have discussed the issue of 'particularism'
in Lagerspetz 1998, 121–29.

29. It follows, for instance, that Czechoslovak nationalism was bad before 1919, good between 1919 and 1939, bad in 1939–1945, good again in 1945–1992 and bad after the New Year of 1993.

30. Assimilationist policies are sometimes defended on the grounds that a common identity is important for the survival or stability of the political community (see the discussion by Mason 1999, 262–71). The argument will obviously carry any weight only with those who see the goal as worthwhile; possibly not, for example, by minority members themselves. They might prefer weak community or secession. To advance the argument is in fact implicitly to side with the majority.

31. Thomas 1992, 29.

32. Dywedir am un profiad ei fod yn un o'r rhai mwyaf ingol sy'n bod [...] sef gorfod gadael daear eich gwlad am byth, troi cefn ar eich treftadaeth, cael eich rhwygo allan gerfydd y gwraidd o dir eich cynefin. [...] 'Chefais i mo'r profiad hwn a diau nas cawsoch chwithau. Ond mi wn i am brofiad arall sydd yr un mor ingol, ac yn fwy anesgor (obledig mi fedrech ddychwelyd i'ch cynefin), a hwnnw yw'r profiad o wybod, nid eich bod chwi yn gadael eich gwlad, ond fod eich gwlad yn eich gadael chwi, yn darfod allan o fod o dan eich traed chwi, yn cael ei sugno i ffwrdd oddiwrthych, megis gan lyncwynt gwancus, i ddwylo ac i feddiant gwlad a gwareddiad arall. Jones 1970, 81–82. Trans. OL.

33. Parts of this paper were presented at the Past and Place Colloquium at Svidja Manor, arranged by the Renvall Institute, the University of Helsinki, 26–28 July, 1998. I am grateful to Lars Hertzberg and Mikko Lagerspetz for comments on the manuscript.

3

Zionism, Nationalism, and Morality

ELIAS BAUMGARTEN

No topic causes more acrimonious debate between Jews and Arabs, even among those who favor a "two-state solution," than the morality of Zionism. Israeli Jews from the "Peace Now" movement often astound Arab audiences when they call Zionism "the national liberation movement of the Jewish people." And Arabs infuriate even many left-wing Jews when they label Zionism a form of racism. Part of the debate is due to confusion about the meaning of Zionism, the relationship of Zionism to other forms of nationalism, and the extent to which partiality toward "one's own" is ethically justifiable. I will try to untangle some of that confusion and to construct a framework for assessing the morality of Zionism.

One source of confusion is the failure to distinguish between Zionism as a pure concept and Zionism as an historical reality associated with the state of Israel. The concept of Zionism does not imply the particular way that Israel has implemented it. One can oppose the policies of Israel, yet defend the idea of Jewish nationalism and even of a (radically changed) Jewish state in Palestine. In this essay I first address the morality of Zionism as a concept, apart from its implementation by Israel. I then discuss the implementation of Zionism and argue for two claims applicable to the current Israeli-Palestinian conflict. I conclude by suggesting a moral requirement for Zionism today, one which has larger implications for the ethics of nationalism.

I stipulate two principles as central to Zionism:

- Jews have a moral right to self-determination or a Jewish state somewhere in the world.

- Jews have a moral right to self-determination or a Jewish state somewhere in Palestine.

The first claim addresses something close to the pure idea of Jewish nationalism completely apart from its implementation in Palestine. The second claim includes a consideration of the competing claims of Jews and Arabs to the land of Palestine. For those who do not think that these principles capture what is essential to "Zionism," this essay can be considered an evaluation of the two principles, which are themselves interesting, controversial, and suggestive of larger issues in the ethics of nationalism.

One further preliminary point. Each claim refers to "self-determination or a Jewish state." In this essay I will assume that political self-determination means statehood because in the modern world nations typically achieve full self-determination by gaining a state of their own. Both Palestinians and Jews—not to mention Kurds, Kosovars, and Croatians—understand their own self-determination in terms of statehood. Moreover, the more general moral debate on the ethics of nationalism focuses on the existence of contemporary nation-states.[1] Perhaps a homeland for Jews would have been possible without statehood, and there are good reasons for the world to develop means by which political communities can achieve self-determination in some form other than that of the nation-state. But I will not tackle that question here. Therefore, in discussing nationalism and Zionism, I will assume that Jewish self-determination would express itself through statehood.

I will discuss three criticisms of Zionism: (1) Zionism is immoral because it is a form of cultural nationalism; (2) Even assuming that some forms of cultural nationalism are morally acceptable, Jewish nationalism is unacceptable; (3) Even assuming that Jewish nationalism is in principle acceptable, Zionism is immoral because, insofar as it includes a claim to a Jewish state somewhere in Palestine, it necessarily violates the moral rights of indigenous Palestinians. I will try to show that the first two criticisms are flawed and that the third criticism is more complex than is generally assumed. However, I will also argue that the third criticism is an important challenge to contemporary Zionism and demonstrates that if it is to be morally defensible, it must radically transform its relationship both to its own past and to the Palestinian people.

Zionism and Cultural Nationalism

The first criticism of Zionism is that it is immoral because it is a form of cultural nationalism. And this invokes a larger challenge: can any nationalism that acts with a preference for members of a particular cultural group be ethically acceptable? On the face of it, any nationalism violates the standard ethical view that all persons should be treated equally and impartially. For people, or for governments acting in the name of people, to grant spe-

cial consideration to others who share a certain nationality but not to "for-
eigners" requires justification. On first view "being French" would not
seem to be a morally relevant criterion for receiving special benefits. How
can it be morally acceptable for people to establish a "French government"
that makes precisely this distinction?

Of course, the matter is not that simple. There are forms of partiality
that are reasonably accepted, such as an individual's entitlement to give
greater weight to the interests of one's own family than to strangers and
perhaps also to favor close friends, even in the absence of contractual agree-
ments.[2] In contrast, racism, the favoring of a people simply because of their
race, is widely condemned. Nationalistic partiality is more controversial;
some expressions of nationalism may be ethically acceptable while others
are not.[3] As with other forms of partialism, we must evaluate nationalisms
with respect to both the *degree* of partialism and the *kind* of partialism that
they sanction. The first criticism of Jewish nationalism is that it sanctions
the wrong kind of partialism because it is a nationalism which favors a par-
ticular culture.

What might be an appropriate form of nationalism for the critic of cul-
tural nationalism? The division of persons into nations might be justified
purely as a matter of administrative convenience, a way in which our gen-
eral obligation to protect welfare can be efficiently distributed. On this
view, the French government would be assigned special responsibility for
French citizens only because they are within the borders of the adminis-
trative unit known as "France." Robert Goodin[4] endorses this approach
and argues that one implication of this model is that if there are people
who have not been assigned protectors, then all states have a responsibility
to them, just as all doctors in a hospital would have some residual respon-
sibility for patients who had not been assigned to a particular physician.

If administered democratically, this kind of "administrative national-
ism" will serve not only to promote economic welfare but also to satisfy
the claim of a group of people to govern themselves, which may itself be
viewed as one element of human welfare. It allows the nation to fulfill what
Yael Tamir refers to as the "democratic version of the right to self-deter-
mination"[5] and what Muhammad Ali Khalidi calls the "right of political
participation."[6] Just as it would be too cumbersome to administer eco-
nomic welfare globally, democracies function best when divided into sepa-
rate jurisdictions.

To the critic of cultural nationalism, the partiality involved in adminis-
trative nationalism is relatively unproblematic. Of course, even the state
organized for administrative convenience will favor its own citizens and not
view every person in the world as having an equal moral claim on its
resources or an equal claim to influence its policies. But the ultimate justi-
fication for administrative nationalism is impartial, and its defense of

partiality within each nation is merely instrumental.[7] It sees the preferential treatment that states offer their citizens as a means toward achieving an impartial goal, the welfare of all people. Under administrative nationalism the state is bound by impartial principles both in the justification for the original establishment of state boundaries and in matters of immigration, a continuation of the process of dividing up people into jurisdictions.

Cultural nationalism is a bolder challenge to the impartiality principle and, to the critic, a more disturbing one. It corresponds to what Tamir refers to as the "cultural version of the right of self-determination,"[8] to Khalidi's "right of national self-expression,"[9] and to Michael Walzer's conception of the right of people to a "common life."[10] Whereas under administrative nationalism each state's responsibilities are the same but simply cover different groups of individuals, for cultural nationalism the state's role goes beyond protecting the life, liberty, and welfare of individuals; it must also protect and promote (and hence "favor") a particular "way of life" which typically includes customs and traditions that have evolved for a particular group of people over time and which generally is embraced by most—but, significantly, not all—of the people currently residing in the state's territory.[11] Hence a French state will have a responsibility to protect "the French way of life" that will distinguish it from an Arab state; the obligations of a German state will be different from those of a Turkish state. And these differences may be reflected in a state's immigration policies.

Zionism, which aims to promote a distinctively Jewish society, is clearly a form of cultural nationalism. As such it is subject to the criticism that it is oppressive, even racist, and in general incompatible with the impartial standpoint of morality.[12] In response, I will offer a qualified defense of cultural nationalism; first, by distinguishing it from racist and other oppressive nationalisms; second, by pointing out, positively, ways that cultural nationalism may be justified; and third, by arguing that the criticism of Zionism for being a form of cultural nationalism comes from an inappropriately idealistic moral standpoint.

First, the promotion of a culture is clearly different from the promotion of a race. It is the existence of a *shared way of life that is judged worth defending* that distinguishes partialism on behalf of a culture from racist partialism. Anyone, regardless of race, may choose to participate in the common life of a culture. Insofar as the common life that defines a "people" is not based on race, it leaves open the possibility for all persons to choose (if they wish) to identify with the country's predominant national culture. Though difficult, it is possible for minorities, those who were once "outsiders," eventually to share in Danish or French peoplehood. An Algerian can "become" French (just as Armenians and Jews have become Turks), whereas it was not possible for a black person in apartheid South

Africa to "become" white. A second difference between cultural and racial nationalism is that cultures or ways of life evolve, and a changing population may, over time, enrich and alter a culture. A nationalism based on race is less open to this kind of evolution. Finally, racist nationalism typically denies equal *citizenship* rights to "alien" races, whereas cultural nationalism may grant full citizenship rights to members of minority cultures.

Even if cultural nationalism is not based on race, its partiality is, according to the critic, still unacceptably exclusionary. To the extent that the "way of life" is based on particular values such as socialism, Islam, Judaism, or Christianity, and that way of life is part of the nation's core identity rather than an issue open to democratic debate, it will exclude those who choose not to embrace it. To the extent that it is based, as is generally the case, on a shared history and identification with particular cultural symbols, it will exclude those who are not members of the dominant culture and who do not wish to assimilate into it. Thus, even if partiality toward a culture is not the same as racism, a state's promotion of a "way of life" may be, critics argue, no less oppressive for those who do not wish to share it.

Though the critic can point to many examples where cultural nationalism (or Zionism in practice) has oppressed minorities, we should not concede that it necessarily does so. The acceptance of cultural nationalism does not imply acquiescing in the exclusion of people or in discrimination against minorities. A culturally based state will express its way of life officially through its language, its holidays, and its national symbols, but this does not mean that all people's basic human and citizenship rights will not be respected. Indeed, reasonable conditions for the acceptability of a state based on cultural nationalism are that it develop constitutional procedures to protect the citizenship rights of minorities, that it guarantee all residents the right to emigrate, and that it include provisions to ensure that all who wish to join the majority culture's national life may do so. More than that: a morally defensible cultural nationalism should seek ways to protect and encourage the expression of minority cultures; for example, through funding schools, museums, and other cultural institutions that express the arts, language, and history of minority cultures. A small minority cannot expect to have its cultural symbols *officially* acknowledged by the state, but to deny a people official expression of their culture's symbols is neither to oppress the people themselves nor to deny them the right of cultural expression. Few would argue that Muslims are necessarily oppressed in Scandinavian countries merely because the cross and not the crescent is on each country's flag.

Aside from not being inherently racist or oppressive, cultural nationalism includes positive features that may justify its existence even from an impartial standpoint. Cultural nationalism responds to some basic human needs, and there are good reasons to want to see these needs satisfied for

many people even where they cannot be satisfied to the same degree for all. Though it is beyond the scope of this paper to develop the relationship between individual human needs and national self-determination, many authors—in particular, Michael Walzer and Yael Tamir—have argued that persons need, and have a right to, the "common life" (Walzer) and "shared public space" (Tamir) afforded by being a member of a self-determining nation.[13] For Tamir,

> Membership in a nation is a constitutive factor of personal identity. The self-image of individuals is highly affected by the status of their national community. The ability of individuals to lead a satisfying life and to attain the respect of others is contingent on, although not assured by, their ability to view themselves as active members of a worthy community . . . Given the essential interest of individuals in preserving their national identity. . . the right to national self-determination should be seen as an individual right.[14]

One problem with this argument as a justification of cultural nationalism is that it is not obvious that the human needs served by cultural nationalism, when considered impartially, will outweigh other human needs that may compete with it. But if the value of cultural nationalism can be established, then the burden of proof is on the critic to spell out those competing needs and to demonstrate both their importance and their incompatibility with any form of cultural nationalism.

A second impartial justification for cultural nationalism is the desirability of preserving a diversity of "ways of life." We regret the loss of an indigenous culture, just as we regret the loss of a species or ecosystem, and one might attempt to argue that cultures or ecosystems themselves have interests and can be bearers of rights. But even if cultures themselves do not have rights, individual human beings have an interest in the preservation of a diversity of cultures, each making actual some of the possibilities of human consciousness through distinctive forms of expression. It is reasonable to view the loss of an indigenous culture's language and way of life as a loss for humanity in general. And it is also reasonable to think that those cultures have a better chance of surviving if they enjoy the protection of national self-determination or, if that is not possible, if they come under the protection of a state that is committed to an enlightened form of cultural nationalism.

Though these are reasonable arguments for cultural nationalism from a purely impartial standpoint, they may not be decisive. Perhaps the most important reason that the criticism of cultural nationalism fails as a challenge to Zionism is that, insofar as it insists on pure impartiality, it adopts an inappropriate standpoint, that of an idealistic rather than a more realistic morality. The distinction, introduced and discussed by Joseph H.

Carens in relation to the ethics of migration,[15] is crucial for discussing the ethics of nationalism. In an idealistic approach, we evaluate behavior in light of our highest ideals, disregarding whether there is any chance that those ideals will actually be met. This is certainly appropriate in discussions of ethical theory that are concerned with fundamental justification. But in discussions of public policy, a more realistic approach is the appropriate one. It would require that (1) what we say ought to be done "should not be too far from what we think actually might happen," and that (2) we avoid "moral standards that no one ever meets or even approximates in their actual behavior."[16] These are rough but nonetheless useful guidelines. Carens suggests that in discussing the ethics of public policy, we want to avoid a "large gap between the *ought* and the *is*," but he is careful also to warn of the danger of a purely realistic approach that would acquiesce in the worst injustices. This concern also applies to the morality of Zionism, and at the end of this paper I will propose a requirement for Zionism that is far from its current practice but which is consistent with "realistic" morality, given the above guidelines. More work needs to be done formulating a *continuum* of possibilities between idealistic and realistic approaches and specifying in some detail how much realism is appropriate for different moral inquiries into nationalism. But even postponing that more exacting project, I think it fair to claim that criticizing Zionism merely because it is a form of cultural nationalism is to adopt an unfruitful kind of ethical idealism.

A more realistic approach is particularly appropriate in assessing Zionism as a form of cultural nationalism for two reasons. First, if Zionism is flawed simply because it is a culturally based nationalism, then it is only flawed in the same way as British nationalism, Lithuanian nationalism, or, most significantly, Palestinian nationalism. Those criticizing Zionism on moral grounds do not intend their condemnation to be so sweeping. Though Palestinians protest at being stateless and express an urgent desire for "a passport," they are not indifferent with respect to which passport they receive. Were the right to belong to a state based purely on a right to be part of some administrative unit that protects individuals, Palestinians might work to become full Jordanians or Israelis. Though the "one-state" solution (one secular democratic state in all of Palestine) approaches this demand, it is doubtful that Palestinian national aspirations would be met if the name of the single state were "Israel" or even "Southern Syria," if its language were Hebrew (or English), and if only Jewish holidays (or no holidays at all) were officially celebrated.

Second, a more realistic approach is especially appropriate for evaluating both Jewish and Palestinian nationalism because the failure of other nationalisms to meet the most ideal ethical standards is the urgent historical context within which their movements for self-determination have

developed. In a world where *other* people achieve freedom and indepen-
dence through cultural nationalism and where states have recently used
their power to oppress them, Jews and Palestinians may be able to gain
security in the present only through a state of their own.[17] Their historical
experience appears to confirm this. Jews residing in Poland, Russia, and
Germany failed to receive the full protection promised by simply being
under the jurisdiction of a state. And no Palestinian in the occupied areas
(and few in Israel itself) would claim that the state adequately considers the
needs of individual Palestinians.

One might argue that the historical experience of Palestinians and Jews
is due to the *failure to implement* the ideals of administrative nationalism
(or even of morally acceptable cultural nationalism) and that it is through
advocating and working toward the achievement of those ideals that both
Palestinians and Jews can overcome oppression. However, this is not an
effective argument against cultural nationalism for contemporary Jews or
Palestinians. Though ethnic bigotry and discrimination are morally wrong
and should be opposed wherever they are found, the actual framework in
which both Jews and Palestinians must make moral choices includes a con-
tinuing history of victimization and a lack of success, as minorities, in "per-
suading" those in power to change their behavior. A realistic morality that
aims to assess the behavior of a people and the character of their national
movement cannot ignore that their choices are made in the context of
actions by others that they cannot control.

A Critique of Jewish Nationalism

Many critics of Zionism accept culturally based nationalism—indeed, most
Palestinians enthusiastically embrace it—but they challenge Zionism on the
grounds that it is morally different from other forms of cultural national-
ism for at least three reasons. First, Jewish nationalism is unacceptable
because Jews are not a "people"; that is, there is no distinctly "Jewish" cul-
ture or way of life, or—a more moderate claim—there is no Jewish culture
sufficiently distinct to justify national self-determination. Second, Jewish
nationalism is unacceptable because its criteria for membership are overly
exclusive. Third, Zionism is unacceptable because Jews lacked a necessary
ingredient for national self-determination, a contiguous territory on which
they were already residing.

The claim that "Jews are not a people" is difficult to defend (or to
refute) because there are no agreed-upon criteria for what constitutes a dis-
tinctive "people." The arguments used against Jewish peoplehood are
often almost ludicrous: "they don't look alike," "they don't eat the same
foods," "they don't speak the same language." While each of these may be

one relevant criterion of peoplehood, no one of them seems necessary. What unites a "people" is a complex matter and obviously differs from nation to nation; Americans and Canadians would meet few of the traditional criteria. Palestinians, dispersed throughout the world like Jews, no longer share a language and never shared one common religion. Yet it would be presumptuous to tell someone who *experiences herself* as Palestinian that she is really an "American" or a "Jordanian" or even, as Israeli leaders used to insist, simply an "Arab" with no more distinctive identity. Ultimately, whether or not someone is a member of a "people" seems most reasonably answered by whether she is a member of a group that *experiences* itself as sharing an identity. Those who do so experience themselves have certain characteristic qualities: they feel part of a shared history (perhaps a history of victimization), they feel pride when their group (or perhaps even a member of their group) is recognized as having performed in a noble or distinguished way, and they feel shame, not merely anger, when something ignominious becomes associated with their group.[18] If these feelings are combined with a general desire to achieve self-determination and a willingness to sacrifice for it, the existence of "peoplehood" cannot reasonably be doubted. There may be pragmatic reasons for regarding the achievement of statehood as undesirable or impossible—insufficient economic resources, for example—but unless someone can rationally demonstrate objective criteria for peoplehood, one cannot deny in such cases that there does indeed exist a people that is striving for self-determination.

A second argument directed against Jewish nationalism is that it is "closed" or exclusive, in contrast to the more "open" or inclusive nationalisms espoused by "genuine" liberation movements. Though this criticism is directed against Zionism in principle, I will focus mainly on the form it takes by those who defend Palestinian nationalism. I will argue that if Palestinian nationalism is not to become a merely administrative nationalism, then it will include the same exclusionary features as the Jewish nationalism it criticizes.

Palestinians often stress that their opposition is not to Jews but to Zionism, and many emphasize that Jews *who come from Palestine* are also Palestinians and can share in the fruits of Palestinian national liberation. This view bases national identity on a shared attachment to land. It claims to be an inclusive nationalism, and it considers Zionism closed or even racist because it excludes people simply because of their ancestry.[19] The old PLO formula of one "secular democratic state" in Palestine was one attempt to implement this view. While this approach denies Jews recognition as a distinctive people entitled to a state of their own, it offers a positive justification for nationhood that can include Jews. This can be looked at in two slightly different ways: (1) a state of Palestine that recognizes the

existence of two different "common lives," Jewish and Arab, but claims that their shared attachment to the same land implies that they should live together under one jurisdiction; (2) a state of Palestine in which a shared attachment to the land is itself regarded as the basis for a single "common life" uniting Arab and Jew. The first form denies the "one nation, one common life" approach, while the second accepts that each nation protects one "way of life" but broadens its conception of what a "way of life" includes. Both conceptions can give some content to being Jewish or being Palestinian Arab and yet both oppose an "exclusive" nationalism based on the culture of only one group or the other.

The idea of a single secular state based on attachment to the land of Palestine probably best captures the deepest Palestinian aspirations and is proposed as an alternative both to a "closed" cultural nationalism and to a mere "administrative" nationalism. The Palestinian dream of a secular state has always been more substantial than a desire for some administrative unit that would issue passports or for a bureaucracy, any bureaucracy, that would promote the health and welfare of Palestinians. The dream includes the use of the Arabic language, the freedom to practice the Muslim or Christian religion, the teaching of Palestinian history, and the commemoration of that history in national holidays. But, according to the proposed challenge, there is no reason why these elements of a "common life" cannot coexist in a single state with a second, Jewish "common life" or that the two together cannot be thought to make up a common life more broadly conceived.

However, to base nationalism on attachment to the same land seems to undermine the whole substantive justification of national boundaries, reducing it in the end to a matter of administrative convenience. There are two possibilities: either Jews and Palestinians are thought to have somewhat separate common lives but tied together into one nation by living on the same land, or else the fact that Jews and Palestinians live on the same land is itself thought to give Jews and Palestinians one common life. But if Jews and Palestinians have separate "common lives" and two such different common lives are to coexist in one country, why not include Jordan, Lebanon, and Egypt as well? Why not the whole Middle East or even Europe? Why divide the land of the world into separate nations unless doing so is judged to be efficient or administratively convenient as a way of distributing responsibility? Once we concede that Jews and Palestinians have different ways of life and once the administrative convenience model of nationhood is rejected, there seems no good reason to group Palestinians with Jews rather than with Jordanians and no basis for grouping Jewish Israelis with Arabs rather than Americans.[20]

If, on the other hand, Jews and Palestinians are thought to constitute a single way of life based on a shared attachment to the land, then again it

is not clear where to draw the boundaries of "the land" to which they are attached. How is it different from the land of Lebanon or Egypt or Jordan? Do not all people in the region share an attachment to "the land" a bit more broadly conceived? Or, going in the other direction, why should not Jerusalemites be considered attached to a "different land" from those living in Tel Aviv? Their relation to what they regard as a holy city is dramatically different from that of people living in secular Tel Aviv.[21]

Once we purge considerations of "culture" or "way of life" of the more traditional kind in order to create a more "open" nationalism, drawing national boundaries based on an attachment to one land rather than another would seem to reduce us to defining political units purely in terms of administrative convenience. If "attachment to land" is interpreted to include anyone who happens physically to reside in a given area, then it will indeed be open and inclusive, but it will justify only an administrative nationalism. On the other hand, if "attachment to land" means something more than this—a shared history of attachment, a bonding of people who are "from" the same place—then it will be a cultural nationalism that will be *at least* as exclusive as Jewish nationalism. Though the Zionist movement does not embrace Palestinian Arab culture (but could in principle, and should, protect its expression as a cultural minority inside Israel), a Palestinian nationalism based on a common historical attachment to the land of Palestine will also exclude (or at least similarly fail to "embrace") the culture of Russians, Austrians, Jews and anyone else who does not share Palestinian *ancestry*. If what is thought morally problematic about a Jewish nationalism is that it promotes a culture based (largely) on ancestry, a matter over which people have no control, then Palestinian (and many other forms of) nationalism must be seen as no less exclusive. Even when nation-states respect the basic rights of minorities, their failure fully to "embrace" minority cultures seems to be an inevitable element of cultural nationalism; the Palestinian idea of a "shared attachment to land," if interpreted as more than an administrative division, is no exception. Though the *implementation* of Jewish nationalism may have involved unique forms of exclusion, there seems to be nothing *in principle* about Jewish nationalism that makes it any less inclusive than other forms of cultural nationalism.

A final argument against Zionism, attempting to distinguish it from acceptable forms of cultural nationalism, is that it lacked one of the ethical requirements of a national liberation movement, residence on contiguous territory on which to construct a nation-state. National movements typically work to control territory on which they are currently suppressed or from which they have recently been expelled, but in its inception Zionism envisioned a state for people scattered throughout the world.[22]

The tie between a people, a national liberation movement, and particular territory is a complex one that, in its most theoretical dimension, is

beyond the scope of this paper. I will limit myself to three brief comments. First, although it is fair to say that those already living in an area have a presumptive claim to its territory over those not living in the same area, there may be some advantage to demystifying the connection between people and land. A group has a better chance of creating a morally acceptable form of nationalism if it sees territory simply as the necessary physical space in which their people can live and express their national culture rather than as the soil where their ancestors' blood has been shed. Some of the greatest problems of nationalism, Jewish nationalism included, derive from an excessive rather than an insufficient tie to a particular territory of the world.[23]

Second, if one questions whether a particular people—in this case, the Jews—are truly a "people" of the kind qualifying for national self-determination, the existence of a strong will to create a homeland even in the *absence* of the close natural ties afforded by physical proximity would seem to be unusually powerful evidence of the experience of a shared identity. And if, as argued above, the qualities of peoplehood depend upon the subjective experiences of its members, the *sense* of peoplehood is the most important evidence of its actual existence. That this shared identity derives in part from a history of persecution at the hands of countries widely separated from one another strengthens rather than weakens the case for Jewish nationalism.

Third, there is no good moral reason *in principle* to disqualify people from building a state on territory merely because most (or even all) of them had never lived there before.[24] Had there truly been a "land without people" and Jews had settled and built their state there, I would see no good reason to consider Jewish nationalism less legitimate because it needed to find a homeland rather than to try to "reclaim" one. What is problematic *in practice* about settling in areas where people have not previously lived is that *other people have a claim to the land*. This is the most crucial challenge to Zionism and the subject of the next section.

Zionism as a Violation of Palestinian Rights

If the first two arguments against Zionism fail, then the idea of a morally defensible Jewish national liberation movement is conceivable. From the standpoint of a more realistic (even if not from a purely impartial) morality, people are entitled to form states to defend a particular culture or "way of life," and if Jews experience themselves as sharing a way of life and are willing to sacrifice to achieve self-determination, their aspirations to national liberation must be respected as much as those of any other people. The final criticism of Zionism concedes all this but argues that though

there is nothing inherently wrong with the idea of Jewish nationalism, Zionism, by definition, infringes the rights of Palestinians. Another way of putting the criticism is to say that if Zionism were fully represented by its first principle, that "Jews have a moral right to self-determination or a Jewish state somewhere in the world," it would be defensible. But since Zionism did not choose a so-called "land without people," since it claims for Jews (under its second principle) "a moral right to self-determination or a Jewish state *somewhere in Palestine*," it necessarily infringes the moral rights of the indigenous people in the area and is for *that* reason morally indefensible.

That the actual establishment of Israel infringed Palestinian rights is hard to dispute. Zionists must confront the dispossession of Palestinians, the devastation of a Palestinian way of life, and the intentional destruction of four-fifths of the Arab villages that once existed in what is now Israel.[25] Similarly, it would be hard to dispute the claim that Israel's current policies infringe Palestinian rights. Israel's infringement of human rights in the West Bank and Gaza has been widely documented in both international and Israeli sources.[26]

Several argumentative strategies are open to the contemporary Zionist, however. One would be to claim that Zionism *in principle* does not imply the infringement of Palestinian rights that has actually occurred (and continues to occur). A second would be to concede that Zionism infringes Palestinian rights but to argue that this infringement is morally justified by more weighty considerations. Finally, the Zionist might concede the moral flaws inherent in Zionism but argue that a morally acceptable form of Zionism is still possible today. I will discuss each of these in turn.

That Zionism in principle does not imply any *particular* course of events, any particular historical infringement of rights, is clearly true, just as any concept does not imply a particular instantiation. However, even if the Zionist movement could have minimized the infringement of Palestinian rights more than it actually did, it is unlikely that any movement to establish a Jewish state "somewhere in Palestine" could have totally avoided infringing the rights of the indigenous people. Unlike the romanticized view of most American Jews and Christians, some leading Zionists have been more forthright in acknowledging the moral costs that were unavoidable elements of Jewish national liberation in Palestine. Three years after famously calling Palestine "a land without people for the people without land," Israel Zangwill reversed himself in a little-known 1904 New York speech:

> There is, however, a difficulty from which the Zionist dares not avert his eyes, though he rarely likes to face it. Palestine proper has already its inhabitants. The Pashalik of Jerusalem is already twice as thickly populated as the United States,

having fifty-two souls to every square mile, and not 25 percent of them Jews, so we must be prepared either to drive out by the sword the tribes in possession as our forefathers did, or to grapple with the problem of a large alien population.[27]

And in 1969 Moshe Dayan said to a group of students:

We came to this country, which was already populated by Arabs, and we are establishing a Hebrew, that is, a Jewish state here. . . . Jewish villages were built in the place of Arab villages. You do not even know the names of these Arab villages, and I don't blame you, since these geography books no longer exist. Not only the books do not exist—the Arab villages are not there either.[28]

The second Zionist argument is more forthright and philosophically more interesting. It concedes that the infringement of Palestinian rights is inherent in establishing and maintaining a Jewish state in Palestine. It claims, however, that this alone does not show Zionism to be in principle morally unacceptable. The infringement of others' rights is not *always* morally wrong since even strong rights claims are not absolute. On an absolutist view, there can never be considerations that justify infringing a right. For example, if freedom from unwanted experimentation were regarded as an absolute right, then it would be immoral to use a person in an experiment against her will even if the fate of the rest of the world were at stake. Most ethical theorists shrink from such absolutism.

In the same spirit, Zionists might concede the infringement of Palestinian rights but defend Zionism on the grounds that the infringement of rights was (or is) *necessary* for the protection of *morally more weighty rights,* such as the saving of human lives and the preservation of a culture threatened with destruction. Determining the "weight" of rights is a notoriously difficult matter, of course. I will not attempt to argue for or against the Zionist case but instead will set out what I think it needs to involve and then argue for two conclusions that are relevant to the current Israeli-Palestinian conflict, whether or not the Zionist defense is successful.

The Zionist argument appeals to two rights, the right of people to protect their own lives and the right of people to defend their own culture when it is threatened with destruction, as Jewish culture was threatened by European persecution culminating in the Nazi genocide. The Zionist argument is that these rights outweigh the Palestinian rights that Zionism necessarily sacrifices.

Even assuming that the two rights invoked by defenders of Zionism exist and have moral significance, the argument needs further clarification. First, there is the factual question of exactly *which* Palestinian rights Zionism infringes. Some argue that it is the right of Palestinians *to live*

where they choose and suggest that the Jewish right to *exist* must take precedence. However, Palestinians would respond that Zionism, by definition, implies not just the "transfer" of Palestinians from one place to another but the destruction of the whole Palestinian way of life, partly because Palestinian culture is based on ties to a particular land. If Zionism implies the destruction of Palestinian culture, its defender will need to show why the right of Jewish culture to survive outweighs the corresponding right of Palestinians.

Second, the right of Jews to protect their lives, to which Zionists appeal—even assuming that this right was (or is) at stake—is not identifiable with the right of self-defense as that right is generally understood. The right of self-defense is generally invoked to permit action to protect oneself from harm against the source of danger, not against a third party. Jewish lives and culture were originally threatened primarily by Europeans, not by Arabs, so Jewish actions against Arabs were not ordinary acts of self-defense.[29] In self-defense it is often thought that one may inflict slightly greater damage than the harm that is threatened.[30] However, when one argues in favor of action against a third party rather than against the original source of danger, one's burden of proof is significantly greater. A Zionist who depends on the claim that the Jewish rights at stake are "more weighty" than the Arab rights is in fact acknowledging this greater burden of proof.

The Zionist appeal to "more weighty" Jewish rights may assume either an impartial perspective or rely on cultural partialism. In either case, a first premise might be:

1. The infringement of Palestinian rights is necessary for satisfying the rights of Jews to preserve their lives and their culture" (that is, for fulfilling the Zionist project in Palestine).

The argument could then proceed in one of two ways.

Impartialist version

2a. Rights of other people may be infringed when it is necessary to do so in order to satisfy rights that are, objectively and impartially, more compelling.

3a. The rights of Jews to preserve their lives and their culture are, objectively and impartially, more compelling than the Palestinian rights that must be infringed.

Partialist version

2b. People in one's own culture are objects of special moral concern; therefore, the rights of people in other cultures may be infringed when it is necessary to do so in order to satisfy rights of one's own people that are impartially of *at least nearly equal importance.*

3b. Jews are a culture, and the rights of Jews to preserve Jewish lives and Jewish culture are, impartially, at least of nearly equal importance to the Palestinian rights that must be infringed.

Again, for either of these arguments to be developed, defenders of Zionism would need to show that the infringement of the Palestinian rights in question is *necessary*, and they would need to spell out which Palestinian rights are in fact infringed and to argue that the Jewish rights are either "more compelling" than the Palestinian rights (in the impartial version) or "at least of nearly equal importance" (in the partialist version).

Obviously the Zionist argument will be easier to make if some form of partialism can be defended, perhaps as part of accepting a "realistic" approach to morality. The partialist argument advanced here is a conservative one, permitting only a slight preference for people in one's own culture. And it is possible that there may be sound, *ultimately impartial* arguments for a moderate partialist principle such as 2b above. For example, it is conceivable that people in a Rawlsian original position would choose such a principle.

Of course, even if this Zionist defense is successful, it would justify only a conceptual Zionism, not the one that has actually been (and is still being) implemented. In fact, of course, many Jews have displaced Palestinians when neither their own lives nor their culture were at stake (especially since 1967). And much Palestinian land has been taken not in order to save Jewish lives or Jewish culture but to preserve a higher standard of living.[31] But the defender of the *concept* of Zionism need not defend these or any other particular actions any more than a defender of Christianity or Marxism needs to defend everything that has been done in its name. A contemporary Zionist can concede moral failings in Zionist history and current practice, yet defend a Zionism that "might have been." More significant for the current crisis, a contemporary Zionist might concede even *inherent* flaws in Zionism but claim that a morally acceptable form of Zionism—that is, a morally acceptable form of Jewish statehood "somewhere in Palestine"—is still possible.

Toward a Morally Acceptable Zionism

I would like to argue for two claims that apply directly to the contemporary conflict between Jews and Palestinians. First, even if the Zionist defense fails, some Jews may nonetheless now have a stronger moral claim to live in the land of Israel/Palestine than some Palestinians. Second, even if the Zionist defense succeeds, Palestinian rights still have moral force and cannot now be ignored. This final claim leads in a direction that may help contribute to the development of a morally acceptable Zionism and holds larger lessons for nationalism in general.

First, imagine that the Jewish rights at stake do not outweigh the Palestinian rights; for example, because it was (or is) *not necessary* for Zionists to infringe Palestinian rights in order to protect their lives and culture. Even if we inferred from this that Zionism is inherently flawed, it would not prove what some Palestinians want to claim, that all Palestinians and no (nonindigenous) Jews are *morally entitled* to live on the land of Palestine. Many Palestinians, including those who now favor "two states" as a political solution, want to claim that any Palestinian has a right to return to the land where his parent (or grandparent) was born, at least if his ancestors did not leave willingly. Yet there is an implied "statute of limitations" on this claim since they do not grant that Jews, who were forced out centuries ago, have the same *moral* right.

Clearly there *is* a significant moral difference between the claim of some Palestinians whose ancestors lived in Palestine for many recent centuries and the claim of Jews, most of whom must go back 2,000 years to establish a tie to the same land. But this difference does not establish that all Palestinians who want to go to Palestine have a right to do so and that no Diaspora Jews have that right.

The Palestinian argument for a right of all Palestinians to the land of Palestine is based on a special kind of tie, "being from" the area. But even assuming that moral claims to land are based on "being from" an area, there is no reason to think that Palestinian ancestral ties always give individual Palestinians a stronger claim than individual Jews to live in the land of Palestine. A typical Palestinian analogy goes like this:

> Imagine that you live in a house, and someone comes from another place and takes your house by force. You have a moral right to reclaim the house that was taken from you.

Our intuitions are fairly clear in a case of this kind. But now imagine the following variation, which corresponds to some instances of conflict between Palestinian Arab and Jewish claims to land:

Your grandfather lived in a house. Someone from another place took
that house by force, and your grandfather went to another place and
established a house there. You were born in this other house. In the
meantime, the person who took your grandfather's house maintained
the house, farmed its land, and perhaps continued to improve it.

Whether or not you have a moral right to your grandfather's old house
would seem to depend on a number of further considerations. Have you
and your parents consistently pressed for a return to the house? Have you
established a home elsewhere? Do you consider yourself a refugee or are
you thriving in your present home? Are any of the current residents of the
house responsible for the original theft and continuing to benefit from it?[32]
One might conclude that there are *some* circumstances where the present
resident of the house, who may know no other home, has a greater tie—
and a greater moral claim—to that land than you do, even if it is granted
that *his ancestors* acted wrongly in taking your grandfather's house. Thus,
even if the defense of Zionism fails, that would not imply that Jews cur-
rently living in Israel have no right to do so or that all Palestinians have a
right to return.

If the failure of the Zionist argument would not negate all current
Jewish claims to live in Palestine, neither would the success of the Zionist
argument negate all Palestinian claims. Though some descendants of
Palestinians are thriving in other parts of the world, many Palestinians
whose ancestors were forced off their land remain refugees, have not estab-
lished new homes, and have made continuous efforts to reclaim their
ancestors' land. These Palestinians, at least, do seem to have a strong claim
based on "tie to land." Moreover, though Jews currently living in Israel
cannot be held accountable for human rights violations committed by their
ancestors, many have not only failed to acknowledge those infringements
but are implicated—especially in the occupied territories—in infringements
of Palestinian rights that are not unlike those of their ancestors.

If the moral defense of Zionism succeeds, it does so on the grounds
that moral rights are not absolute and that what is at stake for Jews and
Jewish culture outweighs the Palestinian rights that must be compromised.
But just as it is reasonable to reject an absolutist view of rights and to be
open to the possibility that rights infringements sometimes may be justi-
fied, another extreme view of rights also seems unacceptable. This is the
view that when rights are overridden by morally more compelling consid-
erations (such as other rights or avoiding truly disastrous consequences),
in these cases rights lose all their moral force. This view would claim not only
that it is morally right to experiment on a person against her will in order
to save the rest of the world but would deny that the person experimented
on was in any way wronged or that any failure to respect a right even

occurred. On this view, when it is necessary to override a moral right, there is nothing to regret and the person who acted is immune from moral criticism because she "did the right thing," all things considered.

Judith Jarvis Thomson and Nancy Davis suggest a middle course between these two extreme views of rights;[33] namely, that there may be cases where it is appropriate to *infringe* a right, but infringing a right does not fully *negate* it. Thus even where the circumstances are such that it is morally appropriate to wrong people and to infringe their rights, these justifiable rights infringements still leave "moral traces"; the infringement of rights, even in a morally permissible act, is not immune from serious moral criticism *or the need to make redress.* This view respects the complexity of moral life and has special relevance to the possibility, today, of a morally acceptable Zionism.

Zionists might insist that a key to overcoming the Israeli-Palestinian conflict is for Palestinians to recognize that even if they will not concede the moral acceptability of past Zionist actions—indeed, even if those actions are not morally defensible—Palestinians should focus on the present and future and acknowledge the right of Jews to live as citizens in a state of Israel. But this second argument, which addresses the infringement of Palestinian rights, points to the challenge Zionists themselves confront both to achieve peace with Palestinians and to create the possibility of a morally defensible Zionism today. A morally defensible Zionism needs to acknowledge that even if the infringement of Palestinian rights can be justified (a difficult task, as discussed above), those rights are not totally negated, the infringement of those rights leaves "moral traces," and *restitution is due* to those whose rights have been infringed.

The lesson is a larger one with important implications for nationalism in general. Even within the framework of a realistic approach to morality, states and peoples may reasonably be required to come to terms with the dark episodes of their histories. Probably all nations have them, and in his classic statement on nationalism, Renan suggests that collective amnesia has been endemic to nationalism:

> Forgetting, I would even go so far as to say historical error, is a crucial factor in the creation of a nation, which is why progress in historical studies often constitutes a danger for [the principle of] nationality. Indeed, historical enquiry brings to light deeds of violence which took place at the origin of all political formations . . .[34]

Renan claims, further, that a heroic past and the memory of past glory are "the social capital upon which one bases a national idea."[35]

For any people, especially a people with a long history as victims of persecution, to acknowledge having also been victimizers requires a

transformation of national identity that may be even deeper than Renan imagined. But if Zionism and nationalism generally are to be morally acceptable, they must overcome Renan's dicta. There is much that can be said, still in the spirit of a realistic morality, about the need to develop institutions and practices to remember and teach the truth about the less glorious—indeed, the most shameful—elements of a nation's past.[36] Many countries, including Germany, South Africa, and the United States, have made efforts toward this end.

For Israel and for Zionism there are two kinds of requirements that come with acknowledging infringement of Palestinian rights as part of Israel's history. One is to make restitution to the Palestinians; for example, by paying reparations to Palestinian refugees, perhaps by means of grants to a Palestinian state. The other requirement is for Israeli Jews to engage in public acts, using the results of recent historical studies to overcome forgetting. These would be acts of national self-examination, but they would also have great significance for Palestinians, including Palestinian Israeli citizens. They include teaching in Israeli schools the truth about the destruction of Arab villages in Israel *after* its War of Independence[37] and creating public memorials and commemorative holidays for Palestinian victims.[38] Through such acts Israel can take an important step toward a morally acceptable Zionism by transforming its relationship both to its own past and, in the present, to the Palestinian people.

ELIAS BAUMGARTEN

University of Michigan–Dearborn

NOTES

I presented versions of this essay at the Center for Middle Eastern and North African Studies at the University of Michigan-Ann Arbor and at Philosophy Colloquia at the University of Colorado-Boulder and the American University of Beirut in Lebanon. I am grateful for the comments of Anton Shammas, Carl Cohen, and Holly Arida (University of Michigan-Ann Arbor); Paul Hughes (University of Michigan-Dearborn); Sanford Kessler (North Carolina State University); Nancy Davis (University of Colorado-Boulder); Ibrahim Dawud (Jerusalem); and Bashshar Haydar and Muhammad Ali Khalidi (American University of Beirut).

1. However, this is a legitimate topic of ongoing debate. Margarit and Raz accept the assumption that in the current international system, self-determination

is achieved through statehood. Yael Tamir (and others) suggests the need to develop more local associations. See Avishai Margalit and Joseph Raz, "National Self-Determination," *Journal of Philosophy* 87 (September 1990), p. 441 and Yael Tamir, *Liberal Nationalism* (Princeton: Princeton University Press, 1993), pp. 140–67.

2. The ethical literature on partiality and impartiality is extensive. See, for example, John Cottingham, "Ethics and Impartiality," *Philosophical Studies* 43 (1983): 83–99 and "Partiality, Favouritism and Morality," *The Philosophical Quarterly* 36: 357–73.

3. Jeff McMahan and Thomas Hurka both discuss the ethics of nationalism in the context of different forms of partiality. See Jeff McMahan, "The Limits of National Partiality," *The Morality of Nationalism,* ed. Robert McKim and Jeff McMahan (New York: Oxford University Press, 1997), pp. 107–38, and in the same volume, Thomas Hurka, "The Justification of National Partiality," pp. 139–57.

4. "What Is So Special about Our Fellow Countrymen?," *Ethics* 98 (July 1988): 663–86.

5. Tamir, *Liberal Nationalism,* p. 69.

6. Muhammad Ali Khalidi, "Formulating the Right of National Self-Determination," *Philosophical Perspectives on the Israeli-Palestinian Conflict,* ed. Tomis Kapitan (Armonk, NY and London, England: M.E. Sharpe, 1997), pp. 71–72.

7. Charles Beitz distinguishes between an intermediate level and a foundational level for justifying the claim that "compatriots take priority." See "Cosmopolitan Ideals and National Sentiment," *Journal of Philosophy* 80 (1983): 593–99. Alan Gewirth argues for certain forms of particularism on ultimately impartial grounds in "Ethical Universalism and Particularism," *Journal of Philosophy* 85 (June 1988): 283–302.

8. Tamir, p. 69.

9. Khalidi, p. 72.

10. Michael Walzer, *Just and Unjust Wars,* (Basic Books, 1977), pp. 53–74 and 86–108.

11. Hurka, p. 148, considers important the distinction between partiality toward the good of one's fellow nationals and partiality toward the "impersonal" good of a flourishing culture, apart from any effects on individuals. Cultural nationalism generally sees the role of the state, and of people acting on behalf of the state or of a movement to gain a state, as favoring one culture over others *because* of the benefits that the flourishing of a particular culture has for individuals participating in it.

12. Paul Gomberg argues for the related claim that individual action favoring conationals is morally equivalent to racism. See "Patriotism is Like Racism," *Ethics* 101 (October 1990): 146–50. In contrast Andrew Oldenquist, attempts to defend civic loyalty and to distinguish it from racism and illegitimate nationalism in "Loyalties," *Journal of Philosophy* 79 (April 1982): 146–50.

13. Walzer, 53–73; Tamir, *Liberal Nationalism,* p. 72–77. Also see Tamir, "The Right to Self-Determination," *Philosophical Perspectives on the Israeli-Palestinian Conflict,* pp. 59–60.

14. Tamir, p. 73.

15. "Realistic and Idealistic Approaches to the Ethics of Migration," *International Migration Review* 30 (Spring 1996): 156–70.

16. Carens, pp. 157–58.

17. From the standpoint of a realistic approach to morality, protection from persecution is a powerful argument for a people's claim to self-determination. Alan Gewirth argues that the long history of persecution of Jews provides the justification for the idea of Israel as a Jewish state. See "The Moral Status of Israel," *Philosophical Perspectives on the Israeli-Palestinian Conflict,* ed. Tomis Kapitan (Armonk, NY and London, England: M.E. Sharpe, 1997), p. 101.

18. Stanley Bates discusses how experiences of pride and shame connect a person to a community. See "My Lai and Vietnam: The Issues of Responsibility," in Peter A. French, ed., *Individual and Collective Responsibility: The Massacre at My Lai* (Cambridge, MA: Schenkman Publishing Company, 1972), pp. 156–57.

19. In fact, Zionism excludes those who fail to embrace Judaism, which is *usually*, but not always, a matter of ancestry.

20. My own personal view, based on travel in Israel/Palestine, is that there are three main "ways of life" in the area: Jewish fundamentalism, Muslim fundamentalism, and secular, democratic Arab-Jewish "Palestinianism" (for lack of a better term). Since the majority in Israel/Palestine share the third way of life, my own ethical *ideal* would be for it to be the basis for a unified national liberation movement. However, it is crucial to point out that people in the area do not experience themselves this way, and it is the people's *own* experience of their identities, not that of an outsider, that is the appropriate basis for determining "peoplehood" and the boundaries for genuine political self-determination. It would be a pointless form of "idealistic" morality to disregard the actual way people experience their national identities.

21. Muhammad Ali Khalidi considers several other possible ways for drawing territorial boundaries, including the idea that certain geographical regions form "natural" autonomous units. He criticizes this notion and treats more sympathetically the principle that "every region should be independent in which a majority of the population so desire, and in case of dispute, the group inhabiting the smallest such geographical region is the one that is given priority." See Khalidi, pp. 79ff.

22. This point was raised by Bashshar Haidar of the American University of Beirut.

23. It is perhaps interesting to speculate about the course of Jewish history had Jews settled on land to which they felt no special ancestral tie. Jewish settlers might have wanted more of Uganda than they originally possessed for its minerals, water, or other resources, but they would not claim it as the land given to their ancestors.

24. In fact Jews had lived continuously in the land of Palestine, although often as a small minority.

25. A thorough treatment of the dispossession of Palestinians and of the decision to destroy Arab villages can be found in Benny Morris, *The Birth of the Palestinian Refugee Problem, 1947–1949* (Cambridge: Cambridge University Press, 1987). Benny Morris, an Israeli journalist and historian, based this study on declassified Israeli, British, and American documents. Also see, by the same author, *Righteous Victims : A History of the Zionist-Arab Conflict, 1881–1998* (Knopf, 1999).

26. See, for example, U.S. Department of State, *Israel and the Occupied Territories Country Report on Human Rights Practices for 1998* <http://www.state.gov/www/global/human_rights/1998_hrp_report/israel.html>; Human Rights Watch, *World Report 1999: Israel, The Occupied West Bank, Gaza Trip, and Palestinian Authority Territories,* <http://www.hrw.org/worldreport99/mideast/israel.html>; and publications of B'tselem: The Israeli Information Center for Human Rights in the Occupied Territories <http://www.btselem.org/btselem/>.

27. Israel Zangwill, *The Voice of Jerusalem* (London: William Heinemann, 1920), p. 88. But Zangwill did not advocate that Jews imitate their forefathers' behavior. In fact he assumed that Jews, as an ethical people, would never do so.

28. Reported in *Ha'aretz,* April 1969.

29. See, for example, Amos Elon (a mainstream liberal Zionist), *The Israelis: Fathers and Sons* (Tel Aviv: Adam Publishers, 1981), p. 22: "The Arabs bore no responsibility for the centuries-long suffering of Jews in Europe; yet, in the end, the Arabs were punished because of it."

30. See, for example, Jane English, "Abortion and the Concept of a Person," *Canadian Journal of Philosophy* 5 (October 1975): 237–39. "How severe an injury may you inflict in self defense? . . . our laws and customs seem to say that you may create an injury somewhat, but not enormously, greater than the injury to be avoided. To fend off an attack whose outcome would be as serious as rape, a severe beating, or the loss of a finger, you may shoot; to avoid having your clothes torn, you may blacken an eye" (p. 237).

31. See, for example, Martin Buber, "A Protest Against Expropriation of Arab Lands," letter to Joseph Sprinzak, Speaker of the Knesset, March 7, 1953, in Paul R. Mendes-Flohr, ed., *A Land of Two Peoples: Martin Buber on Jews and Arabs* (Oxford: Oxford University Press, 1983), p. 262. "We know well, however, that in numerous cases [Arab] land is expropriated not on grounds of security, but for other reasons, such as expansion of existing settlements, etc. . . . In some densely populated villages two-thirds and even more of the land have been seized. As Jews and citizens of the State of Israel, we find it our duty to cry out against a proposed law which will add no honor to the Jewish people." [The law was adopted 3 days later.]

32. See Khalidi, p. 92.

33. See Nancy Davis, "Rights and Moral Theory: A Critical Review of Judith Thomson's *Rights, Restitution, and Risk,*" *Ethics* 98 (July 1988): 806–26. Davis is not herself an advocate of a theory or rights and claims that the requirement to compensate those injured may apply more generally to actions that are, "all things considered," the right ones.

34. Ernest Renan, "What Is a Nation?" in *Becoming National: A Reader,* ed. Geoff Eley and Ronald Grigor Suny (New York: Oxford Univeristy Press, 1996), p. 45.

35. Renan, p. 52.

36. See, for example, Martha Minow, *Between Vengeance and Forgiveness: Facing History After Genocide and Mass Violence* (Boston: Beacon Press, 1998).

37. New school textbooks are beginning to do exactly this, relying on work of historical studies of the kind Renan warned may threaten nationalism. According to *The New York Times,* "instead of portraying the early Zionists as pure, peace-

loving pioneers who fell victim to Arab hatred, the new historians focus on the early leaders' machinations to build an iron-walled Jewish state regardless of the consequences for non-Jews living here." "Israel's History Textbooks Replace Myths With Facts," August 13, 1999, p. A5.

38. The "Deir Yassine Remembered" project is one such attempt. See <http://www.deiryassin.org/>

PART II

For and Against

PART II

4

Patriotism:
Morally Allowed, Required, or Valuable?

IGOR PRIMORATZ

After a long period of neglect, patriotism is being discussed again by philosophers and political theorists. The renewed interest in the subject is due to the ongoing debates between impartialists and partialists in ethics and between liberals and communitarians in political philosophy. But it surely owes something to the resurgence of its close relation, nationalism, and the wish of some philosophers to say something helpful on the significance and moral status of a type of outlook that has made a considerable impact in politics in the last decade or so.

Patriotism has had its critics and its defenders. But neither have always been as precise as one might wish about the moral position they have been attacking or defending. This lack of precision is more damaging to a defense of patriotism than to its critique. If patriotism is morally unacceptable, that is all there is to it, morally speaking. But if it can be convincingly defended, if the claim about its moral unacceptability can be refuted, it is still not clear just what has been established. Patriotism may be merely morally permitted. Or it may be morally required, a moral duty. Then again, it may be neither: it may be morally good to be a patriot, although it is not something that can be enjoined as a duty. Patriotism would then be something to praise or admire, but the lack of it would not be a ground for moral condemnation.

In this paper I focus on this question. Before taking it up, I need to say a few words on the definition of patriotism.

1. What Is Patriotism?

The word "patriotism" is sometimes used in a sense that contrasts it with "nationalism." In ordinary usage in contemporary Western societies,

"patriotism" normally has positive connotations, while "nationalism" does not and, indeed, often implies a measure of disapproval or criticism. Accordingly, people sometimes describe the way they relate to their country or nation as patriotism, while branding the same attitude of others to *their* country or nation as nationalism. Another way of contrasting the two is in terms of a defensive versus aggressive attitude. In "Notes on Nationalism," George Orwell portrays patriotism as devotion to a particular place or way of life one thinks best but has no wish to impose on anyone else; patriotism is thus essentially defensive. Nationalism is said to be bound up with the desire for power; a nationalist wants to acquire as much power and prestige as possible, not for himself, but for his nation, in which his individuality is submerged.[1]

This, of course, is not very helpful. If we aim at getting clear about the moral status of patriotism, we should rather define it in a way that is not question-begging. It might be useful to define both patriotism and nationalism in a morally neutral way and on the same level, as two partly similar, partly different attitudes. Patriotism is, basically, love of and concern for one's country. Nationalism might be defined analogously as love of and concern for one's people or nation (where the latter is meant in an ethnic, rather than merely political, sense). The subject of this paper is patriotism; although some of what I will be saying on patriotism, *mutatis mutandis,* also applies to nationalism, I wish to put the latter aside.

The definition of patriotism I will be assuming here requires two clarifications. As we are morally bound to show some concern for human beings in general and many if not most of us tend to feel a measure of such concern anyway, patriotism must involve *special* concern for one's country and compatriots. Patriotism is not the same as love of and concern for humanity; a patriot loves her country *more* than any other, and is *more* concerned for the interests of her country and compatriots than for the interests of other countries and their inhabitants.

So far I have mentioned the patriot's country and compatriots, but not the state and fellow-citizens. Such an apolitical definition does seem to capture a possible, minimal sense of patriotism. In this sense, a completely apolitical person can be a patriot. But the word is hardly ever used in this sense today. As a rule, the *patria* to which the patriot is devoted is not merely a geographical, but also a political entity; the people about whose interests she is particularly concerned are not only her compatriots, but also fellow-citizens. The special concern that defines patriotism in its contemporary sense is also a concern for one's state. It involves a degree of active participation in public, political life of the patriot's country, in which the common interests are articulated, discussed, and promoted. Accordingly, normally we would not describe a completely apolitical person as a patriot.[2]

2. Is Patriotism Morally Allowed?

There is a tradition in moral philosophy that rejects patriotism in no uncertain terms. One type of objection presents patriotism as an irrational belief in the superiority of one's own country over all others and the willingness to promote its interests at the expense of other countries. Its typical manifestations are the absence of any critical assessment of one's country's policies, a knee-jerk support of those policies, an aggressive stance towards other countries, militarism, and jingoism. It makes for international tensions and leads to war. According to the other main line of argument, patriotism offends against the requirement of universality and impartiality of moral judgment. It is an arbitrary, morally illegitimate type of partialism, deriving its force from what William Godwin called "the magic in the pronoun 'my'."

On the other hand, some philosophers have questioned the type of universality and impartiality of moral judgment which requires that, for the sake of morality, we renounce so many of those personal feelings, loyalties, and relationships that provide a large part of the value and meaning of our lives, and also that we learn to ignore certain highly important special moral commitments and attend exclusively to the impersonal, universal moral duties. In this context, some have defended the type of partiality enjoined by the love of one's country. In his seminal lecture "Is Patriotism a Virtue?," Alasdair MacIntyre has gone further, and maintained that patriotism constitutes the very foundation of morality and that, accordingly, patriotic considerations ought to override other, more abstract moral considerations that might come into conflict with them. If a person's love of country is not strong enough to trump love of humanity or respect for universal justice, it is not true patriotism, but merely its "emasculated" version that ultimately reduces to an empty slogan.[3]

Still other philosophers have tried for a middle-of-the-road position: one that safeguards the demands of universality and impartiality properly circumscribed, while making room for a constrained and thus morally acceptable type of patriotism. I am referring to the writings of Marcia Baron and Stephen Nathanson in defense of what Nathanson terms "moderate patriotism."[4] I find their arguments convincing, and do not propose to improve upon them. Nor will I summarize those arguments. I will merely briefly describe the type of patriotism they have defended.

Moderate patriotism is not exclusive. Its adherent is willing to universalize the judgment according to which she is allowed to prefer her country and compatriots to other countries and their inhabitants and grant that everyone is entitled to this sort of partiality to their country. This shows her claim that she is allowed to be partial to her country to be a genuine moral judgment; for universalizability is a defining trait of such judgments.

An extreme patriot who is not willing to universalize his stand and denies that foreigners have the same right to be patriots of their countries thereby ceases to participate in moral discourse on the subject, and adopts the stance of a morally indefensible and intellectually suspect exclusivity.

Moderate patriotism is not exclusive in yet another sense. Its adherent shows special concern for her country and compatriots, but that does not prevent her from having a measure of concern for other countries and their inhabitants. Moreover, moderate patriotism allows for the possibility that under certain circumstances the concern for human beings in general will override the concern for one's country and compatriots. Such patriotism is compatible with a decent degree of humanitarianism. Extreme patriotism, by contrast, gives greater weight to the interests of one's country and compatriots than to those of other countries and their inhabitants whenever the two come into conflict.

Finally, moderate patriotism is not uncritical, unconditional, unlimited. Its adherent is not convinced in advance that her country is always in the right, and that any other country that stands in its way must be in the wrong. She is willing to submit to critical scrutiny her country's stance in international politics, its political and military objectives and the methods it uses in pursuing them. When the result of such scrutiny is unfavorable to her country, she will no longer support it in its conflict with another country simply because it is her country. An extreme patriot does not even entertain the idea of critically judging his own country. In general, a moderate patriot expects her country to live up to certain basic moral requirements and in that way, too, deserve her support, devotion, and special concern for its interests. When it fails to do so, she will support it no longer. Such a patriot, for instance, will not support the rule of her country over a territory to which it has no valid right and whose inhabitants are opposed to its rule over them, or in the waging of an unjust war. An extreme patriot, on the other hand, remains committed to the policies of his country in such cases.

This difference between the moderate and morally acceptable, and the extreme and morally illegitimate variety of patriotism, is nicely captured in two maxims—one short and widely popular, the other slightly longer and much less popular. One is: My country, right or wrong! The other is: My country, right or wrong; if right, to be kept right; and if wrong, to be set right.[5]

3. Is Patriotism Morally Required?

To say that moderate patriotism is morally acceptable is not to say that it is morally valuable or even required. Philosophers who have discussed the

moral standing of patriotism and defended its moderate variety, such as Marcia Baron or Stephen Nathanson, do not distinguish between these three positions clearly and consistently enough.[6] But neither the second nor the third thesis follows from the first, and if we are to accept either the claim that patriotism is a duty, or the claim that it is morally valuable, its proponents need to provide further argument.

In line with the conclusion of the preceding section, "patriotism" will henceforth refer only to its moderate version. What type of argument could establish the thesis that patriotism is not only morally permitted but also positively valuable, or even obligatory?

One might be tempted to give short shrift to the latter idea. Patriotism is, by definition, *love* of one's country. But we cannot be duty-bound to love anyone or anything, since it is not within our power to choose to do so or not. Feelings are not a matter of free choice; therefore, they are not subject to moral prescription or proscription. This, however, is too quick. Many people talk about "the duty of patriotism," and criticize those they feel do not live up to it or even dare to renounce it. If we accepted this argument, we would not merely reject the claim of patriotic duty as unconvincing (as, in my view, we should); we would have to pronounce all such talk fundamentally, irreparably confused. What we need to do instead is to acknowledge that, when discussing whether patriotism is a duty, what we are referring to is not the *feeling* of special love of or concern for one's country, but rather the giving of special weight to the interests of one's country in one's *choices* and *actions*.

On one view, such choices and actions are enjoined by a rule justified by its acceptance utility. The rule of patriotism, calling for special concern for the interests of one's own country and compatriots, has the same basis and status as all other special duties: such duties mediate our fundamental, general duties and thus make possible their most effective discharge. They do so by providing for a division of moral labor, indispensable since our capacities for doing good are limited by our circumstances and each one of us can normally be of much greater assistance to those who are in some way close to us than to those who are not. Thus, for instance, charity begins at home because one will do much more good by attending to the needy at home than by traveling to the other end of the world in order to do good there.

However, the rule-utilitarian justification of the duty of patriotism will not be readily embraced by patriots. They will most likely find it much too weak, tenuous, and indeed alien to what they feel patriotism is all about. For—to explain the latter point first—what it says is that the duty of patriotism is a mere pragmatic device for assigning to individuals some of the universal duties. It owes whatever moral force it has to the moral weight of those universal duties. Accordingly, as a recent proponent of this

understanding of patriotism grants, "it turns out that 'our fellow country-men' are not so very special after all."[7] They merely happen to be the beneficiaries of the most effective way of expressing our concern for other human beings. And, on a practical level, the duty of patriotism construed in rule-utilitarian terms will be flawed in the way all special duties are when understood in this way. It will be overridden on each and every occasion when acting out of universal human concern would have even slightly better consequences.[8] That, obviously, will be much too often for any patriot worth his salt.

Another line of argument for the duty of patriotism ascribes intrinsic value to citizenship, and attempts to show that this value generates the duty of special concern for one's country and compatriots.[9] This has been cogently criticized by Friderik Klampfer, who confronts the adherent of this approach with a dilemma. If citizenship is to be valuable in itself, and to a degree that makes it possible to ground the duty of patriotic partiality, it must be conceived as a very rich and intrinsically significant relationship. But the notion of citizenship so conceived will leave out many compatriots. On the other hand, if the duty of patriotism is to have its proper scope, that is, to apply to all compatriots and only to them, it must be reduced to its formal, legal terms. But citizenship so defined can have, at best, some instrumental value, and is much too weak to generate the duty of patriotism.[10]

Still another line of argument, on which I wish to focus, is suggested by John Horton's attempt to justify political obligation by deploying the notions of positional obligations, membership, and identity.[11] Although the concept of patriotism is neither equivalent to, nor necessarily included in, that of political obligation, Horton's argument for the latter is relevant, since his conception of this obligation is considerably richer than the obligation to obey the laws and authorities of one's country. It also includes a concern for the interests of one's polity. What sort of concern? Obviously, it has to be a *special* concern for one's polity and its members, and not merely an instance of concern one has for all human beings and communities. This special concern for the interests of one's polity includes a concern for the interests of its members as one's compatriots, and participation in its political life in which the welfare of the community as a whole is articulated and promoted.

In attempting to determine one's proper relation to one's polity, Horton makes use of the concept of positional obligations. Family obligations are a standard example. The obligations one member of a family has to another cannot be explained by referring to a free and deliberate act of undertaking an obligation. Nor are they based on the feelings one family member has for another; for they also hold in the absence of such feelings. They are not in need of justification in terms of some fundamental moral

principles such as justice or the common good, but rather obligate in their own right. "It is generally sufficient to point out that one does stand in a certain relationship to this or that member of one's family. . . It is often sufficient to point out that a man is this boy's father to attribute certain obligations on the part of the man. It is both unnecessary and misleading to seek some further moral justification for the obligations."[12] These obligations follow directly from one's membership in the family; they are an integral part of our understanding of the institution of family, and this institution would not exist without them. An individual is in most cases born into a family, and finds herself obligated to other members of the family by virtue of being its member.

To be sure, a family and a polity differ in some important respects. But the similarities are more to the point. An individual is in most cases born into a polity, and finds himself under appropriate obligations to other members and to the polity as a whole by virtue of his membership. "Membership in a polity is rarely optional and, where it is, it may be so only by courtesy of that polity: it is normally acquired simply by being born into a political community and is frequently sustained through continued residence within its territory. These are the conditions which standardly characterise membership."[13]

Both family and polity membership are important parts of our identity. This explains the sense of identification with one's family and polity. This identification is given expression in various ways. One may value the achievements of one's own or any other polity; but one can only be proud of the achievements of one's own polity. One may condemn the crimes of one's own or any other polity; but one can only be ashamed of the crimes perpetrated by one's own polity. The reason for this is the way one relates to the deeds and misdeeds of one's own polity, a way in which one does not and cannot relate to actions of any other polity: the former, but not the latter, are experienced and considered as, in a sense, one's own. An individual can even oppose his country's policies, and yet feel shame or even guilt for them. For those policies, as the policies of *his* country, are implemented in his name too.

This identification is not merely subjective and one-sided; others too tend to identify the individual with her polity and what it does. The authorities and fellow citizens expect that the individual will identify with the polity and act accordingly. On the other hand, an individual is sometimes on the receiving end of acts of foreigners and policies of foreign states that give expression to the idea of collective responsibility. The idea of collective responsibility is much too often applied in ways that are irrational and morally indefensible; but that is not to say that the idea itself is morally untenable. The practice of war reparations, for instance, is generally considered both reasonable and morally appropriate in certain circumstances; but

such reparations are for the most part paid by people who bear no indi-
vidual responsibility for the war. To appeal to an individual's identification
with his polity, therefore, is not to appeal to "merely subjective notions or
feelings."[14]

It will be objected that positional or membership obligations are not
necessarily *moral* obligations. If they were, the fact that a person is a mem-
ber of the Mafia would imply that that person's obligations as a *mafioso*
are moral obligations. Horton replies that positional or membership
obligations are constrained by basic moral principles: membership in a
morally illegitimate group such as the Mafia or the morally indefensible
position of concentration camp guard clearly do not entail any moral
obligations. But the fact that fundamental moral principles set *limits* to
obligations pertaining to institutions does not show that moral legitimacy
of those institutions and the obligations they generate *derive* from those
principles. At least some institutions, groups, positions that are not
morally illegitimate do generate positional or membership obligations as
genuinely *moral* obligations, and those obligations are not in need of any
further justification. The position of father is one example; membership in
a polity is another. Some of these groups or institutions play such a cen-
tral role in the life of the individual that they become part of the individ-
ual's identity, an indispensable part of the answer to the question who he
is. That holds true of the obligations bound up with membership in those
groups or institutions. Membership in a polity, then, enjoins the obliga-
tions contained in the concept of patriotism. Special concern for the wel-
fare of one's polity and its members and participation in its political life
are indeed moral obligations; they are based directly, and solely, on one's
membership in the polity. To acknowledge the membership is to acknowl-
edge the moral obligations bound up with it; to deny their moral force is
to deny the membership.

Does this argument succeed in showing that patriotism is not only
morally allowed, but also required? It seems to me that it does not.

Patriotism is presented as an obligation bound up with the individual's
position that has not been freely and deliberately chosen, with membership
acquired by birth into a polity and continued residence in it. The nature of
such obligations is explained by using the example of family and obliga-
tions bound up with membership in a family, with the position of a family
member. In the first step of the argument, then, there is a partial analogy
between family and polity. But this step fails—not, as one might expect,
because the analogy is only partial, but because family is not a good exam-
ple of the type of moral obligation Horton has in mind. His analogy seems
plausible only at first sight; its plausibility is due to its generality. When we
take a closer look and start distinguishing between various types of family
obligations, we get a rather different picture.

It is readily seen that obligations spouses have to one another are primarily obligations they undertook freely and deliberately by the act of contracting a marriage (in any relevant sense of "marriage").[15] Obligations parents have to their child, too, are primarily generated by the parents' choice to beget a child, or to act in such a way that, whether they mean to beget a child or not, they may do so. The bringing of a child into the world is bound up with the moral obligation of nurturing and bringing up the child. (The trivial nature of this remark sufficiently explains why, having said that a man is the father, we feel no need for any further argument for the claim that he has certain obligations to the child.) A child at first has no moral obligations to the parents or to anyone else, as such obligations presuppose a certain degree of maturity. Once that degree is reached, the child's obligations to the parents, if any, would seem to be primarily those of gratitude. To be sure, in a normal, healthy family in all three cases there are also relations of friendship, and such relations involve certain mutual obligations. Finally, it seems that moral obligations between siblings can only be those of friendship.

Neither obligations of gratitude nor those of friendship are generated by some act of freely and deliberately undertaking such obligations. But these obligations are irrelevant to an analogy with patriotism. It is not and indeed cannot be maintained that the obligations one has to compatriots are obligations of friendship. Friendship is a personal relationship, while the relation between compatriots is not and cannot be personal in any polity we are likely to live in.[16] Nor is it claimed that moral obligations to compatriots are a case of obligations of gratitude; arguments against the gratitude theory of political obligation apply with equal force to an attempt to interpret patriotism as required by the duty of gratitude to one's polity.[17] Other moral obligations within the family—the obligations of spouses to one another and their obligations to children—are not obligations we find we have independently of our free and deliberate acts that express or imply commitment. Horton repeatedly points out that we are born into a family and a polity, and argues that this fact and the fact of our continuous residence generate our obligations to family members and compatriots. But this claim is mistaken. The fact of birth can, by itself, ground no moral obligations of the person born. If this fact is *all* that can be adduced in support of the claim that an individual has certain moral obligations, then it is not at all clear that the individual indeed has such obligations. If, for instance, one is a child of one's parents *only* in the biological sense, if the parents have never done anything in the way of nurturing and raising their child after bringing it into the world, it would seem that one has no filial moral obligation to them at all. It is said that blood is thicker than water; it may well be, but it is still not clear just how blood relationship can, by itself, generate moral obligations. The same holds of

continuous residence, whether in a home or a homeland. The standard arguments against attempts to ground political obligation on one's continuous residence in one's country are equally damaging to an attempt to ground the obligations of patriotism in the same way.[18]

The second step of the argument, focusing on identity and membership, is no more successful than the first. I suspect that any plausibility it may have is a result of an ambiguity of these terms. Both terms can be used either in (a) a factual, morally neutral sense, or (b) in a sense that involves certain moral obligations. An individual can (a) reside continuously in the country since his birth, be registered as a citizen, and possess all the usual documents. He may speak the country's language and fully participate in its social and cultural life. He can even participate in its political life (perhaps only with a view to promoting the interests of his class or region). He can obey the country's laws and authorities (perhaps without ever giving the subject much consideration, perhaps because he figures that disobedience does not pay). That might include paying taxes, serving in the army, and so on. When asked who he is, what he is, his reply may include a reference to the country he lives in, the polity whose citizen he is, as an important item without which the reply would be significantly incomplete. In view of all this, he can refer to the country as *his* country. Of course, (b) he can also believe he has a moral obligation to show special concern for the welfare of his country and compatriots and to take part in the country's political life, in which its welfare is shaped, articulated, and promoted, and possibly even a moral obligation to obey its laws and authorities. In replying to the question who and what he is, he may mention these beliefs and the behavior to which they give rise, holding that otherwise the reply would remain significantly incomplete.

But (a) and (b) are two different accounts of membership, or two different (partial) accounts of identity, and although the latter may well accompany the former, it need not do so. If someone, in answering the question who and what she is, mentions (a), but expressly rejects (b), the answer will not be inconsistent. It will not be reason enough for us to say that her identity is incomplete, or that her talk of "her country" is a result of some misunderstanding, or an indication of hypocrisy. In other words, not everyone who intelligibly and sincerely speaks of "her country" is necessarily a patriot. A person who is not a patriot is not necessarily a person with flawed, incomplete identity or spurious membership, nor one who defaults on one of her moral obligations. On the other hand, a person who feels as a patriot and acts accordingly is not thereby carrying out a moral obligation. She is merely doing something she is morally allowed but not required to do. The argument aiming to establish patriotism as a moral obligation that focuses on positional obligations, membership, and identity does not succeed.

4. Is Patriotism Morally Valuable?

If patriotism is not morally obligatory, that need not mean that it is morally neutral, merely morally allowed. There is a further possibility, a stance in between these two positions. One might grant that patriotism is indeed not morally required, but argue that it is more than merely morally permitted: it is morally valuable. It can be conceived as a moral virtue. Some moral virtues are obligatory: justice or truthfulness are not something we may choose to stick to, but are not bound to do so. But that does not hold of all moral virtues: some are not required, but it is good if we possess them. An example of the latter type is the sort of concern for those in extreme need or misery shown by Mother Theresa, or for people in great danger and distress exhibited by members of humanitarian organizations such as Doctors Without Borders. A person showing concern for others well beyond the degree of concern for others which is requied of us all, is thought to be a morally better person than the rest of us (other things being equal). On the other hand, when we fail to follow the example set by such persons, that is no reason for moral condemnation. For what such persons are doing is *beyond* the call of duty. Patriotism is a *special* concern for the interests of one's country and compatriots, that is, a concern beyond what we owe other people and communities; is it not, then, one of such virtues?

The question to ask at this point is: Is a patriot a *morally* better person than a nonpatriot (other things being equal)? Is the special concern for one's country and compatriots, which defines patriotism, *morally* valuable? And if it is, just why? If we ask the analogous question about the kind of concern for other human beings shown by Mother Theresa or by members of Doctors Without Borders, the answer would seem to be that such concern is morally valuable for the same reason that makes a more modest degree of concern for other humans a duty falling on each one of us. The same moral value, sympathy for and assistance to people in need of it, grounds a certain degree of concern for others as a general moral duty and explains why a significantly higher degree of such concern is a moral ideal. This explanation, however, does not apply in the case of patriotism. Patriotism is not but another extension of the duty of concern for others; for it means a special concern for *my* country *because it is my country*, for *my* compatriots *because they are my compatriots*. Unlike Mother Theresa, who showed concern for every destitute, sick, dying person she could reach, and Doctors *Without Borders*, the concern of a patriot is by definition selective; and the selection is done by the word "my." But the word "my" cannot, by itself, play the critical role in an argument meant to prove that a certain line of action is *morally* valuable. If it could, one might deploy the same type of argument to establish that moderate tribalism

(understood as love of and special concern for one's tribe) or moderate racism (understood as love of and special concern for one's race) are *morally* valuable too.

5. Conclusion

If what I have been saying is correct, then patriotism remains morally allowed, but no more than that. It is neither a morally obligatory position, nor one that is optional, but morally valuable if adopted. It may be a virtue in some nonmoral sense (a political virtue, perhaps), but it is not a moral virtue. And, other things being equal, a patriot is not a morally better person than one not given to this particular type of partiality.[19]

 IGOR PRIMORATZ

Department of Philosophy
The Hebrew University
Jerusalem

NOTES

1. *The Collected Essays, Journalism and Letters of George Orwell*, vol. 3, ed. S. Orwell and I. Angus (London: Secker & Warburg, 1968), p. 362.

2. Historically, "patriotism" is a political concept. See M. G. Dietz, "Patriotism," in T. Ball, J. Farr, and R.L. Hanson, eds., *Political Innovation and Conceptual Change* (Cambridge: Cambridge University Press, 1989).

3. A. MacIntyre, *Is Patriotism a Virtue?* (Lawrence, KS: University Press of Kansas, 1984).

4. See M. Baron, "Patriotism and 'Liberal' Morality," in D. Weissbord, ed., *Mind, Value, and Culture: Essays in Honor of E.M. Adams* (Atascadero, CA: Ridgeview Publishing Co., 1989); S. Nathanson, "In Defense of 'Moderate Patriotism'," *Ethics* 99 (1989/90); *Patriotism, Morality, and Peace* (Lanham, MD: Rowman & Littlefield, 1993); "Nationalism, Patriotism and Toleration," *Synthesis Philosophica* 9 (1994).

5. The former is an abridged form of the words of Stephen Decatur, U.S. naval officer (1779–1820), in a toast made at Norfolk, Virginia, in 1816: "Our country! In her intercourse with other nations, may she always be in the right; but our country, right or wrong." The latter is from a speech of Carl Schurz, German-American politician (1829-1906), in the U.S. Senate in 1872.

6. Thus M. Baron first appears to be arguing that moderate patriotism is valuable (op.cit., p. 272) or deserves to be regarded as a virtue (p. 284), but later says

that the claim she is defending is more modest: patriotism is only "a plausible candidate for being a virtue" (p. 290). As she explains, her aim "is not the lofty one of showing that properly understood, patriotism is a virtue, but only that there is, for someone who accepts the 'morality of liberalism', at least one conception of patriotism which it is plausible for her to hold to be a virtue" (pp. 299–300 n. 37). But we are not told just why one should hold that moderate patriotism is indeed a virtue; and what Baron's arguments show is only that such patriotism is morally permissible.

S. Nathanson, too, vacillates between different claims for moderate patriotism. Sometimes he seems to be defending such patriotism as but a morally permissible preference for one's own country (*Patriotism, Morality, and Peace,* p. 169); sometimes he portrays it as a special duty, analogous to the duty one has to one's family (ibid., pp. 42–44, 65–66, 71); sometimes he seems to be suggesting that moderate patriotism is a virtue (ibid., p. 113); at other times still, he presents it as a moral ideal (ibid., pp. 48, 199, 209). But, again, there is no explicit argument for any of the positive claims for moderate patriotism; what Nathanson's arguments actually establish is only that this type of patriotism is morally allowed.

7. R. E. Goodin, "What Is So Special about Our Fellow Countrymen?," *Ethics* 98 (1987/88): 679.

8. On this see I. Primoratz, *Justifying Legal Punishment* (Atlantic Highlands, NJ: Humanities Press International, 1989), pp. 118–37.

9. For a sketch of this argument, see A. Mason, "Special Obligations to Compatriots," *Ethics* 107 (1996/97).

10. See F. Klampfer, "Can the Appeal to Intrinsic Value of Citizenship Really Help Us Justify Special Duties to Compatriots?," in P. Kampits, K. Kokai, and A. Weiberg, eds., *Applied Ethics: Papers of the 21st International Wittgenstein Symposium* (Kirchberg am Wechsel: Austrian Ludwig Wittgenstein Society, 1998), Part I.

11. J. Horton, *Political Obligation* (London: Macmillan, 1992), ch. 6.

12. Ibid., pp. 147, 156.

13. Ibid., p. 150.

14. Ibid., p. 154.

15. This is true even of arranged marriages, as long as the "arrangement" falls short of duress. In cases where it amounts to duress, such marriages may be thought by society to generate marital obligations, but they do not.

16. I am leaving aside the classical idea of "civic friendship," which is not a personal relationship and therefore does not count as friendship in the modern sense of the word. Aristotle describes it as "mere friendship of association," which "seems to rest on a sort of compact" (*The Nicomachean Ethics,* trans. D. Ross [London: Oxford University Press, 1963], 1161b, p. 212).

17. See A. J. Simmons, *Moral Principles and Political Obligations* (Princeton, NJ: Princeton University Press, 1979), ch. VII; J. Horton, op.cit. pp. 100–102.

18. See A. J. Simmons, op.cit., ch. IV; J. Horton, op.cit., ch. 2.

19. Thanks to John Horton, Friderik Klampfer, and Stephen Nathanson for helpful comments on a draft of this paper.

5

On Liberalism's Ambivalence Regarding Nationalism

CHRISTOPHER HEATH WELLMAN

Liberals have long been conflicted about nationalism. Whereas many regard national enthusiasm as a dangerous, atavistic passion to be censored by reason, others celebrate it as a healthy and laudable component of any rich life. In this essay, I try to explain and justify both positions. In my view, liberals have good reason to be ambivalent about nationalism insofar as it paves roads *both* to rewarding lives and to senseless conflicts. Here I am interested in focusing specifically on the ways in which nations are simultaneously helpful and harmful to the extent that they limit our alternatives in deciding how to live a good life. Studying this feature of nations helps us understand why nations play the role they do and, more importantly, what policies we should adopt toward them.

After a brief definition of nations, I divide this essay into three sections. First I suggest that nations owe their prevalence and importance to the way in which they limit their members' effective options for the good life. Next I explain why this feature leads liberals rightly to be wary of nationalism. Third and finally, I explore several potential liberal responses to nationalism, evaluating each for its sensitivity to the advantages and drawbacks of national affiliation.

What is a Nation?

Too often, discussions of nationalism are obfuscated as authors conceive of the concept in widely different ways. Thus, it is important to make explicit from the outset what I mean by the term "nation." As I understand it, a nation is a cultural group of people who identify with one another and either have or seek some degree of political self-determination. As such, nations have three types of features: cultural, psychological, and political. Consider each in turn.

Nations are cultural groups in that their members must share some combination of the following attributes: language, religion, moral codes, territory, dress, literature, crafts, arts, holidays, history, etiquette, and social mores. This is not an exhaustive list, nor is any of these features either necessary or sufficient. In my view, a nation is a cluster concept, so that different groups may qualify as nations in virtue of sharing various configurations of these characteristics, and the same feature may be more or less important to different nations. For instance, speaking French is paramount to the Quebeckers whereas fluency in Hebrew is secondary to the Jews.

It is not enough, however, merely objectively to share these attributes; these common characteristics must make a subjective difference. To qualify as a nation, a group's members must view themselves and others as belonging to the group in virtue of these common characteristics. Thus, Basques might constitute a nation whereas the collection of left-handed, hazel-eyed people would not because only the former sufficiently identify with one another. Typically, this identification is such that a person will not only take pride in the successes (and be ashamed of the failures) of her conationals, she will likely see herself as having special standing among her conationals, a standing which involves both special rights and responsibilities. Any given Kurd, for example, is likely to feel personally motivated and morally obligated to assist another Kurd before she would be so inclined toward a similarly imperiled nonnational.

Finally, a group must either have or seek political self-determination. At its extreme, a nation might have or covet its own state, but this is not necessary. Less dramatically, a cultural group might have or seek merely special status within a larger multinational state. Typically, nations lobby for special language, religious, or property rights. Native American groups in the United States and Canada are prime examples of groups with distinctive political statuses.

The Value of Nations

Clearly, nations are valuable for various reasons, but one of the most important is the way in which they lend meaning to their members' lives by restricting their effective options. It is odd to say that something is valuable insofar as it limits one, so let me explain this point with an analogy.

Imagine two classmates: Ally and Beth. These two have much in common; both are healthy, twenty-two-year-old college graduates living in the same city. Although they share this much, Ally and Beth are also quite different. In particular, while each has reason to expect she will lead a good life, Ally seems to enjoy much brighter prospects than Beth. Beth suffers

no handicaps; it is just that Ally enjoys an extraordinary number of gifts. In comparing the two, first consider Beth, a relatively shy, average-looking, nonathletic, young woman who did reasonably well in all of her schoolwork and particularly excelled in writing. She has won several awards for her column in the college's newspaper, has already published two short stories, and most recently impressed her advisors with the novella she submitted as her senior thesis. Like most of us at her age, Beth cannot be certain what she wants to do for the rest of her life, but she plans to pursue a career in print journalism and ultimately hopes to establish herself as a novelist. Ally, on the other hand, seems blessed with many more options. She is like Beth in being a gifted writer, but quite unlike her in having a variety of other striking talents. She was the captain of both the college's basketball and soccer teams, was active in student government, and plays the piano in a jazz quintet. In addition, her spectacular looks have since high school enabled her to earn good money as both a print and runway model. Finally, (as if this were not enough) Ally is independently wealthy thanks to a trust fund to which she gained access upon graduating from college.

It is not tough to guess who will live a more rich, rewarding life. We should expect Beth to flourish, but Ally seems poised for an extraordinary life. She has the talents which make Beth's life look promising plus many other opportunities and resources. Thus, Ally might choose to become a writer, but she could just as easily pursue a career in politics, music, acting, television journalism, modeling, or even (living off of her assets) do nothing at all. What is more, if Ally did share Beth's aspiration to become a novelist, she would enjoy the decided advantage of not having to take a journalism job to support herself; unlike Beth, Ally could leisurely write novels without worrying about mundane matters like paying the rent. In sum, Ally seems both to have an easier road to becoming a successful writer and to have numerous other inviting options as well.

If we had to choose whose shoes to fill, I dare say that few would struggle with the choice; virtually all of us would jump at the chance to occupy Ally's lot. In opposition, I contend there is reason to believe that Beth stands a better chance of living a rich and satisfying life. There are three bases of support for this surprising conclusion. (1) Second parties tend to distract one from what is most important by attending to one's features that glitter, and, insofar as Ally is adorned with spectacular attributes, she is more apt to lose focus upon those matters which most make a life worth living. (2) No matter what route Ally ultimately pursues, she would face regrets from which Beth is free because, unlike Beth, Ally is turning her back upon viable (and radically different) options. (3) Most importantly, Ally would have trouble throwing herself into any single endeavor because she faces such a tough decision, and, to the extent that she is unable to

commit to one route, Ally is likely to derive less satisfaction from this pursuit. Let me say a little more about each of these concerns.

First, notice that it is not always to one's long-run advantage to have striking characteristics, even when they generally inspire admiration. Think, for instance, of the stock high school characters, the captain of the football team and the homecoming queen. As is regularly noted, these types do not always return to school reunions with a great deal of post-graduate success. Many times, these characters flounder after school because they lack the tools necessary for post-scholastic challenges. Instead of studying and otherwise preparing for the future, the sports hero and social queen get caught up in the moment; they invest all of their time, energy, and self-esteem into their roles as high school "celebrities." The end result, of course, is that they are left relatively ill-equipped to contend with life after graduation. Ally is vulnerable to the same type of trap. Because she is wealthy, attractive, and socially graceful, she will invariably receive more attention than Beth. Certainly this attention can be helpful, but, as with the football player and homecoming queen, it can also be a distraction. It can lead Ally to spend more time attending to her looks and wealth, for instance, leaving her with less energy to devote to other things (like her career, avocations, family, and friends) which are more important and ultimately more rewarding. To the extent that Beth is free from similar distractions, she has an advantage over Ally.

The second drawback to Ally's many opportunities is that it sets her up for profound regret. To appreciate this, imagine two graduate students at Harvard: one of whom was admitted to no other comparable school, the other chose Harvard over Oxford, Stanford, and UCLA. On the one hand, the student admitted nowhere else can embrace her studies at Harvard without ever looking back. The second student, on the other hand, will always wonder how things might have been had she studied elsewhere. During the tough stretches, she will likely lament the choice she has made, and even on good days she might regret that she did not get to study and live in Los Angeles, Palo Alto, or Balliol College. Of course, even if she chooses and fully embraces the career for which she is best suited, Ally is apt to have regrets much more poignant than those of the student at Harvard. This is because the various goods from the divergent types of life open to Ally are incommensurate. The thrills of a successful life in politics or television journalism, for instance, are radically different from those which accompany an equally successful life as a writer. Thus, even if Ally is strong enough to steer clear of the distractions mentioned above and enjoys a career in writing comparable to that of Beth, she is likely to be haunted by regrets foreign to Beth.

Third and most important, Ally would have trouble throwing herself into any one endeavor because she faces a tough decision. For Beth, it is

relatively clear-cut: she has a talent, enjoys exercising this talent, and has the opportunity to pursue it. For Ally, however, it is not so simple. She too has a talent for writing, but Ally also enjoys a host of other gifts. And because fully committing to any one pursuit means turning her back to the others, we would expect Ally to be torn. Certainly, it is harder to dedicate oneself to writing when it means forgoing a career in acting or modeling. In addition, there is no urgency that she commit to anything because her trust fund affords her the luxury of not committing. (Anyone who has experienced the difference between writing philosophy papers with and without deadlines will appreciate the significance of this point.) Thus, her situation is at once like and unlike that of Buridan's ass who starved to death when faced with a choice between two equidistant, identical bales of hay. Her station is reminiscent of the ass's because she faces a choice between (if not identical options) various incompatible and incommensurate goods, but it is also dissimilar (and worse) because Ally will not starve to death if she fails to commit one way or another. The problem is that, while she will not physically perish, Ally will spiritually wither because the best human life comes from the zealous pursuit of one's autonomously chosen projects. Insofar as she is unable to choose and passionately pursue a type of life, Ally's prospects for a rewarding life appear much less rosy than we might initially suspect.

For these reasons, I think we should have concerns about Ally's life that we need not have regarding Beth's. This is not to allege that Ally is poised for a miserable existence, nor is it even to suggest there is no reason for Beth to envy Ally. Rather, these are just three ways, albeit important ways, in which Beth's prospects compare favorably to Ally's, and, ironically, each of Beth's advantages stems from her having *fewer* talents and opportunities. Beth's good fortune stems from the fact that she has a particularly salient talent which she has the opportunity and necessity to pursue.

Before applying these insights to our understanding of nationalism, it is worth pausing to note that my choice situation is not entirely novel; it is echoic of that in Socrates' retelling of the Myth of Er in Book X of the *Republic*. According to Socrates, when it came time for Odysseus to choose the character into whom he would be reincarnated, he chose an unremarkable, private citizen who quietly did his own job and minded his own business. My conclusion is like that of Socrates in that I celebrate Beth's life, and Socrates (through Odysseus) champions the life of a commoner, but our points of emphasis en route to this conclusion are quite different. Whereas Socrates exhorts us to shun all that which glitters, I emphasize that it is actually to one's advantage to have (1) limited options and (2) the necessity to choose one of these options. With this in mind, we are now in a better position to see how nations are valuable to their members, at least in part, because they limit their options.

Bearing in mind our comparison of Ally and Beth, I want now to call attention to two features of modern life: its luxury and its essentially social nature. First, note that modern life is enormously luxurious. That is to say, we need not toll endlessly just to survive; instead, we enjoy a great deal of discretion with respect to how we work and what we do to support ourselves. Rather than being forced to spend every waking moment searching for food, shelter, and clothing, we can employ ourselves variously for only a portion of the day and still have ample resources for amenities. This luxury brings with it many questions: How should I employ myself? What should I do with my leisure time? How should I dress? What should I read? How ought I to attend to my spirituality? How ought I to adorn myself? How should I express myself artistically? These are questions born of luxury because they are queries to which one could not attend were one consumed solely with survival; only those of us with time, energy, and resources to spare can meaningfully indulge in these types of concerns.

But how do we answer these questions? What reason could we possibly have to work at one job rather than another, to dress in a certain fashion, to attend to our spirituality in one manner rather than another? To answer these questions, one must appreciate that modern humans are essentially social; we see ourselves through the eyes of others. This is crucial because this perspective provides the framework within which to structure our choices. Among life's endless array of alternatives, we select from those options approved of by those with whom we identify. This is what it means to be social. I could dedicate my life to counting the number of leaves in trees or the number of blades of grass in a neighborhood park, but these pursuits have no value for me. The reason I find no meaning in such endeavors is largely because no one values such occupations or the people dedicated to them. Moreover, it would not be enough to have just *anybody* value these pursuits. If some distant culture celebrated fast and accurate leaf counters, for instance, this would not alter my impression of the activity. Leaf counting could hold no appeal unless the people with whom I identify applaud this endeavor. Without this identification, their esteem has no meaning to me; I find no value in their valuing me.

The upshot is that humans look at themselves through the eyes of others when choosing among the endless ways in which they might lead their lives. If others did not endorse a subset of ways of living as valuable, there would be insufficient reason to embrace one activity rather than another. Without one's nation, in other words, one would be a human version of Buridan's ass, frozen in the face of endless, indistinguishable options. The chief value of nations, as I see it, is that they help one to distinguish between otherwise indistinguishable ways of living; they save us from what would otherwise be a paralysis of modern luxury. Just as Buridan's ass has

no reason to prefer one bale of hay to the other, we have no reason to dedicate ourselves to either counting blades of grass or throwing an inflated piece of animal skin through a round hole. Except: our nation might value one more than another. My nation, for instance, celebrates basketball players rather than grass counters, so this gives me reason to pursue the former over the latter. Because of my social nature, I can find value in basketball in a way that I could not in either grass or leaf counting.

If life were devoid of luxury, nations would be unnecessary, and if humans were not essentially social, nations would be inefficacious. Because modern life is both luxurious and social, however, nations are valuable precisely because they limit their members' effective options. Before moving on to review the liberal unease with this feature of nationalism, it is worth quickly noting several points which confirm this description of nationalism's value.

To begin, this analysis helps explain the extent to which nationalism is a ubiquitous modern phenomenon. It was common to suppose that nationalism would fade after the two world wars; the standard thinking was that increased free trade, travel, accessible information, and political/economic interdependence would combine to create an inhospitable environment for nationalism. National sentiment has obviously not been extinguished, however, and my discussion helps us understand why. Certainly the developments listed above play an increasingly important role in shaping various cultures, but nothing about globalization can diminish the extent to which nations remain an essential feature of modern life. As long as we remain social and our lives luxurious, we will need nations (or something very like them) to structure our lives. Indeed, my account also explains why nations have so often been attached to religions and why the former seem increasingly to be occupying the bright lights of center stage as the latter recede into the shadows. We should expect nations to pivot around a specific religion because religions are by design equipped to instruct one about the good life. What is more, it is no surprise that secular nations should gain prominence as religions wane because something must fill the void caused by the latter's decline; there is no reason that humans should magically outgrow the need for direction just because the theoretical and normative tenets of the standard religions ill-fit the conditions of modernity. Rather, it is altogether predictable that we would look elsewhere for direction as religions lose their hold on us. Thus, not only does my account of the value of nations help explain their prominence in a time when many predicted their obsolescence, the proliferation and character of contemporary nations confirms my explanation of their importance. In sum, nations are crucial because they limit our choices as to how to live a good life.

Liberalism's Distaste for Nationalism

Even if one accepts my account of their value, there remains much about nations to worry. In this section I will focus on two particular concerns: one "internal" and the second "external." The internal concern involves a nation's affect upon its own members; we might be ill at ease with the fashion in which nations limit the lives of their members. The external objection highlights the impact nations have upon nonmembers; liberals have ample cause to dislike the way nations provoke their members to regard nonnationals. Consider each of these in turn.

A cornerstone of liberalism is the premium it places upon individual self-determination. As such, liberals take pause at anything which restricts an individual's effective options. Think, for instance, of how we struggle with the Amish preference for educating their children in seclusion from society at large. Even if a liberal ultimately affirms the parents' right to raise their children in this way, she will likely have poignant reservations about the child's right to an effective choice regarding her future. The Amish do not at gunpoint force their children to follow in their footsteps, but anyone who genuinely values self-determination will worry that there is a sense in which the Amish cannot be authors of their own lives if they are kept ignorant of viable alternatives. Liberals might have analogous misgivings about nations. A nation does not put a gun to its members' heads (no one *forcibly prohibits* me from dedicating my life to counting blades of grass, for example), but, to the extent that it restricts one's set of potentially meaningful alternatives, its seems to place effective boundaries upon one's self-determination.

At this point, an advocate of nationalism might object that I am being unfair. Properly understood, nationalism does not limit self-determination; rather (as my discussion in the previous section is meant to illustrate), nationalism *facilitates* self-determination. Certainly there are boundaries within which one can exercise self-determination, but nationalism is to be applauded as that which provides the structure within which one can be self-determining, not criticized as that which limits autonomy. Remember, nations enable one to find meaning in activity, so it seems odd to accuse them of limiting one's realm of meaningful endeavor.

Supposing that this defense of nationalism can be sustained (as I suspect it can), there is still room for misgivings. In particular, even if it is wrong globally to condemn nations merely because they limit their members' effective options, we should be concerned about the *manner* in which many do so. One might worry, for instance, about nations which endorse an overly restrictive set of options, thereby providing members with an insufficient latitude within which to choose a meaningful life suited to their own distinctive talents, tastes, and preferences. In part because nations

define talents and shape our tastes and preferences, but also because an overly restrictive constellation of values would have trouble garnering the general assent necessary to sustain a nation, I think that we need not be overly concerned with this possibility. There is a variant of this charge, however, which cannot be dismissed so blithely. In particular, we cannot abide nations that distribute effective options unevenly; it is problematic if a nation does not supply "as many and as good" prospects to all sexes, races, and castes. Most obviously, cultures often make it disproportionately hard for some to value themselves. A nation which discourages women from gaining education or entering civic buildings and privileged religious areas, for instance, is one which is likely to reserve the most rewarding posts for men. Alternatively, a culture might disproportionately saddle women with onerous demands such as unrealistic and unhealthy appetites, physical ideals, or fashion paradigms. Whatever one thinks of a nation encouraging different sexes into different roles, it is wholly unacceptable to reserve a less rewarding or otherwise second class life for women. In United States culture, for instance, women face a much steeper incline to the good life. Not only do females confront many more obstacles en route to our culture's most heralded prizes and positions, women who are able to overcome many of these hurdles are routinely criticized for being culpably "hard" or "driven." Thus, even when there is no legal or otherwise external barrier to their pursuit of the good life, women can be dramatically disadvantaged by a culture's values. Insofar as they celebrate equality, liberals must be concerned about the inegalitarian affects a culture's values may have upon its members. Moreover, because so many nations are profoundly chauvinist, this cannot be dismissed as a minor worry.

A second and more timely concern about nations centers around the deleterious affect they can have on nonmembers. Identification with one's conationals is often accompanied by indifference or even antipathy toward the members of other nations. At best this can lead to a neglect for nonnationals; at worst it can cause outright conflict. Thus, the most vehement objection to nationalism has always been that nations inspire their members to behave monstrously toward nonnationals.

It is often alleged that cross-national antipathy is no accident; nations inherently foster an aversion to the "other." Assuming I am right about the role nations play in shaping our values, we can see why there is an element of truth in this. To appreciate fully why one might be threatened by a nonnational, notice first that it is natural to be drawn to one's conationals. Given the common values which typically unite fellow members of a nation, two conationals are likely to have similar hopes, fears, ideals, dreams, tastes, and preferences. As such, not only will they have much in common to discuss (as two antique lovers might), their interaction is apt

to be mutually affirming; each confirms the other's values. This affirmation occurs as a second person celebrates one's accomplishments, commiserates with one's disappointments, understands one's fears, shares one's dreams, appreciates one's fashions, and the like. By analogy, think of how people with and without children tend to seek each other out. People with young children gravitate toward one another, for instance, in part because of compatible schedules and time constraints, but more so because of their common interests, opportunities, struggles, and joys. Those of us with children find strength and valuable companionship in one another because we are simpatico in this way. It is the same with conationals, of course, and this explains why we seek out one another's company.

Having considered our tendency to be drawn to conationals, it is easier to see why we might be indifferent if not overtly antagonistic toward nonnationals. The key difference between members of distinct nations is their values; most dramatically, they have different aspirations and life projects. These divergent values can be unsettling because they are typically not susceptible to rational adjudication. That is, there is no way for the member of one nation to dismiss the values of another as rationally inferior. Without going so far as to label a nation's values completely arbitrary, I do believe they are highly contingent upon convention. In this respect, a nation's values are not unlike the words in a language. Initially, there is no reason why the English word 'dog' must refer to a dog (as opposed to a cat, say), but once English-speaking people have settled upon the convention of referring to dogs with the term 'dog', there is a conventionally created reason to refer to dogs with the word 'dog.' One who grows up among Anglophones might find the English words quite natural, but their fittingness stems only from the conventional fact that others have also settled upon them. Similarly, the meaning I find in playing basketball—rather than leaf counting—depends upon the fact that people with whom I identify (my conationals) value basketball. And if I was a member of a different type of nation, I might well think that basketball is absurd and dedicate my spare time instead to developing my talents as a leaf counter.

This is key, of course, because my preference for basketball stems principally from the values of others, not any rational or otherwise objective judgment. This is not to say that I make no reasoned judgments in pursuing the good life (hopefully, I think rationally in choosing which of the lives my nation endorses is best for me, and I may even appeal to some of my nation's values to revise other of its features which seem inconsistent or otherwise ill-fitting), but these judgments are largely *internal* to my nation and its value system. For the most part, my allegiance to a particular nation does not spring from a rational evaluation. Rather than choose a nation *de novo*, we typically find ourselves having emerged within one; the process is more organic than discrete. None of this is meant to be novel (it is a sta-

ple insight of communitarians, for instance), but attending to it here can help us see why we are threatened by nonnationals.

It would not be unsettling to have contact with someone who espoused different values if you could demonstrate that her values were irrational, misguided, or otherwise inferior to your own. Under these circumstances, one need not question the values around which one has constructed one's life. If one cannot demonstrate the rational superiority of one's value system, however, it can be quite daunting precisely because it forces one to confront the arbitrariness of one's core values. It highlights the fact that one has fashioned a life based on values which are neither universal nor necessarily preeminent. One's life is as it is merely because of the accident of one's upbringing—one was raised among people who happened to value the things they did—and one would likely have a vastly different life woven from radically different materials if only one had emerged in a different time or place. Of course, this can be most disturbing (indeed, it is akin to the phenomenon of which Sartre made so much) because it unveils the paralysis of modern luxury which had initially been solved by one's nation. Remember, nations solve the problem of luxury by providing a structure within which we can make meaningful choices. Without them, we would be paralyzed, having no reason to embrace any one option over another. We take (at least a portion of) our nation's value system as a given and then choose various elements of our life according to our particular tastes, preferences, and more personal values. This is a recipe for a rewarding life, however, only if we can take our culture's values as a given, as objective rather than arbitrary. Sustained (and reflective) contact with another culture is so disquieting, then, because it undermines our nation's capacity to play this role. Once we recognize our culture's values are conventional instead of absolute, we cannot in good faith take them as a given. We must acknowledge that, just as I might dedicate myself to baseball rather than basketball, I could also pursue grass counting rather than either. This is unsettling, of course, because, while I have always realized that the activity of basketball is no more objectively meaningful than baseball, I have always taken it for granted that it has more intrinsic value than counting blades of grass. If I recognize that my nation enjoys no privileged status above others, I see that I could *choose* another; I have no good reason to take my culture's values as given. With this awareness, I no longer seem to have sufficient reason to pursue any type of life in preference to another. My nation becomes impotent, and I am once again, as Buridan's ass, paralyzed by endless, rationally indistinguishable options.

Of course, admitting that one's nation is arbitrary in this way exacts a hefty psychic toll, and we should not be surprised that people would rather not confront this conclusion. As with any type of denial, avoidance is common, so it is to be expected that people would shun nonnationals since

their presence brings us face to face with the issue. Where possible, others are ignored; where this is not possible, we join with conationals in either ridiculing or villifying those who are different. When their presence is pervasive enough to be threatening, we might try to eliminate them either by driving them away or even, at the extreme, killing them off. Think, for instance, of how the Athenians treated Socrates. At first they roundly mocked him for his unorthodox values, but, as his persistent questioning began to unmask their common prejudices, the Athenians asked him to either stop practicing philosophy or move away. Finally, when he refused to leave, they killed him. In general, though, as long as enough conationals join in condemning others for their "deviant" values, one can keep this facade in place. Denial remains a viable option, and one can persist in the comfort of viewing one's culture's values as a given.

As should be clear, this account is confirmed by the long history of inter-religious hostility. Moreover, it allows us to explain why nations sometimes conflict so vehemently with those only slightly different (like the Catholics and Protestants in Northern Ireland). At first glance, one might expect groups to conflict in direct proportion to their dissimilarity; the greater the divergence in values, the greater the animus. Clearly, history does not bear this out, however, and my account helps explain why. The reason we are sometimes most troubled by those only a little different is that we cannot so easily dismiss their differences as absurd. If someone is utterly unlike us, we can readily write her off as a "heathen" or "barbarian." If someone shares a good portion of our values, on the other hand, then we cannot do so; she enjoys a certain credibility in our eyes in virtue of her embracing so many of the right values. As such, she is that much more threatening since she presents a more difficult case to our facade of value objectivity. For an interpersonal example, consider a mother whose daughter espouses virtually all of the mother's traditional values. Suppose further that the mother is homophobic and believes homosexuality to be a sin. Imagine how difficult it would be for the mother to come grips with her daughter's homosexuality. Obviously, part of the mother's difficulty would stem from her belief that the daughter is sinning. Another reason it would be so daunting, though, is because her daughter's experience poses a forceful challenge to her value system. Because the daughter has adopted so many of the "right" values, she cannot be summarily dismissed. Thus, the daughter's homosexuality is especially threatening to the mother because it leaves less room for the latter to deny all challenges to the objective correctness of her value system. Similarly, it is understandable that nations sometimes clash most violently with groups only marginally different.

In sum, taking a closer look at the role nations play in limiting our effective options reveals that the tension between nations is no accident; it should not surprise us that we are sometimes threatened by others whose

values conflict with our own. More generally, the discussion in this section illustrates that, in spite of whatever benefits nations might provide, liberals have at least two principal concerns. Regarding its members, we must worry about the manner in which the nation limits their prospects for a good life. And regarding its nonmembers, we should be concerned about how the nation leads its members to treat others.

Potential Liberal Responses to Nationalism

Given these concerns outlined above, it is understandable that some would want to extinguish national affiliation. In this section, I argue that no such campaign could be successful. After indicating why nations are (for the time being) ineliminable, I quickly sketch a preferable liberal response to nationalism.

As much as some liberals might prefer a world devoid of nations, they cannot merely be wished away; the crucial role that they play in our lives entails that something must be offered in their stead. Moreover, I suspect that any attempt to replace nations with a more benign alternative would be frustrated for lack of a feasible substitute. Consider the obvious candidates: families, religions, and countries.

Families might seem a promising replacement for nations (insofar as they supply fertile ground for the cultivation of values), but even if we assume that this locus of values would not create moral problems of its own, families appear too small to perform the functions of a nation. Size matters in this context because a sufficient number of people must share one's values in order for one to have confidence in them. Unless enough others corroborate one's conception of the good, one is prone to dismiss it as merely idiosyncratic or otherwise inauthentic. The fact that one's family is too small a group to anchor values is evident from how often children are embarrassed by their families. Rather than view their family's behavior as appropriate, it is routine for children to be ashamed of the way their siblings or parents talk, dress, eat, look, or otherwise comport themselves.

Religions, on the other hand, appear invulnerable to this objection. As noted earlier, nations are often attached to religions and their value systems, so religions seem ideally suited to guide one toward a given way of life. Still, two problems remain. The first is that not everyone is religious and an increasing number of those who qualify as nominally so are not sufficiently invested to fashion their lives according to their religion's guidelines. Second and more important, even if everyone were devoutly religious, it is not clear why this arrangement would be an improvement over its nationalist counterpart. Recall that our interest in replacing nations

stems, at least in part, from their proclivity to conflict, but the history of religious interaction is generally a textbook for cynics. Thus, even if feasible, religions would at best be an unattractive substitute for nations.

Next, one might suggest countries as surrogates for nations. The first thing to notice, however, is that mere political alliances will not suffice. In order to substitute for nations, a country must do more than collect taxes and supply services, it must somehow advance values around which citizens can shape their lives. Once a country takes on this role, however, it is not merely a political unit, it has essentially become a nation-state. As such, it is not so much an *alternative* to a nation as a politically fortified nation. Moreover, this political empowerment raises new worries such as how a state can become culturally homogenous without resorting to ethnic cleansing and whether the political power of a nation-state only exacerbates our worries about people's lacking effective freedom to choose their own conception of a good life.

Thus, it appears that a liberal cannot simply work to replace nations with family, religion, or country. Yet there is still another possibility one might consider before conceding that nations are ineliminable; namely, one might seek a liberal community based on the fundamental value of universal, equal respect. In fact, liberals have conjured such communities in response to communitarian protests that liberalism must conceive of individuals as unencumbered atoms. In retort, liberals wax poetic about liberal communities unified by a common commitment to vigorously upholding the rights of others. I do not deny that this picture of a liberal community is in many ways attractive, but it could not perform the crucial function of a nation. The problem is that, while nations and this type of liberal community are both based on values, the latter celebrates the wrong type of value. Respecting others is a superb principle, but it does not tell one how to live, it does not discriminate among conceptions of the good. Indeed, if liberals are correct to claim that the liberal state picks out only a conception of the right which is nonprejudicial with respect to competing conceptions of the good, then nations will always be required as supplements to any purely liberal state.

Thus, even ideal liberal communities are like families, religions, and countries in being either inadequate or unpalatable substitutes for the nation. Once we recognize that nations (or something like them) are a necessary fixture on modernity's landscape, we can abandon our vain attempts to replace them and begin making a virtue out of necessity. But how can we best minimize the evils of nations? To answer this question, we must recall our two principal concerns: (1) nations can restrict members' prospects for a rewarding life, and (2) members of distinct nations too often harbor antipathy for one another.

Because of the intractability of the problems outlined in the preceding section, I fear that no proposal will allow us to steer clear of all difficulties. Still, the best prospects, in my opinion, will come from following Canada's cue and working to support all cultures in an open, liberal democratic environment. The hope is that cultivating such an atmosphere will inspire a general appreciation for liberal values so that, whenever undesirable elements of nationalism arise, they will be tempered by a genuine respect for the rights of all involved. I regret that I cannot supply more detailed recommendations, but our discussion thus far does point the way to four bits of advice: (1) Know that nations cannot be eliminated. (2) Do not try to challenge minority nations. (3) Actively support imperiled nations. (4) Encourage interaction among nations. Consider briefly the reasoning behind each of these.

First, do not mistakenly imagine that nations can be completely eliminated; there is no such thing as a nationless state. What people too often mistake as nationless is actually an environment in which the dominant culture fails to recognize its distinctive values because these values strike its members as perfectly natural. A facade of impartiality is made possible only because the "others" have an insufficient presence to force the majority to acknowledge the particularity of their outlook. Thus, any attempt to create a nationless state is especially dangerous because it combines the majority's hegemonic entrenchment of its own cultural bias with the minority's inability to press for its own cultural inclinations in a putatively "culture-free" environment.

Second, do not try to homogenize one's state; allow for existing nations to flourish. For a variety of reasons, campaigns to eliminate minority nations are more likely to backfire than succeed. Most obviously, since every culture spawns a counterculture, striving for a monolithic society seems futile. As Nietzsche explained in delightful parables featuring lambs and birds of prey, those who find it difficult to fashion a rewarding life within the context of the culture's values typically create a more hospitable subculture within which many of the dominant culture's values are inverted. Furthermore, nothing can strengthen a nation's resolve more than a common aggressor. Just as patriotism typically swells when a country is at war, national sentiment flows most copiously when a nation is challenged. Indeed, it is tough to imagine what could more effectively unite Kurds, for instance, than an aggressive campaign to eliminate them. In the face of such oppression, differences which might otherwise loom large fade into the background and only commonalities seem important. As a result, any effort to exterminate minority cultures is likely to have the converse of its intended effect.

Third, building upon the preceding point, actively support imperiled nations. Not only will assisting vulnerable cultures help those whose

nations are reinforced, it will benefit others as well. The members of the bolstered nations will gain from their culture's added strength because it is easier to pursue a meaningful life within the context of a vibrant culture. Insofar as we conceive of ourselves through the eyes of those with whom we identify, it is immeasurably more difficult confidently to espouse and pursue values when the people with whom we identify are apathetic, uncertain, or conflicted about these values. This, of course, is what is involved in an imperiled culture, and this explains why those within such an environment operate at such a disadvantage. Although less dramatically, others in society also gain from the improved health of these decaying nations because it provides greater opportunity for effective choice between nations (or, more likely, amalgams of nations). Since not everyone is ideally suited to flourish within the cultural confines of the nation from which she emerges, it is advantageous to have a variety of cultural influences within one's grasp. The greater the diversity of values upon which one may draw, the better one's prospects are for finding a suitable cultural home. Thus, it is in several respects helpful to strengthen splintering nations.

Fourth and finally, encourage and facilitate interaction between nations. In making this recommendation, my hope is that more regular and meaningful contact will render each of us better able to appreciate the humanity of nonnationals. Perhaps people will see firsthand the folly of their prejudices. It must be acknowledged, however, that this recommendation may well be a two-edged sword. While greater interaction can lead people from different cultures to realize that their commonalities outnumber and outweigh their differences, it might also lead to violence as people become frightened by their heightened awareness that their own way of life is neither unique nor uniquely rationally defensible. Moreover, it is a lamentable fact that increasing interaction also increases the opportunity for conflict and scapegoating. In view of these considerations, I advance this last point with trepidation and the qualification that, more than the others, it must be applied only on a case-by-case basis and after a thorough assessment of the likely effects.

None of these recommendations is a panacea, but hopefully they will combine to help us render nations less destructive. The grand irony of nationalism is that the very feature which makes nations valuable to the point of indispensable—they limit our effective options for the good life— also makes them a source of evil. If the analysis offered here is on target, however, perhaps we can more dexterously access the good without leaving ourselves vulnerable to the bad.

Conclusion

As much as any issue in political theory, nationalism polarizes scholars into extreme camps. While many condemn national sentiment as irrational and inherently dangerous, others champion it as natural, proper, and deserving of respect. The only point of consensus among the various theorists is that we must learn more about nations and the best way to approach them. In this paper I have sought to address these questions by exploring the nation's feature of limiting its members' effective choices for the good life. Certainly nations are extremely varied and complex, and I do not mean to suggest that the aspect upon which I concentrate here is anything like the whole story, but the nation's role of limiting options does strike me as pivotal. If I am right, this feature helps us understand (1) why nations are valuable, (2) why they are dangerous, and (3) how we ought to manage them. In the end, attending to this aspect of nations teaches us much about the subject and confirms the suspicions of both advocates and detractors. Ultimately, nationalism is a phenomenon about which liberals have good reason to be ambivalent.

CHRISTOPHER HEATH WELLMAN

Department of Philosophy
Georgia State University

6

National Partiality:
Confronting the Intuitions[1]

DANIEL WEINSTOCK

Recent defenders of nationalism have pointed to the fact that most people feel that their obligations towards their compatriots are either more numerous or more stringent than those which bind them to people from other countries as evidence that something is seriously amiss with the universalism which allegedly underpins liberal theory. That people believe quite strongly that they have such special obligations is taken as a datum for which different theories of justice must somehow offer an account. It is taken to be a measure of the theoretical success of a theory of justice that what we might call the "special-obligations thesis" can be derived from it.[2]

Universalist theories obviously fare quite poorly by this test. Indeed, they start from the premise that all persons matter equally from the moral point of view, while nationalists claim that the needs and the preferences of our compatriots generate reasons more numerous and/or more stringent than those to which the needs and preferences of others give rise. Many people sense that they owe more to their compatriots than they do to noncompatriots. Universalists must then somehow show that the best way in which to give expression to the moral equality of all persons is by the kind of moral division of labor which national partiality instantiates. Thus, for example, consequentialists will try to show that, for epistemic as well as for organizational reasons, the needs and preferences of all persons are better satisfied if we each attend to those whose needs and preferences we best understand, and to whom we can deliver goods and resources most reliably and efficiently, namely, our compatriots.[3] And rights-theorists have tried variously to show that the very possibility of human rights presupposes that states exist which enforce the rights of its citizens but not of noncitizens,[4] or that nations resemble mutual-benefit associations whose members have rights and obligations toward one another, but not toward

nonmembers, because of the benefits and burdens which their association involves.[5]

Such attempts at deriving special obligations from universalist premises have, in my view, failed, largely because the arguments do not have as their most natural conclusions that we have such obligations to *all* of our compatriots, and *only* to our compatriots. The mutual-benefit model, for example, does not explain why we should exclude resident aliens who are not compatriots, or why we should include compatriots who, because of some infirmity or incapacity, do not contribute to the creation of benefits.

The failure of universalists such as liberals to account for the moral legitimacy of the special bonds linking us to our compatriots is moreover taken by nationalists as raising the following thorny problem: Liberals standardly believe that one of the functions of the state is to redistribute resources between more- and less-fortunate citizens. But, to quote a prominent protagonist of the recent *renaissance* of nationalist theory, "[c]ommunal solidarity creates a feeling, or an illusion, of closeness and shared fate, which is a *precondition* of distributive justice."[6] In other words, liberals who insist upon the moral equality, from the point of view of each individual person, of all persons, fail to will the means necessary to the attainment of the end to which they aspire, namely that of a just society. Liberal theories of distributive justice thus purportedly contain a suppressed nationalist premise.

Liberal theories, especially those which view the development of extensive welfare states redistributing goods between the most and the least well-off citizens as a requirement of justice, have thus apparently been placed squarely on the defensive by nationalist writers. The only way out for such theories, or so it would seem, is to continue searching for an argument which might connect universalist premises with the kinds of particularist conclusions which might remove the tension in liberal theories to which nationalists have pointed. Though I can't argue for this claim now, this avenue does not strike me as particularly promising.[7] I will take an entirely different tack in this essay. What I wish to do is to question both the *status* and the *content* of the intuitions which nationalists take as data in arguing against liberals on the question of national partiality. My overall argument will proceed in four stages: (I) I will argue that we have good reason to be quite cautious in granting the status of "considered convictions" to the intuitions that we arguably have to the effect that our obligations toward our compatriots are more numerous and more stringent than those which link us to noncompatriots. (II) I will hold that nationalist claims concerning partiality among compatriots depend upon fudging an ambiguity concerning the deontic status of the special obligations claim. If the nationalist claim is that we *must* give more importance to the needs and preferences of our compatriots than to those of others, then it is

implausible. But if the claim is simply that we *may* do so, it is far less ambitious and far-reaching than it is standardly advertised to be. (III) I will hold that the argument according to which our sentiments somehow point us in the direction of those persons whose needs and interests matter most to us is corrosive both for the liberal view of distributive justice *and* for the nationalist view. This is because the lines of our natural sentiments cut across the lines marked out by nation-states. (IV) I will end by suggesting that the nationalist theoretical edifice is seriously out of equilibrium because it fails to match up in a convincing manner the *reasons* we might have to manifest national partiality with either the *contents* of special obligations ("what, precisely, are we being partial about?") or the *target* of these obligations ("who, precisely, are we supposed to be partial *to*?").

I

If nationalist writers are correct, then we all have, or at least those of us not in the grip of some abstract philosophical theory have, strong moral intuitions according to which we owe more to our compatriots than we do to others. There is, moreover, on their view, more certainty attached to these intuitions than to any abstract theory purporting to account for the totality of our moral and political obligations. And so, theories must be built up on the basis of, rather than in opposition to, such epistemologically privileged intuitions. David Miller, for example, proposes that we adopt a broadly Humean approach to political philosophy according to which "philosophy, rather than dismissing ordinary beliefs and sentiments out of hand unless they can be shown to have a rational foundation, leaves them in place until strong arguments are produced for rejecting them."[8] And since "people generally do exhibit such allegiances and attachments" [viz. national ones], we should "try to build a political philosophy which incorporates them."[9]

Now Miller is clearly being disingenuous if he is suggesting that liberals standardly hew to a universalist line attributing no importance to intuitions. The most important contemporary liberal, John Rawls, has famously argued that a principal criterion for the justification of a theory of justice is that it account for our firmest "considered judgments."[10] In order to attain the degree of reliability required to be truly "considered," a judgment must itself meet certain epistemic requirements. We must, according to Rawls, exclude from the set of considered judgments all judgments formed under the influence of factors likely to distort the use of our moral capacity. Summarizing conclusions which he had arrived at in "Outline of a Decision Procedure for Ethics," published in 1951, Rawls writes that in order to isolate considered moral judgments "we can discard

those judgments made with hesitation, or in which we have little confidence. Similarly, those given when we are upset or frightened, or when we stand to gain one way or the other can be left aside."[11] And though he does not mention this in the sections of *A Theory of Justice* devoted explicitly to metaethical issues, Rawls clearly also thinks that in isolating a set of considered moral judgments *pertaining to the main issues of political philosophy,* we ought to control for the impact which the institutions within which we live have upon our judgments. He believes that the institutions of what he calls the "basic structure" of society—"the way in which the major social institutions distribute fundamental rights and duties and determine the division of advantages from social cooperation"[12]—have a significant impact upon our wants and desires, as well as on our normative conceptions to do with social justice and ideals of the person. Unjust institutions will tend to generate unreliable judgments concerning social justice by artificially limiting the range of policy options which people might consider under different institutional arrangements, or by hiding from view certain plausible and realizable human ideals. And so it is a mistake in Rawls's view simply "to acquiesce without linking in the moral and political conception implicit in the status quo."[13] And despite his official pronouncements in favor of a Humean moral epistemology ascribing more credence to our natural sentiments and intuitions than to abstract theory, David Miller himself, in an article reviewing experimental work seeking to tease out people's views about distributive justice, warns against taking people's beliefs about "macro-justice" at face value. He writes that "if we ask people what an ideally fair distribution across society would be, their answers may be influenced by their perceptions of the current distribution; or if we ask them what responsibility society has to meet people's needs, they may draw for their answers upon existing welfare practices."[14] In other words, one of the factors that risks introducing distortion into the exercise of our moral capacity, and for which we want to control in order to arrive at a set of considered moral judgments pertaining to the political domain on the basis of which theory construction can proceed, has to do with the impact which unjust or less-than-perfectly just institutions have upon our judgments.

Let me put the point a slightly different way. It doesn't seem farfetched to suppose that our preinstitutional intuitions about what our redistributive obligations are are fairly indeterminate.[15] The political institutions within which we live have as one of their many functions to fill in the blanks, that is, to channel our inchoate sense that we owe something to those less fortunate than ourselves in a determinate direction, in accordance with some more or less fully worked-out theory of distributive justice. These institutions and the theory they embody in turn help to flesh out our own views about distributive justice. For example, different polit-

ical parties among which we as voters have to choose might put forward substantially different views of what distributive justice requires, and thus both shape and limit our views about what the range of realizable institutional arrangements is. And if these institutions are unjust, there will be good reasons to think that the intuitions formed under their pervasive influence will be unreliable.

There is no need for the reader to accept each and every element of the broadly Rawlsian picture I have briefly sketched concerning the conditions under which our particular judgments can be viewed as sufficiently reliable to guide theory construction. All that I need is that she accept (a) that our intuitions and spontaneous judgments about moral and political issues are not self-validating; (b) that the institutions that make up the basic structure of society exert an influence on these intuitions and judgments; and (c) that unjust institutions will yield unreliable intuitions and judgments. If these propositions are true, it follows that we cannot simply assume that people's intuitions about social justice are as reliable as nationalist thinkers such as Miller think they are. But let us consider the following objection: "it may very well be the case that we need to be particularly prudent in elaborating theories of justice on the basis of just *anyone's* convictions and intuitions about justice. But we who live in liberal democracies form our intuitions and judgments under the influence of institutions which are about as just as any that human history has given rise to. Our constitutions and Bills of Rights are built around rational principles which (though we may at times have trouble living up to them) affirm the fundamental equality of all persons, and prohibit that this ideal of equality be compromised in the name of any of the human characteristics, such as race, gender, sexual orientation, and the like, which have, in the past, been at the basis of legally sanctioned discriminatory practices. We can thus be fairly certain that an individual raised under such just institutions will (once other distorting factors such as self-interest, emotion, and the like are controlled for) develop reliable judgments and intuitions concerning social justice."

Now I do not want to evaluate the general plausibility of this line of argument. I want to make the far more limited claim that, no matter what its plausibility for many of the other questions with which a complete political philosophy must deal, the objection is *least* plausible when it comes to what people owe noncompatriots. For though most liberal democracies have overcome the thought that differences between men and women, blacks and whites, heterosexuals and homosexuals can plausibly justify differing bundles of rights and entitlements,[16] they have yet to question whether the difference between citizen and noncitizen, or compatriot and noncompatriot justifies the massive difference in the relative importance which liberal democratic states attribute to the needs and interests of these different categories of persons. And the reason for this is quite plain: while

the liberal-democratic state has plainly been realizing its foundational values in ever increasing degrees by prohibiting discrimination in treatment on the basis of race, gender, sexual orientation, and the like, it cannot as easily reconsider the distinction between citizen and noncitizen as a justified basis for unequal treatment. Let me explain.

Individuals are by their very natures affectively linked to a plurality of different kinds of groups (based on kinship, religion, profession, etc.), and thus to a plurality of networks of need and interest. One of the functions of the state as it has emerged in the modern era in the form of the nation-state has been to broaden the focus of individuals' moral attention toward the larger and more impersonal group constituted by the "nation." There is much scholarly debate around the question of how and why, precisely, the emergence of the modern nation-state occurred, or rather, why the nation came to be seen as the privileged and most natural locus of political organization.[17] Whatever the exact causes of the emergence of nations as a principal focus of human identification, it seems clear that the emergence of nations and that of the modern state as a form of human governance were largely coeval. And whatever the causal relations between them (do nations create states or do states create nations?), it seems clear that they have become conceptually linked in modern political consciousness. The concept of national self-determination implies that national groups are morally entitled to control their own destinies, if necessary by acceding to statehood; and, most importantly from the point of view of the point I am trying to make, part of the state's legitimacy derives from its championing the interests of the national group it represents. What this means is that, unlike discrimination based on race, gender or sexual orientation, discrimination based upon national membership is written into the very essence of the modern nation-state. To question the massive difference in the weight given by modern states to the needs and interests of their own citizens and that attributed to the needs and interests of nonnationals would be to question the historical *raison d'être* of the modern nation-state, even of those modern nation-states which come closest to realizing distributive justice *among* their citizens.

Now it seems clear that the simple fact that modern nation-states which are reasonably just in their internal affairs nonetheless treat the needs and interests of their own citizens as being of much greater moral importance than those of others does not in and of itself constitute a justification of national partiality. Grounding differential treatment upon the compatriot/noncompatriot distinction may still be just as immoral as discrimination based on any of the traits which are now covered by the Bills of Rights of most liberal democracies.[18] What the nationalist must provide us with are moral grounds which could justify, rather than simply explain, why states are entitled to base differential treatment on such a distinction. If

claims (a) to (c) defended above have merit, he cannot simply point to the fact that people as a matter of fact believe very strongly indeed that they owe more to their compatriots than they do to others to respond to this challenge, for people's spontaneous judgments and intuitions may often reflect the impact of the institutions under which they live and of the conceptions of justice which those institutions embody. If these conceptions are indefensible, then it is likely that people's intuitions and judgments will be tainted in ways which should prevent us from taking them, as Miller urges that we should, as building-blocks in the task of theory construction. And if what I have claimed about the modern nation-state's inability to question the moral relevance of the compatriot/noncompatriot distinction in the same manner as it has, for example, questioned the relevance of the male-female distinction is plausible, then it follows that we ought to be *particularly* cautious in accepting as self-validating people's intuitive beliefs about national partiality pertaining to matters of distributive justice.

A final note before bringing this section to a close. I want to address the concern that, by arguing that a moral judgment or intuition can only become the type of "considered conviction" upon which theory construction can be based *if* it does not unduly reflect elements of the institutional status quo which a normative theory of justice might legitimately want to reject, I have in effect invalidated *all* recourse to moral intuition, since our moral intuitions are bound to reflect to some degree or other the institutions and underlying views of justice into which we have been socialized. It is in response to concerns such as this one that the kinds of thought-experiments of which Rawls's original position is an exemplar come into their own. Indeed, what such a thought-experiment enjoins us to do is to think about fundamental matters of social justice *as if* certain factors which in everyday life render our moral judgments less than fully reliable did not obtain, and to use the results of such thought-experiments to obtain critical purchase upon present practices. As is well-known, Rawls holds that those aspects of our identities from which we must abstract to reflect upon social justice so as to offset the impact upon the use of our moral capacity which tend to make our judgments less than fully considered include one's "class position or social status" or one's "fortune in the distribution of natural assets and abilities."[19] If what I have claimed above about the state's inability to question the moral relevance of the compatriot/noncompatriot distinction is true, it would follow that a thought-experiment such as the original position, in order to generate reliable judgments, would have to have us abstract from our status as citizens of particular states, so as to avoid the resulting views about justice simply reflecting existing patterns of international privilege. In this manner, we might hope to generate reliable, "considered" judgments and intuitions about the relative moral importance of compatriots and noncompatriots.

II

The foregoing remarks have had to do not with the *nature*, but rather with the *status*, of our alleged intuitions concerning national partiality. I have tried to show that the degree of certainty which many nationalist thinkers attach to them is highly inflated. Such intuitions can only serve as elements in theory construction if they survive some kind of epistemic test controlling for the impact of factors known to distort moral judgment. I argued that given the sway which the nation-state system holds on our conception of the world order, and given the state's natural partisanship for its own citizens, we have good reason to suppose that whatever intuitions we have concerning our greater obligations toward our compatriots are at least open to question.

But we have not yet inquired into the nature of the special obligations which nationalist writers point to. This inquiry can, I think, be divided into three more specific questions; (1) *what*, precisely, do we owe to our compatriots? (2) *who*, precisely, are the individuals to whom these obligations are owed?; and (3) what is the *deontic status* of these alleged special obligations? I will deal with the latter question in this section of this essay, and defer questions 1 and 2 to the final section.

The special-obligations (SO) claim that we intuitively feel that the material deprivation of the worse-off members of our own state constitutes a more pressing or urgent reason for us than that of people from far-off lands does is ambiguous between two possible formulations:

The strong SO claim: we *must* give greater weight to the needs of our compatriots in deliberating about distributive justice.

The weak SO claim: we *may* give greater weight to the needs of our compatriots in deliberating about distributive justice.[20]

The strong SO claim captures the essence of the nationalist special obligations position best, at least at the level of rhetoric. For example, Yael Tamir writes of our "intuitive belief that it is particularly cruel to overlook the suffering and hardships of those we have a particular reason to care about—our fellow members."[21] And I think that the strong SO thesis is implied by the following statement of David Miller's: "In acknowledging a national identity, I am also acknowledging that I owe special obligations to fellow members of my nation *which I do not owe to other human beings*."[22] The espousal by nationalists of the strong SO thesis is unsurprising: the nationalist defender of the special-obligations thesis typically

claims that our compatriots stand in different, and most importantly, in more obligation-generating relations to us than other human beings do. It would be a disappointing result indeed for him if the most that can be derived from this is the rather moderate claim that we may give our compatriots special standing in our moral deliberation concerning our distributive obligations, though we may also choose not to. So it stands to reason that the nationalist defender of special obligations would be drawn toward the strong SO thesis.

I want to claim, however, that this position is implausible. And to substantiate this claim, consider the following thought-experiment: imagine a society in which taxes are levied according to the following simple mechanism. The sums of money which individuals must give up in order to help meet the needs of less well-off people is determined according to the theory of distributive justice X. (The reader is free to replace X by the specific theory of distributive justice she deems most just.) All citizens must pay some fixed proportion of their income to ensure the welfare of others, but they are free to distribute the resulting sum between domestic and foreign welfare programs according to their feelings and convictions. Now imagine that a convention has been established among the members of society such that the rate by which people are expected to discount the needs and interests of others as compared to the needs and interests of compatriots is, say, 1 to 3. Imagine an individual within that society, call him The Cosmopolitan, who decided, in spite of this convention, to distribute his tax-money between conationals and others equally. Would we be willing to say of such a person that he was acting *immorally*, as the strong SO claim would require? This would strike me as highly counterintuitive. After all, the cosmopolitan will have abided by the general obligation that he contribute a proportion of his income determined by a progressive rate of taxation which for the sake of argument I will postulate instantiates the most plausible theory of justice, whatever that might be. And he has not lacked concern for his compatriots; rather, he has simply allowed the interests of others to weigh as heavily with him as those of people closer to hand. I doubt that we would want to say of either the cosmopolitan or of his fellow-citizens, to the extent that they do pony up their fair share, that they have acted immorally. Now what I want to suggest is that the general claim which allows us to account for the intuition that neither the people who have established the 1-to-3 convention nor the individual who discharges his distributive obligations at the rate of 1 to 1 is acting immorally is the weak SO thesis. Let me now say a few words about it.

There is at first glance something paradoxical about a position which tells us that we *may choose* to take up certain obligations or not. An obligation is, after all, an *obligation*. Admittedly, there are some types of obligations which we only incur by virtue of specific agreements which we freely

undertake, and so there are certain obligations which we can avoid simply by not undertaking the obligation-creating agreement. But what I have here been calling our redistributive obligations are not of this kind. The needs of others constitute reasons for us, independently of any agreement which we may have reached with them. They are natural duties, and therefore not ones we can avoid simply by not contracting. So the question remains: how can there be obligations which we can choose to take up or not?

I think the answer to this question can easily be provided by following Onora O'Neill and others in seeing our distributive obligations as a species of *imperfect obligation* in the Kantian sense.[23] Imperfect obligations point to maxims or policies which we must take up, but which leave us some latitude and discretion as to the precise manner by which we will discharge them. For Kant, duties of self-improvement and of mutual aid are of this kind. I do not want to engage in Kantian scholarship here in order to determine why Kant thought that our duties of mutual aid are only imperfect, or to show that there are resources within the Kantian construal of the notion of an imperfect duty to avoid the imperfect status of these duties giving rise to moral backsliding.[24] The general idea is that given, first, that there is no practical limit on the amount of aid which we could provide in order to ensure that people's needs are met, and second, that Kant understood that morality only makes sense to agents with individual desires and projects, duties of mutual aid have to be integrated into a structure that incorporates a significant degree of self-other asymmetry. Now since we cannot possibly respond to all the needs of others that might constitute reasons to act for us, and since ought implies can, it follows that we not only can, but must, select a subset of the total set of human needs as the beneficiaries of our benevolent action in order to define clearly what our obligations of mutual aid are. And since reason alone gives out short of fully specifying who these beneficiaries are, that is, since it simply generates the imperfect obligation without telling any particular individual how to discharge it in her particular life, there is no objection from a Kantian standpoint in following the path traced out by our emotions, and coming to the aid, first and foremost, of those with whom we feel most linked, provided that the total amount of aid we give is sufficient from the point of view of the criterion set forth by the idea of an imperfect obligation.

So this analysis of our distributive obligations in terms of Kantian imperfect obligations allows us to make sense far better than the strong SO thesis does of the intuition that neither the person who discounts the interests of nonconationals by the rate of 1 to 3 nor the person who distributes his aid equally among conationals and nonconationals is acting immorally. But note now that the weak SO thesis just is the Kantian doctrine of imperfect duties applied to the question of whether we should or shouldn't

accord priority to our conationals in determining the content of our dis-
tributive obligations. It tells us, briefly stated, that provided we do take up
the maxim of mutual aid to a sufficient degree, we can choose to distrib-
ute our aid between different categories of people as we see fit.

I conclude from this that only the weak SO thesis, and not the strong
SO thesis most commonly advertised by nationalist defenders of imperfect
obligations, is plausible. And the weak SO thesis is a much less distinctive
thesis than that which special-obligations theorists usually put forward. If
it could be successfully defended, it would allow us to defend the choices
which some might make to give greater weight to the needs of individuals
toward whom they feel bound by special associative ties than to the simi-
lar needs of strangers. It would therefore, for example, constitute an argu-
ment against utilitarian defenders of the view that we *must* consider the
needs and interests of all people equally when we deliberate about what we
owe others.[25] But it would not pull much weight against the claim that we
may define our obligations of mutual aid in such a way as to give the needs
of all potential beneficiaries equal weight.

The nationalist special-obligations theorist can try to get around this
difficulty by appealing to the fact that, while it may be true that, strictly
speaking, the needs of others constitute reasons for us to act, whether they
be located in our own country or half-way around the world, people's sen-
timents and intuitions about justice as a *matter of fact* naturally incline
them toward attaching more weight to the needs of their fellow country-
men, and thus, if the weak SO thesis is true, these sentiments and intu-
itions can appropriately be allowed to break the tie among the surfeit of
obligations with which they would otherwise be confronted. I want now
to provide grounds for thinking that this empirical hypothesis might actu-
ally be much shakier than nationalists think, and that reliance on people's
spontaneous intuitions and beliefs about the appropriate target for benef-
icent action is just as dangerous for the nationalist theorist concerned to
ensure justice *within* national communities as it alleged to be for the ethi-
cal universalist.

III

I want now to make a general point about the appeal to intuitions and
emotions. Notwithstanding the doubts which I put forward in the first
part of this paper concerning the reliability of our alleged intuitions about
the legitimacy of national partiality, I want to argue that such an appeal
might ultimately be self-defeating for the nationalist special-obligations
theorist. Briefly, the same feature of our intuitions and sentiments which,
according to these theorists, tells against universalist moral theories might

also end up undercutting the type of view of justice they would want to see applied *within* nations. Let me now explain why.

Many defenders of special obligations take their cue from a general critique of the universalist standpoint in ethics. They deny that we could or that we should want to be the types of agents who reason about their moral obligations in abstraction from their real-world networks of friendship and community. Our sentiments and our pretheoretical considered convictions are for such theorists a better guide to our obligations than any universalist theory could ever be.[26]

Now the problem with this kind of an approach from the point of view of theorists who want to defend special obligations is the following: special-obligations theorists do not pretend that we ought to take the sentiments and convictions which people have about their distributive obligations simply at face value. Though there may very well be a gap between the obligations which universalist theories ascribe to us and those which we are spontaneously inclined to recognize, it is not as if special-obligations theorists are not also caught with a similar problem. Indeed, they do not believe that people's obligations ought simply to be determined by the natural direction in which fellow-feeling inclines them. What our considered convictions about distributive justice purportedly tell us is that we ought to treat compatriots and others differently. But special-obligations theorists do not claim that we ought to trust our sentiments and convictions in the same way in order to determine how resources should be distributed *among* our compatriots. On the contrary, Miller, for example, argues that it is perfectly appropriate for impartiality to apply to relations among compatriots, even if some of them are naturally inclined to favor members of some smaller unit, say members of their family or of their religious group.[27] The sentiments of national allegiance which people display simply help us to trace morally significant borders in the moral landscape; they do not tell us what principles to apply within the regions they mark out for us.

The problem with such a position is that it is patently unstable. Why, given the incorrigible, self-justifying status which particularists ascribe to the real-world commitments within which situated, embedded selves are already immersed, shouldn't these commitments be allowed to determine the nature of these obligations all the way down, as it were? The problem with a position such as Miller's, which follows our sentiments as far as the borders of the nation, but then subordinates them to an impartialist perspective, is that he can offer no basis for inter-compatriot impartiality, unless he can show that, fortuitously, people's sentiments already incline them toward it. And I can see at least two reasons to think that a lack of fit between people's intuitive sense of their moral obligations and what impartiality would require of them is at least conceivable, and probably in fact

instantiated in many real-world liberal democracies. First, it could very well be that people might come pretheoretically to endorse views which might not stand up to much philosophical scrutiny.[28] Second, and most importantly from the point of view of this paper, it would be miraculously fortuitous indeed if people's intuitions about who the beneficiaries of their redistributive obligations were coincided perfectly with the set of beneficiaries identified by special-obligations theorists. It would require that the moral borders which people pretheoretically recognize as significant be the same as those which are presupposed by theorists who hold that justice must be impartially assessed among compatriots, but that partiality can manifest itself in relations with others. And this assumption strikes me as wildly implausible. Modern societies are multiply pluralistic. The identities of modern citizens therefore involve them in a multitude of infranational and supranational patterns of affiliation which are often in competition with national affiliation. The complexity of modern societies often manifests itself through cultural pluralism, as in the cases of multicultural immigrant societies and of multination states. It could be argued that in cases such as these, the gap between individual sentiment and national affiliation might be closed by nation building in the case of multicultural societies, and by secession in the case of multinational ones. But secession merely solves one problem by creating new ones (since seceding states will contain minorities which might in turn come to constitute robust foci of identification), and nation-building has run up against the stubborn persistence and resilience of regional or other cultural identities. What's more, both the secessionist and the nation-builder share the mistaken assumption that the only types of affiliation with which national identity must compete are ethno-cultural ones. I have argued elsewhere that this is a mistaken assumption. People form bonds along regional, religious, linguistic, sexual, and a multitude of other kinds of lines, and it is entirely likely that the groups within which these aspects of our identities are embedded would, in the absence of the types of pressures which the state brings to bear upon us to focus on our ties with our conationals, vie with the nations to which we belong for a place among the beneficiaries of our distributive obligations.[29]

Another factor which belies the somewhat complacent belief that our pretheoretical beliefs about whom we have obligations of justice towards will match the view which defenders of special obligations toward our compatriots think we ought to have is that, while the considerations which I have just put forward point to patterns of amity within modern societies more complex than those which nationalist theorists allow, modern societies are also unfortunately marked by patterns of enmity which might lead to some members of society being *less* inclined to contribute to the welfare of some of their compatriots perhaps even than towards

groups and individuals in other countries. The lines along which such patterns of enmity can emerge are just as complex as those which carry the patterns of amity discussed a moment ago: class, religion, language, region, ethnicity can all be sites of group enmity against which a just state, armed with a view of justice which does not simply track people's intuitive views about justice, is going to have to exert counterpressure in order to ensure that citizens take up the obligations they have toward *all* their compatriots.

The last type of affiliation to which I want briefly to point, and which further undercuts the naive view that people's pretheoretical views can be trusted to ensure justice among conationals is supranational. Indeed, most states in the world are multicultural, in that a significant proportion of their populations are immigrants or children of immigrants who are still affectively tied to their countries of origin. Were we to allow people's emotional ties to determine the beneficiaries of their distributive obligations, there is at least *prima facie* reason to expect that they will recognize more of an obligation towards the members of their country of origin than the state to which they presently belong would deem compatible with the degree of partiality it expects will hold between the individuals over whom it has jurisdiction. What's more, they will take up these obligations on grounds which the nationalist will be hard-pressed to oppose: these obligations will indeed link the individuals of a state with other individuals with whom they still share the types of affective and historical connections which are partly constitutive of what nationality is. This points us to the ambiguous nature of the concept of "nationality," to which I shall return later on.

The general point I want to make here is that a wholesale reliance by nationalists upon those sentiments and considered convictions which we allegedly harbor, and which nationalists tend to point to as evidence of the irrelevance, from the personal point of view, of universalist ethical theories, risks undercutting their own positions as well. This is because people's convictions might point towards conceptions of national justice which we might have good reason to oppose, and because the lines of moral salience which our emotions and convictions trace will very likely be quite different from those which the nationalist would want us to trace.

In a recent response to an earlier article of mine, David Miller has argued that nationalists need not appeal to sentiment in accounting for our sense that we owe our conationals more than we do others. Rather, he argues, what justice requires within a given kind of relationship is determined not by how I *feel* about the people with whom I am in the relationship, but rather by the *nature* of the relationship. If I feel rather coolly today towards a friend towards whom I felt quite warmly yesterday, it is the fact that we are friends, rather than the precise temperature of my feelings toward him from one day to the next, that determines the nature and content of my obligations.[30]

I want to make two replies to this line of argument: first, in my view it gives up rather more to the universalist than Miller should be comfortable with. For presumably, the values present in the bond of friendship, and which justify its being a source of moral obligations, are not to be determined on a case-by-case basis, but rather characterize friendship as *such*, regardless of what beliefs we have about our relations of friendship or about the obligations which such a relationship entails. In other words, they trump those individual moral intuitions which in Miller's officially stated view were supposed to be the building blocks of an adequate political philosophy. What's more, they trump these intuitions from a universalist standpoint. What Miller is saying is that friendship as *such*, rather than this or that particular friendship, involves certain duties and obligations. But this sounds very much like the kind of universalist claim which Miller was initially at pains to avoid.[31] Thus, Miller's way of dealing with the problems which an excessive reliance on sentiment raises comes at the price of forcing him out of the particularist metaethic which he had originally seen as particularly propitious for the grounding of special obligations. I take Miller's response on these claims as evidence of the fact that nationalist defenders of special obligations cannot avoid for very long this kind of recourse to a universalist perspective. I will return to the problem which the taking up of such a perspective raises for the nationalist in the final section of this paper.

The second problem, however, which holds even if nationalists could somehow contend with the metaethical difficulty I have just pointed out, is that the objection made earlier in this section, to the effect that there is no reason to think that our natural affections will not link us to groups both within and outside national boundaries in a way which might pose a difficulty for the nationalist thinker wanting to ensure impartiality within national borders can be entirely recast in the terms suggested by Miller. Indeed, cannot members of infranational groups such as kinship networks, unions, regional associations, and the like claim that, regardless of how individual members of these associations feel about one another at any given time, the very nature of such relations dictates that members should evince partiality toward one another? And might not the same be said about supranational groups, such as religious groups, national diasporas, and the like? To claim that nationality is the *only* relationship which by its nature requires members to recognize obligations to one another that they do not have vis-à-vis others is to ignore the varied nature of the commitments which constitute people's identities by definitional fiat.[32]

I want now briefly to sum up what I take myself to have made at least plausible:

(1) The kinds of intuitions upon which special-obligations theorists base themselves in order to argue for the claim that we do in fact have more extensive redistributive obligations towards our conationals might actually be less reliable than they think, at least if we accept a broadly Rawlsian story about the conditions which intuitions must meet if they are to count as "considered."

(2) It is implausible in any case for special-obligations theorists to hold that we *must* view our obligations toward our compatriots as more demanding. The most that they can plausibly claim is that we *may*.

(3) Special-obligations theorists should be more careful in appealing as they do to our emotions and to our prereflective intuitions in order to oppose universalists, for the types of considerations to which these emotions and intuitions give rise could end up corroding their own views about justice *among* conationals.

IV

We have thus far really only scratched the surface of the national partiality debate. If the arguments developed above have been successful, I have shown that the alleged intuitions we have concerning our special obligations to our compatriots are not as reliable as they need to be to ground a full-bloodedly nationalist political philosophy, that the only plausible formulation of the special-obligations thesis is the weak one which claims that we *may* give greater weight to our compatriots' needs and interests, and that the nationalist reliance upon people's spontaneous affective links to determine the boundaries of distributive justice might end up being incompatible with liberal nationalists' insistence upon impartiality *within* national boundaries. As I mentioned above, ambiguities still surround what we might call the "what" question ("what, precisely, do we owe our compatriots?"), the "who" question ("who, precisely, are these special obligations owed to?"), as well as the linking up of various answers to these two questions with the different reasons which might be provided to justify national partiality of some kind.

Let me first consider the "what" question. I have been operating until now with the simplifying assumption that our special obligations toward our compatriots are paradigmatically obligations of material aid. But a perusal of the recent philosophical literature reveals that our obligations towards our compatriots are taken to be of different *kinds*. While all the authors whose writings I have canvassed agree that material aid looms large within the set of special obligations which bind us to our compatriots,

many of them believe that we also have other kinds of obligations, including cultural obligations (the obligation to contribute to the continued health and flourishing of our national culture),[33] and civic obligations (the obligation to take an active role in national institutions).[34] Note that these obligations are logically distinct: As a member of nation X, I can contribute through my novels to the health of the culture of X while doing nothing to contribute to the welfare of my fellow Xian, and I can contribute to the material well-being of my fellow Xian while speaking to him in the language of nation Y. And so on.

Let's turn now briefly to the "who" question. Note that the claim that we have special obligations towards our compatriots is at least doubly ambiguous because of the (at least) three senses that can be given to the final term in that expression. By "compatriot" we might mean one of three things: we might mean a *concitoyen*, that is a citizen of the same state; a conational, that is, a member of the same nation; or a coresident, that is, a person who resides, in the full legal sense, on the same territory as myself. Though these concepts may coincide extensionally to a significant degree, they also are intensionally completely different. Residency and citizenship are legal notions which denote different levels of legal attachment to a state, while nationality denotes membership in an historical community which may or may not coincide with the borders of a state.

Once we place the distinct senses which the concept of "compatriot" might be given in different contexts side by side with the various types of obligation which might plausibly be taken to constitute our special obligations toward our compatriots, the following suspicion arises: our various obligations might not all be owed to precisely the same set of compatriots. States don't have cultures, nations do. And so to the extent that we have obligations to contribute to the continued existence and flourishing of the national culture which has provided us with the cultural goods in the absence of which we could not have developed as whole individuals, these obligations are owed to the members of our nation. The civic obligation however seems to apply to our *concitoyens*, those individuals with whom we share common social and political institutions. I may very well have cultural obligations which bind me to my expatriate conational living abroad, but it is somewhat artificial to maintain that I have civic obligations toward her. As far as our distributive obligations are concerned, to the extent that that which grounds them in the eyes of nationalist defenders of special obligations is the proximity and neighbor-like quality of compatriots, there seems to be no reason to deny these to people residing in the legal sense on the same political territory as us, even when they are not formally citizens.

The complexity surrounding our obligations to our compatriots, both as far as their contents and as far as their beneficiaries are concerned, can

be brought out even more fully by setting out the very different kinds of *grounds* upon which these different obligations rest. Here is a by no means exhaustive list of the kinds of justification of special obligations contained in the recent literature:

(1) National ties provide individuals with the kind of security of identity and self-worth that families provide, and are therefore to be prioritized in an analogous manner. Call this the kinship argument.[35]

(2) Individuals' obligations towards their nations stems from the *gratitude* they ought to feel towards the nation to which they belong for the important role it performs in the development of the individual's sense of self. Call this the gratitude argument.[36]

(3) Others again have argued that shared history is at the basis of the obligations we owe members of our nation. Call this the argument from history.[37]

(4) Some have also pointed to the fact that our special obligations toward our compatriots, when they exist, are justified at least in part by the values realized by members of the nation acting in concert. Call this the argument from achieved value.[38]

(5) Some authors have also attempted to derive an obligation to contribute to the continued existence of nations by pointing to the good which accrues to all people from the plurality of national cultures. Call this the argument from plurality.[39]

(6) Others have likened nations to mutual advantage associations, and have tied our special obligations to the benefits which we all derive from taking part in such a scheme, advantages which would be unavailable to individuals acting alone or in smaller units. Call this the argument from mutual advantage.[40]

(7) And it has also been argued along Kantian lines that, in order to secure the conditions required for the enjoyment of our innate right to freedom, we must set up laws which define the rights and obligations which bind individuals together, but that such systems of laws are only necessary for individuals who enter into frequent interaction and who might therefore, outside of a system of laws, constitute threats to each others' ability to enjoy the right to freedom. Call this the argument from proximity.[41]

It is not my intention to evaluate these various justificatory grounds within the confines of this brief essay. Some are implausible on their face as

justifications for national partiality: the argument from pluralism for exam-
ple gives rise to a *general* obligation for all people to promote the existence
of a large number of national cultures, and does not provide members of
individual national cultures with *specific* reasons to contribute to *their* cul-
ture. And the argument from history *taken by itself* in my view lacks any
justificatory force. The mere fact that you and I share a long history might
very well mean that we share a long history of strife, enmity, and foul-deal-
ing, hardly the type of thing that could be taken to ground obligations.
Shared history can only provide people with reasons to recognize greater
obligations toward one another if it instantiates the kind of value invoked
by the other types of justification, and so the argument from history is par-
asitic upon these other types of argument. I simply want to make two
remarks about the role which the grounds adduced by different authors
are taken to play in the justification of national partiality. First, note that
these types of grounds are the kind which what Hurka has called "univer-
salist particularists" are wont to adduce. The general claim made in very
different ways by the authors I have mentioned here is that nations matter
because they instantiate or allow for the realization of important, attractive
human values, be they psychological security, individual autonomy, or
whatever. The important point is that these are values the importance of
which can be fully appreciated from an impartial point of view. One need
not take up the perspective of any one national group in order to appreci-
ate the values in question. Indeed, the value which members of national
groups ascribe to the goods which they derive from their participation in
the life of their nation would be severely undercut were this not the case.
But this is to say that, given a consequentialist moral theory recognizing a
plurality of perhaps incommensurable values, the importance of national-
ity can be accounted for from within the terms of a nonparticularist the-
ory. The significance of this observation from the point of view of the
problem of national partiality is the following: we can imagine a conse-
quentialist theory which would tell us that our links to our compatriots
instantiates values important enough to ground obligations toward them,
and that the satisfaction of the needs of people who are not our compatri-
ots realizes values upon which we also have reason to act. From the point
of view of such a pluralist consequentialist theory, the intrinsic merits of
the bonds which tie us to our conationals and the needs of others both
represent important values, and unless we possess an overarching
metavalue such as utility or a ranking principle such as the one which pri-
oritizes liberty over welfare in Rawls's theory, the mere fact of pointing to
grounds for our obligations to our compatriots does not yet provide us
with reasons to think that these obligations are *special*, that is that they
ought in some robust sense to take priority over the obligations which tie
us to others. Briefly stated, from the point of view of a consequentialist

theory such as the one I am imagining, the mere fact of identifying *grounds* for our obligations to our compatriots does not mean identifying grounds for national *partiality.*

The second point I want to make is that the variety of values which might be instantiated by bonds among compatriots further complicates the picture I began to paint above by pointing to the plurality of our obligations and the plurality of associated groups to which these obligations are owed. First, these grounds do not all target the same *groups.* The argument from mutual advantage points to obligations I might have towards those with whom I am presently involved in some mutually beneficial social scheme, regardless of whether we share a culture or not, regardless indeed of the question of whether we share a citizenship. The argument from gratitude points to obligations which I have to contribute to the continued existence of the culture from which I derived whatever goods we think cultural belonging provides to people in the development of their individual traits and capacities. If I am an immigrant to a new land, these obligations will have the members of my native culture as beneficiaries. If I am a member of a multicultural or multinational state, it will generate obligations towards a subset of the total set of my *concitoyens.* And so on. Second, the various values adduced above as grounds for national partiality do not all target the same *obligations.* It is quite easy to see how the argument from kinship or the argument from mutual advantage might generate obligations of material aid; it is less clear that they ground anything in the way of cultural obligations. I don't want to run through the entire list of proposed arguments to show that none of them succeed in grounding arguments for the totality of the obligations we are taken to have toward our compatriots, as I take this to be plain enough.

The upshot of these two remarks is that nationalist defenders of special obligations owe us a much more complicated story than that which they have thus far put forward to justify national partiality. They will first have to disambiguate both the concepts of *obligation* and that of *compatriot.* And they will have to show precisely how the grounds which they adduce justify not only that we have obligations towards our compatriots, but also that these are somehow special, and not simply to be placed side by side with the obligations we also have toward others. And they will also have to show more clearly how the plethora of different values which are said to be realized in national ties link up with one or the other of the types of obligations listed above, as well as with one or the other of the groups which are denoted by the ambiguous term, 'compatriot'.

DANIEL WEINSTOCK

Université de Montréal

NOTES

1. Earlier versions of this paper were presented at Concordia University, McGill University, and the University of Toronto. Thanks are due to the audiences present for providing me with much food for thought.

2. See, for example, David Miller, "In Defense of Nationality," in *Journal of Applied Philosophy* 10, no. 1 (1993): 5. He writes: "What we can do is to start from the premise that people generally do exhibit such attachments and allegiances, and then try to build a political philosophy which incorporates them."

3. Robert Goodin considers an argument of this kind, and concludes that its implementation would require quite a massive reorganization of the state system as we know it, since it is clearly the case that the present division of the world's population into nation-states does not satisfy the utilitarian requirement that all people's preferences be given equal weight in the utilitarian calculus. Thus, such an argument could not, given the current distribution of the world's resources, respect the moral division of labor which national sentiments spontaneously trace. See Robert Goodin, "What Is So Special About Our Fellow Countrymen?," in *Ethics* 98 (July 1988).

4. See Alan Gewirth, "Ethical Universalism and Particularism," in *Journal of Philosophy* 85 (1988).

5. See Richard Dagger, "Rights, Boundaries, and the Bond of Community: A Qualified Defense of Moral Parochialism," in *American Political Science Review* 79 (1985).

6. Yael Tamir, *Liberal Nationalism* (Princeton, NJ: Princeton University Press, 1993), p. 121. Emphasis added.

7. For a very able criticism of many of the main arguments of this kind, see Andrew Mason, "Special Obligations to Compatriots," in Ethics 107 (April 1997). Mason himself holds that we can argue from the universal right to citizenship to the kinds of special duties to which nationalists point, by pointing out that citizenship conceptually involves partiality. This strikes me as altogether too quick. For the argument does nothing to specify the proper scope of national partiality. Indeed, as has recently been pointed out by Thomas Pogge, partiality might be appropriate in some contexts (sports partisanship, pride in artistic or scientific achievement) and not in others. See Thomas Pogge, "The Limits of Nationalism," in Jocelyne Couture, Kai Nielsen, and Michel Seymour, eds., *Rethinking Nationalism, Canadian Journal of Philosophy,* Supp. vol. 22 (Calgary, Alberta: University of Calgary Press, 1996).

8. Miller, "In Defense of Nationality," p. 4. Cf. his *On Nationality* (Oxford: Oxford University Press, 1995), p. 58, n. 11.

9. Miller, "In Defense of Nationality," p. 4.

10. See John Rawls, *A Theory of Justice* (Cambridge, MA: Harvard University Press, 1971), pp. 48–51.

11. Rawls, A Theory of Justice, p. 47. The earlier article is John Rawls, "Outline of a Decision Procedure for Ethics," *Philosophical Review* 60 (1951).

12. Rawls, *A Theory of Justice,* p. 7.

13. Ibid., p. 260.

14. David Miller, "Distributive Justice: What the People Think," in *Ethics* 102 (1992), 557.

15. Miller himself acknowledges this. See *On Nationality*, p. 68.

16. This is, of course, only approximately true, as the fact that most liberal democracies still do not grant the same legal status to gay and to straight couples attests.

17. For an excellent overview of the principal positions, see Michel Seymour, Jocelyne Couture, and Kai Nielsen, "Introduction: Questioning the Ethnic/Civic Dichotomy," in Couture, Nielsen, and Seymour, eds., *Rethinking Nationalism*.

18. For a thought-provoking argument to this effect, see Garrett Cullity, "International Aid and the Scope of Kindness," in *Ethics* 105 (October 1994).

19. John Rawls, *A Theory of Justice*, p. 12.

20. This ambiguity is briefly alluded to by Samuel Scheffler in his "Liberalism, Nationalism and Egalitarianism," in Robert McKim and Jeff McMahan, eds., *The Morality of Nationalism* (Oxford: Oxford University Press, 1997), p. 200.

21. Yael Tamir, *Liberal Nationalism*, p. 99.

22. David Miller, *On Nationality*, p. 49 (cited in n. 9, above).

23. Onora O'Neill develops this notion and applies it to the issue of international distributive justice in her Faces of Hunger (London: Allen and Unwin, 1986). For a thorough study of the relevant Kantian texts, see Marcia W. Baron, "Latitude in Kant's Imperfect Duties," in *Kantian Ethics Almost Without Apology* (Ithaca, NY: Cornell University Press, 1995).

24. I have done some of the exegetical spadework in my "How Not to Bridge the Gap: Cummiskey on Kantian Consequentialism," forthcoming in *Canadian Journal of Philosophy*.

25. This view has classically been defended by Peter Singer in his "Famine, Affluence and Morality," in *Philosophy and Public Affairs* 1 (1972). It has recently been recast in Peter Unger, *Living High and Letting Die* (Oxford: Oxford University Press, 1996).

26. Aside from Miller, another philosopher who takes this view is Alasdair MacIntyre, in "Is Patriotism a Virtue?" in M. Daly, ed., *Communitarianism: A New Public Ethics* (Belmont, CA: Wadsworth), 1994.

27. See Miller, *On Nationality*, p. 54 (cited in n. 9, above).

28. For example, Miller shows that individuals placed in experimental settings tended to view desert as a criterion of justice to a much greater degree than most philosophical theories of justice would admit.

29. See my "How Might Collective Rights and Liberalism Be Reconciled?" in R. Bauböck and J. Rundell, eds., *Blurred Boundaries; Migration, Ethnicity, Citizenship* (Aldershot, Brookfield, VT: Ashgate, 1998

30. David Miller, "Nationality: Some Replies," in *Journal of Applied Philosophy* 14 (1997): 75. A similar point is made by Yael Tamir in her *Liberal Nationalism*, p. 98, though the language of feeling and emotion pervades her text.

31. Thomas Hurka has called this kind of position "universalist particularism." It claims that certain special relations in virtue of their very nature yield obligations of the same kind wherever they occur. See his "The Justification of National Partiality," in McKim and McMahan, eds., *The Morality of Nationalism*.

32. Cf. Allan Buchanan's conclusions in his "What's So Special About Nations?" in Couture et al., *Rethinking Nationalism*.

33. See in particular MacIntyre, "Is Patriotism a Virtue?" (cited in n. 26, above).

34. This is emphasized by Mason, "Special Obligations to Compatriots."

35. See Hurka, "The Justification of National Partiality."

36. See Jeff McMahan, "The Limits of National Partiality," in McKim and McMahan, eds., *The Morality of Nationalism*.

37. This justification is invoked in the already cited works by Hurka, MacIntyre, and Miller.

38. Hurka emphasizes this justification in "The Justification of National Partiality."

39. This justification can be found in the final sections of Tamir's *Liberal Nationalism*.

40. See Richard Dagger, "Rights, Boundaries, and the Bond of Community: A Qualified Defense of Moral Parochialism."

41. See Jeremy Waldron, "Special Ties and Natural Duties," in *Philosophy and Public Affairs* 22 (1993).

7

The New Nationalisms

GILLIAN BROCK

Nationalism has been a cause of great misery in the world. In this century alone we have seen a number of hideous forms of nationalism leading to genocide, ethnic cleansing, forced relocations, and civil wars. The violent conflicts between Serbians, Croatians, and Muslims in the former Yugoslavia; the Hutus and the Tutsis in Central Africa; Palestinians and Jews in the Middle East; Afrikaners, Zulus, and Xhosas in South Africa; and the Nazis and non-Aryans, are just some of these.

Yet a number of philosophers have recently written about the unappreciated moral value of nationalism. Yael Tamir, for instance, argues that "the liberal tendency to overlook the value inherent in nationalism is mistaken"[1] and that nationalism offers a set of moral values worthy of respect and serious consideration. David Miller also defends a kind of liberal nationalism that encompasses several theses including: identifying with a nation is a defensible way of understanding your place in the world; the duties owed to fellow nationals are different from and more extensive than duties owed to other humans; and "a proper account of ethics should give weight to national boundaries."[2] There are a number of others who have recently weighed in on the side of nationalism, including Will Kymlicka, Jeff McMahon, and Thomas Hurka.[3]

The New Nationalists[4] emphasize that the nationalism they defend is a kind of liberal nationalism, one that blends values central to both liberalism and nationalism. There are several reasons to think one might have trouble blending nationalism and liberalism. Nationalists typically build a way of life around the acceptance of traditions, inherited rules, loyalty, solidarity, authority, and subservience to national ideals. By contrast, liberals emphasize individual reflection and choice, respect for personal autonomy, toleration, consent of the governed, free speech, and so on. One might predict that combining these two might lead to a number of tensions and sticking points, and as I show, this is indeed the case.

If the New Nationalists want to provide a thorough defense of the notion of some kind of liberal nationalism, they have at least the following four tasks:

(T1) They must show why nationalism is valuable; so they must provide a case that nationalism has some aspects that have value.

(T2) They must show how their brand of nationalism can circumvent a host of objections levelled at many traditional forms of nationalism. For instance, they must show how the (allegedly) morally acceptable kind of nationalism (or "liberal" nationalism as it is mostly called) can be distinguished from fascism, Nazism, and more objectionable forms of nationalism that promote, or result in, genocide, ethnic cleansing, and the like.

(T3) They must show how what survives (T2) counts as nationalism.

(T4) They must explain what political implications defensibly and coherently follow from claims of nationalism. So, for instance, Tamir's nationalism entails that we have a right to culture and a right to self-determination, though it is a further question whether the latter right should take the form of granting control over territory. Whether or not nations have rights to self-determination and, if so, whether this entails control over territory are key issues.

Here I shall have most to say about (T1), (T2), and (T3), though as we will see, (T4) has a bearing on all these issues.

To give the reader some sense of where I am heading, I argue for at least the following theses: Against (T1), I show how aspects of nationalism thought to be valuable are really features coextensive with nationalism. Nationalism is mistakenly identified as the source of value. In fact, typical defenses of the value of nationalism really point in another direction. It is political communities that are the (more defensible) source of that value, and moreover, political communities provide the aspects identified as valuable more reliably. (As I argue, the defense of (T1), with its emphasis on authentic cultural choice, really points away from, rather than in the direction of, self-determining separate national communities.)

Against (T2), I show how the mechanisms for initiating, communicating, and perpetuating national identities tell against any radical separation between "the good nationalisms" and "the bad." Liberal nationalism can distinguish itself from morally problematic forms of nationalism only if it is rendered vacuous; however, it then picks up the quality of being extraordinarily demanding. If liberal nationalism fails to distinguish itself

adequately from these morally problematic forms of nationalism it does not meet the basic requirements of an ethically defensible view. I discuss three sets of considerations which form the basis of a defensibility screen that all adequate nationalisms must pass.

Against (T3), I argue that what survives the defensibility screens for nationalism is, arguably, not much like nationalism at all. It is more like global humanism or cosmopolitanism, though it seems more demanding than such views. And, of course, if it does not survive the ethical defensibility tests, it must be rejected on basic moral grounds.

The strongest argument the New Nationalists want to press is that nationalism is not necessarily morally objectionable: a case can be made that nationalism is valuable and that it does not necessarily fall prey to moral objections. I argue that what survives after the objectionable elements have been removed is a form of nationalism both very insipid and very demanding, not much like what the New Nationalists want to celebrate. So, if there is a victory here for nationalism, it is a hollow one.

I. Nations and National Identity: Some Preliminaries

What exactly is a nation? This, of course, is a very important question: if nations are to be accorded self-determination or to have cultural rights, we need some criterion for individuating them.

Tamir writes: "a group is defined as a nation if it exhibits both a sufficient number of shared, objective characteristics—such as language, history, or territory—and self-awareness of its distinctiveness."[5] For Tamir, a nation is a cluster concept, but it centrally involves recognition and mutual obligation.

> A mere category of persons (say, occupants of a given territory, or speakers of a given language, for example) becomes a nation if and when the members of the category firmly recognize certain mutual rights and duties to each other in virtue of their shared membership of it. It is their recognition of each other as fellows of this kind which turns them into a nation, and not the other shared attributes, whatever they might be, which separate that category from non-members.[6]

Tamir believes that culture is crucial in enabling members of a nation to recognize each other as members, and thus different from others. For Tamir, culture "embodies patterns of behavior, language, norms, myths and symbols that enable mutual recognition. Consequently, two people are of the same nation if, and only if, they share the same culture."[7] For Tamir, culture is the glue that holds nations together.[8]

There are problems with this account; for instance, how do we distinguish between cultural groups and nations? Also, there may be all sorts of difficulties with deciding whether there is one nation or two when there are many similarities but no mutual recognition, or not enough mutual recognition, and so, no sense of mutual obligation. Indeed, if nations have a right to self-determination (and possibly a right to territory), there might be further incentives to accentuate differences, and to refuse to recognize each other as members of the same cultural strand in the hopes of being declared a separate nation with its own right to self-determination (and, possibly, territory).

Tamir simply bites the bullet on all these issues, especially the last:

> There is no objective way to determine when two cultures are too close to be separated, and when the differences between them are significant enough to justify the emergence of a new group. Hence, when members of a particular group sharing some identifying national characteristics define themselves as a nation, they ought to be seen as one, lest they become victims of a needless injustice.[9]

She quickly adds that not all demands for national recognition, when accepted, also lead to entitlement to establish one's own nation-state. She draws a distinction between the right to self-determination and the right to territory: all nations may deserve the former, but not all nations deserve the latter.

There are some problems, then, in trying to be precise about what constitutes a nation. It is not as difficult to capture what the subjective experience of identification with a nation typically encompasses, however. Miller identifies at least the following five features as being involved in thinking of oneself as a member of a national community: First, members must mutually recognize one another as compatriots, and believe that they share some relevant characteristics. Second, they believe their identity embodies a certain historical continuity. They believe the community stretches backwards and forwards across generations, has had a shared past and is likely to have a shared future. Third, nations are active communities. Conationals do things together, such as, take decisions and achieve results. Fourth, members believe the nation has geographical connections to a particular place. Fifth, the people who share a national identity must have a set of common characteristics, a common public or national culture.

A couple of points deserve emphasis from Tamir's and Miller's accounts. First, culture is said to be the glue that holds nations together. (Henceforth, I use the term 'culture' as short-hand for national culture.) Second, part of one's national identity is defined in terms of acknowledging responsibility for other members of one's nation. Both Tamir and Miller observe that membership in a national group is based on mutual

acceptance and identification. Part of displaying one's national identity is showing identification with, and responsibility for, other co-nationals.

II. Why Think Nationalism Valuable?

At least two kinds of arguments are offered for the value of nationalism: (a) ones about the importance of nationalism to identity and (b) others based on the instrumental benefits of nationalism. I examine each kind in turn, starting with identity arguments.

(a) Identity Arguments

Nationalists typically start off by observing that people come into the world as members of certain nations. They grow up in national communities and inherit a national culture. The New Nationalists recognize that it is not just the givenness of finding oneself belonging to a culture that accords the value (and wisely so: it is difficult to see how simply finding oneself belonging to a national culture is even a *prima facie* reason for thinking it valuable and worthy of protection).[10] Rather, they emphasize the role of reflection and authentic choice in an agent's decision to value cultural goals and projects and so, sometimes, her choosing to have culture become a constitutive feature of her identity. The New Nationalists take seriously criticisms about whether one can really reflect meaningfully on cultural affiliation and they are at pains to show how this is possible and an important part of why we should respect people's choices to make culture a constitutive feature of who they are and who they want to be in the world.[11]

The argument seems to be that, because culture is so important to people's self-image, we should ensure that their cultural communities flourish. People have this interest so we ought to promote it. But surely what must also be shown to give an adequate philosophical defense is that this is an interest worth promoting: this feature of identity deserves protection and it deserves protection in this way. Whether or not our cultural interests are worth promoting depends on the culture at issue, what it values, how it expresses itself, and so forth. If it promotes racism and sexism—for instance, beliefs that one group is "The Chosen People" and that another, indeed all others, need "a light unto nations" to show them the way—it is not clear whether this is a feature of anyone's identity that is, or should be, worth promoting (in the absence of further information). Indeed, everyone (the individuals at issue, the groups they belong to, and non-members) might be better off abandoning such destructive ideas and adopting more cosmopolitan or global humanist views instead.

So, I do not think the constitutive argument is going to get us very far by itself, because we will need to know what constitutive features ought to be nurtured and which suppressed, and whether cultural constitutive features should be encouraged depends on the content of the culture at issue. We certainly don't get a blanket justification for the promotion of all cultures by this sort of argument. Whether a culture is worth preserving depends on some of the ethical content of the culture, how it encourages members to treat their fellows and nonmembers. I discuss some of the ethical desiderata and threshold requirements in a later section.

Let us suppose that we can come up with a list of moral conditions or constraints that distinguish the sorts of national cultures that are worth preserving from those that are not, and that we narrow our focus so that the constitutive claim is meant to hold for only those cultures that meet the conditions. How far will this argument get us, then?

A defense of the importance of culture must also say something about why cultural membership (rather than say membership in other groups) should be singled out for special attention, especially if individuals value these other memberships more than cultural membership. This becomes a particularly acute issue if there is to be distribution of resources according to cultural membership (as Tamir suggests there should be) and if various political rights are to be recognized. Why should cultural membership be singled out for special attention in this way? We all know people whose membership in a particular group (say, of stamp collectors, music appreciators, golfers, or professional philosophers) is highly constitutive of their self-identity, indeed, in many cases the most salient feature of their self-identity. Their self-identity may be crucially, indeed wholly tied up with the flourishing of (say) the community of professional philosophers. If the arguments for cultural rights to self-determination in virtue of nationalism have merit, they should work to give all sorts of other groups similar rights too.[12]

The "Why culture rather than something else?" question is at best answered by saying that a certain kind of national culture (yet to be discussed) may be one of the things we can defensibly value and wish to preserve under certain conditions. (We certainly don't yet have an argument about how it compares with other valuable group memberships, social or public goods and so the extent, if any, of public support it should receive.)

(b) The Instrumental Benefits of Nationalism

Tamir celebrates the instrumental dimensions of national membership. National membership can

provide a set of beliefs, interests, and behaviours, as well as a coherent, transparent, and intelligible environment in which individuals can become self-determining. . . . In the open and ever-changing modern world, life in a cultural environment that is familiar, understandable, and therefore predictable is a necessary precondition for making rational choices and becoming self-determining.[13]

A couple of comments on this sort of defense deserve mention. First, if national membership is to help us to become self-determining, the content of what is taught is not irrelevant. We should assist people to become self-determining, for instance, by promoting skills in critical examination, rather than teaching dogma. Second, does this set of considerations show that membership in a *cultural* community, or rather that membership in *a* community, is a necessary precondition for making rational choices and becoming self-determining? It seems that if arguments of this kind show anything, they show that there are benefits in having a (any) culture, rather than none, such as that a culture can provide a context in which individuals can become self-determining,[14] and that people's lives go better when they form caring relations with others. But we can concede such points without accepting the conclusions the New Nationalists need to establish. So, for instance, if the value of culture reduces to its instrumental value, why embrace one culture rather than another? If any will do, why privilege the birth or inherited culture? Surely we can dream up better ones, ones which meet a range of ethical desiderata (to be discussed below). Indeed why not try to promote some cosmopolitan or "world culture" and thereby spread the benefits that accrue to community members further and wider?

Furthermore, from the arguments presented, it is not clear that *(national) culture* is the salient feature, rather than other aspects of communities. Being brought up in certain kinds of stable communities, whether united by culture, or other ideals, may provide the sorts of benefits referred to (indeed, more reliably as I argue below). I return to this point later, but first we need to look at the threshold of moral acceptability nationalisms must meet.

III. The Good and the Bad Nationalisms

The sorts of nationalisms the New Nationalists endorse are overwhelmingly liberal in flavor. They are polycentric; they are said to promote respect for other cultures and for individuals. According to Tamir, nationalism could be more pluralistic and less ethnocentric than is commonly assumed. So, for instance, Tamir says liberal nationalism "celebrates the

particularity of culture together with the universality of human rights, the social and cultural embeddedness of individuals together with their personal autonomy."[15] Also, liberal nationalism "fosters national ideals without losing sight of other human values against which national ideals ought to be weighed. The outcome of this process is a redefinition of legitimate national goals and the means used to pursue them."[16]

As I have already pointed out, we need to draw up some criteria about which national cultures are going to be "moral starters" rather than "nonstarters." For instance, I take it that any nationalism that advocates genocide or ethnic cleansing is a nonstarter, no matter what other value it might have. In drawing up the criteria we will want to focus on three particular sets of questions:

(R1) How does the culture encourage us to treat fellow members? What actions towards fellow members are encouraged as permissible or praiseworthy by the culture? What are we obligated to do for fellow members? What are they obligated to do for us? Are some members of the group to be treated differently and, if so, on what grounds?

(R2) How does the culture encourage us to treat nonmembers?

(R3) By what process do we acquire the cultural identity? What institutions and mechanisms are in place to perpetuate the culture? What stories are told to youngsters about why this identity should be preserved? What is said about the origins of the nation?

I will entertain the hypothesis that nationalisms may be defensible so long as they show adequate respect and fairness to members and nonmembers. Of course, this is vague and potentially question-begging, but I shall be able to make my points without these features becoming problematic. As we will see, it is not clear that any nationalisms pass the minimal moral requirements, and those that might seem to be rather insipid yet demanding forms of nationalism.

I shall discuss these three sets of questions in reverse order. What we discover in discussing (R3) has a bearing on all the other issues.

(R3) By What Process Do We Acquire a National Identity?

Let us start at the very beginning and ask about the origins of national identities.[17] Russell Hardin has much of relevance to say about the darker sides of cultural groups, why they typically form, and how they typically

sustain themselves. As he argues in *One for All: The Logic of Group Conflict*,[18] "explaining how someone gets or maintains an identification may say a lot about the morality of the identification or of action from it."[19] Among the many telling arguments offered are ones which highlight the role of self-interest in initiating and maintaining national identities. Individuals identify with groups because it is in their interests to do so. There are all sorts of instrumental benefits in aligning with a group, from providing a relatively secure and comfortable environment, to gaining access to resources, information, and social power.

> We coalesce because it is individually in our interest to do so so long as others cooperate as well. What we need to guide us in coalescing with others is merely the evidence of sufficient leadership in sufficient numbers to make our joining them clearly beneficial. If others were coalescing around a different leader or a different group, we would be as pleased to join with them. On this evolutionary theory of the growth of power, fitness leads not merely to survival but also to increasing fitness. Power may not simply be a resource that can be expended until it is gone; rather, it may derive from coordination that re-creates itself.[20]

As he argues, widespread identification with an ethnic group can be a source of great power of at least two different kinds: power to coordinate others and power over resources. Maintaining either kind of power may be especially helped by group norms of exclusion and difference. The norms can operate to provide a certain collective benefit for members of the group, the benefit of increased power. It becomes in the interests of the group, especially its leaders, to have widespread compliance with group norms. Following the norms helps to reinforce them, raising the costs to those who do not follow them. So, the norms can work coercively both for members and nonmembers: members may have little realistic choice but to comply with the norms or face expulsion, and nonmembers must conform to the wishes of the powerful group (in virtue of their being powerful).

So, it may be entirely rational "to do what produces a particular identification and, once one has that identification, it is commonly rational to further the interests determined by that identification."[21] Comfort and discomfort have a great deal to do with what one believes to be right and wrong. Familiar habitual ways of doing things are the sorts of "sunk costs of each person's upbringing and cultural knowledge." "Our cultural sunk costs have been transmuted into information and putative knowledge that is not merely gone. Much of it is a resource to us in our further actions."[22]

Members socialized to one set of norms are likely to have strong preferences for doing things in the ways they have learnt to do them. There will be a preference for doing things in ways that seem comfortable and familiar. People are acculturated to prefer the comforts of home. Indeed,

it becomes perfectly rational to want to act in ways that have become familiar and comfortable, as Hardin argues.

All of this tells somewhat against the New Nationalists' claim that communities help us to become self-determining. It becomes rational to prefer the familiar, so it is not the case that we enjoy the benefits of a community and then easily detach ourselves from the attitudes, preferences, and beliefs we acquire. Cultural communities are not ladders that can be tossed aside easily. These ladders leave permanent traces.

If Hardin is right in explaining the motivations for initiating and maintaining national identities, surely this is no irrelevance. If the origins of nations and national identities are indeed as unsavory as his analysis suggests, this might undercut their normative force. Moreover, if he is right about some of the functional explanations of why we join these sorts of groups, and about the psychological features of how we would choose to join groups so long as they are consonant with our self-interest, this sheds some light on the motivational questions. We can choose to join other sorts of groups that provide the same benefits.

Another morally worrisome set of considerations is that the history of the world hitherto suggests that national identities are forged in opposition to other nations. For there to be an "us" there must be a "them" and these national identities are consolidated by wars, conquest, colonization, and subduing and "civilizing" of other nations. National identities typically involve antagonism towards others as a constitutive feature, and so they are conducive to further antagonism.[23] As part of most (all?) groups' historical self-understanding is a certain antagonism towards an identified "other." But this "us and them" mentality can reiterate and result in increasing isolation.[24] Promoting conditions for people to develop and have autonomy over their affairs (as Tamir advocates) can lead to more and more separatism, breeding and fostering antagonism rather than respect, cooperation, and so forth.[25]

Perhaps this says something about the sorts of cultures we should tolerate: those that are overridingly liberal; those that don't make "usses and thems, and thems are bad" part of the constitutive belief set. But how can this be done? The mythology celebrates *our* victories, *our* struggles against adversities, *our* triumphs against the enemy, *our* successes against the odds. How do we celebrate these, but successfully transmit to younger generations that the enemies were frequently just as good as ourselves and, really, we should respect them too. And if we are to respect other nations, it would appear that we must say things like: "Our nation is good, but not necessarily better than any other. These are our traditions, some of which have been rejected, others revised and reinterpreted in the light of other values, but others' traditions may be just as valuable" and so forth. This is

not how cultural stories tend to be transmitted, nor could it be anticipated that many nationalists would want to say things of this kind.

A further potentially worrisome feature is that national identities tend to involve considerable myth. Should we discard national identities because they contain so much fiction? Miller believes not, since the fictions may be necessary for creating national identities, and so they are instrumentally valuable in contributing to valuable social relations. But portraying the myths as benign social-cohesion mechanisms misses some of the functions of these myths and the messages they communicate. In these stories, people of the nation are very often heroic and virtuous. In these stories there are evil perpetrators of injustice and heroes. The stories must start at certain points and end at others. They must leave out what came before and what came after. Those depicted as villains and evil provokers will have their own versions of events. They might find other bits of the history more salient and so remember the course of history as unfolding rather differently. These myths can fuel national hatred and an "ethnic cleansing" centuries after the events the myths claim to retell. These myths can be far from benign.

In this section I have suggested that the process of creating national identities in the world invariably (and possibly necessarily) involves questionable mechanisms, and actions and values that are in conflict with liberalism. Also, by examining some of Hardin's work we saw how it becomes rational to prefer the familiar, so it is not the case that we enjoy the benefits of a community and then easily detach ourselves from the attitudes and beliefs we acquire. Cultural communities are not vehicles for self-determination that can be tossed aside easily, as the New Nationalists would have us believe. The community to which we are first enculturated matters a great deal.

(R2) How Does the Culture Encourage Us to Treat Nonmembers?

As I have already discussed, the history of creating national identities has typically been one where national identities are established in opposition to others. Indeed, on some accounts the very idea of creating national identities must involve such opposition.[26] But what sorts of relations could nationalists defensibly have with non-members? Let us look first at Miller's position, which involves a range of interesting claims.

Miller states that we have at least five sorts of obligations we ought to acknowledge to non-members of our nation who are neighbors:

1. We have a duty to abstain from materially harming another state.

2. We have a duty not to exploit states vulnerable to our actions.

3. We have a duty to comply with international agreements.

4. We have "obligations of reciprocity, arising from practices of mutual aid whereby states come to one another's assistance in moments of need."[27]

5. More problematically, we have "obligations to ensure the fair distribution of natural resources."[28]

Now, of course, if these obligations to nonmembers were recognized by a nation, much of the sting of nationalism might evaporate. Indeed, if a nation recognized all these obligations to nonmembers it would be like no other nationalism known to humankind. Nevertheless, this could constitute a worthy ideal which nationalisms should try to approximate.

Tamir, too, has some strong views about obligations to nonmembers. For instance, those wealthy nations that want to restrict immigration on the grounds that they wish to preserve the current national and cultural *status quo* have obligations to try to improve standards of living in poorer countries. Liberal nationalists may preserve the homogeneity of their nations only if they have fulfilled their "global obligation to assure equality among all nations."[29]

One might begin to suspect that the sorts of liberal nationalisms outlined by the New Nationalists may be, in effect, indistinguishable from some varieties of cosmopolitanism or global humanism, if we take seriously what they say about obligations to nonmembers. They both outline extensive sets of obligations to nonmembers which require us to ensure that nonmembers' lives are not totally miserable in important ways. Perhaps, then, if the defensibility of your nationalism hangs on your making efforts to ensure all other nonmembers' well-being is being taken care of, there might be no more than a difference of emphasis between (justified) liberal nationalism and cosmopolitanism. It seems that both Miller's and Tamir's kind of liberal nationalism would treat nonmembers fairly well, in theory at least.

Indeed, their view may be *more demanding* than cosmopolitanism. Cosmopolitans say everyone counts equally. Liberal nationalists say it is only morally acceptable to give special weight to conationals' concerns if everyone else has had the requisite moral attention. Liberal nationalism turns out to be an even more demanding view on this understanding than cosmopolitanism. And yet in some form or another liberal nationalists must be committed to some strong view of this kind to avoid charges of racism.

(R1) How Does the Culture Encourage Us to Treat Fellow Members?

Tamir presents what she calls "the morality of community" which she uses to explain some of the ethical implications of nationalism. She concedes that the ethical implications of nationalism derive from connections between feelings of belonging and moral obligations which are not unique to membership in a nation but are also characteristic of membership in other constitutive communities. She then states her Associative Thesis. The Associative Thesis holds that "we are affiliated and, therefore, morally obligated."[30] But this moves too quickly.

1. The simple act of affiliating seems an unlikely source of moral obligation to fellow members. I join a discount liquor club. I get cheap booze. It is not clear what sort of obligations I now have to all fellow members of the club. So it must be certain sorts of affiliations that are relevant here, or, still more plausibly, it is certain kinds of acts that generate obligation. The kinds of acts would be the sort that Tamir refers to above, namely, acts which are conducive to the individual's becoming a mature, rational, and self-determining adult. But such acts already generate obligations in virtue of the receipt of benefits. The important acts are the ones which bind or obligate us anyhow: acts helping us to mature and develop generate obligations of gratitude and reciprocity to those who have cared for, and in other ways benefited us, be these parents, family members, community members, or other citizens. The reference to conationals is coextensive with the things that do matter morally anyhow.[31]

2. If one is free to renounce one's inherited culture, as the New Nationalists are at pains to emphasize, any obligations which might stem from simple association can be renounced, so the Associative Thesis is surely false by Tamir's own lights. And again, when the Associative Thesis might seem to have force, the force of the obligation derives from other elements that are key. We either voluntarily decide to commit to advancing the flourishing of the nation, in which case it is the voluntariness of the undertaking that binds us, or we may decide, after due reflection, to choose not to associate or affiliate, and so we have no clear blanket obligation (that might stem simply from membership or affiliation) to do anything for members. In each case it is the voluntariness of the undertaking that generates the responsibility, not any given association. So, in neither case does the Associative Thesis do any work.

Indeed, to hold to the Associative Thesis might mean that some are unfairly burdened. If I find myself born into an unjust community, and I have obligations to fellow members simply in virtue of the Associative Thesis, I might have obligations to promote injustice.[32]

The affiliations are binding only if we choose to make them binding, and this must be the case if the reason why we think cultural identities are valuable is that they are self-chosen.[33]

3. The Associative Thesis begs the question of which association generates the moral obligation. Is it association with other nationals, or association with other citizens, or all other residents of political communities, or indeed a range of other options? Belonging to *which* community, associating with *which others,* grounds moral obligation here? Being associated with other citizens seems to have as much (or more) going for it as being associated with others of one's nation (as it has been defined by the New Nationalists).

It is of some importance to get the right affiliation sorted out as the one that generates the relevant obligation. It seems to me that the New Nationalists do not do this well enough. It is not clear that their arguments distinguish sufficiently between assessing the merits of nationality or membership in a scheme of political cooperation. We can certainly concede the value of membership in political communities without conceding the value of membership in national ones.

I turn to a case of the sort of muddle I think the New Nationalists are guilty of; one in which Miller confuses why we are obligated to others. Miller assumes that it is because we are conationals when I see it rather as stemming from our cooperation in a political community.

Miller asks: "Why should an immigrant Turk in Holland be provided with benefits that are not provided for Turks in Turkey? A common sense of nationality is needed to underpin the claim for equal respect."[34] But he is wrong here. The reason why an immigrant Turk in Holland deserves benefits that may not be available to Turks in Turkey is not because they are conationals, but rather that they are co-operators in a political community, and the terms of cooperation may require that certain benefits and burdens be distributed equitably to all cooperators in that political community. Resident aliens may be entitled to benefits that nationals living abroad may not be because of their status as (contributing) members of a certain political community.[35]

One might ask: What, anyhow, is so special about conationals? Why not think of oneself as simply thrown together with fellow citizens or conationals in the same sort of random way as a group of people might be thrown together in a lifeboat? There is much to be said in favor of such a story. Miller thinks this analogy is inappropriate for various reasons, including this one:

No one can reasonably complain if a lifeboater jumps across to the first piece of wreckage that floats by, preferring to take his chances alone, whereas in a

national community a case can be made out for *unconditional obligations to other members* that arise simply by virtue of the fact that one has been born and raised in that particular community.[36]

Again, passages like these beg the question of which particular community is the relevant one for generating obligations to repay debts for the benefits referred to. Furthermore, passages like these show that there is a tension between claims made about the autonomy of the people choosing to identify with their nations and the unconditional nature of obligations to conationals.

IV. Concluding Remarks

There are multiple strands to culture, some of which are powerful and frightening, others full of lessons about life and the human condition, still others totally benign. Life can be enriched by certain kinds of engagements with other cultures. But, of course, life can be entirely brutal and vile when some cultures get to express what is most important to them. How do we rein in the bad ones, while letting the beneficial or innocuous ones flourish? And in the reining-in process, are we guilty of thinning out what is interesting about diverse cultures so that we are left with a sort of EPCOT Center view of cultures, in which experiencing another culture consists in eating exotic foods and having its music piped through the bazaars or gift shops in which one can buy different souvenirs?

In this essay I have argued that any nationalism that adequately meets the minimal requirements for nationalism's being morally acceptable is of necessity (a) a very weak form of nationalism, not the sort that defenders of nationalism would typically want to celebrate and (b) too demanding, if we take the claims discussed in the last two sections (especially those made under (R2)) seriously. To the extent that a version of nationalism meets the ethical considerations, it compromises the robustness of its nationalism and/or becomes even more demanding than global humanism or cosmopolitanism. No nationalism currently embraced today meets these desiderata; moreover, it is unlikely that any would meet them, or even aspire to meet them. Furthermore, it is not clear that the ideals articulated by Tamir and Miller as defensible kinds of nationalism are coherent or achievable if global humanism is not.

I made the claim that the aspects of nationalism identified as valuable are provided more reliably by political communities. I should say a little more about this here. One of the claims made by the New Nationalists is that a stable community is needed in order to become self-determining. I have already made the point that any stable community will do. Moreover,

there is more to be said in favor of political ones than cultural ones. First, as Hardin points out, being enculturated into one national community rather than another means that it becomes rational to prefer the habitual patterns of behavior, and so it is less likely one will choose other ways of life at a later point. This tells against the claim that national communities help us become as self-determining as we could be. Second, what is said to be valuable about cultural identity is that it is authentically chosen, a freely embraced and meaningful aspect of one's life. In order for one's cultural identity to be freely chosen, or to be able to make cultural choices one must have real options. Having real options frequently means living in a culturally plural environment. Indeed, perhaps ironically, in order to see the value of the national identities (those being crucially authentically self-chosen) we need to have access to others' ways of life, and the easiest form of this is to live in a multicultural, heterogeneous, political community. How can we acknowledge that cultural identities are relevantly authentically self-chosen if there are no other *viable* alternatives one could have selected?

Furthermore, to a large extent present identities are built out of inherited materials. Certainly identities one adopts earlier in one's life are like this. But identities must be reflected upon if they are to be authentically chosen and, for others to respect their importance, they must pass ethical constraints. I, as chooser, need to sift through which of the inherited bits and pieces I will retain and which I will revise or discard. I must have an independent way to evaluate this, and so I still need all the materials of a good liberal education, not to mention the tools for good moral evaluation. Again, it can be expected that political communities consisting of citizens with a range of affiliations and identities can provide this more reliably than separate, autonomous, cultural communities.

A final point is worth raising. The New Nationalists want to argue that the psychological facts of human motivation tell decisively in favor of nationalism. So, for instance, Miller states that his aim has been to show that "the ethics of nationality is plausible, resting as it does on well established facts about human identity and human motivation. The onus is on the universalist to show that, in widening the scope of ethical ties to encompass equally the whole of the human species, he does not also drain them of their binding force."[37] Miller is right to think that the question of motivation is important, but wrong to think we must, therefore, embrace nationalism, and this for a couple of reasons:

1. People increasingly have multiple identities: subnational, supranational, and cross-national ones. Our multiple identities mean we are members of overlapping communities. Interlocking relations and communities mean we are already connected to others in many different kinds of ways.

2. Miller poses the issue as a false dichotomy: we must be universalists

or particularists of some kind. But neither of these gets one to a commitment to nationalism. Even if I am a particularist, as he urges that one should be, I cannot have particular relations with *all* my conationals. At a certain point I must be connected to some of them by abstract ideas about what is important to them, and universalism is not much more of a leap from that.

So the psychological arguments presented for nationalism do not point unequivocally in the direction of nationalism. We saw this also when considering some of Hardin's work. The psychology of affiliation is somewhat malleable, and certainly not as inflexible as nationalists would have us believe. This is good news for those who believe world peace is more likely to be achieved by promoting global humanism rather than nationalism.[38]

<div align="right">GILLIAN BROCK</div>

The University of Auckland
Auckland, New Zealand

NOTES

1. Yael Tamir, *Liberal Nationalism* (Princeton, NJ: Princeton University Press, 1993), p. 4.

2. David Miller, *On Nationality* (Oxford: Clarendon Press, 1995), p. 11.

3. See, for instance, Thomas Hurka, "The Justification of National Partiality," in *The Morality of Nationalism,* Robert McKim and Jeff McMahan, eds., (New York: Oxford University Press, 1997), pp. 139–57; Will Kymlicka *Liberalism, Community and Culture* (Oxford: Clarendon Press, 1989); and Jeff McMahan, "The Limits of National Partiality," in *The Morality of Nationalism,* pp. 107–38.

4. Though there are a number of New Nationalists, in this paper I concentrate particularly on the views of Tamir and Miller, both of whom have published important books on liberal nationalism.

5. Tamir (cited in n. 1, above), p. 66.

6. E. Gellner, *Nations and Nationalism* (Oxford: Blackwell, 1983), p. 7; op. cit., Tamir, p. 67.

7. Tamir, p. 68.

8. Ibid., p. 8.

9. Ibid., p. 68.

10. To give an analogy, we might find that human nature has a persistent drive for domination and aggression. Simply finding this out does not give us a defense of why we should seek to ensure conditions whereby such drives should flourish rather than be curbed or managed, constitutive though they be.

11. See, for instance, Tamir, pp. 20–22.

12. So, if we insert "profession" for "nation" all through Tamir's argument, *Liberal Nationalism,* pp. 73–74, do we also get the salient conclusions: rights to (say) professional self-determination, a public space where members of the profession can express themselves and live according to their values, government support (in the form of vouchers?) for professions (or more accurately, government support for individual rights to professional self-determination), and "to individual expressions of its implementation, however restricted?"

13. Tamir, p. 84.

14. Ibid., p. 14.

15. Ibid., p. 79.

16. Ibid., p. 79.

17. An important question to keep in mind, and that I return to later, is this: If we learn that the origin of some institution is morally suspect and there are not enough good, independent moral reasons for continuing with the suspect institution, shouldn't we abandon it on moral grounds? No matter how much we have come to depend on the institution, surely (on moral grounds) it should be given up.

18. Russell Hardin, *One for All: The Logic of Group Conflict* (Princeton, NJ: Princeton University Press, 1995).

19. Ibid., p. 8.

20. Ibid., p. 28.

21. Ibid., p. 60.

22. Ibid., p. 69.

23. Avishai Margalit has such a view in "The Moral Psychology of Nationalism," in *The Morality of Nationalism,* p. 79.

24. Consider, for instance, the Orthodox Jewish community belief that Jews should live separately from non-Jews. Within the Jewish community finer and finer discriminations are made between people, so much so that it is common for various sets of Jews to refuse to have anything to do with one another, and some, such as the ultra-orthodox, have nothing to do with anyone but members of their own strand of ultra-orthodoxy. There are a number of jokes about this phenomenon. One involves a Jew shipwrecked on a desert island who builds two synagogues: one in which to worship and one to scorn.

25. Also, giving groups autonomy can mean that an individual member's autonomy is compromised if he is no longer protected by the rights of the larger group (say). Furthermore, some of the justification for why culture and cultural diversity is defensible (offered by, e.g., Tamir) is simply then hollow. Cultural diversity, combined with more and more separatism and isolation, does not necessarily lead to the sort of growth and enrichment of people's lives that Tamir and others celebrate.

26. Avishai Margalit has such a view in "The Moral Psychology of Nationalism," p. 79.

27. Miller, *On Nationality* (cited in n. 2, above), p. 104.

28. Ibid., p. 105.

29. *Liberal Nationalism,* (cited in n. 1, above), pp. 161–62.

30. Ibid., p. 136.

31. Take a clear example of this: We owe a debt of gratitude to all those who fought against the Fascist Axis in the Second World War to preserve the sort of relatively peaceful way of life we enjoy in most Western countries. Many countries will focus on those who died defending their country, and so there will be monuments, national days of remembrance, and so forth. This is not inappropriate, but often its scope is rather more limited than it ought to be. In effect we owe a debt of gratitude (sometimes a bigger debt, especially if you are a country like New Zealand) to many from other nations who also fought on the side of the Allies. The debts of gratitude we owe may correlate only very roughly with conationals.

32. She does deal with such cases, but not very convincingly. See, for instance, *Liberal Nationalism,* p. 17, and the mob discussion.

33. In order to decide whether to affiliate self-consciously and reflectively, we may want to know what obligations we will thereby undertake. Surely national communities in which members are self-consciously reflecting on their national identities have a certain instability to them: we may be counting on some folks to do things and they may be rejecting just these aspects of the community.

34. Miller, p. 139.

35. Enlightened, progressive countries realize this. Consider, for instance, the case of New Zealand. In New Zealand, citizens who have lived abroad for more than about three years may not vote, whereas resident aliens who have lived in New Zealand for one month may register to vote.

36. Miller, p. 42, emphasis mine.

37. Miller, p. 80.

38. For helpful comments on an earlier draft, I am grateful to John Bishop, Tim Dare, Stephen Davies, Rod Girle, Paul Hurley, Tim Mulgan, Robert Nola, Andrew Sharp, George Sher, Rian Voet, Bob Wicks, and Martin Wilkinson.

8

Nationalist Arguments, Ambivalent Conclusions*

MARGARET MOORE

This paper examines three types of normative arguments that are put forward in defense of liberal nationalism.

In Part 1, I consider what I call the intrinsic value argument. This is the argument that national identities are intrinsically valuable and that national identity should therefore be recognized and supported by the state and the international state system. In Part 2 I consider instrumental arguments for liberal nationalism. These are arguments that claim that national identity or national solidarity is instrumental to some other good. I consider two versions of this kind of argument: on the first version, national ties or national solidarity are viewed as instrumental to the good of liberal justice; the second argues that national ties or bonds of (national) membership are instrumental to democratic governance by facilitating trust and enhancing democratic representation. Part 3 focuses on the cultural argument. According to this argument, national identity is internally linked to (liberal) autonomy through the concept of culture. On this argument, put forward variously by Miller, Kymlicka, Tamir, and Margalit and Raz, liberal autonomy presupposes a range of options; these options are provided from within cultures; and, moreover, cultures give value or meaning to these options.[1] A liberal, therefore, has good reason to be concerned about the viability of these "societal" options or "encompassing groups" or "nations" because they are internally connected to autonomy.

I don't claim that this typology is exhaustive but only that most of the recent normative work on nationalism can fit into these three kinds of arguments. I then analyze the implications of these arguments for the issue of minorities. One theme that I focus on is the policies toward national minority groups that could be defended by a liberal nationalist. This is an important issue because most states are not nationally homogeneous but are comprised of different national and cultural groups.

Many liberal nationalists have been at pains to distinguish the nationalism of groups which accept liberal rights, the rule of law, democratic governance, and redistributive justice from the nationalism of illiberal groups, which attempt to use nationalist discourse in order to consolidate power or pursue aggrandizing policies.[2] They tend to treat the nationalism of liberal-democratic minority nations, such as Scotland, Quebec, and Catalonia, quite differently from the nationalism of nations lacking in strong liberal-democratic traditions. However, most liberal nationalists don't focus specifically on the problem of minorities within their territory. When the issue of minorities is discussed at all, it is often considered under the rubric of liberal rights and rules of justice. This does rule out some of the policies that Brubaker describes as pursued by nationalizing states—such as displacing members of another national group from key sectors of the economy, expropriating land from a rival national group, and attempting to control the group's associational and organizational life[3]—but it does not tell us whether liberal nationalists should grant special rights to national minorities on their territory.

The normative arguments typically employed by contemporary liberal nationalists can endorse both (1) national self-determination projects, by which I mean political projects aimed at securing increased political autonomy or independent statehood for national minorities, and (2) nation-building projects, by which I mean projects aimed at facilitating the creation of common national identity. They can therefore justify two quite different strategies toward national minorities.

Let me clarify what I mean by nation and by national identity. Will Kymlicka has usefully distinguished between nations, which typically aspire to some form of collective self-government, and other groups, such as immigrant ethnic groups, which have a distinctive culture and way of life, but, unlike national groups, they seek, not self-government, but inclusion in the new society.[4] Moreover nations, unlike immigrants, typically have a territory that they regard as their homeland which serves as the basis of their claim to self-government. This definition leaves open the role that ethnicity plays in the formation of various national identities[5] but it also makes clear that there is no reason to regard nations as ethnically exclusivist. Indeed, most forms of liberal nationalism endorse as the most normatively acceptable and functional forms of national identity ones that are inclusive and civic.

1. Intrinsic Arguments

The first kind of argument is one that suggests that the bonds of attachment that conationalists feel have *intrinsic* moral value. On the intrinsic

argument, a nation is a particular kind of community, and is entitled to the moral regard that communities normally command. This argument is developed at some length by David Miller in *On Nationality;* and variations of this argument are put forward by Paul Gilbert and Thomas Hurka.[6]

Miller's version of this argument develops the idea that the national attachments that people feel have intrinsic ethical significance through an analogy with a family that thinks it is (genetically) related but in fact is not. His point is that even if some of the reasons grounding the belief that a group constitutes a nation or a family are, in fact, untrue, the feelings of attachment and shared belonging can still be ethically valuable. If we accept that the feelings of belonging in a family are valuable—even if based on false beliefs about the genetic relationship in the family—then we should accept that the same is true of nations, which are often also based on some historical myth-making.

In his article, "The Justification of National Partiality," Thomas Hurka argues that nations and nationality are intrinsically valuable because conationals are creating a good in common. This is developed through an analogy with the goods created in a good marriage. People in a good marriage create goods internal to the marriage. These goods need not be grand ones nor unique to that couple: they are benefits produced jointly, such as companionship and love, but they are, nevertheless, objectively good. Hurka then argues that Canadian national identity is valuable because Canadians are rightly proud of the various goods that they have created in common: they have maintained political institutions and through them the rule of law in Canada, which ensured liberty and security for all Canadian citizens; and other goods, such as universal health care, have also been produced through the relationship. Hurka extends this same argument also to Quebec. Quebeckers, he argues, are justly proud of the goods they have created: many of these are the same liberal-democratic goods that are produced in Canada as a whole, and replicated in many other places, such as a flourishing democracy and the rule of law. Others are more specific to Quebec: they have managed to keep their language and culture alive. Hurka's point is that these are objectively good and have been produced by Quebeckers in their relations with each other.

One problem with the intrinsic value line of argument is that it fails to distinguish nations from other intrinsically valuable communities (that produce objectively valuable goods). The authors who advance this argument tend to take the question of how to justify particularist attachments as the basic problem. Their argument proceeds by noting that memberships and attachments in general have ethical significance (analogous to membership in and attachment to a family). However, the precise obligations or responsibilities that people have to their fellow nationals is

somewhat indeterminate: in Miller's formulation, they will flow from a shared public culture which results from deliberation over time about what it means to belong to that nation;[7] on Hurka's formulation, there is some obligation to fellow nationals if they are all engaged in a common relationship that produces objectively valuable goods (many of which are internal to that relation).[8]

Because the basic problematic is the defensibility of nonuniversalist ethics—of duties and obligations that do not encompass everyone equally—this argument does not show that nations are "special" in some way. The argument deflects the criticism that national attachments are somehow flawed because they are nonuniversalist in scope. So, while this argument is a useful corrective to a purely impartialist ethics, and points to the intrinsic value of these bonds of membership and relations of trust, it does not get us very far: specifically, it fails to distinguish nations from other intrinsically valuable communities (or, in Hurka's formulation, communities that produce objectively valuable goods).

Gay communities, for example, have a claim to be intrinsically valuable. Like conationals, members of the gay community have relations of mutual trust and their network of relations provides a context in which its members can feel secure and gain self-respect. They can enjoy love and tolerance and a sense of belonging. Within the gay community, people can enjoy the goods of participation and community; and they can practice a quite specific, and profoundly ethical duty toward other gays—the duty of rescue.[9] In practice, of course, the celebration of secular and ethnic identities may take place at the expense of national identities, as Miller, particularly, is at pains to note;[10] and yet, the intrinsic value argument is unable to prioritize these claims, or give us much guidance on how to weigh them when they compete.

The intrinsic value argument, then, does not distinguish *between* particularist attachments—but only argues, quite persuasively, that we should give intrinsic ethical significance to such attachments. Moreover, and of even greater relevance for the purposes of this paper, this argument has difficulty coping with the very likely situation that national groups will be commingled on the same territory and the jurisdictional unit in which self-determination is to occur includes a national minority in addition to the majority national groups that aspire to be self-determining. This is a very likely scenario, as most states are not nationally homogeneous.

For example, if Quebeckers' national aspirations are justified on the grounds that national identity and bonds of attachment are *intrinsically* valuable, then, it must also be true that aboriginal nations *within* Quebec, who have a different national identity, and create a different good in common, are entitled to the same rights, because *their* national identity is also *intrinsically* valuable. This obvious point is often overlooked, because the

intrinsic value argument tends to proceed in abstraction from the question of territory. National communities are justified as intrinsically valuable, but there is no normative argument regarding territory, and hence, very little consideration of what should be done when two national groups are commingled on the same territory.

This suggests that the intrinsic value argument can be used to justify national self-determination projects as well as nation-building projects. It can justify nation-building because it suggests that national identity is intrinsically valuable and is justified in being supported by the state. But it also suggests that the nationalism of smaller peoples is justified because intrinsically good, and so may encourage them to achieve their own self-government, their own political autonomy. And, just as it justifies the state in proceeding with nation-building, so it would seem to justify the international state system in supporting or recognizing the intrinsically valuable relationships encapsulated within a national self-determination movement. Certainly, there is nothing internal to the argument that would prevent a minority residing on the territory of a state from using this argument to justify *their* independence.

2. Instrumental Arguments

A second kind of justificatory argument for liberal nationalism are instrumental arguments. These view national identity as *instrumental* to the achievement of some other good.

2.1. National Bonds as Instrumental to Liberal Justice

One prominent version of the instrumental argument for liberal nationalism is that a free society can operate only if its citizens accept certain solidarities and liberal virtues. Revisionist liberals have argued that communitarians are right that social justice may require attention to inculcating certain kinds of (liberal) virtues and fostering certain kinds of communities. They have tried to focus on the kind of society necessary for liberal citizenship, and to address squarely the issue of what kind of argument or defense can ground the particular obligations that flow from citizenship in a particular just society.

In his book, *Liberal Purposes*, William Galston departs from the neutralist liberal view that citizenship obligations appropriate to a liberal political community will be formed spontaneously through the interplay of the family, civil society, and the political institutions of the state.[11] Instead Galston focuses on the role of the state in inculcating virtue in its various

political and social institutions but especially through education. He also departs from the view endorsed by Rawls in *Political Liberalism* by suggesting that the issue of the rational justification of liberal rights and liberal political institutions is quite separate from the motivational issue of how to ensure that the relevant rights and duties will be honored.[12] Galston writes: "On a practical level, very few individuals will come to embrace the core commitments of liberal societies through a process of rational inquiry. If children are to be brought to accept these commitments as valid and binding, it can only be through a process that is far more rhetorical than rational."[13]

Moreover, Galston takes the view that liberal citizenship cannot focus only on the justice or fairness of the political principles that are embodied in the state, but must also develop an emotional pride and identification with fellow citizens and with the particular institutions of the society. Because liberalism is operationalized everywhere within particular states, what is also required is a positive attitude of affection for the comembers of the state, and the political institutions and practices of one's particular state. Thus he argues that "civic education . . . requires a more noble, moralizing history: a pantheon of heroes who confer legitimacy on central institutions and constitute worthy objects of emulation. It is unrealistic to believe that more than a few adult citizens of liberal societies will ever move beyond the kind of civic commitment engendered by such a pedagogy."[14]

In Galston's view, the sacrifices necessary for the realization of the common good require an emotional identification with the state and with its members. Although Galston typically terms this "patriotism," it is extensionally equivalent to civic nationalism, both in terms of the requirement that there are bonds of affection for comembers(conationals) and sentiments of affection for the political project (the nation) that unites them.

This argument—that citizenship requires bonds of attachment to the state and to fellow citizens (or conationals)—is an instrumental argument for a form of nationalism. It conceives of national identification as instrumental to achieving the good of liberal citizenship, which, in turn, is supportive of principles of justice and respect for diversity. And, like many other theorists of nationality, Galston accepts that this kind of nation-building requires a re-interpretation of history that will function to secure the emotional ties of pride to fellow citizens and to the political project. In this respect, Galston is echoing the analysis of E. Renan, who argues, in his famous essay, "What is a Nation?," that nation-building requires "getting one's history wrong." According to Renan, the society has to be capable of forgetting those parts of its history that will interfere with the development of a sense of pride in it.[15]

Sometimes, this argument is expressed in terms of redistribution. In Miller's view, for example, a shared national identity engenders trust

among members and this helps to support a redistributive practice. Miller's argument is a variation of the communitarian insight that, unless people feel bonds of membership to the recipients, then redistribution by the liberal state will be experienced by the individual (who is taxed) as coercive and therefore as incompatible with individual freedom. He also seems to be making the empirical claim that the political will supporting redistribution will not be there if groups don't share a similar national identity, a similar sense that they are engaged in a common political project.

This kind of argument is intuitively plausible, but the empirical evidence supporting the positive link between shared national identity and liberal justice is unclear at best. Indeed, if we think broadly and comparatively about societies that have strongly felt national identities and try to correlate this with levels of redistribution, it is difficult to come up with much positive support for this proposition.

The reason for this, I think, is that the relationship between the two is extraordinarily complex: not only does the self-perception of the national identity affect levels of redistribution, but there is a large bureaucratic and legal structure that intervenes between political sentiments and public policy.[16] The enormous complexity of the relationship between social justice and national identity can be illustrated through the example of Northern Ireland within the United Kingdom. This is instructive because there is a sharp asymmetry between British and Northern Irish identity—with Northern Irish Catholics identifying with Ireland, Northern Irish Protestants identifying with Britain, and Britons, on the whole, regarding Northern Ireland as non-British. Yet, despite this asymmetry, the British subvention to Northern Ireland, paid for by the British taxpayer, is one of the largest amounts of regional redistribution in the United Kingdom.[17] This suggests that any simple or direct relationship between shared national identity and redistributive justice is too simple: in fact, there is an enormous bureaucratic structure that maintains redistributive obligations, despite people's sentiments.

However, the Northern Ireland–United Kingdom example also suggests that the instrumental nationalist argument cannot be dismissed, that, where there is a persistent feeling of unshared identity, and substantial one-way redistribution (that is, the relationship cannot be argued for in reciprocal terms, as mutually beneficial), the long-term continuation of this redistributive policy may be in jeopardy.

At the time the British welfare state was set up, British sentiments of national identity seemed to include the Northern Irish as part of their nation and the territory as part of the United Kingdom, when they thought about it at all. Since that time, particularly since "the Troubles" in the late 1960s, Britons have come to regard the province as "a place apart" and the people who live there as unlike them. This suggests that

sentiments are not immediately reflected in public policy: at the very least, there is a substantial time-lag between the two, which can be accounted for in terms of the mediating bureaucratic, legal, and political structures.

However, with poll after poll showing that the British taxpayer would like to get out of Northern Ireland, there is also a desire (on the part of the British) for a solution there, with at least one of the two major political parties (the Labour Party) advocating withdrawal from the province. It is also reflected in the fact that Northern Ireland is one of the few places in the world that has a constitutionally recognized right to secession (to join Ireland) should the majority wish it. This desire, on the part of the (mainland) British, to dissociate themselves, in legal, juridical, territorial, and public-policy terms, from the province seems to reflect, at least in part, the asymmetry in national identity between (mainland) Britons—who think of Northern Irishmen as non-British—and (Protestant) Northern Irishmen— who think of themselves as "British." This suggests that, while the relationship between social justice and shared national identity is far from direct, nevertheless the instrumental nationalist argument for social justice should not be dismissed. It suggests, as instrumental nationalists have argued, that in the absence of reciprocity and shared identity, the political will may not be there to discharge these obligations over the long term. Shared national identity may not be crucial to the delivery of social justice, or even the most important element, but the dispositions associated with shared national identity are useful in supporting liberal redistribution; or, to put it conversely, that, in their absence, and in the absence of mutual benefit, a social justice program may be precarious over the long term.

This more nuanced argument doesn't support all forms of nationalism but only those that are demonstrably supportive of just regimes. If the liberal justice argument is correct (including all the empirical claims), then this would mean that just states are justified in nurturing national identifications with co-nationals and with the political project. In short, nation-building is justified; but national self-determination projects are much more problematic. There are two reasons for this. First, this argument tends to be biased toward larger nations that are capable of supporting a redistributive practice. Second, the argument proceeds by justifying states in inculcating emotional ties in order to facilitate justice. It takes the existence of a state for granted and only regards nationalism as justified insofar as it is instrumental to just public policies.

While it is difficult to justify a national self-determination project on this argument, it is not impossible. One could, perhaps, claim that a particular state is comprised of two mutually antagonistic groups, who have no desire to engage in a redistributive practice. In this case, nation-building has manifestly failed, and the best one could hope for is a political settlement (partition/secession) which separates the groups so that each can

establish rules of justice in their own community. This pragmatic argument makes sense, and demonstrates that this argument could be modified to support national self-determination, but it is also a fairly stringent test for justified secession (manifest failure to support justice and expectation of success in the event of secession). To see that it is stringent, one need only recall my earlier point—viz., that political sentiments do not directly translate into public policy, and that the claims of justice can often be met even in a political community comprised of citizens fairly indifferent to the claims of others.

The instrumental liberal justice argument seems, on the face of it, to avoid the problems with the intrinsic argument, and specifically the criticism that it is ambivalent in its conclusions between nation-building and national self-determination projects. This instrumental argument clearly justifies state-directed nation-building projects, and can support national self-determination projects only with difficulty.

However, this brings us to a problem with the structure of this argument. This argument works by separating the motivational basis of nationalism from its justificatory basis. The benefits that national bonds and national sentiments carry with them involve the nationalist in believing that the nation is worthy of regard, that there are ties of history and membership shared by co-nationals. It is precisely these sorts of sentiments that help to facilitate liberal justice. So, although the justificatory argument is unlikely to support national self-determination projects, the sentiment that undergirds nationalism—which is encouraged by the state—can be used to support national self-determination projects. One troubling aspect of this argument is that it escapes the criticism (of being ambivalent) only because it seems to violate the liberal transparency requirement. It supports nationalism, not for the reasons accepted by people themselves (who feel these ties of national membership) but for quite different reasons. So, like Government House utilitarianism, it seems to involve a certain amount of manipulation by the state. However, unlike utilitarianism-and this is the second troubling aspect of this argument—the easy analogies between one national identity and another may make the emotional force of nationalism quite difficult to confine only to those groups large enough and privileged enough to enjoy their own state. By legitimating national sentiments and national bonds, this argument may have the (indirect) consequence of encouraging national self-determination projects.

2.2 National Bonds as Instrumental to Democratic Governance

There is another version of an instrumental argument for nationalism. This is the argument that a shared national identity helps to undergird

democratic institutions, by facilitating trust and making possible better representation. In the nineteenth and early twentieth century, many writers assumed a close relationship between nationalism and democracy. The basis of this assumption seemed to be an association between the ideas of national and democratic sovereignty, internal and external self-determination. This is evident in Ernest Renan's definition of the nation as "un plebiscite de tous les jours,"[18] which suggests the consensual and democratic basis of national communities. In seeming support of this view, many nineteenth- and early twentieth-century nationalists were committed to democratic governance. The potential for divergence between nationalism and democracy was not evident, as nationalists/democrats (often one and the same person) organized to fight the democratic Russian, Austro-Hungarian, and Ottoman Empires.

The intellectual expression of this line of argument is, of course, John Stuart Mill's discussion "On Nationality" in *Considerations on Representative Government*. There he argues that democracy can flourish only where "the boundaries of government coincide in the main with those of nationality."[19] His argument in support of this contention is based on an analysis of the necessary conditions for a flourishing democracy: "Among a people without fellow-feeling, especially if they read and speak different languages, the united public opinion necessary to the workings of representative institutions cannot exist."[20]

Mill's recognition of the need for a common national identity, combined with a nineteenth-century view of historical progress and an ethnocentric view of the merits of different nations led him to believe that the "great nations" would enjoy independence and the smaller nationalities would be assimilated into their "orbit." It is, however, no longer plausible to assume that the demise of smaller nationalities is historically inevitable. Once we jettison Mill's assumption of the assimilative power of the larger nationalities, it becomes apparent that Mill's argument merely supports the principle that state and national boundaries should coincide.

Contemporary political theorists have argued that there are other, plausible connections between democratic representation and shared national identity. One argument, which has been used in the context of other identity- based politics, goes like this: democracy involves vertical dialogue—that is, some discussion between the representative and the represented. The representative has to be sufficiently aware of, and receptive to, the concerns of her/his constituents. This is partly a matter of certain kinds of character traits, such as sympathy, and not a matter of national identity at all. However, there is strong evidence that sharing an identity helps to facilitate the kind of dialogue that is a component of good representative democracy. In the United States, for example, there is evidence that black constituents feel more comfortable with, and are more likely to voice their

grievances or concerns to their representatives, if their representatives are black. This, in turn, will ensure that government policy can be made with an awareness of the concerns and perspectives of this particular group.[21] This is a good argument for devising electoral ridings or districts to ensure that such groups are more likely to have black representatives.

In nationally divided societies, the salient division is national identity. Solutions such as redistricting do not apply to these types of societies: they work only where the excluded group wants to be included, wants a greater say in the governing of the society. In societies with a common nationality (even if there are other kinds of divisions, such as racial divisions, gender divisions, class divisions), there are mechanisms available to ensure that all groups have symbolic power; and that there is vertical dialogue between representative and constituent. In cases where a state has two groups with competing and mutually antagonistic national identities, the situation is quite different. The problem in nationally divided societies is, first, that the majority-vote rule that confers legitimacy is itself a mechanism of exclusion (since politics tends to follow national lines and who is in the majority and who is in the minority is known in advance);[22] and, second, that attempts to construct different democratic arrangements (beyond simplistic majority vote) to take into account the divisions in the society are extremely fragile and problematic.[23]

This type of argument suggests that a shared national identity is instrumental to a well-functioning democracy. It is not absolutely essential, since there are institutional systems designed to facilitate democratic governance in nationally divided societies (Lijphart's famous consociational or power-sharing democracy; and Horowitz's recommendation of a vote-pooling system to encourage interethnic accommodation[24]) but these are difficult to establish and are, notoriously, unstable. All this suggests that effective representation, and the stable functioning of democratic systems, is much easier in states where there is agreement on the state and on the state boundaries (there is a shared national identity). It suggests the instrumental advantages of ensuring that state and nation do coincide.

Like the intrinsic argument and the liberal justice argument, this argument for liberal nationalism proceeds in abstraction from the issue of disputed territory, or the problem of different national identities overlapping on the same territory. This argument simply points to the instrumental advantage of shared national identity for democratic governance. Like the intrinsic argument, this argument can be used to justify national self-determination projects (on the part of a minority nation) or nation-building projects (by the state). The argument doesn't give us much direction which, normatively, should be preferred.

The two, of course, cut across one another: if you facilitate the various national self-determination projects of different peoples within your bor-

ders, you run the risk of not having a shared overarching national identity. And if you engage in nation-building to assimilate or incorporate national minorities into the common political project, then, you deny their right to be self- governing or self-determining which would seem to be justified, certainly on the intrinsic argument, and also perhaps on the instrumental argument regarding democratic governance. On the national self-determination interpretation of these arguments, equality is achieved by treating each national group equally, as being equally entitled to self-government in a Wilsonian vision of the world as a great "family" of nations. On the nation-building interpretation of these arguments, equality is achieved by treating each person equally and by including all in a common civic project. But of course the treatment of national minorities in the two cases is very different.

3. The Cultural Argument

The third, and most popular argument for liberal nationalism is the cultural argument. This argument identifies liberalism with the value of individual autonomy; and then attempts to examine the conditions under which individuals can be said to be autonomous.[25] The important move in this argument is the claim that culture provides the context from which individual choices about how to live one's life can be made. According to Miller, "A common culture . . . gives its bearer . . . a background against which meaningful choices can be made."[26] Kymlicka follows the same line: "[I]ndividual choice is dependent on the presence of a societal culture, defined by language and history, and . . . most people have a very strong bond to their own culture."[27] Not only does the culture provide the options from which the individual chooses, but it infuses them with meaning. This is important to the argument: the autonomous ideal of a self-choosing, self-forming being presupposes some conception of value according to which the life is constituted, and this conception of value is provided by a national (or societal) culture.

 Since a rich and flourishing culture is an essential condition for the exercise of autonomy, it is claimed that liberals have a good reason to adopt measures that would protect culture. At this point, the argument has only shown that the existence of (some) flourishing cultural structure is necessary to the exercise of autonomy, but not a particular culture. I think that this formulation is broadly correct: a Flemish nationalist may care passionately about the continued existence of the Flemish language and culture, but it would be hard to argue that his/her children would be unautonomous or unable to flourish if they became assimilated into the French culture. Some culture is clearly essential to provide options, and to give

meaning to these options, but one would have to be an extreme bigot to claim that the well-being and autonomy of individuals could only be provided by the Flemish culture.[28]

Some of the criticisms of the cultural argument for liberal nationalism have focused on the transitions from (a) the importance of culture to the exercise of individual autonomy to (b) the liberal-nationalist conclusion that particular cultures should be protected.[29] However, I think that liberal nationalists are right to claim that there is empirical evidence to support the view that individuals have strong bonds to their own culture, at least as that applies to national minorities, ensconced on their homelands. John Stuart Mill, writing in 1861, could look back to a quite recent past and write: "Experience proves it possible for one nationality to merge and be absorbed in another: and when it was originally an inferior and backward portion of the human race the absorption is greatly to its advantage."[30] Walker Connor, writing in the late twentieth century, has argued that national cultures have become such a powerful source of identity that he can think of no case in the twentieth century where territorially concentrated national minorities, on their own territory, have voluntarily assimilated. Indeed, he claims that assimilationist measures directed at minorities tend to backfire, and almost always lead to a consolidation of the minority identity.[31] There are many examples of groups (for example, Crimean Tatars, Kurds) that have struggled to resist assimilation, often at great cost to themselves.[32]

Drawing on the "legitimate interest" that people have in ensuring "access to a societal culture" and the "deep bond [that most people have] to their own culture," Kymlicka argues in favor of self-government rights for national minorities.[33] Similarly Miller argues that "everyone has an interest in not having their inherited culture damaged or altered against their will" and that sometimes the only way to prevent this is to use the power of the state to protect aspects that are judged to be important.[34] The culture argument, then, is employed to justify special rights for national groups based on a conception of the importance of culture to the exercise of autonomy. But if national identity is so important to people— if the protection of their culture is important because it underpins their sense of who they are, which in turn is crucial to the exercise of choice— then this must also be true for the national minorities within the state who have a different culture and a different national identity. In other words, the culture-based argument depends on the claim that culture is an important background condition to the exercise of autonomy. But in any state that has national minorities—and most states do—the culture of the minority (which is important to them, presumably) is marginalized by the state, because the state is viewed as the political expression of the majority culture. Like the other two arguments—the intrinsic and the instrumental

arguments—this argument considers only the value of national identity to its members, and so fails adequately to consider the fact that states are territorial, and encompass individuals with diverse identities.

The interesting twist in this argument—which is missing from the other two—is that its proponents attempt to avoid the objection that this would lead to endorsing a destabilizing "secessions from secession" scenario. They avoid this by defining an encompassing culture in such a way that some institutional recognition of the culture—in schools, government, and so on—is part of the definition of what it means to be an "encompassing culture." This has the effect of granting self-government rights to national groups that have already achieved some *institutional* recognition of their culture, but denying it to other, less favored groups, who are probably even more oppressed, because they have not managed to secure any institutional recognition of their distinct culture or identity.

The problem with this is that it fails to address the most egregious cases of group injustice, in which people have been denied any kind of recognition of their distinct identity. And it is a serious problem for the liberal nationalist, who is seeking to combine liberal principles of justice and fairness, equal rights under the law, with a defensible nationalism which recognizes the importance to people of their national identity.

4. Resolving Nation-Building and National Self-Determination Projects

Thus far, this paper has argued that, because liberal nationalists tend to focus either on the intrinsic or instrumental value of national identity, or on the role it plays in the exercise of autonomy, they have profound difficulty dealing with the empirical fact that states are not merely comprised of members but of territories, and that most territories are comprised of different national groups. Specifically, I have argued that the three kinds of arguments—intrinsic, instrumental, and cultural—for giving institutional recognition to national identity are ambivalent between nation-building and national self-determination conclusions. By "ambivalent" I mean that they give us very little reason to support one strategy over the other, and that this is extremely troublesome because the two are, to some extent, mutually exclusive.

Because these arguments tend to be ambivalent between nation-building and national self-determination projects, it is difficult to talk of the appropriate liberal nationalist policy with respect to national minorities. The appropriate policy of liberal nationalist nation-building is full equality, full inclusion; and the appropriate policy of a liberal nationalist national self-determination project is full equality of national groups in a kind of

Wilsonian world where each nation, however small, is at least entitled to be self-governing in the world family of nations.

This result does seem to be disturbing for a liberal nationalist, since the justificatory argument that grounds the argument for nation-building (say)- also justifies another group in resisting that nation-building. Or, to look at it from the other angle, the very argument that justifies one's national self-determination project also seems to justify the nation-building project of the group that you aspire to be politically autonomous *from*.

Now, at this point it might be objected that national self-determination and nation-building are not really in any necessary tension: liberal nationalists can justify national self-determination for groups which could be viable, just, and democratic states, and nation-building to "mop up" the remaining minorities.[35] I agree that this is the procedure usually adopted by nationalists. Many liberal nationalists, while not discussing the tension at all in direct terms, have tended to argue in favor of national self-determination and national recognition for certain favored groups and then assumed that this self-determination will take place within existing administrative boundaries, where a nation-building policy with respect to minorities can be implemented. However, I think that which minorities could benefit from their own state, or from more limited forms of political autonomy short of outright secession, and which should be subject to an assimilationist campaign that "mops" them up, will likely be contested, with most minorities arguing for political rights, and majorities seeking to deny them.

An alternative strategy involves distinguishing between minority nations and national minorities, in an effort to reduce the endless proliferation of secessions within secessions.[36] On this conception, national minorities are "minority extensions of neighboring nations."[37] Minority nations are distinct national groups that share the same territory as another group which is the majority national group on the territory.[38] This distinction is often applied to Quebec: on this conception, the national majority are the French-speaking Quebeckers; the English-speaking people, who are a historic community in Quebec (not recent immigrants) and who tend to identify themselves as Canadians, are a national minority; and the aboriginal peoples on the territory of Quebec are minority nations. This distinction has important normative implications, since only nations (majority nations and minority nations) are entitled to political self-government rights.[39]

It is somewhat unclear, however, *why* the political aspirations toward self-government (with conationals) is denied only in the case of national minorities. Much of the work in this argument is done by two concepts: first, the notion of the territorial integrity of the existing unit; second, the idea that the group is not a nationally or culturally *distinct* group but has

conationals in another state. With respect to the first point, it is unclear why territorial integrity trumps the claims only in the case of national minorities; with respect to the second, it is unclear why it would matter (normatively) to the Croat in Bosnia, the Irish in Northern Ireland, the Anglophone in Quebec (in the event of full secession), that somewhere else on the globe there is a country called Croatia, Ireland, or Canada that is representative of their culture (but is not the state in which they live). It seems to me that there are arguments that could be made to answer these queries,[40] but it is difficult to see how they would be consistent with *liberal* nationalism, which tends to adopt individualist forms of justification.

A third, more persuasive strategy for reconciling the tension between national self-determination and nation-building projects involves abandoning traditional nation-building (conceived of in French assimilationist terms, as absorbing minority groups into a dominant national culture and identity) in favor of a form of nation-building that involves encompassing different nations through strategies of accommodation.

This strategy is based on Connor's argument, discussed above, that traditional nation-building is not effective, at least where territorially concentrated national minorities (not immigrants) are concerned, and indeed that attempts at nation-building, in the sense of assimilation, are likely to lead to a consolidation of the minority identity. It is based on Connor's insight that, even while extensive acculturation may occur, assimilation does not necessarily follow: being more alike in all kinds of ways may not erode different identities, and, in fact, as long as there is some cultural marker, some way of telling the groups apart, the possibility of a latent (or dormant) nationalism becoming reactivated, is always present.

What I think Connor's analysis suggests is that any attempt to create a common political project will have to proceed by recognizing the variety of identities. The political culture of the state will have to be made, as far as possible, permeable in the sense that a variety of cultural groups will feel included; that they will feel that it is possible to be both Muslim and Canadian; both native and Quebeckers both Quebeckers and Canadian. This might involve removing any sort of special discrimination that the group suffers, which unfairly disadvantages the group; or perhaps, in the case of a group like the natives in Canada, where they aspire to be politically autonomous, it may involve giving them self-government rights, so that the members of the group do not feel threatened by the majority culture—they do not view it as threatening to their identity as native, because they, as natives, are making this choice themselves.

Some might object that the right to self-government is a right not to be included, and so is inconsistent with a common political project. However, I think it is more accurate to say that self-government is a right to decide for oneself whether or not one wishes to be included, and the

extent to which one wishes to be included in a common life. Since this is so, self-government might make possible the construction of a nested identity where members feel that it is possible to be both native and Quebecker, or native and Canadian, because the two identities are not constructed in opposition to one another.

This does not completely resolve the tension between nation-building and national self-determination projects. The persuasiveness of the instrumental nationalist argument (considered in Part 2) depends on the insight that we have to attend to the ways in which we can have a common life, or common framework in which people are able to meet and discuss their commonalities and to recognize each other as fellow citizens. However, it does suggest that a strategy of accommodation toward national groups and a permeable political culture may be the only way that liberal nationalists can deal with the ambivalent conclusions suggested by their own arguments.

<div align="right">MARGARET MOORE</div>

University of Waterloo
Waterloo, Ontario

<div align="center">NOTES</div>

*Earlier versions of this paper were presented at: the Conference on Nationality, Citizenship and Solidarity, Université de Montréal, Montreal, Canada, 21–24 May, 1998; the American Political Science Association Annual Meeting, Boston, Massachusetts, 3–6 September, 1998; and the Conference on the Study of Political Thought, University of Wisconsin at Madison, 6–8 November, 1998. I am grateful to a number of people who commented on the paper, especially Rainer Baubock, Allen Buchanan, Avigail Eisenberg, Krishan Kumar, John McGarry, David Miller, Kai Nielsen, Alan Patten, Michel Seymour, Jeff Spinner-Halev, Yael Tamir, Daniel Weinstock, and Bernie Yack. I also thank the Social Sciences and Humanities Research Council of Canada for research funding.

1. David Miller, *On Nationality* (Oxford: Clarendon Press, 1995), pp. 85–87; Will Kymlicka, *Multicultural Citizenship* (Oxford: Clarendon Press, 1995), pp. 8, 82–83; Yael Tamir, *Liberal Nationalism* (Princeton, NJ: Princeton University Press, 1993), pp. 6, 76; Avishai Margalit and Joseph Raz, "National Self-Determination" in Will Kymlicka, ed., *The Rights of Minority Cultures* (Oxford: Oxford University Press, 1995), pp. 75–92.

2. See, for example, Kai Nielsen, "Liberal Nationalism and Secession" in Margaret Moore ed., *National Self-Determination and Secession* (Oxford: Oxford University Press, 1998); pp. 103–33 at 107–8.

3. See Rogers Brubaker, *Nationalism Reframed: Nationhood and the National Question in the New Europe* (Cambridge: Cambridge University Press, 1996) pp. 90–93.

4. See Will Kymlicka, *Multicultural Citizenship* (Oxford: Clarendon Press, 1995), especially ch. 2.

5. I am sidestepping here an important debate in the history and sociology of nationalism concerning the importance of ethnicity in the initial formulation of national identity. See Anthony Smith, *The Ethnic Origins of Nations* (Oxford: Blackwell, 1986); Ernest Gellner, *Nations and Nationalism* (Ithaca, NY: Cornell University Press, 1983); E. J. Hobsbawm, *Nations and Nationalism since 1780* (Cambridge: Cambridge University Press, 1990).

6. Paul Gilbert, "The Concept of a National Community," *The Philosophical Forum* 28, nos. 12 (Fall–Winter 1996–97) 149–66; Thomas Hurka, "The Justification of National Partiality" in Robert McKim and Jeff McMahan, eds., *The Morality of Nationalism* (New York: Oxford University Press, 1997), pp. 139–57, especially at 149–51.

7. Miller, *On Nationality*, p. 26.

8. Hurka, "The Justification of National Partiality," pp. 151–52.

9. See Brian Walker, "Social Movements as Nationalisms or, On the very Idea of a Queer Nation" in Jocelyne Couture, Kai Nielsen, and Michel Seymour, eds., *Rethinking Nationalism; Canadian Journal of Philosophy*, Supp. vol. 22 (1996), 505–47, especially at 526–27.

10. Miller, *On Nationality*, pp. 133–39.

11. A similar view is taken by Eamonn Callan, in *Creating Citizens: Political Education and Liberal Democracy* (Oxford: Oxford University Press, 1997); pp. 103–15. Like Galston, Callan accepts that a positive attitude of attachment to conationals and to the political community is a prerequisite for liberal citizenship, although he disagrees with Galston about the fundamental value of liberalism (for Galston, it is diversity; for Callan, it is autonomy) and also about the extent to which the abridgment of reason is a necessary part of education for citizenship.

12. Rawls's proposed remedy for what he calls the "stability" problem is, first, the requirement that there be an overlapping consensus on a political conception, and, second, an account of the reasonable person, to whom his theory is addressed. This solution explains why reasonable people should endorse and abide by fair or just political principles, but it doesn't explain the special obligations that the individual has for the state she lives in, or why the individual should undergo special burdens to redistribute wealth to comembers, rather than to anyone in the world.

13. William Galston, *Liberal Purposes: Goods, Virtues, and Diversity in the Liberal State* (Cambridge: Cambridge University Press, 1991), p. 243.

14. Ibid., p. 244.

15. Ernst Renan, "What Is a Nation?" in Alfred Zimmern, ed., *Modern Political Doctrines* (London: Oxford University Press, 1939), pp. 186–205, at p. 190.

16. See Daniel Weinstock, "Is There a Moral Case for Nationalism?," *Journal of Applied Philosophy* 13, no. 1 (1996): 87–100.

17. For a discussion of the extent to which national identity is not shared, see John McGarry and Brendan O'Leary, *Explaining Northern Ireland* (oxford:

Blackwell, 1995), pp. 300–301; and for a discussion of the extent of the British subvention to Northern Ireland, see Bob Rowthorn and Naomi Wayne, *Northern Ireland: The Political Economy of Conflict* (Cambridge: Polity Press, 1988), pp. 82, 156–57.

18. Ernest Renan, "Discours et Conferences" (1887). Quoted in Alfred Cobban, *National Self-Determination* (Oxford: Oxford University Press, 1994), p. 64.

19. John Stuart Mill, "Considerations on Representative Government" in *Utilitarianism: On Liberty and Considerations on Representative Government* (London: Everyman Library, 1993), p. 394.

20. Mill, "Representative Government. . . . ," p. 392.

21. Jane Mansbridge, "What Does a Representative Do? Descriptive Representation in Communicative Settings of Distrust, Uncrystallized Interests, and Historically Denigrated Status," pp. 21–24; Melissa S. Williams, "Impartiality, Deliberative Democracy, and the Challenge of Difference," pp. 9–12. Both papers prepared for the Conference on Citizenship in Diverse Societies: Theory and Practice (Toronto, Ontario, October 4–5, 1997).

22. This problem has been well documented in Northern Ireland from 1921 to 1972, which was governed democratically on a Westminster first-past-the-post majoritarian system. See Brendan O'Leary and John McGarry, *The Politics of Antagonism: Understanding Northern Ireland* (London: Athlone Press, 1996), pp. 107–52.

23. Notable failures include Northern Ireland in 1974 and Cyprus, 1960–1963. In the case of Lebanon, on the other hand, the power-sharing regime did last for thirty-two years. That could be considered a success.

24. See Arend Lijphart, *Democracy in Plural Societies: A Comparative Exploration* (New Haven, CT: Yale University Press, 1977), and Donald Horowitz, *Ethnic Groups in Conflict* (Berkeley, CA: University of California Press, 1985).

25. Yael Tamir, for example, defines liberalism in terms of respect for personal autonomy, reflection, and choice in *Liberal Nationalism* (Princeton, NJ: Princeton University Press, 1993), p. 6. Kymlicka also "defend[s] a certain vision of liberalism—grounded in a commitment to freedom of choice and (one form of) personal autonomy" in *Multicultural Citizenship*, p. 7.

26. Miller, *On Nationality*, pp. 85–86.

27. Kymlicka, *Multicultural Citizenship*, p. 8.

28. This point is made in Thomas Hurka, "The Justification of National Partiality," pp. 145–46.

29. See, here, Alan Patten, "The Autonomy Argument for Liberal Nationalism," *Nations and Nationalism* 5, no. 1 (1999): 1–17; and Allen Buchanan, "The Morality of Secession" in Will Kymlicka, ed., *The Rights of Minority Cultures* (Oxford: Oxford University Press, 1995), pp. 350–74, at p. 357.

30. Mill, "Representative Government. . . .", p. 395.

31. Walker Connor, *Ethnonationalism: The Quest for Understanding* (Princeton, NJ: Princeton University Press, 1994), pp. 51–55.

32. John McGarry, "Demographic Engineering," *Ethnic and Racial Studies* 21, no. 4 (July 1998): 613–38; Connor, *Ethnonationalism*, pp. 38–39.

33. Kymlicka, *Multicultural Citizenship*, p. 107.

34. Miller, *On Nationality*, pp. 86–87.

35. This was suggested to me by Alan Patten. The terminology is his.

36. This strategy is developed by Michel Seymour, "Une conception sociopolitique de la nation," *Dialogue* 37, no. 3 (1998) and Michel Seymour (in collaboration with Jocelyne Couture and Kai Nielsen), "Introduction: Questioning the Ethnic/Civic Dichotomy," in Jocelyne Couture, Kai Nielsen, and Michel Seymour, eds., *Rethinking Nationalism*, Supp. vol. of the *Canadian Journal of Philosophy* (1996), pp. 164; and is adopted by Kai Nielsen, "Liberal Nationalism and Secession" in Margaret Moore, ed., *National Self-Determination and Secession* (Oxford: Oxford University Press), pp. 103–33.

37. Seymour (with Couture and Nielsen), "Introduction," p. 38, n. 6.

38. This is adapted from Seymour (with Couture and Nielsen), "Introduction," p. 38, n. 6.

39. Proponents of this distinction accept that, over time, a group's status may change. Any reasonably dynamic conception of the interaction between the political structure, civil society, and national identity will have to allow for the possibility that the national identification of a group can change. Thus, while the Anglophone minority in Quebec currently identifies with Canada, and with fellow Canadians as conationals, over time, and especially if they experience a political climate different from the rest of Canada in a sovereign Quebec, their aspirations (to be part of Canada) might change as well as their locus of identification (e.g., if they begin to identify with fellow Quebec Anglophones rather than all Canadians, they might constitute a minority nation in their own right).

40. In the case of Israel, for example, one justificatory argument for the establishment of the State of Israel is that the Holocaust demonstrated that there had to be some state, somewhere in the world, where Jews were in the majority. On this justificatory argument, the fact that there is a Jewish state somewhere on the globe, is normatively important.

9

Liberal Egalitarianism and the Case for Supporting National Cultures*

ALAN PATTEN

1. Kymlicka's Project

Liberal egalitarians agree that the state should protect and promote the freedom of the individual and strive to establish equality of opportunity and resources. They tend to disagree, however, about what these principles entail concerning the state's attitude to the success or failure of the different national cultures which coexist in many modern political communities. To some it seems obvious that, given the profound importance of culture in shaping a person's identity and outlook, treating people in accordance with liberal egalitarian principles means ensuring the equal survival and success of the cultures to which they belong. Actual practice seems to accord with this conviction to at least some degree in many places in the world: in countries like Canada, Belgium, Spain, and the United Kingdom, to mention just a few, minority cultures are provided with at least some of the political and financial resources needed to ensure their own survival and flourishing.

To others, however, it is just as obvious that treating people according to liberal egalitarian principles means adopting a policy of *laissez faire* with respect to the success or failure of the different national cultures which coexist in the community. It is argued that intervention to prop up ailing cultures may violate the basic rights and liberties of some individuals and will almost certainly involve redistributing certain resources and opportunities from nonmembers to members of the culture in question, thereby disadvantaging nonmembers and creating an inequality. This conviction has also influenced actual practice—for instance, in Canada where opponents of Quebec's cultural and linguistic policies have frequently adopted the rhetoric of both liberty and equality.[1]

Resolving this dispute is one of the most urgent priorities for a liberal egalitarian theory of nationalism. Nationalism is often defined as a doctrine about how politically meaningful boundaries should be drawn. But it is clear that many nationalists also affirm a doctrine about how the state, in the context of a given set of boundaries, ought to exercise its power and authority: they hold that the state has an important responsibility to preserve and promote one or several of the national cultures found within its borders. Indeed, the nationalist claim that national and state boundaries ought to coincide is sometimes premised quite explicitly on this latter view. One reason why state and national boundaries should coincide is that this will help to ensure the preservation of a threatened national culture.[2] In line with this idea, cultural preservation is sometimes cited as one of the legitimate grounds for secessionist projects.[3]

It is important, then, for an evaluation of nationalism from a liberal egalitarian standpoint to try to adjudicate between the conflicting claims about the legitimacy of state intervention on behalf of struggling national cultures. Over the past decade or so, the most important intellectual contribution to this debate has almost certainly been the work of Will Kymlicka. In a series of books and articles Kymlicka has managed to refocus the attention of contemporary political theorists on the problem of minority cultures and to define the terms in which much of the debate is now conducted.[4] His central thesis is that liberal egalitarian principles can be shown to ground a substantive set of group-differentiated entitlements or cultural rights. Examined from the perspective of protecting and promoting individual freedom, or from the perspective of establishing equality of opportunity and resources, liberal egalitarian principles can be employed to defend a set of rights, policies, and institutional mechanisms which help to ensure that national cultures survive and flourish.

An important objection to Kymlicka's project is that it grounds the right to national cultures in liberal egalitarian values which members of some of those cultures may not themselves endorse. It has been argued, for instance, that it is pointless to defend the rights of aboriginal peoples by appealing to a connection between secure cultural membership and individual freedom, since those peoples do not themselves place the same value on individual freedom as Western liberals.[5] Although I will not attempt to argue it in any detail here, I do not think that this objection to Kymlicka's approach is decisive, even if it does limit the scope of the project more than Kymlicka concedes. One important reason to develop arguments that can appeal to liberal egalitarians is that people attached to, or influenced by, liberal egalitarian principles are often powerful opponents of cultural rights.[6] A second reason to do so is that many of the themes which arise in Kymlicka's work—themes such as anomie and the loss of valuable cultural options—have implications not just for individual freedom but for a

broader range of values and ideals some of which are likely to have resonance in traditional, non-Western cultures.

My aim in this paper will not be to question the liberal egalitarian framework in which Kymlicka operates. Instead, I want to explore and assess Kymlicka's claim that a commitment to liberal egalitarian principles can be shown to ground a substantive set of cultural rights. I will show that there are several distinct ways in which Kymlicka's statements about the connections between freedom, equality, and culture might be construed and that none of these, in their present form, lead to his desired conclusion. I will then go on to develop a revised version of Kymlicka's argument which I think can generate the conclusion he wants—what I shall term *the argument from linguistic incapability*. Finally, I indicate several important limitations faced by the revised argument that point to the need for further research in this area. The result is a mixed assessment of Kymlicka's attempt to reconcile liberal egalitarian principles with support for minority cultures. In its present form, Kymlicka's argument does not go through. It does provide resources out of which a more successful argument can be constructed but even this argument faces important limitations.

2. Locating the Problem

At the beginning of the paper I contrasted two different kinds of policies that a liberal egalitarian might endorse with respect to the survival and flourishing of the different national cultures in the political community: a policy of *intervention* and a policy of *laissez faire*. Before examining Kymlicka's position further it is important to set out and refine the distinction between these two approaches, since it turns out to be quite problematic.

The main problem is that the distinction seems to ignore the fact that the state cannot comprehensively avoid intervening in the domain of culture. As Kymlicka points out, decisions about which languages will be used in government, education, and the courts, how political boundaries will be drawn, and who can have access to radio and television airwaves, to mention just a few examples, all have a profound impact on the capacity of different cultures in the community to survive and flourish.[7] It might seem more accurate, then, to say that the real debate is not between interventionist and laissez-faire approaches to culture but between different positions on the *scope* of legitimate state intervention in the domain of culture. The members of endangered minority cultures can be seen as demanding parity of treatment with those in the majority: they would like to enjoy the same official advantages and protection as the majority culture, through policies of official bilingualism for instance. Their opponents, on the other

hand, can be viewed as opposing this extension of official advantages and protection to minority groups, often on the grounds of efficiency and social unity.

I think that the debate about minority cultures does take this form in a number of real-world political controversies. In the United States, for instance, the debate about extending greater cultural recognition to Hispanics often unfolds along roughly these lines. In certain other real-world controversies, however, there do seem to be recognizably "interventionist" and "laissez-faire" approaches opposing one another. In Canada, for instance, this is illustrated by both the debate over Quebec's language policies and the controversies concerning native land claims. Many Francophone Quebeckers argue that policies such as official bilingualism are unlikely to secure their distinctive language and culture and hence that a more interventionist approach, involving (for instance) minor restrictions on the use of English in certain contexts, is required as well. Similarly, what many native people would like is not to have the same land entitlements and legal framework as the majority population but to have a special set of entitlements and regulations which allow them to secure their distinctive traditions and way of life.

An unhelpful way of understanding the interventionist/laissez-faire distinction, then, is to view it as a distinction between an approach which advocates some intervention in the domain of culture and an approach which advocates no intervention: it is inevitable, and probably desirable, that the state's policies and institutions will have implications for the different cultures in the community. On the basis of the examples I just mentioned, however, it is possible to construe the distinction between the two approaches in a second, more analytically useful way. The laissez-faire approach can be viewed as (a) striving to confer the same official advantages and protection on all cultures in the political community in those areas of policy where it is difficult for the state to refrain from intervening but (b) refusing to intervene on behalf of a culture in other areas of policy, even where that culture is faced with decline or extinction. This can be contrasted with an interventionist approach which calls for special, group-differentiated entitlements, policies, and institutional mechanisms designed to protect cultures if and when they face decline or extinction.

A great strength of Kymlicka's most recent work is that it draws attention to the incoherence of the interventionist/laissez-faire distinction when it is interpreted in the first way suggested above. This being said, his main argument—the argument connecting freedom and equality with secure cultural membership—is best viewed as a critique of laissez faire in something like the second, more sophisticated sense that I have just outlined.8 Starting from liberal egalitarian principles, Kymlicka thinks he can defend the legitimacy of group-differentiated entitlements designed to protect endangered

cultures against arguments for a laissez-faire approach that emphasizes both parity of treatment for all cultural groups in the community and a refusal to intervene at all in certain spheres relevant to cultural success or failure.

3. The Structure of Kymlicka's Argument

The main representatives of liberal egalitarianism in Kymlicka's writings are almost invariably John Rawls and Ronald Dworkin. In setting out the details of his own position, Kymlicka tends to opt for Dworkin's version of the theory and to keep the exposition as simple as possible. I will do the same in this paper. Although I will not be able to show it here, I very much doubt that Kymlicka's argument would be any stronger if he opted for the Rawlsian variant of the theory instead.

According to Dworkin, the liberal view of equality requires both that each individual enjoy an extensive set of rights and liberties and that a certain distribution of resources be in place, which he terms "equality of resources."[9] Equality of resources is established in the distribution of a society's material goods and resources only when the value of each person's bundle of goods and resources measured in terms of the opportunity-cost it imposes on others is the same. The basic idea is that if I appropriate some resource that is relatively precious to other people then, for equality to be established, they should be able to appropriate other correspondingly valuable resources instead. The idea works most smoothly in a one-period world in which people have identical talents and handicaps and there is no production. But there are reasons to think that it could be extended, more or less imperfectly, to apply to more complex societies like our own.[10]

Kymlicka's question, then, is this: What should we should think about support for struggling cultures if we adopt Dworkin's view of equality? At first glance, the answer seems clear. As Dworkin shows, if each person starts with equal purchasing power, the opportunity cost metric of equality lends itself naturally to the use of market prices to measure equality.[11] For instance, all else being equal, if I prefer to consume a relatively scarce good which others would also like to consume, and there are no significant economies of scale in the provision of that good, then, in a market, I would have to pay a relatively high price for that good and would have fewer resources left over to spend on other things. This seems right because I am asking others to forgo something they would like to have and make do with something else. If I were to be permitted to pay less than the market price for the good in question, then not only would others be forgoing a good that they would also like to consume but they would still

have to compete with (more of) my resources in acquiring other things they want.

In this vein, it could be argued that the fact that some cultures are difficult to maintain, and may well disintegrate if left to the cultural marketplace, is a reflection of the fact that they are relatively "expensive" to maintain. The members of a disintegrating culture are unwilling to pay the high cost of the activities, or the scarce resources, needed for the culture to survive. To impose some of this cost on others through a subsidy, or a restriction on certain rights, liberties, or opportunities, would be to create an inequality: not only would those others be foregoing scarce resources they would themselves like to enjoy but they would still have to compete with members of the culture for remaining resources. In effect, some people would be paying less and others would be paying more than the full cost of their respective ways of life measured in terms of social opportunity cost.

At first glance, then, Kymlicka's claim that support for minority cultures can be grounded in liberal egalitarian principles seems to fail, at least for Ronald Dworkin's version of the theory: endorsing Dworkin's liberal egalitarianism seems to mean that one should opt for a policy of laissez faire, rather than support, for imperilled minority cultures.

Before declaring the matter to be closed, however, we should recall that it is crucial for Dworkin's position that equality requires not only the establishment of a market but also that individuals bring to the market equal assets or endowments.[12] Where individuals start life with different endowments of capital, or with different talents, handicaps, and so on, then, on its own, the market cannot establish equality or justice. This is not to say that liberal egalitarians like Dworkin oppose all material inequalities, since some inequalities will reflect different ambitions that people have and different choices that they make: people have different preferences for labour and leisure, enjoy different degrees of good and bad luck in the gambles they take, and so on. What liberal egalitarians do hold is that no individual's share of resources should be diminished simply because of bad luck in the natural and social distribution of endowments: an equal distribution of resources should, in Dworkin's phrase, be "ambition-sensitive" but "endowment-insensitive."[13]

The concern to compensate for endowment inequalities means that liberal egalitarians like Dworkin do not advocate a policy of pure laissez faire but instead think that the state should intervene to equalize the assets that individuals bring to the market. It is precisely this idea which Kymlicka hopes to exploit in attempting to reconcile liberal egalitarianism with a policy of supporting imperilled cultures. His claim is that security of cultural membership is one of the assets or endowments that individuals bring to the marketplace and thus is something which members of different cultures in the community should enjoy equally. Because the members of endan-

gered minority cultures do not enjoy the same secure cultural membership as their majority culture counterparts, there is a good liberal egalitarian case for intervention to support those cultures grounded in the aim of diminishing the effects of bad luck in the distribution of endowments.

Kymlicka's argument involves three central, claims:

(i) Secure cultural membership is an important good.

(ii) The good of secure cultural membership is something which is enjoyed to greater and lesser degrees by the members of different cultures in the community.

(iii) The disadvantages associated with insecure cultural membership require and justify intervention to support struggling minority cultures.[14]

He needs to establish (i) in order to show that someone lacking secure cultural membership is suffering from a disadvantage. He needs (ii) to persuade us that there are members of endangered minority cultures who do suffer from this disadvantage. And (iii) is necessary if he is to show that this is a disadvantage that liberal egalitarians should compensate for by providing support for endangered minority cultures.

Kymlicka argues for (i) on the grounds that secure cultural membership is an important condition of individual freedom. He thinks that (ii) follows from the fact that members of some minority cultures are lacking this important condition of their freedom or are able to secure it only at great expense. And he defends (iii) by arguing that whether or not one is placed in this predicament is a question of the circumstances one finds oneself in rather than the choices that one makes and in this sense is part of the endowment which one brings to the marketplace.

In effect, then, Kymlicka's suggestion is that, looking at the problem from the perspective of either of the main elements of liberal egalitarianism, a case for supporting struggling cultures can be made. Because secure cultural membership is a condition of individual freedom, the liberal egalitarian commitment to freedom is consistent with a policy of supporting endangered cultures. And because insecurity of cultural membership is a predicament that one finds oneself in and not the result of a choice that one makes, the liberal egalitarian commitment to compensating for unchosen inequalities is also compatible with a policy of intervention. In fact, the two parts of Kymlicka's argument are meant to work together: the fact that individual freedom is at stake shows why insecurity of cultural membership is so disadvantageous; and the fact that insecurity of cultural membership is part of one's unchosen circumstances shows why this is a disadvantage which calls for liberal egalitarian intervention.

4. Freedom and Culture in Kymlicka's Argument

As I will show in section 7 below, I think it is possible that an argument having this structure might be successful, at least under certain conditions. But I do not think that Kymlicka's argument works and will try to show that first. Two different reasons given by Kymlicka for thinking that cultural membership is an important condition of freedom will be explored. I then argue that, depending on which of these reasons one takes Kymlicka to be appealing to in defending (i), either his argument for (ii) is unsuccessful or his argument for (iii) is unsuccessful: that is, he either fails to show that anyone is disadvantaged with respect to the good of cultural membership or he fails to show that secure cultural membership should be treated as a compensable part of an individual's endowment. Whichever reason is focused on Kymlicka's argument does not go through and the case for reconciling liberal egalitarians to supporting minority cultures has not succeeded.

In defense of (i) Kymlicka claims that one's culture is a "context of choice." He explains this, in turn, by arguing that "freedom involves making choices amongst various options, and our societal culture not only provides these options, but also makes them meaningful to us."[15] Cultural membership, he says, "is a good in its capacity of providing meaningful options for us, and aiding our ability to judge for ourselves the value of our life-plans."[16] These and other remarks made by Kymlicka suggest that secure cultural membership is an important condition of freedom, and therefore a good, for two distinct reasons.

One is that it is in virtue of being a member of a secure culture that the different options facing an individual chooser have meaning. What makes options "valuable" or "meaningful" is the fact that they are "identified as having significance by our *culture*, because they fit into some pattern of activities which is culturally recognized as a way of leading one's life."[17] Without the "beliefs about value" that I internalize from my culture, Kymlicka thinks, I could not be free because I would have no perspective from which to guide and construct my life.

The second reason suggested in these passages why secure cultural membership is an important condition of freedom is that an individual's culture makes available the options corresponding to his or her beliefs about value. As a member of a culture I not only develop certain beliefs about value—marriages should be arranged by parents, Sundays should be a day of rest, and so on—but I also have access to institutions and practices that make it possible for me to realize those beliefs in my day-to-day life. If none of the options that are meaningful to me were available, then I would have no way of following my own perspective in guiding and constructing my life and I could not be said to be free.

Let us call the first reason for thinking that secure cultural membership is an important condition of freedom, or "context of choice," the *meaning-providing* reason and the second reason the *option-providing* reason. As I indicated above, my strategy will be to evaluate steps (ii) and (iii) of Kymlicka's argument in the context of an exploration of each of these reasons in turn.

5. The Meaning-Providing Reason

The meaning-providing reason explains the importance of culture for freedom not in terms of the options provided by a culture to individual choosers but by focusing on the ways in which cultures imbue those options with meaning and value. Can this explanation provide a basis for steps (ii) and (iii) of Kymlicka's argument?

To consider this version of the argument it is necessary to make one further distinction, this time between two ways in which a culture could fail to provide meaning to the options confronting its members.[18] A culture (let's call it Small) might fail to provide meaning to the options faced by its members because its members increasingly look to some other culture (Big) for interpretation of the value and meaning of the options they face. That is to say, exposure to Big might cause members of Small gradually to change their beliefs about value so that at some point the culture which provides their options with meaning is no longer Small but a transitional amalgam of Small and Big, and eventually it might make sense to say that their meaning-providing culture is Big. Alternatively, it could be the case that Small fails to provide meaning to the options faced by its members because its members gradually cease to have any beliefs about value and enter into a state of anomie. I shall call these the *assimilation* and *anomie* cases respectively.

Kymlicka gives conflicting signals about the assimilation case. On the one hand, he rejects the suggestion that changes in the character of a community—including, presumably, changes in beliefs about value—represent a threat to the security of individuals' cultural membership. For instance, French Canada's "Quiet Revolution" of the 1960s was a massive change in the character of French Canadian culture but, according to Kymlicka, it never represented a threat to the existence of that culture: "the existence of a French-Canadian cultural community itself was never in question, never threatened with unwanted extinction or assimilation as aboriginal communities are currently threatened."[19] On the other hand, he expresses sympathy with "the desire of national minorities to survive as a culturally distinct society,"[20] suggesting that he would be concerned about the assimilation case described above in which members of Small lose their *distinct* culture.

The point worth emphasizing, however, is not the ambiguity in Kymlicka's position but the fact that nothing in the meaning-providing reason for (i) *allows* him to appeal to the assimilation case in defense of (ii). According to the meaning-providing reason, secure cultural membership is an important condition of freedom because cultures provide meaning to the options faced by individual choosers. But in the assimilation case individuals never go *without* beliefs about meaning and value. Their beliefs *change* from those associated with Small to those associated with Big, perhaps with a transitional phase in between showing influences of both Small and Big, but individuals always have some beliefs about value.[21] For this reason, cultural assimilation (in the sense described above) is not a threat to individual freedom and should be of no concern to Kymlicka.

It is worth lingering over this conclusion for a moment since it is precisely the distinctiveness of their culture that many advocates of support for minority cultures are concerned to protect. They do not want to see their culture gradually blend into the more powerful majority culture to which it is exposed and they attach particular importance to preserving their language and political institutions as a barrier to this kind of assimilation. From what we have seen so far, however, nothing in Kymlicka's argument should give this kind of advocate of support for minority cultures any comfort. Kymlicka fails to show that there is any important connection between protecting individual freedom and preserving the *distinctiveness* of minority cultures against assimilatory pressures.

The anomie case seems much better equipped to lend support for (ii). It is not at all inconceivable that members of a disintegrating culture could find themselves slipping into a sense of hopelessness and despair in which nothing seems valuable or worth doing. There may be nothing they can do to prevent this, or, if there is, they might have to use a relatively high proportion of their resources to keep the culture secure. Unlike the assimilation case, the anomie case is arguably one in which freedom is at stake: someone ending up in this predicament seems to be left with very little in the way of an inner life or perspective from which to manage and direct his or her own life.

It would be a mistake to ignore this case altogether, but I have some doubts about its empirical applicability. The evidence of depression, despondency, and suicide in some indigenous cultures in the New World suggests that there has been some tendency for members of these cultures to slide into a state of anomie after prolonged exposure to European cultures.[22] But even here it is difficult to distinguish the effects of generations of poverty and treatment as second-class citizens from the effects of cultural erosion *per se*. Moreover, even if the anomie case does approximate the experience of certain indigenous peoples, its application to other minority cultures seeking support looks less promising. For example, in the

cases of Quebec, Scotland, and Catalonia, it would seem faintly hysterical to argue that people are in danger of slipping into anomie if they are not given the means of preserving their cultures. The assimilatory attraction of neighboring majority cultures seems to pose a much more real danger to these and other similar cultures.

Setting these empirical speculations to one side, we might ask why it is, in the anomie case, that individuals are losing their beliefs about value, given that it is not because of the attraction of the beliefs about value of the majority culture (for this would turn it into the assimilation case). Kymlicka's main explanation of this phenomenon involves the claim that, because of the actions and decisions of members of the majority culture, the members of the minority culture lose control over resources and policy decisions crucial for the survival of their culture. The minority culture, he says, may be outbid for important resources (for example, the land, or means of production on which their community depends), or outvoted on crucial policy decisions (for example, on what language will be used, or whether public works programs will support or conflict with the culture's work patterns).[23]

Why should control over resources and policy decisions be necessary to prevent loss of one's beliefs about value? One reason is that, if members of the majority culture control key resources, or have key decision-making functions, then they may, intentionally or unintentionally, influence the character and development of the beliefs about value of members of the minority culture. Think, for example, of the potential impact on a group's beliefs about value of the introduction of international satellite television into the local community. This, however, is not the anomie case but the assimilation case discarded earlier: there is no *absolute loss* of beliefs about value, just a change from one set of beliefs to another.

A second reason why control over resources and policy decisions may be necessary to prevent loss of one's beliefs about value does seem compatible with the anomie case. Outside control of a culture's resources and policy-making apparatus may mean that the options and practices corresponding to the culture's beliefs about value become unavailable. For example, where some resource, such as land, is particularly important to the realization of a culture's beliefs about value, it becomes possible that the market activity of nonmembers of the culture could make that realization impossible, or at least very expensive: even in a democratic and basically equal society, members of the culture might be outbid or outvoted by nonmembers wishing to use the land for their own purposes.[24] And if members of the culture are unable to reaffirm their beliefs about value by realizing them in their day-to-day choices, then it would not be too surprising if after some time they began to lose those beliefs about value.

I think this second case could lead to anomie—although, as I noted earlier, I have some doubts about how empirically likely it is, particularly outside of the aboriginal case which Kymlicka concentrates on. Setting this empirical worry aside, however, we have now found a way in which the meaning-providing reason might provide a basis for (ii): it is conceivable that members of some minority cultures could be differentially advantaged with respect to the good of secure cultural membership. Having made the step from (i) to (ii) of Kymlicka's argument, the question now is whether the step from (ii) to (iii) can also be taken. If, as I have been suggesting, the anomie case arises when the options corresponding to a culture's beliefs about valuable become unavailable, then, to answer this question, we need to turn our attention to the option-providing reason: for the question now is whether the possibility of anomie arising from the unavailability of the options and practices corresponding to a culture's beliefs about value is sufficient to justify special support for that culture.

6. The Option-Providing Reason

It should be pretty clear, I think, that (ii) is quite plausible if we focus on the way in which cultures provide options for individuals which correspond to their (culturally conditioned) beliefs about value. There is nothing mysterious about the suggestion that members of some minority cultures could find it much more difficult than their majority-culture counterparts to find and afford options that are meaningful to them—and to this extent to enjoy freedom. This is illustrated, as we have seen, by the case of cultures which place value on ways of life which require vast amounts of land.[25]

The problem for the option-providing reason arises not at (ii) but at (iii). If he is going to rely on the option-providing reason, Kymlicka needs to show not only that members of some minority cultures find themselves at a disadvantage with respect to the availability of meaningful options, but also that this good provided by cultural membership should be treated as part of an individual's endowment and thus as something which a liberal egalitarian should be concerned to equalize.

The main difficulty with the step to (iii) is that it seems vulnerable to the same offensive and expensive tastes objections that are often made against the ideal of equality of welfare.[26] Whether or not one is free on the version of Kymlicka's argument being considered depends on whether one has a range of options corresponding to one's beliefs about value to choose from. And this, of course, partly depends on what one's beliefs about value are. If one has offensive or very expensive beliefs about value, then one would need, on this account, a range of corresponding options in order to be free. And according to liberal egalitarians like Rawls and Dworkin, at

least, this hardly seems like a good argument for providing (or subsidizing) an expensive or offensive way of life for anyone.

Consider, for instance, the stock case of someone with "champagne" tastes and beliefs about value.[27] Imagine that this person's idea of a good life involves control over a large estate, drinking expensive claret, having a large retinue of servants, possessing a townhouse in the city, and so on. In a society guided by liberal egalitarian principles, it seems safe to say, the options corresponding to his beliefs about value will be unavailable, or at least very expensive, and to this extent his freedom will be threatened. But even if beliefs about value are unchosen in the relevant sense (for example, they are the product of upbringing and it is not possible for the individual in question to "school" himself out of them), liberal egalitarians hold that it would be wrong to think that this person is owed special support, or even that he is entitled to any kind of special compensation. To this extent, it would seem, Kymlicka's claim to have grounded the case for minority rights in the principles of liberal egalitarianism cannot be judged a success: liberal egalitarians think that people should be held responsible for their ambitions and beliefs about value, but Kymlicka's argument for minority rights seems to suggest that they should not be.

Nor does it help to return to the meaning-providing reason and insist that members of minority cultures will suffer the unfreedom associated with anomie if they are unable to realize their beliefs about value in their day-to-day choices. It is conceivable that someone with champagne tastes might sink into a state of anomie because of his inability to reaffirm his beliefs about value in his everyday life. To this extent, his freedom might be at risk. But it would still seem wrong to a liberal egalitarian to think that he is owed any special compensation for his predicament or that his way of life should be given any special support.

Kymlicka's most detailed discussion of the step from (ii) to (iii) can be found in chapter 9 of *Liberalism, Community and Culture*. In that discussion he explicitly anticipates the expensive-tastes objection I have just been outlining:

> If aboriginal rights were defended as promoting their chosen projects, then they would, on a liberal view, be an unfair use of political power to insulate aboriginal choices from market pressure. We can legitimately ask that aboriginal people form their plans of life with a view to the costs imposed on others, as measured by the market.[28]

If, for example, aboriginal people have chosen an expensive life style involving a large amount of land, then "it is only fair that they pay for this costly desire in a diminished ability to pursue other desires that have costs for society."[29]

Kymlicka claims, however, that minority rights can be defended "not as a response to shared choices, but to unequal circumstances." There is a way of making the move from (ii) to (iii) which does not run foul of the expensive-tastes problem. I think that this claim is correct, and will explain why in the next section. In the remainder of this section, however, I will show that *Kymlicka's* defense of the claim is unsuccessful.

One suggestion made by Kymlicka is that an individual's culture should not be considered as the product of her choice but as the "context of choice." On this view, it is a mistake to reduce cultural membership to the status of a preference or life style, since culture is the context in which different preferences and life styles are made available. The problem with this suggestion is that it fails to advance the argument any further. To say that a culture is a context of choice is, for Kymlicka, to say that it (1) provides the meanings and beliefs about value which guide individual choice, and (2) provides the options corresponding to these meanings and beliefs about value. We have already seen in the previous section that serious difficulties arise for Kymlicka's argument if it relies on the meaning-providing function of culture: if a minority culture is in decline *because* of the attraction of the majority culture, then it is not clear that anybody is going without beliefs about value. We are now considering whether the argument can go through if the option-providing function of culture is appealed to instead. The worry is that this variant of the argument will be stymied by the expensive-tastes objection, an objection which liberal egalitarians, at least, take very seriously. The suggestion that culture is a "context of choice" does not provide an answer to this worry but simply restates the claim.

The same is true of another motif of Kymlicka's discussion as well: the suggestion that what is at stake is not the satisfaction of some preference, or the realization of some belief about value, but the very "survival" or continued "existence" of the cultural community.[30] The relevant senses in which a cultural community can be said to exist, for Kymlicka, are the meaning-providing and option-providing senses. So, once again, pointing out that a culture's continued existence is at risk does not provide an answer to objections to the meaning-providing and option-providing variations of the argument but simply restates the claim.

Kymlicka's most interesting suggestion is that the unavailability of options corresponding to the beliefs about value of minority-culture members should give rise to liberal egalitarian intervention because it arises not from the preferences and choices of the members of that culture themselves but from the choices of other people. As we have seen, he stresses that those in the minority risk being outbid or outvoted by members of the majority culture. But no one chooses to be born into a minority rather than a majority culture and no one chooses the fact that, because of the

choices of the majority, it is difficult to maintain meaningful options in some minority cultures.

Unfortunately this argument is inconsistent with the liberal egalitarian position which Kymlicka starts from. The problem is that there is no general requirement that liberal egalitarians intervene on behalf of people who find that the options they value are expensive or unavailable because of the choices and preferences of others. Some people, for example, prefer independent films to Hollywood blockbusters. Unless they live in a big city, however, or go to the considerable expense of travelling to a big city, this option will probably not be available to them because the preferences and choices of most other people are different. This is a case in which some people find their preferences frustrated by the choices and preferences of others, but it is not one in which liberal egalitarians would call for intervention. For liberal egalitarians, it is fair that those with minority film preferences should have to pay a relatively high price to satisfy those preferences because the resources they are asking others (in this case, the majority) to give up—for example, use of the local cinema—are relatively precious to those others. Intervention in this kind of situation would mean that some would be paying more and others would be paying less than the full cost of the resources they use measured in terms of social opportunity cost.[31]

7. The Argument from Linguistic Incapability

I am attracted to Kymlicka's claim that there is an important connection between individual freedom and culture, although, as I pointed out in discussing the assimilation case, we need to be careful in formulating what exactly this connection is. The most serious problem in Kymlicka's theory arises in his explanation of why the insecure freedom of minority-culture members is something which should activate liberal egalitarian intervention. Kymlicka's position seems vulnerable to the offensive/expensive-tastes objection and none of his arguments to the contrary are successful at dispelling this impression. There is thus an important gap in Kymlicka's attempt to reconcile liberal egalitarianism with cultural rights. Kymlicka has shown why cultural membership might be an important condition of individual freedom but he has not shown why insecurity of cultural membership should cause liberal egalitarians to abandon laissez faire.

My aim in this section will be to try to plug this gap in Kymlicka's approach by outlining a different reason for thinking that liberal egalitarians should intervene in this kind of situation. One way to plug the gap might be for liberal egalitarians to bite the bullet on at least some expensive tastes and abandon their insistence on holding people responsible for all of their ambitions and beliefs about value.[32] For the purposes of this

paper, however, I would like to set this possibility to one side and develop a different argument which remains clearly within the boundaries of liberal egalitarian thought. The argument remains true to the basic spirit and structure of Kymlicka's theory but locates the disadvantaging feature of a minority-culture member's situation in a different place than the ones suggested by Kymlicka.

My argument makes use of two concepts which will need some explanation. The first is the idea of a *viable linguistic community*. Speakers of some language L are part of a viable linguistic community, I shall say, if and only if the population of L-speakers in the community in which those individuals live is sufficiently numerous and concentrated to allow them to engage in the full range of human activities and pursuits in that language. Thus, for instance, in a viable linguistic community, L-speakers would be able to work, practice their religion, participate in political debate and decision-making, form friendships, have a rich family life, and so on, all in their own language. The linguistic community of L-speakers falls below a threshold level of viability when the population of L-speakers becomes too small or too dispersed to allow those individuals to engage in such activities and pursuits in their own language.

The second concept we need is the concept of *linguistic capability*. An individual has a linguistic capability with respect to some language L, I shall say, if and only if she is able to speak L or could learn to do so without excessive cost—where an ability to speak L implies an ability to engage in a range of activities and pursuits such as those mentioned above in the language L. An individual has a linguistic incapability with respect to some language if she is unable to master that language sufficiently to engage in such activities and pursuits or if she could do so only at great expense.

With these two ideas in hand the argument can now proceed quite straightforwardly. The main point can be made by considering a community with two principal cultures, Minority and Majority, each having its own language. For a variety of reasons, let us say, the population of Minority is gradually declining and the population of Majority is growing: this might be because the birth rate in Minority is stagnant and immigrants are choosing to integrate into Majority, or it might be for some other reason. At some point the Minority linguistic community will be in danger of falling below the threshold level of viability: the population will become too small or too dispersed to support a full range of activities and pursuits in Minority language.

Furthermore, and this is the crucial point, it is conceivable, even likely, that some of the remaining members of Minority will be linguistically incapable with respect to the language of Majority: despite the fact that an increasing proportion of the community belong to Majority, they will be unable to master the language of Majority or will be able to do so only at

great personal cost. These people will suffer from a grave disadvantage if their linguistic community becomes unviable. As the community becomes less viable, they become increasingly unable to engage in a range of important human activities and pursuits. To this extent, their freedom in the option-providing sense is clearly diminished and, as I suggested in section 5, this may have further implications for their freedom in the meaning-providing sense. This disadvantage is one which should concern liberal egalitarians. It does not arise merely in virtue of the ambitions or preferences of the individuals concerned, or merely in virtue of the fact that the choices of others make those ambitions difficult to realize. Rather, it arises in virtue of a kind of handicap which individuals in that situation suffer from: they are unable to master the Majority language which is increasingly required to get through life.

I should hasten to add that this argument provides a basis for liberal egalitarian intervention on behalf of some struggling minority cultures; it does not *fully justify* such intervention. A full justification would require an assessment of the costs and burdens that a policy of intervention would place on various people, including both members and nonmembers of the culture in question.[33] These costs might be so high that intervention would create an even greater inequality than the one it is meant to prevent. For instance, if intervention on behalf of the culture involved significant constraints on free speech, then, from a liberal egalitarian perspective, this would almost certainly be too costly. Even if the costs do not seem that high at a given moment, over the long run the accumulated burden may outweigh even fairly significant disadvantages suffered by those who are unable to master the majority language. It remains possible, however, that the burdens imposed by a policy of intervention would not be very costly relative to the disadvantage suffered by those who are unable to master the majority language and thus that intervention could be fully justified.

As it stands, this argument is fairly limited in application since it only applies to minority cultures which are defined in terms of language. Having made the point about language, however, it seems possible to extend the argument to other kinds of minority cultures as well. Cultures can differ not only along linguistic lines but in terms of the basic outlook and conceptual framework of their members. It is not difficult to imagine, for instance, a case in which the member of a minority culture is able to learn the language of the majority but is unable to master the attitudes, conventions, and basic outlook that are required for him to get along in the majority culture—for instance, in the workplace, or in forming personal relationships, or in contributing to political debate. Individuals in this situation might be able to master the vocabulary, grammar, and pronunciation of the majority language but not the thought processes and conceptual orientation which make up the culture for a native speaker.

As in the linguistic case, these individuals would be greatly disadvantaged if their cultural community were to become unviable, and it might well make sense to say that their freedom is at risk. Once again, it would seem, liberal egalitarians have grounds for intervention on behalf of an endangered culture: individuals face loss of their freedom not because of their own choices or ambitions but because they are unable to master the conceptual framework and basic outlook of the majority culture.

Note that this final turn in the argument is not necessarily invulnerable to a suitably formulated analogue of the offensive/expensive-tastes objection invoked in the previous section. It is conceivable that a subculture of people with champagne tastes could find it difficult to master the outlook and thought processes of those in the mainstream of society. But the argument I have been sketching does help us to see one important difference between cultures and subcultures which should minimize the likelihood of this kind of case arising. Members of subcultures typically share a common societal culture with others in the community: they share a language and history, participate in many of the same institutions and practices, have access to the same media and entertainment, and so on.[34] It is thus difficult for them to claim that they are unable to get along in the mainstream culture. It will often be nearer to the truth to say that they choose not to participate in the mainstream culture, or that they disvalue, or even despise, aspects of that mainstream culture. With distinct societal cultures, by contrast—cultures which are more or less institutionally complete—the claim that some individuals are likely to be incapable of integrating into the majority culture becomes much more plausible.[35]

8. Final Thoughts

It turns out, then, that Kymlicka's central claim about minority cultures can be defended: liberal egalitarian principles are under certain conditions reconcilable with a policy of supporting minority cultures. In its present form, Kymlicka's discussion of the connections between freedom, equality, and culture does not generate the conclusion he wants. But an argument from linguistic incapability can do the remaining work that is required. In concluding, however, it is worth pointing out two limitations of this approach to culture, limitations which do not necessarily negate its value but suggest that more work needs to be done.

The first limitation has already been alluded to: because it is important to balance the disadvantages borne by those who cannot integrate into the majority culture against the costs and burdens imposed by interventionist policies, the argument is only likely to go through for a restricted range of cases. In many of the cases where some members of a disintegrating minor-

ity culture are unable to integrate into the majority culture, it would nonetheless be unpalatable to introduce measures aimed at protecting the culture, given the costs and burdens that such a policy would entail for both members and nonmembers of the culture in question. Training and other forms of special support and assistance might be owed to people in this situation but there is no requirement that the state intervene to prevent cultural decline.

The second limitation arises because of the narrowness of the incapability criterion itself. A feature of the argument I have been sketching is that cultural support is only due to people who have attempted *as far as they can* to master the language and outlook of the majority culture. People who refuse to make this effort should be held responsible for their predicament, in which case their incapability is no longer grounds for liberal egalitarian intervention. Now, on its own, this does not represent a serious difficulty for the argument, since the people who are incapable in the relevant sense depend on others (including those who are capable) to make up a viable community. But it does, I think, point to a slightly different intuition that many people are likely to have about minority rights. This is the intuition that, even if everyone in a minority culture could effortlessly assimilate into the majority, there is something legitimate about their desire not to, their desire to preserve their own distinct identity. As Kymlicka puts it, "even where the obstacles to integration are smallest, the desire of national minorities to retain their cultural membership remains very strong."[36] Kymlicka's point, I think, is that, even if members of a costly minority culture are able to assimilate easily into the majority, they should not be faced with the choice of doing so or paying the high cost of remaining within their own culture: they have a legitimate interest in the survival of their own culture which justifies some kind of support or compensation from the rest of the community.

I share Kymlicka's intuition about this point but I do not think that his approach, even on my own version of it, can possibly explain it. So long as the argument hinges on what is chosen and what is unchosen in a person's situation it cannot condone intervention on behalf of a people who could assimilate into the majority culture but would prefer not to. In light of these limitations, I believe that further work needs to be done on the relationship between liberal egalitarian principles and support for culture: it is worth investigating whether there are any other reasons, besides the ones explored in this paper, why liberal egalitarians should abandon their preference for laissez faire and opt for intervention instead.

ALAN PATTEN

McGill University
Montreal

NOTES

*Many thanks to Will Kymlicka for comments on an early draft of this paper and to Jerry Cohen for his comments and for showing me his unpublished paper "Multiculturalism and Expensive Taste." Thanks also to Dario Castiglione, Iain Hampsher-Monk, David Miller, Stuart White, Andrew Williams, and participants in the Nuffield College and University of Exeter Political Theory Workshops for comments and discussion. This paper was completed with the assistance of research grants from FCAR and SSHRC.

1. For good discussions of the Canadian debate see C. Taylor, *Reconciling the Solitudes: Essays on Canadian Federalism and Nationalism* (Kingston, Ontario: McGill-Queen's University Press, 1993), ch. 8, and J. Tully, "The Crisis of Identification: The Case of Canada," *Political Studies* 24, Special Issue (1994): 77–96.

2. See, for instance, David Miller, *On Nationality* (Oxford: Oxford University Press, 1995), p. 88; Joseph Raz and Avishai Margalit, "National Self-Determination" in J. Raz, *Ethics in the Public Domain* (Oxford: Oxford University Press, 1994).

3. See, for instance, the discussion in Allen Buchanan, *Secession: The Morality of Political Divorce from Fort Sumter to Lithuania and Quebec* (Boulder, CO: Westview Press, 1991), pp. 52–64.

4. In this paper, I shall focus on Kymlicka's two most important works on this subject: W. Kymlicka, *Liberalism, Community, and Culture* (Oxford: Oxford University Press, 1989), and W. Kymlicka, *Multicultural Citizenship* (Oxford: Oxford University Press, 1995). Note that I will sometimes use the terms 'minority' and 'national' culture interchangeably even though they are not always synonymous. Whether or not some national culture is a 'minority' depends on the context but the moral issues are often the same, whichever term is used.

5. See C. Kukathas, "Are There Any Cultural Rights?," *Political Theory* 20 (1992), sec. III.

6. Kymlicka, *Liberalism, Community, and Culture*, pp. 153–54.

7. See Kymlicka, *Multicultural Citizenship*, pp. 108–15.

8. See, for instance, Kymlicka, *Liberalism, Community, and Culture*, pp. 138, 150.

9. For the claim that liberal equality requires an extensive set of rights and liberties, see R. Dworkin, "What is Equality? Part III: The Place of Liberty," *Iowa Law Review* 72 (1987): 1–54. For the claim that it requires "equality of resources" and for an exposition of this ideal, see R. Dworkin, "What is Equality? Part II: Equality of Resources," *Philosophy and Public Affairs* 10 (1981): 283–345. For an overview of Dworkin's position, see his "Foundations of Liberal Equality," in Grethe Petersen, ed., *The Tanner Lectures on Human Values*, 11 (Salt Lake City, UT: University of Utah Press, 1990), pp. 36–42.

10. See Dworkin, "What Is Equality? Part II" (cited in n. 9, above).

11. Ibid., pp. 284–90.

12. Ibid., p. 289.

13. Ibid., p. 311.

14. Kymlicka, *Liberalism, Community, and Culture*, p. 162. Note that Kymlicka combines (ii) and (iii) into a single proposition.

15. Kymlicka, *Multicultural Citizenship*, p. 83.

16. Kymlicka, *Liberalism, Community, and Culture*, p. 166.

17. Ibid., p. 165. Emphasis in the original.

18. This paragraph and the three that follow are adapted from my article, "The autonomy argument for liberal nationalism," *Nations and Nationalism* 5, no. 1 (1999): 1–17, at pp. 8–9.

19. Kymlicka, *Liberalism, Community, and Culture*, p. 167.

20. Kymlicka, *Multicultural Citizenship*, p. 105.

21. A similar argument is made by John Tomasi in "Kymlicka, Liberalism, and Respect for Cultural Minorities," *Ethics* 105 (April 1995). A weakness in Tomasi's paper is that it fails to consider other possible construals of Kymlicka's position on the relationship between freedom and culture. In particular, he does not consider what I am calling the option-providing reason or the anomie case of the meaning-providing reason.

22. Kymlicka, *Liberalism, Community, and Culture*, p. 166.

23. Ibid., p. 183.

24. Ibid., p. 183.

25. Ibid., pp. 146–48.

26. Dworkin, "What is Equality? Part I: Equality of Welfare," *Philosophy and Public Affairs* 10, no. 3 (1981): 185–246. For an excellent critical discussion of these objections, see G. A. Cohen, "On the Currency of Egalitarian Justice," *Ethics* 99, no. 4 (1989): 906–44.

27. Dworkin, "What Is Equality? Part I," pp. 189–90.

28. Kymlicka, *Liberalism, Community, and Culture*, pp. 186–87.

29. Ibid., p. 187.

30. Ibid., p. 169.

31. For discussion of this sort of case, see Dworkin, "What Is Equality? Part II," pp. 288–89, and "What Is Equality? Part III," p. 31.

32. This strategy is urged by G. A. Cohen in "Multiculturalism and Expensive Taste" (unpublished).

33. For a good discussion of some of these costs and burdens, see Denise G. Réaume, "The Group Right to Linguistic Security: Whose Right, What Duties?" in J. Baker, ed., *Group Rights* (Toronto: University of Toronto Press, 1994), pp. 127–34.

34. For the concept of a "societal culture," see Kymlicka, *Multicultural Citizenship*, p. 76.

35. Where members of a subculture really are unable to integrate into the mainstream culture, and are disadvantaged by this fact, then it seems to me that liberal egalitarians may have no choice but to recognize that they are eligible for compensation and support.

36. Kymlicka, *Multicultural Citizenship*, pp. 85–86.

10

Does Membership in a Nation as Such Generate Any Special Duties?

FRIDERIK KLAMPFER

1. Introduction

The aim of the paper is to examine the prospects of providing a satisfying moral justification for nationalism. By nationalism I shall mean a deep concern for the existence and flourishing of one's own nation, conjoined with the belief that one may, or even should, give priority to the promotion of others' well-being, or to the satisfaction of others' needs and interests, or to the protection of others' rights (or whatever the principal moral goal may be) over the well-being, needs, interests, rights, of one's conationals over those of others. Call the attitude described in the second part of the clause, national partiality, and the requirement to display it the principle of national partiality (NP). Such an attitude is undeniably and persistently attractive to the masses all over the world. Despite this there seems to be at least a prima facie moral case against it.

In the paper I will assume that the most troubling feature of this form of nationalism is its inadequacy to accommodate the basic requirement of moral egalitarianism or impartialism.[1] According to moral egalitarianism, all persons are morally equal in the sense that whatever moral rights they might have, or whatever treatment or good they might be entitled to, they all have the same rights, or are entitled to the same treatment or (amount of) good. Moral impartialism, on the other hand, claims that one should give, in moral reasoning and action, equal consideration to the interests (good, well-being, happiness, rights, dignity) of everyone[2] affected by his or her action.[3] Though the idea of moral egalitarianism is difficult to spell out[4] and perhaps even more difficult to defend,[5] it is still, in this or some other similar form, central to our understanding of morality and as such not easily dispensable. And since it is not disputed by many of those who defend nationalism as a form of partiality, I'll simply take it for granted that

there is a prima facie moral obligation to treat all humans alike, and that in light of this fact the burden of proof must fall on the shoulders of the defenders of national partiality.[6]

For those not convinced by this brief statement one might want to supply what seems to be another powerful consideration. To accord special normative status to a particular group of people, such as one's own nation and conationals, one might say, is to discriminate in your moral attention (that is, attention to positive rights, interests, well-being, . . .) between persons, and to discriminate on the basis of what is clearly a morally arbitrary—because undeserving—feature. The obvious problem with such an objection to national partiality, of course, is to show, in a convincing manner, that if a person, A, is not morally responsible for being F (that is, cannot be praised or blamed for being F), then her being F cannot serve as a basis for any particular pattern of (re-)distribution of rights and duties (PDRD). Or, in other words, that one cannot possibly take "being or having F" as a reason for denying the bearer of the trait standard treatment or equal attention. The controversial inference is then from premises "having F or lacking F is morally undeserving" and "PDRD follows the pattern of distribution of F in the population" to the conclusion "PDRD is morally arbitrary." The opponent may object that what is really important is whether being F is morally relevant, not whether it is morally deserving. Notice, however, that even if we grant her the last point, this, rather than undermining the strength of a request for a justification of NP, only reformulates it—the proponent of NP has to show that by adjusting her PDRD to the pattern of distribution of F in the population she does not screen off a pattern of distribution of some morally irrelevant feature (personal allegiances and attachments as such will also fall into this category, unless their objects can be shown to owe their special normative status either to some of their morally relevant intrinsic feature or to some morally relevant feature of the relation itself).

One can find, in the literature on patriotism and nationalism, several different statements of what is (more or less) the same perplexing moral issue: (i) Is patriotism/nationalism a virtue or a vice? (MacIntyre) or (i') Is the special (selective) concern for one's country/nation and compatriots/conationals one of those virtues which, though not required, are at least praiseworthy from the point of view of morality? (Primoratz); (ii) Can patriotism/nationalism (as a form of favoratism or partialism) ever be morally justified? (Wolf, Gomberg); (iii) Can there be a form of patriotism/nationalism that is both allowed by universal morality and required by special moralities? (Nathanson); (iv) Is a patriotic/nationalist (partialist) attitude (in moral thinking, feeling, deciding, and acting) morally preferable to the cosmopolitan or is the opposite true? (Nussbaum); (v) Is a patriot/nationalist a morally better person than a nonpatriot/nonna-

tionalist (other things being equal)? (Primoratz); (vi) Can relations of conationality and citizenship justify departures from impartiality, and if yes, how extensive can these be? (McMahan); (vii) Can there be a special duty (obligation, responsibility) to give priority to the needs and interests of one's compatriots/conationals? (Mason, Hurka); (viii) Does every nation as such have at least a prima facie right to a substantial degree of self-government, including the right to its own independent state? (Buchanan). Thus the problem can be formulated either as a question about what is virtuous, or in terms of what is obligatory to some, but not to others, or in terms of what is morally good or preferable or praiseworthy, or in terms of what is morally permissible, or in terms of what one is legitimately entitled to.

In the paper I will consider, and finally respond negatively to, the following question: Does membership in a nation as such, that is, independently from its contribution to other human goods (of the instrumental or contributive value it may have), generate moral reasons for (strong enough to amount to at least a prima facie duty of) partiality towards one's conationals (and hence for discrimination, in one's attention, consideration, feelings, and behavior, against foreigners), which one can arrive at simply by reflecting upon the kind of relation conationality is, that is, simply by thoroughly investigating its nature?[7]

The focus of my attention will thus be on the attempts to ground special obligations to conationals in the very nature or the very character of the relationship of nationality. In other words, I'll be concerned only with the so-called internalist justifications for NP, that is, the attempts to ground one's nation's or conationals' special normative status in some intrinsic feature of the relation of nationality, be that feature normative or not. My aim is to show that the internalist justification for NP is flawed. It is not nationality per se that matters morally; even if eventually we have to concede certain special duties to our conationals, their basis and justification would presumably lay in some feature that does not exclusively and/or nonaccidentally pertain to the relation of nationality.

The internalist strategy admits two basic possibilities which must be carefully explored and assessed: (i) that the relationship of nationality is such as to be deserving of being wanted, cherished, preserved, promoted, . . . for its own sake; and (ii) that the relationship of nationality is by itself, that is, regardless of its potential impact on individuals' well-being, a source of special duties to conationals. I will first briefly consider and reject attempts to derive special duties, owed to all and only members of one's own national group, from universal moral principles or corresponding duties (such as that of gratitude for bestowed goods or benefits or of fairness toward those with whom one interacts in a mutually beneficial way). I will then deal at greater length with the proposal to justify special duties

to conationals by appeal to the intrinsic or final value of nationality. Contrary to such proposals, I will maintain that, as an inquiry into its nature reveals, the relationship of nationality cannot provide grounds for ascribing a noninstrumental (intrinsic or final) value to the membership of such a group. And that, furthermore, even if one would grant that, there are good reasons for believing that such value-ascription would nevertheless fail to ground special duties to a group of people nonaccidentally encompassing all and only one's conationals.[8] I will conclude my paper with some modest suggestions about certain immediate as well as indirect consequences of such principled failure for other possible formulations of the same moral problem. I will contend, rather than convincingly show, (1) that the lack of intrinsic moral significance must also be detrimental to the attempt to show that a nationalist's disposition to a selective moral concern (as well as its manifestations) is a virtuous character trait; as well as to the attempt to prove (2) that such a person is, in virtue of displaying additional concern and love for certain others, superior, from a moral point of view, to those lacking this capacity.

Let me start by introducing some useful distinctions. Let's call a national partialist holding the belief that all people may or should be partial to their own nation and conationals, a universalist national partialist (UNP), and the one claiming that only members of the nation N may or should be partial to their own nation and their conationals, a particularist national partialist (PNP). In the present essay I will consider only the universalist NP and use the expression "national partialist" to refer only to the proponent of that form of NP. Now NP can either claim that one may (occasionally) be partial to his/her fellow nationals or that one *should* (always) be partial to them.[9] Call the first version the permissive NP and the second the demanding NP. Although the main target of my criticism throughout the paper will be the demanding NP, some conclusions drawn will apply to the permissive version of NP as well.[10] Finally, let's say of a duty, that it is universal if it is equally (to the same extent) owed to everyone, and that it is special if it is owed (to the same extent) only to some (an individual or a group of people), but not to all.

1.1. Desiderata

Before turning to my discussion of different proposals for an internalist justification of NP, let me first formulate what I take to be three relatively uncontroversial general requirements that every plausible justificatory account of NP should meet. First, the relation "membership in a nation" which is supposed to generate moral reasons for nationalist partiality must be an objective feature of the world and in principle recognizable from any,

not just the agent's own, point of view.[11] Call this the objectivity requirement. Secondly, if such a relation is to provide grounds for duties of loyalty and partialist or selective moral concern for one's conationals, it should be morally valuable or otherwise significant in itself, not just derivatively. Call this the intrinsic-significance requirement. And thirdly, whatever the account of the source of value or intrinsic moral significance of nationality that one may finally come up with, this account must be capable of grounding special duties of partiality to all and only one's conationals rather than just permissions thereof, or duties with respect to something, or duties to a group of people which only partly and/or contingently coincides with the class of *all and only* one's conationals.[12] Call this the precise-scope-and-strength requirement. In what follows I will try to show, with respect to what I take to be the most plausible account of nationality, that it cannot accommodate all three requirements.

Before proceeding let me, however, briefly defend the above mentioned requirements against the charge that they are (a) arbitrary and/or (b) too demanding. We can quell both concerns by pointing to a rationale that internally links those requirements. Here is just a provisional sketch of such a rationale: special obligations impose burdens on those who must discharge them, and at the same time deprive the nonclaimants of some of the goods and services which they seem, as humans or simply as moral agents, prima facie entitled to.[13] Such a redistribution of rights and duties is most often nonconsensual. Moreover, since it usually follows a pattern of distribution of some contingent social or biological trait in the population (parents' origin, mother tongue, birthplace, . . .), being deprived of certain goods for that very reason looks, at least at first glance, morally undeserving and thus unfair. The strength and the scope of special moral obligations must therefore be backed up by weighty and relevant moral considerations. It is difficult to see how a false belief about membership of some group of people in virtue of sharing certain properties N_1, N_2, N_3, . . . with them, even though it may occasionally create strong morally acclaimed feelings, can carry this burden, especially for those who (by rejecting the ascription of those properties to themselves or to others), themselves refuse to take part in such a self-deceptive enterprise. Imaginary relations cannot possibly ground special moral obligations between their relata, or at least they cannot do that for or against outsiders, that is, non-believers—whereas what a typical nationalist would want is moral grounding for ascribing mutual obligations to all those who allegedly share the properties N_1, N_2, N_3, . . . , not just to those who happen to believe they do. The same reasoning applies in the case of the other two requirements: nothing less than something of considerable and enduring moral significance or value can justify significant alterations in the patterns of rights and duties; and the justificatory goal cannot be considered accomplished unless

the scope of such special duties coincides, in a nonaccidental and noncontingent way, with the group of moral agents encompassing all and only one's conationals. Hence, there is a natural link from the requirement of objectivity (grounds of a legitimate claim will have to be objective rather than subjective) via the requirement of intrinsic significance (these objective grounds must be somehow morally significant in themselves) to the requirement of scope and strength (only morally significant objective features of national belonging can actually ground special duties to *all and only* one's conationals).

2. Internalist Moral Justifications for NP

Bearing in mind the above three requirements, we can now make a provisional list of possible internalist justifications available to the nationalist partialist (NP) and assess their initial plausibility. I will concentrate upon two proposals: (1) the so-called universalist justification and (2) the attempts to justify special duties to conationals by appeal to the alleged intrinsic value of the relation of nationality.

2.1. Universalist Justifications for NP

Reasons for partiality to one's conationals, just as for any other form of partiality (to one's own children, parents, friends, partner), may be of either a nonmoral or moral kind. I will consider only moral reasons for partiality, thereby leaving out the possibility that there might be nonmoral reasons for partiality which (occasionally, at least) can override moral reasons for impartiality.[14] Moral justification for partiality can take different forms. A duty to nationalist partiality can be, for example, derived from some more general moral principle. Moral reasons that such principles generate can be of the consequentialist, axiological, or deontological kind. If, for example, nationalist partiality (or a general disposition for it) could be shown to have consequences that are good (or, in a maximalist form of consequentialism, better than the consequences of not having and displaying such a disposition) from an impartial point of view, then everyone would have not just a good moral reason, but also an (at least prima facie) obligation of the consequentialist kind for favoring his/her own conationals over others. The same universalist form of demanding NP could be supported by moral reasons of a deontological kind as well. If membership of a nation were beneficial to every single member (if it provided him/her with goods, such as cultural and artistic achievements, a sense of belonging, security, strength, and stability, a mode of self-transcendence and a focus for collective iden-

tification strongly motivating beneficial co-operation and commendatory self-sacrifice, and so on), then the principles of gratitude and fairness would apply which, besides recommending her to feel grateful for bestowed goods, would also dictate her to benefit others in return and to take upon herself the due share of burdens in mutually advantageous cooperation.[15]

Now, whether there really are any such general consequentialist and deontological reasons for partiality is clearly an empirical question and one we cannot decide before carefully examining the (comparative) effects on the individuals' well-being of people living together in political communities, founded on the principle of nationality, and interacting in certain ways rather than in others.[16] The attempt to derive moral reasons for nationalist partiality from more general and less controversial moral principles, however, runs the following risk. One possible objection (raised by several critics) is that one owes, according to justifications for partiality in purely universalist terms, a duty of partiality (or selective concern) to her conationals not in virtue of their being her conationals (that is, in virtue of standing in certain relation to, or of sharing common history of interaction with them), but in virtue of their being her benefactors (or her being their beneficiary).[17] It is only thanks to the contingent fact that one's benefactors are at the same time one's conationals that one has special duties to them. Such a justificatory account of special duties to conationals thus fails to capture what seems to be "essential and eliminable" (MacIntyre) to nationalism, namely the idea that one owes special duties of loyalty and selective concern to her conationals (or to a nation)[18] simply in virtue of being related in a certain way (as a conational) to them, simply in virtue of her membership of a nation. In other words, that being related in that way to them, sharing a particular history of association and interaction with them, makes them somehow special for her, distinct from others who do not stand in the same relation of conationality to her.[19] Or, as MacIntyre (1984) aptly puts it, whatever merits and achievements of one's nation are taken as a grounds for one's loyalty to and concern for its cause, them being merits and achievements only partially explains and justifies nationalist's attitudes to his nation—what matters equally, if not more, and what makes the object of his love and concern so special is the fact that they are the merits and achievements of *his* nation.[20]

The defect of universalist justifications for NP is thus twofold: they cannot account for the fact that for a typical nationalist it is his nation as such, rather than (as) a community of benefactors and beneficiaries, or a community of people pursuing the same conception of the common good, which is the primary object of love and concern. And they are incapable of proving why, as nationalists firmly believe, we should take the relation of nationality, rather than any other morally significant relation, which the

former only contingently exemplifies or instantiates (such as the relation between a beneficiary and a benefactor), as determinative of the scope of special moral obligations. Insofar as one's conationals enjoy their special moral status (as beneficiaries of one's duties) only in virtue of being her benefactors, they must be indistinguishable, from a moral point of view, from other benefactors who are not her conationals; but since the former are morally indistinguishable from the latter, they must, accordingly, also be treated alike.

2.2. The Intrinsic-Value Argument for NP

Let me now turn to the so-called "intrinsic-value argument."[21] According to this argument, certain relations to others, such as friendship, partnership, family, citizenship, are constitutive of human good or indispensable to human flourishing; cultivating and fostering these relationships (or the character traits and dispositions which are conducive to them) is thus a necessary condition for living a good human life; and membership of a nation is one of those relations.[22]

The intrinsic-value argument for nationalist partiality displays the following general structure: The relation of nationality is an intrinsic good; therefore everyone has a prima facie moral reason (a prima facie duty) to promote and cultivate it; the (obligation of a) partialist concern for one's conationals is partly constitutive of the relation of nationality (or, in an slightly different version of the same argument: is partly constitutive of its goodness);[23] thus everyone has a moral obligation to show partialist concern for his or her conationals.

How can an appeal to the intrinsic value of a relation support the claim that standing in such a relation to a person B is a sufficient condition for having special obligations or responsibilities towards B to take care of her needs and interests? We can illustrate this by way of a favorite partialist example, that of close or intimate relationships. Take Joseph Raz's analysis of friendship: (1) friendship is an intrinsically valuable relationship (it is properly valued, cherished, promoted, . . . for its own sake); (2) part of what it is for two people to be friends is for each to be under certain obligations to the other, and these obligations are justified by the moral good of friendship; (3) these special obligations are internally related to the good of friendship, that is, they are part of that good.

Let's expand a bit on these claims. Friendship is morally valuable for its own sake because it involves the expression of mutual concern, allots a central role to altruistic emotions such as sympathy and compassion, and increases willingness to give oneself to another. Part of what it is for two people to be friends is to be under a moral obligation (other things being

equal) not to betray each other's confidences or to use those confidences manipulatively, and to have responsibilities toward each other to provide comfort and support when needed. The obligations of friendship are internally related to the good which justifies them; they are partially constitutive of the moral good of friendship, because they are partially constitutive of friendship. Or for those who, like me, are not particularly convinced by the last inference (since not everything that is constitutive of something good need also be constitutive of that thing's goodness), the following may look like a more promising attempt: part of what is morally good about friendship is either that friends have certain obligations to each other or that these obligations are occasionally discharged, where either the former or the latter is partially constitutive of friendship.[24]

The intrinsic value argument for nationalist partiality along these lines (there are other, more naive versions, which fail to accommodate Hurka's[25] concern about the validity of inferences from claims about what people's good consists in, to the conclusions that we ought to care more about some people's good than about others') is open to several objections. Let me briefly mention only a few of the moves which effectively block the inference from the statement of some relationship's alleged goodness to the existence of special duties between its relata.

(i) nationality is not an intrinsic good; being an exemplary Slovene (loyal to the Slovene cause, contributive to the national culture, either in one's role as a consumer or in one's role as a producer, giving priority, in the promotion of others' well-being, to the well-being of Slovenes over that of others, . . .) or Scottish or French Canadian is not a necessary condition for living a morally good life; in this respect, being a member of a nation is unlike being a partner or a friend or a family member; therefore, there can be no obligation to cultivate and foster one's own national culture;

(ii) nationality is an intrinsic good (that is, is a necessary component of a morally good life), but since it is only one among many intrinsic goods and we are not in any privileged position with regard to its preservation and flourishing,[26] we can have no strict obligation to cultivate or foster this rather than some other intrinsically good thing;

(iii) though nationality is an intrinsic good, the obligation to show a partialist concern for one's conationals is neither constitutive of nationality itself, nor is its fulfillment constitutive of the good of nationality.

Let me begin with the last point. There are good reasons for doubt-
ing the very adequacy of an account of nationality in terms of constitutive
special duties to conationals. Mason (1998) provides, apart from an anal-
ogy with friendship (which, on its own, is not much more plausible either)
no compelling reasons for such a move and I doubt that there are any.[27]
Why should one assume that partiality itself, let alone the duties thereof,
is *constitutive* of nationality? Such an assumption is controversial enough
even in the case of friendship that Mason employs as a model for citizen-
ship/nationality. It is not providing assistance to a friend in need (rather
than to someone else in need) out of a sense of duty to her which is con-
stitutive of friendship, but rather the very same kind of act (and a dispo-
sition for it) out of love, inclination, and altruistic concern for her. Acting
out of the sense of duty toward a friend can only be, as noticed by many
authors, disruptive of the relation of friendship. It is not the fulfillment of
special duties of partiality to a friend which makes (among other things)
friendship intrinsically good, but rather the opposite—being a friend
entails, among other things, being specially sensitive or responsive to your
friend's needs, and we owe special duties of partiality to our friends only
insofar as we have a duty to form and sustain intrinsically valuable rela-
tions (of which friendship is one of the most paradigmatic).

There is a more general point I'd like to make here. Different intrinsi-
cally valuable relations may have different bases of intrinsic goodness (that
is, be good in virtue of different good-making properties). That's why
there is not much prospect of identifying a single common basis of the
intrinsic goodness of all special relations. The same will probably be true of
the attempts to provide one single, unifying justification for partiality
towards all those standing in special relations to oneself. These relations are
simply too diverse in their nature to allow for such a unitary account—they
display considerable differences in the degree of intimacy, closeness, inten-
sity of emotional involvement, typical feelings displayed, types of interac-
tion and their purpose, and the like. Hence, one cannot draw any direct
conclusions about the permissibility or even obligatoriness of patriotic or
nationalist partiality on the basis of, say, insights about the nature and/or
value of parenthood or friendship. Each kind of relation asks for a specific
justificatory account of partiality within the constraints outlined by the
three requirements mentioned above. Some such accounts will be, in
virtue of the respective relations sharing more or less the same basis of
intrinsic value, practically exchangeable, others with a more specific basis of
intrinsic value won't, while still others will turn out to lack any basis of
intrinsic value altogether. For example, partnership and friendship which
share roughly the same ground for intrinsic value (common history, close
emotional ties, benevolence, altruistic motives, love for the other for cer-
tain valued character traits of his/her, . . .), will allow for roughly the same

justification for partiality, whereas friendship and nationality which display few, if any, common characteristics will require quite different justifications for it.

What about the prospects for finding, in the very nature of the relation of nationality, some basis for the ascription of intrinsic value? I believe that, in contrast to the relation of citizenship, the justification of special duties of partiality to conationals by appeal to the intrinsic value of nationality cannot even take off the ground. Here are some reasons for my pessimism. Nationality is, simply enough, membership of a nation. According to a minimalist definition of the nation, offered by Hobsbawm and endorsed by many others, including Buchanan (1996), Lichtenberg (1997), McMahan (1997), Miller (1992 and 1995), Nathanson (1997), and Wellman (2000), a nation is any sufficiently large body of people whose members regard themselves as belonging, by virtue of possessing certain objective characteristics (other than just the belief about the belonging itself), to a 'nation'. Membership in a nation (nationality) is thus essentially a matter of sharing certain beliefs (about common ancestry, history, culture, language, origin, character traits, as well as their respective value) and feelings (of love and concern for and loyalty to the nation, of attachment to a particular territory, "the homeland," and so on) with enough others.

The fact that what is alone constitutive of a nation is some subjective (certain beliefs held by its members about themselves and others) rather than objective (that is, belief-independent) feature of its members (same language, same ancestors, or same commonly admired character traits—since none of these seems to be necessary for membership in a nation), makes it extremely difficult to build a plausible defense of NP upon the assumption that the relationship in question is intrinsically valuable or significant. Firstly, it is highly implausible to claim any intrinsic value for membership constituted by shared (factual and evaluative) beliefs and feelings of its members alone. For if rather than being good in itself, these beliefs and feelings are only good insofar as they are true or appropriate, nationality cannot possibly be intrinsically valuable ("being true or appropriate" cannot, according to a classical idea, be an intrinsic property of beliefs and feelings, since the belief's being true or the feeling's being appropriate is not independent of the existence of any other thing).[28]

Secondly, even if those beliefs themselves were true (which most of them aren't), this could hardly amount to a value great enough to justify partiality if one takes seriously into account the intuitive appeal of the so-called voluntarist and distributive objection (for the formulations of those see Scheffler [1997]). Knowledge may have been more appropriate for this role, yet nationalists, even when their beliefs are true, are seldom justified in holding them. And even if loving what is in itself good is itself good, what nationalists love typically is something other than just a group of

people sharing (or having shared) certain beliefs and feelings. Thirdly, even if there were any intrinsic value to the membership of a nation, defined in minimalist terms, it could at best provide grounds for reciprocal duties between people sharing those beliefs and feelings, rather than to everyone whom the nationalist would typically want to ascribe such duties to.

One may want to object to the above line of reasoning by pointing out that we can get quite a different result by simply replacing a minimalist definition of a nation by a somewhat richer account. Sharing certain beliefs and feelings with enough other people may be necessary for the formation of a nation, but it is certainly far from being the whole story. True, one might concede, some form of nationalist consciousness or sentiment, perhaps even a certain degree of self-deception, is needed for self-representation that is constitutive of a nation. People have to regard themselves as well as certain others to belong, in virtue of possessing certain common traits, to the same group of people ("nation"), and very often a whole national community mythically represents itself as sharing the same ancestry, as originating from the same ethnic core. But nations are much more than just communities of (false) belief. They are, as Margalit and Raz (1990) put it, "encompassing cultural groups," groups whose culture pervades the whole range of an individual's major life activities and functions as an important source of self-identification. Nations transmit values and meanings, they supply "the context of choice" necessary for the exercise of our capacities for autonomy and moral agency. Nations provide "a coherent, transparent, and intelligible environment in which people can become self-determining," "familiar, understandable and thus predictable cultural environment which is a necessary precondition for rational choice." (Tamir [1993]; 84). And, last but not least, think about all those goods that are either somehow internal to the relation of nationality (such as cultural and artistic achievements, sense of belonging, stability and security, mode of self-transcendence), or to which nationalist sentiments and attachments seem particularly conducive (such as willingness to self-sacrifice and beneficience, a feeling of equal worth as a basis for self-respect and pride, . . .). Surely all these must amount to at least some intrinsic or final value, surely it must make the relation of nationality worthy of love and concern in itself and for its own sake, irrespective of whether its cognitive grounds happen to be epistemologically sound or not.

Miller (1995) strengthens this point by way of analogy with family life. Surely a life of a family can be intrinsically valuable (and thus a source of prima facie moral reasons/duties), even though (some of) its members mistakenly believe that they are genetically related when in fact they are not. So why should we then take the falsehood of some constitutive beliefs as a reason against ascribing intrinsic or final value to the relation of nationality? There are several things wrong with this line of reasoning. First,

notice that the (false) belief in genetic relatedness of the members of the family is clearly dispensable in the constitution of a family, whereas (false) beliefs about the existence of objective and valuable common traits in the case of a nation are not. Furthermore, it is doubtful to suppose, as Miller did, that it is biological ties between parents and children as such which *alone* ground the duties of parents to their children, rather than different kinds of acts which count as taking over the responsibility for a child (where these may include, among others, bringing the child into existence—conceiving, giving birth to—or a conscious decision to take care of the needs of an already born child or infant). Adoptive parents can certainly assume the same kinds of obligations, both in their source and strength, toward the adopted child as biological parents are supposed to have to their offspring—even more so because we still lack an account of parental duties and since nothing in Miller's description of the case rules out the possibility that parental duties, in the given example, may be derivative of other, more general moral duties, such as the duty of beneficence or of nonmaleficence. I am not maintaining that the falsehood of a belief constitutive of some relation, automatically devalues it. My point is rather that, since neither the content nor the existence of such constitutive beliefs can account for the alleged value of the relation in question, the source of its value must lie in the content of family life, that is, in the kind of interactions and affiliations that these beliefs give rise to. What I am asserting is thus the truth of a conditional: provided the given relation is, in virtue of its intrinsic nature, valuable, then the fact that it is based on a false belief, won't make much moral difference. In the case of a nation, however, it is exactly the truth of the antecedent which is highly controversial.

Let me now turn to the previous argument. The problem with that argument is that it doesn't really support the conclusion in favor of the NP. First of all, nothing in what is said above suggests that the public culture which does all these wonderful things for each individual is or must be national. True, values and meanings embedded in customs and traditions which help to shape our views on and our understanding of the world are transmitted, among others, through language and languages are, at least for the most part, nation-specific, but this, besides being a rather trivial point, only amounts to showing that national belonging is instrumentally rather than intrinsically valuable. Furthermore, as many authors have convincingly shown,[29] nationality is only one of many possible sources of self-identification, more important for some people and/or at some point in their lives, but less important for other people and/or at another point in their lives. It is not pretentious to assume that one could make a similar point about every single function that nations are supposed to perform. No reason has been given so far for believing that for each single individual there is exactly one, and no more than one, *national* culture which

provides all these services. But if nations are neither alone nor uniquely effective in doing this important job, then it is far from clear how the above reasoning, even if it would make a prima facie case for special obligations to some selected group of people, could guarantee the right scope of those special obligations. It is rather improbable to expect that all these distinct sources of self-identification, meaning, and values, turn out to pertain to one and the same national culture. But unless this is so, what reason could there be for singling out, morally, one's nation and its members and for according it the privileged normative status that it enjoys in a nationalist mind?

3. Conclusion

In this essay I have tried to build a case against the so-called internalist justifications for nationalist partiality. According to them, the relation of nationality (of membership in a nation) is by itself a sufficient ground for certain special obligations to one's conationals. Contrary to that, I maintained that what ultimately matters, morally, is and cannot be nationality per se, but at best some other feature that is only contingently and imperfectly associated with shared nationality. Since this feature may sometimes be found among foreigners as well, we may and do have duties toward those foreigners which are similar in form, basis, and perhaps even strength to those we ordinarily acknowledge toward our fellow conationals. My rebuttal proceeded along two lines of argumentation. The first one was to show the principled inadequacy of certain internalist justifications, cast in universalist terms. These turned out, on inspection, to be incapable of grounding special obligations to all and only one's conationals, rather than to a group of people who happen to be, at the same time, one's conationals. The second line of argumentation was directed against the attempts to justify special obligations to conationals by appeal to the alleged intrinsic value or significance of the relation of nationality. Against these I contended that nationality, if we take a minimalist account of it, cannot provide the basis for any intrinsic or final value or significance, and that, as soon as a somewhat richer, more objectivistic account of what it means to be member of a nation, is supplied for it one can hardly avoid losing the required scope of corresponding special duties.

Suppose I have shown that the features of nationality in virtue of which certain general moral principles apply, thereby generating special obligations to conationals, are neither essential nor unique to nationality, and that nationality is not valuable in itself, that it is not something worth wanting or pursuing or cultivating or fostering for its own sake. Did I thereby prove that nationality does not and cannot by itself generate any

special duties to conationals? Certainly not. There may be other possible internalist justifications for NP that I simply overlooked. Furthermore, I am well aware of the limited scope of my rebuttal of the intrinsic value argument for NP. Intrinsic value is not the only possible ground for non-derivative (special) duties. To show that something is not intrinsically valuable does not amount to showing that it cannot be an actual or possible source of nonderivative duties. The same conclusion applies to the reverse order of justification: we cannot, by showing that something does not by itself generate duties (of preservation, fostering, . . .), prove that it is not intrinsically or finally valuable, since one can plausibly question the validity of the principle that we are obliged to preserve and promote everything that is of intrinsic or final value.[30] Finally, the warnings of some authors that one should not blur subtle distinctions between intrinsic value, final value, nonderivative value, essential value, and unconditional value, or make oneself guilty of direct inferences from claims about what is valuable in virtue of having some intrinsic property to the claims about the goodness of its existence or of its having this property are yet another reason for caution. I might have proved that nationality is not valuable in itself or that it does not need to be valued for its own sake, but this still leaves open the possibility that it might nevertheless be a good thing to enjoy something like membership in a nation.

Despite all these reservations, however, the prospects for a plausible internalist justification for NP seem much slimmer once we realized how fundamentally flawed the two most prominent attempts of this kind are. Furthermore, if we have supplied pretty good reasons for believing that the relation of nationality is of no intrinsic moral significance, then this can hardly leave the way we deal with other questions about nationalism unaffected. The consideration "She is Slovene (or Scottish or French Canadian)" will no longer count as a valid moral reason for discriminating among the possible objects of one's concern and assistance. This, on the other hand, must determine at least the answers we give to the questions (i), (iv), and (v)—showing greater concern for the well-being of one's conationals *because they are one's conationals* would mean being selective *for the wrong reason*,[31] allowing your moral judgment to be influenced by what is a morally irrelevant consideration. Thus it seems that a disposition for national partiality, since a disposition for discriminative behavior, motivated by false reasoning, cannot be said to be a virtuous or morally preferable character trait after all.

FRIDERIK KLAMPFER

University of Maribor

NOTES

1. The requirement of impartialism that I have in mind corresponds to what McMahan, following Hill, calls "substantive" as opposed to "formal" impartiality. Or, to borrow the illuminating formulation of M. Friedman, it is not impartiality as a privileged standpoint for critical (unbiased) moral thinking, but rather impartiality as a specific moral duty (for example, of those who fill the public role of dispensing goods among competing applicants to favor certain others—their compatriots or conationals—in care, assistance, attentiveness, and loyalty). As many authors did not fail to notice, impartiality in the latter sense may well be permitted or even called for by impartiality in the former sense (i.e., on unbiased critical moral reflection). For more details on the distinction see McMahan (1997, 116–17), and Friedman (1989, 646).

2. That is, in the case of long-term effects of our actions, even of those presently nonexistent, as rightly pointed out by Gutmann (1996, 69): "Our primary allegiance is to no community, whether it be of human beings in our world today or our society today. Our primary moral allegiance is to justice—to doing what is right. Doing what is right cannot be reduced to loyalty to, or identification with, any existing group of human beings. Morality extends even beyond the current generation, for example, requiring that we consider the well-being of future generations."

3. We might call the first the principle of moral equality and the second the principle of equal consideration. Now I am certainly not claiming that the two are equivalent or that the former entails the latter (except in some accommodated form which, however, begs the question against national partialism). Many different considerations might block this inference: one could, for example, argue that only those (physically) close to the agent can be affected by his actions; or that rights only generate negative universal duties, whereas positive duties, on the other hand, are generated by the duty of benevolence and as such, since there can be no unlimited benevolence, are necessarily limited in scope; or that one does not fail to show due respect to the dignity of another person by giving priority to someone else's interests over his; or that the duty of benevolence is an imperfect duty allowing us to choose how and against whom we will discharge it. But since I am not claiming that any form of partiality as such is irreconcilable with a moral point of view, but only that, given the intuitive appeal of the principle of moral equality, there must always be good moral reasons for a departure from impartiality, acknowledging some pull towards the principle of equal consideration might just be enough for my purposes.

4. See Williams (1973) for a formulation of the two horns of dilemma that a moral egalitarian cannot escape.

5. See Pojman (1992) for a penetrating criticism of it.

6. For the view that national partiality (more exactly, the singling out of the nations, among many possible sources and objects of personal identifications, allegiances, and attachments, as single bearers of the right to self-determination, thereby according them special normative status) violates the principle of equal respect for persons, see Brighouse (1996) and Buchanan (1996). For a defense of the opposite claim, namely that equal consideration, required by the moral point

of view, is to be paid to everyone's *rights* rather than interests and that caring about some people's interests more than others' may be perfectly compatible with according everyone equal rights and thereby showing equal respect, see Velleman (1999).

7. I have decided to state the moral issue of nationalism in terms of the forms (vi) and (vii) respectively, because these two versions most accurately represent what is the minimal core of any genuine nationalist standpoint.

8. My strategy thus resembles Buchanan's in (1996). I try to show that nations' special normative status, even if they have one, can neither be derived from an account of what it is to form a nation nor does it follow from a reflection upon what it means to be member of such a group.

9. Or in terms of a selective concern for the well-being of others:"You may show greater concern for the well-being of your conationals" and "You have a duty towards your conationals to show greater concern (to care more) for their well-being than for that of others."

10. Cf. R.W. Miller (1998) for an illustration of how easy and natural the step from a permissive to a demanding version may be.

11. In this I follow McMahan (1997).

12. Buchanan (1996) tries to show that some of the most popular liberal solutions, such as those by Kymlicka and Margalit and Raz, violate the second constraint.

13. Scheffler (1997) uses the names "voluntarist" and "distributive" objection to refer to these two considerations and concedes that together they make quite a strong case against any form of partialism.

14. This nonstandard view is defended by S. Wolf in Wolf (1992).

15. A general consequentialist (instrumental) justification for partiality is presented in Goodin (1995). It is criticized as basically unsatisfying by Gomberg (1990), Mason (1997), and McMahan (1997). A deontological justification for partiality along those lines is defended by Gewirth, Dagger, and McMahan (1997) as well as (probably) Hurka (1997). In contrast to them, Miller (1992) provides a moral justification for NP in terms of a moral ideal of a community of people determining its own future which nationality and citizenship are supposed to be the necessary conditions for. A. Gutmann (1996, 71) proposes a justification for NP which comprises both deontological and consequentialist elements: "Our obligations as democratic citizens go beyond our duties as politically unorganized individuals, because our capacity to act effectively to further justice increases when we are empowered as citizens, and so therefore does our responsibility to act to further justice. Democratic citizens have institutional means at their disposal that solitary individuals, or citizens of the world only, do not."

16. Some of the universalist justifications for partiality, however, are clearly more suitable for patriotic than for nationalist partiality. This much at least is true of some attempts (most recently by Velleman [1999] and R. Miller [1998]) to show that the undisputed principle of moral equality or equal respect for all is not only compatible with, but actually demands a strongly biased duty of special concern for a limited group of people in matters such as tax-financed aid. A brief explanation, however, shows why such a strategy is in principle unavailable to proponents of nationalist partiality. Everyone has a special interest in leading a

social life based on mutual respect and trust and hence feels committed to providing adequate incentives for compatriots to conform to the shared institutions that one helps to impose on them, or to obey the laws one helps to create. This basic social trust and mutual respect might be seriously at risk, however, if the failure to provide, for example, tax-financed aid sufficient to relieve serious burdens of inferior life-prospects among compatriots were due to the provision for neediness abroad. Now, even though nationalist sentiments may be conducive to establishing and preserving basic social trust and respect among the many citizens of a country, there is certainly no particular need for the latter and hence no essential role for the former to play in the promotion and preservation of nations.

17. Or, in the case of consequentialist justification, in virtue of his/her partial concern being producive of (more) good (than his/her impartial attitude).

18. As McMahan (1997, 130) would like to have it: "One has duties of gratitude to the nation . . . duties involving partiality among conationals that derive from this source are not ones that people owe directly to one another, . . . (they) are, in the first instance, owed to the nation itself."

19. Cf. MacIntyre (1984) for a similar point.

20. Let me briefly mention that the consequentialist version of a justification of partiality in general terms is facing, besides the one above, its own peculiar difficulties. The most troubling among them is that instrumentally valuable partialist attitudes and behaviors (i.e., those producive of [more] good), while they can give rise to certain duties, can neither give rise *to* duties to one's conationals rather than *with respect to them* (or with respect to the valuable relationship of membership itself), nor generate special duties to *one's own* conationals rather than to *other people's* (since all the consequentialist principle requires is the promotion of that good which one can best promote and one might not always be in a position to promote the good of his conationality better than that of others).

21. I borrow the label from Lichtenberg (1997). A belief that one's nation or one's membership therein is intrinsically valuable or otherwise significant forms a necessary component of any genuine nationalist standpoint. The same is true of a belief that it is in virtue of one's membership of a nation that one acquires special duties either towards one's conationals or with respect to (the preservation and the promotion of) that good. A person simply would not qualify as a nationalist if her concern for the institutions and traditions of her own nation were motivated by, say, a belief in a universal duty to preserve equally valuable traditions of all nationalities, as well as a belief that this duty is best served if everyone gives priority, in caring, to her own traditions. Such a grounding of a right, or even a duty, to nationalist commitments is simply too contingent on the efficacy, in discharging this universal duty, of the described division of moral labor. More on this point Gomberg (1990).

22. As McMahan (1997) says, certain relations (the example he gives is a loving relationship) are not just essential to the good life but are also partly constitutive of the moral life: "Morality urges us to foster loving relations and to care specially for those we love not just because this is good both for us and them, making our lives richer and deeper, but because this is the right way to live."

23. See Mason (1997).

24. Mason (1997, 440) is not perflectly clear on that, though he seems to pre-

fer the second interpretation: "the good of friendship includes the fulfillment of obligations."

25. Hurka (1997, 148).

26. MacIntyre (1984), despite appearances, does not set to prove the opposite. His claim is merely that only Slovenes can display the kind of loyalty to a Slovene cause that is determinative of Slovene *nationalism*.

27. The same complaint can be applied to Yael Tamir's account of a nation in terms of mutually acknowledged special rights and duties of its members. See Tamir (1993, 67ff.).

28. One can get to such a conclusion in two rather simple steps. First, according to Moore's classical formulation, a kind of value is intrinsic, "if the question whether a thing possesses it, and in what degree it possesses it, depends solely on the intrinsic nature of the thing in question," that is, on one of its intrinsic properties (Moore 1993, 286). And controversies about the proper account of intrinsic properties aside, we can say that a property is intrinsic just in case a thing's having it (at a time) depends only on what that thing is like (at that time), and not on what any wholly distinct contingent object (or wholly distinct time) is like. For further details see Vallentyne (1997, 209).

29. Buchanan (1998) and Miscevic (2000) among others.

30. Some authors, Rabinowicz and Ronnow-Rasmussen (2000), for example, insist that a particular value may call for different types of response: some values are such that the best response is to exemplify or instantiate them, others call for producing as much of them as possible, and still others call for honoring them by refraining from doing what would violate them. Thus it is not true that the only response fitted to a valuable object is promoting and/or preferring it.

31. For a more detailed defense of this claim see Primoratz (in the present volume).

REFERENCES

Avineri, S., and A. De-Shalit, eds.1992. *Communitarianism and Individualism*. Oxford: Oxford University Press.

Buchanan, A. 1996. "What's So Special about Nations?" In:Couture, Nielsen, and Seymour (1996), 283–309.

Brighouse, H. 1996. "Against Nationalism." In Couture, Nielsen, and Seymour (1996), 365–406.

Cohen, J., ed. 1996. *For Love of Country: Debating the Limits of Patriotism*. Boston: Beacon Press.

Couture, J., K. Nielsen, and M. Seymour, eds. 1996. *Rethinking Nationalism*. Calgary, Alberta: University of Calgary Press.

Friedman, M. 1989. "The Impracticality of Impartiality." *Journal of Philosophy*: 645–56

Gomberg, P. 1990. "Patriotism Is Like Racism." *Ethics* 101 (1990): 144-50.

Goodin, R.E. 1995."What Is So Special about Our Fellow Countrymen?" *Ethics* 98 (1988): 663–86. Reprinted in R. E. Goodin, *Utilitarianism as a Public Philosophy*, Cambridge: Cambridge University Press, 1995, 265–87.

Gutmann, A. 1996. "Democratic Citizenship." In Cohen (1996), 66–71.

Hurka, T. 1997. "The Justification of National Partiality." In McKim and McMahan (1997), 139–57.

Lichtenberg, J. 1997. "Nationalism, For and (Mainly) Against." In McKim and McMahan (1997), 158–75.

MacIntyre, A. 1984. "Is Patriotism a Virtue?" Lindley Lecture, Lawrence: University of Kansas Philosophy Department.

Mason, A. 1997. "Special Obligations to Compatriots." *Ethics* 107, no. 3: 427–47.

McKim, R., and J. McMahan, eds. 1997. *The Morality of Nationalism.* New York and Oxford: Oxford University Press.

McMahan, J. 1997. "The Limits of National Partiality." In McKim and McMahan (1997), 107–38.

Miller, D. 1992. "Community and Citizenship." In Avineri and De-Shalit (1992), 85–100.

———. 1995. *On Nationality.* Oxford: University of Oxford Press.

Miller, R.W. 1998. "Cosmopolitan Respect and Patriotic Concern." *Philosophy and Public Affairs* 27, no. 3 (Summer 1998): 202–24.

Miscevic, N. 2000. "Introduction: The (Im-)morality of Nationalism." In the present volume.

Moore, M. 1999. "Nationalist Arguments, ambivalent conclusions." *The Monist* 82, no. 3: 469–90; reprinted in the present volume.

Nathanson, S. 1993. Patriotism, Morality, and Peace. Lanham: Rowman and Littlefield.

———. 1997. "Nationalism and the Limits of Global Humanism." In McKim and McMahan (1997), 176–87.

Nussbaum, M. 1996. "Patriotism and Cosmopolitanism." In Cohen (1996), 2–17.

Pojman, L. P. 1992. "Are Human Rights Based on Equal Human Worth?" *Philosophy and Phenomenological Research* 52, no. 3.

Primoratz, I. 2000. "Patriotism: Morally Allowed, Required, or Valuable?" In the present volume.

Rabinowicz, W., and T. Ronnow-Rasmussen. 2000. "A Distinction in Value: Intrinsic and for Its Own Sake." Forthcoming.

Scheffler, S. 1997. "Relationships and Responsibilities." *Philosophy and Public Affairs* 26, no. 3: 189–209.

Tamir, Y. 1993. *Liberal Nationalism.* Princeton: Princeton University Press.

Vallentyne, P. 1997. "Intrinsic Properties Defined." *Philosophical Studies* 88: 209–19.

Velleman, J. D. 1999. "Love as a Moral Emotion." *Ethics* 109, no. 2 (January 1); 338-74.

Wellman, C. H. 2000. "On Liberalism's Ambivalence Regarding Nationalism." In the present volume.

Williams, B. 1973 "The Idea of Equality." In B. Williams, *Problems of the Self,* London: Cambridge University Press.

Wolf, S. 1992. "Morality and Partiality." *Philosophical Perspectives* 6: 243–59.

11
Is National Identity Essential for Personal Identity?

NENAD MISCEVIC

I. Introduction:
The No-Personality-without-Nationality View

Half a century ago it was customary to link nationalistic views to organi-cist metaphors of society. Isaiah Berlin, writing as late as the early seven-ties, proposed as a part of the definition of nationalism that it is the conviction that men belong to a particular human group, and that "the characters of the individuals who compose the group are shaped by, and cannot be understood apart from, those of the group" (1972, 341). Further, the nationalist claims, according to Berlin, that "the pattern of life in a society is similar to that of a biological organism," and that the needs of this 'organism' determine the supreme goal of all of its members. One can recognize in this combination of the idea of national character shap-ing the characters of individuals and the idea of organic unity the more psychology- and biology-oriented descendants of the older discourse of the "spirit of people." Now, contemporary defenders of nationalism, above all its philosophical defenders, don't use this language any more: it is hard to find the organicistic metaphor and almost impossible to find the metaphor of 'national character' so popular in the first half of twentieth century. Where have all the metaphors gone? What has happened to them? The answer is almost obvious: they have all been replaced by one master-metaphor: that of *national identity*. As Perry Anderson (1991, 7) puts it, the notion of national identity is a "moral substitute" for the ideal of national character. "The narrower conception of identity fitted this role well, suggesting a more intimate, idealised bond than the gross links of daily custom." The idea of organic unity shaping the life of each of its indi-viduals-cells is easily translated into the identity-talk: *the national identity of the group is essential for the personal identity of each of its members.* The

very identity of individuals, of persons (not only of groups), is deeply
dependent on their community. Let me stress that "national" in this con-
text does not refer primarily to statist-civic nationality, but to a cultural
and/or ethnic belonging. This is the view that I would like critically to
examine in the present paper. Let me call it the *no-personality-without-
nationality* view. It relies upon the assumption that "there is nothing to
people except what has been socialized into them," as R. Rorty (1989,
177) puts it. Others (for example, Sandel) describe the members of one's
community as "fellow participants in a way of life with which my identity
is bound" (Sandel 1992, p. 22). and go on to speak of "constitutive com-
munity" (p. 23), meaning community constitutive of its members' person-
ality. Avishai Margalit (1997, 83) claims that "belonging to a national form
of life means being within a frame that offers meaning to people's choice
between alternatives, thus enabling them to acquire an identity." Finally,
here is a nice example from the pen of Gertrude Himmelfarb. "Above all,
what cosmopolitanism obscures, even denies, are the givens of life: parents,
ancestors, family, race, religion, heritage, history, culture, tradition, com-
munity—and nationality." None of these are accidental; all are essential to
a given individual. And all of them enter the identity of individual, which
is "neither an accident nor a matter of choice. It is given, not willed."
Trying to reject any of these traits brings "costs to the self." Moreover,
"the 'protean self', which aspires to create an identity de novo, is an indi-
vidual without identity" (Himmelfarb 1996, 77).

A critical discussion of the no-personality-without-nationality view
demands a framework of a theory of identity. In the present essay, in sec-
tion two, I shall only sketch the bare bones of a proposal on how to view
identity, distinguishing several senses of the term, and developing a very
sketchy account of identification with one's nationality. In the third sec-
tion, I finally apply the analysis of identity to the view under discussion.
The conclusion to be defended is that *the view fails in crucial respects.*

Let me spend the rest of this introductory section to detailing the con-
sequences of the no-personality-without-nationality view and its conse-
quences. Here is a wonderfully straightforward formulation offered by K.
Nielsen:

> A person's need for self-identity or self-definition. Self-realisation and a sense
> of self cannot be sustained simply by creative activity or an identification with
> humanity. Development of human powers, Feuerbachian species-being, indif-
> ferent to particular culturally specific self-definitions, is probably impossible,
> but, even if possible, it is not sufficient to provide anything like an adequate
> self-definition. As G. A. Cohen well puts it, 'A person does not only need to
> develop and enjoy his powers. He needs to know who he is and how his iden-
> tity connects him with particular others. He must, as Hegel saw, find some-
> thing outside himself which he did not create, and to which something inside

himself corresponds, because of the social process that created him, or because of a remaking of self wrought by later experience. We are, to put it crudely, lost if we cannot identify ourselves with some part of an objective social reality: a nation, though not necessarily a state, with its distinctive traditions. What we find in people—and as deeply embedded as the need to develop their talents—is the need not only to be able to say what they can do but to say who they are. This is found, not created, and is found in the identification with others in a shared culture based on nationality or race or religion or some slice or amalgam thereof.' Given this nature of our human nature, national consciousness and the forging and sustaining of a nation are extremely important to us whoever we are). Under modern conditions, this securing and nourishing of a national consciousness can only be achieved with a nation-state that corresponds to that national consciousness. (Nielsen 1993, 32)

Let me supplement Nielsen's text with other sources. According to Sandel, we need

loyalties and convictions whose moral force consists partly in the fact that living by them is inseparable from understanding ourselves as the particular persons we are as members of this family or community or nation or people, as bearers of that history, as citizens of this republic. Allegiances such as these are more than values I happen to have, and to hold, at a certain distance. They go beyond the obligations I voluntarily incur and the 'natural duties' I owe to human beings as such. They allow that to some I owe more than justice requires or even permits, not by reason of agreements I have made but instead by virtue of those more or less enduring attachments and commitments that, taken together, partly define the person I am. To imagine a person incapable of constitutive attachments such as these is not to conceive an ideally free and rational agent, but to imagine a person wholly without character, without moral depth. For to have character is to know that I move in a history I neither summon nor command, which carries consequences none the less for my choices and conduct. (Sandel 1992, 23)

Now, among all the traditional, historically developed forms, the nation is the best and the most reliable one. Nationalist claims are justified since the nation is precious for the very identity of its members; moreover, the value of the nation is prior to the actual decision and will of each particular member. Each stable and mature decision of a person (and the acts of will attendant upon it) depends upon causally and follows in time the establishment of a stable identity of its particular owner, so that the causal and temporal priority then reflects in the priority of satisfaction. One should first actualize the condition (stable identity) by the appropriate means (that is, national state), and then the condition will enable each of its members to form her volitions in a mature and respectable manner. No

national state, no individual identity; no such identity, no stable and respectable decisions.

We can now try to reconstruct the line of reasoning derived from the no-personality-without-nationality view in the form of an argument, to be called the argument from identity. It starts from a general thesis about identity and community: in order to have a stable and mature identity, the person must belong to a firm community, not of one's own choosing:

> A lasting and stable identity is a necessary condition of the flourishing of each human being, and of the very possibility of particular political choices of the individuals. It is largely independent of the will of the particular person, the carrier of the identity, since it is a condition enabling the person to have a determinate will at all.
>
> Human beings need to belong to a unified and given (that is, unchosen and involuntary) comprehensive community, and to participate in its life in order to acquire and maintain a lasting and stable identity.
>
> The best candidate for an identity-forming and—protecting community is ethno-nation, the carrier of national identity.
>
> (Ought) The preservation of a given ethno-national culture—in a relatively pure state—is a good independent from the will of the members of the culture, which ought to be assured by adequate means.

The conclusion is very often linked to the statist thesis (in order that such a community should preserve its own identity it has to assume the political form of a state) and to a claim of right: the ethno-national community has the right in respect to any third party and to its own members to have an ethno-national state. Note on the positive side that the argument is very appropriate for the contemporary framework of political thought, since it grounds the value of ethno-nation upon the value of individuals; on the other hand it is favorable to the nationalist since it is not indiscriminately individualistic, since the value in question is a community-dependent value, which is not at the mercy of individuals' whims.

II. From Identification to Identity

(a) The Varieties of Identity

Let me first reiterate our initial distinction. It is drawn between (a) the national identity of a group or community, which I shall refer to as national

community-identity (for example, the national identity of Croats as people) and (b) the national identity in the sense of the belonging of an individual to the group (the Croatian identity of Ivan the Croat). I shall describe the former as national individual identity. Many authors move from one to the other without warning. Anthony Smith, in his book National Identity, introduces the issue of identity by discussing Oedipus's tragic discovery of his true identity, goes on to speak of "categories and roles of which each individual self is normally composed," and then smoothly moves to community identity. O. Dahbour, in his introduction to an issue of *Philosophical Forum* on "National Identity as a Philosophical Problem," talks exclusively about national community-identity, but then concludes by depicting "national identity as a complex of philosophical claims . . . about human action, agency, membership and solidarity" (p. 16), which seems primarily to refer to national individual identity. The two notions, the national community-identity and national individual identity are certainly distinct. The ease with which even the most sophisticated authors switch between them, and the concomitant lack of warning will certainly not confuse the sophisticated reader. Still, it might unwittingly reinforce the impression that the two smoothly mix together, and thereby suggest a bond between national identity and personal identity. This in turn makes it easier for readers to swallow the no-personality-without-nationality view.

In this section I am going to focus upon the national identity of individuals, so the term "national identity" will be used in this sense only. Many authors writing about national belonging distinguish, implicitly or explicitly, the mere brute fact of being born the member of some ethno-national group or other, that is, a merely factual (ethno-)national identity, from the conscious and endorsed one. The distinction is an extremely natural and useful one, indispensable for the historian of nationalism. A Lavinian peasant speaking Lavinian counts as a Lavinian in the eyes of the anthropologist, but need not be aware at all of his Lavinian belonging. (Such was indeed the case with the majority of people in Central, South-Eastern, and Eastern Europe two centuries ago: a Bulgarian and a Serb, each speaking a different language, were officially counted as belonging to the same religious-political group within the empire, and no issue of their "nationality" was ever raised. They themselves have lived in blessed ignorance of their particular cultural-ethnic-national belonging.) We thus arrive at the following division of the meanings of "national identity":

This brute factual belonging is both politically and philosophically of minor interest, as will be argued in section three.

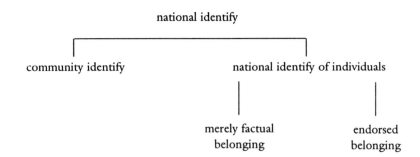

national identify

community identify national identify of individuals

merely factual belonging endorsed belonging

(b) Cognitive and Affective Identifications

The really interesting matter is the conscious and endorsed belonging, that is, endorsed national identity. A natural way to describe it is in terms of *identification*, an originally Freudian notion, later developed by Erikson. Many students of identity, notably Flanagan, among others, note the strong link between identification and endorsed identity. Let me now focus upon this link, since it promises an account of endorsed national identity. The intentional objects of identification are features, in this case the feature of belonging to an ethnic, cultural, or national community. Note that the feature need not in general be real or factual: a Serbian orphan raised as a Croat by a Croatian family, completely unaware of her factual ethnic belonging, can identify with the feature of being a Croat, although she is obviously not one in the brute-factual sense.

Most often one describes identification in terms of positive valuing of a trait or feature F, plus considering it important or essential to oneself. This general hunch, however, has to be elaborated. First, since a positive attitude towards F implies some taking into account of F, and of one's exemplifying F, there must be some cognitive attitude involved. Second, the elaboration has to accommodate cases like the following: Quasimodo is a hunchback who is rather unhappy about his condition, which he sees as of paramount importance in his life. Intuitively, he identifies himself as a hunchback, but this identification is, unfortunately, accompanied by an intense negative attitude towards the trait. A nineteenth-century Jew ashamed of being one would be a case in point for national identity. (One of the pioneering works on psychology of identification, E. Goffman's "Stigma," is centered around this kind of case, which has to be taken into account by any philosophical story about identification.)

Let me now take the first step toward analyzing identification, and propose a distinction between cognitive and affective-valuational identification with a feature, say one's national belonging. Simple things first: in order to

identify oneself with one's nationality N, one has to ascribe N to oneself. (In order to identify herself with her Englishness, Jane has to believe that she is an Englishwoman.) The ascription of a feature takes place against the background of one's understanding of oneself. But just ascribing it is not enough. Coming to identify oneself with one's feature F involves at least coming to accept F as one's lasting feature. But even more is needed. In order to identify herself with her being a beauty, Jane has to ascribe to her physical outlook an important role in her life, a significant "causal role" as philosophers often call it. Similarly with the national belonging. As Otto Bauer wrote in the twenties: "When I become aware that I belong to a nation, I realize that a close community of character ties me to it, that its destiny forms me and its culture defines me, that it is an effective force in my character" (Bauer 1923, 62–63).

A person who sees herself as primarily an Englishperson might firmly believe things such as, "The reason I am so kind and civil is that I am English," "The reason I do not harass women at my working place is that we, the English, care about decency." So, on the purely cognitive side, it is important to see the feature as (causally) determining the thought and behavior of oneself. Why is it so? I propose that we take a page from John Campbell's book on self, in which he stresses that "the basic conceptual skills implicated in the idea of oneself as causally structured in two dimensions: as internally causally connected over time, in that one's later states causally depend, in part, on one's earlier states, and as a common cause of various correlated effects in the world around us" (Campbell 1994, p. 203).

By ascribing a significant causal role to N, the person integrates N into her picture of herself in accordance with her general self-conception as depicted in the paragraph just quoted. In the temporal dimension of connectedness the salience of N is measured by its contribution to what kind of person one now is, in the world-oriented direction of one's causal powers its salience is measured by its contribution to their actual profile.

Now what about the desiderative (conative) component of identification? When N is seen as positive, the identification consists in endorsing it, valuing it highly, and starting to care about its preservation. Notice that care involves deep emotional ties, a cathexis, as psychoanalysts would put it. The metaphor of ties can be partly cashed in terms of valuation: by valuing N, the identifier also values oneself as the carrier of N. Let me quote Otto Bauer again: "Thus the idea of the nation is bound up with the idea of my ego. If someone slights the nation, they slight me too; if the nation is praised, I have my share in this praise "(1923, 62–63).

The valuation guides the particular desires of the identifier. Of course, coming to care about N is to a large extent involuntary. To borrow a hypothesis from authors like de Sousa and A. Baier, coming to have an

emotional attitude might be tied to early paradigmatic situations in which a trait is admired by parents or siblings. So, if the feature is available and noticed sufficiently early, it might figure in some of such early paradigmatic situations. For instance, being loyal to one's peers is an early trait, and the relevant emotion might be originally acquired in the context of a peer group, and become a focus of one's identification. Let me illustrate the proposal sketched here with a help of a diagram:

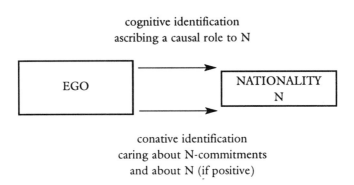

<div align="center">

cognitive identification
ascribing a causal role to N

</div>

<div align="center">

conative identification
caring about N-commitments
and about N (if positive)

</div>

Now we have to face the Quasimodo or the embarrassed Jew problem. Quasimodo identifies himself with his condition, which he sees as of paramount negative importance in his life. In what does his identification consist? Well he does firmly believe that given that one is a hunchback one is committed to certain lines of conduct, for instance, being extremely discreet in one's dealings with the opposite sex and very reticent about friendships. This commitment dictates (in a dramatic and unfortunate manner) the course of his life. Now, we would like to say that being a hunchback is a part of Quasimodo's identity. Quasimodo's care, however, is not directed to his physical trait (he hates it and does nothing about it), but to the (alleged) commitments it carries. (Compare him to the other famous hunchback, Shakespeare's Richard III, who seems rather undisturbed by his physical condition. Richard sees no commitments flowing from his physical appearance, and does not identify himself with his condition.) The distinction between the care for F and the care for F-commitments is thus needed to accommodate the cases of negative attitude. In such cases the care is directed to the commitments and not to the trait itself. This is where the distinction between caring for the trait and caring for the commitments it carries comes in handy. In short, to identify oneself with F involves on the conative side caring about F commitment, and, when F is seen as positive, caring for F itself. As far as valuation

goes, the identification with a trait perceived as negative causes the devaluation of the trait and the devaluation of oneself as its carrier: our embarrassed Jew values his Jewishness negatively, and devalues himself for being a Jew.

This distinction can also help us with merely imaginary features. Don Quixote identifies himself with his imaginary status as a hidalgo. Is "being a hidalgo" part of his psychological identity? No, common sense replies, and I concur. However, the set of alleged commitments is real for him, so the beginning of his identification with his role as a hidalgo is starting to care about the F-commitments of being one.

Now, an achieved identification with N should encompass at least the following spontaneous (if not also reflective) attitudes

- acceptance of the (alleged) fact that N has been for some longer time of central causal relevance for oneself as one now is, and has shaped the powers and liabilities one now has,

- deep care about N (and, when positive, about its preservation), and about N-commitments

- readiness to enhance the powers of N (and/or at least N-commitments) in the future.

A puzzle arises at this juncture: How can a set of traits and roles which is obviously in large part assumed and "constructed" be felt as intrinsically characterizing its owner? In order to resolve it we should look more closely at the consequences of identification.The more one identifies with one's national belonging the more prominent it becomes in one's life. It is the basis of a self-fulfilling prophecy: after a while an originally superficial trait to which one has an identificatory attitude may really become essential in one's life. Many imaginary features do not become real, nor for that matter, stabilized by being identified with (you cannot become a hidalgo just by wishing), but the (alleged) commitments can and often do (Don Quixote actually becomes more and more of a noble personality).

Notice now the interplay between cognitive and affective-valuational ties. The later ties make N salient for cognitive elaboration: a proud Serb (or an embarrassed Jew) will go on explaining his achievements (or alternatively failures) by appeal to his typically Serbian (or Jewish) traits he is proud (or ashamed) of. This ascription of causal powers to (imagined) national traits will again strengthen the emotional-valuational engagements. In general, the identificatory attitudes towards a typical features F normally enhance and stabilize F (if F is liable to enhancement), and/or its causal relevance. The enhancement of F normally stabilizes the identification attitudes towards F. This spiraling process normally produces a

homeostatic cluster centered around F (an "F-cluster") which perpetuates itself, a part of one's "second nature." The interaction and homeostasis account for the puzzle of how superficial, "constructed" properties can be felt as intrinsically characterizing and controlling its owner.

Various identificatory feature-clusters can coexist and interact (for example, a "macho"-cluster interacting with a "good father"-cluster typically results in a commitment to raise one's son as "a real, tough male"). The mutually incompatible clusters tend to create problems, and some of the troublemakers are typically weeded out in the maturation process. The set of features centrally important to the person at some given time might still not be a definitive "character," since it lacks proper stability and duration. But now, consider the set of mature and stable identificatory feature-clusters that guide one's mind and heart. I submit that this set is precisely one's stable psychological identity in the requisite sense. It is not merely objective. It is not merely a mere cognitive construction (unlike Flanagan's "self-represented identity"). It has a subjective and an objective component which stabilize and/or enhance each other.

The requisite notion of a "wide" identity, which sees identity as a cluster of stable identifications, is, I hope, rather handy for the discussion of endorsed national identity of individuals. The right thing to do at this juncture would be to compare the present proposal with established proposals from authors like Charles Taylor, O. Flanagan, and D. Wong. Unfortunately, this has to be left for another occasion, since the issues of nationalism are waiting in the wings to be addressed. Let me briefly mention what I hope are its principal virtues:

- First, it does not by itself prejudge in favor or against pro-nationalist (or in general communitarian) views,

- Second, it includes features (that can be at least in principle) related to cultural demands, if possible rich and varied cultural demands This makes it suitable for addressing the issues of moral standing of ethnical cultural claims

- Third, it fits well with the line popular in social psychology which stresses the achievement status of social identities. It allows for the possibility that the endorsed identity is built up and constructed, by the subject in question or by her community, over a longer period of time, which is central in the relevant psychological literature. (This compares favorably with the other kind of identity focusing upon the set of stable, objective features central to a person, and helpful for a third party in identifying her. This notion of identity, favored by Flanagan, Rorty, and Wong, has no principled ties with achievement, and falls out of the psychological tradition).

- Fourth, it analyzes the notion of endorsed national identity in terms of a more simple notion of identification, and further analyzes the later in terms of simpler notions of cognitive and affective ties between the identifier and her national belonging. This is as it should be: intuitively, the most important kind of social identity has to do with features with which one *identifies* oneself. One's valuational attitude (conscious or not) to a feature F or at least to its commitments is a necessary condition for F's being part of one's social identity.

- Fifth, by pinpointing the simpler components of identity, it leaves space for detailed causal research about identification, to be done by psychologists, sociologists and historians: what circumstances prompt the formation of particular ties, what pressures lead to self-ascription of a feature, what social circumstances contribute to the valuation of a feature.

- Sixth, it allows for a change in social identity, in contrast to the absolute, ontological Identity, in the sense debated by modal metaphysicians. It thus fits well with the research of change and restructuring of ethnic-national identities.

I shall assume that the above analysis is relatively uncontroversial, acceptable by both friends and foes of nationalistic views.

III. Is National Identity Essential for Personal Identity?

Armed with our basic distinctions, we can now at least begin to probe into the no-personality-without-nationality view. Is national belonging or national identity of an individual essential for one's identity, both in the literal, numerical sense, and in the wide (somewhat metaphorical) psychological sense? Let me note for the record that I find it difficult to believe that serious and civilized pro-nationalist authors literally mean what they say, or seem to say, about national identity. Take the two key claims, that unchosen identities are so much more important—in point of fact as well as morally—than the chosen ones, and that among the former the national identity is paramount. On a literal reading that would entail that the loyalty to unchosen identities (race, gender, nation) should *for the most part* prevail over loyalty to the chosen ones. Now, how about crucial decisions in one's life, say marriage, choice of friends, choice of career and place(s) to live: is it possible that the loyalty to race and nation should here play a role, indeed a paramount role? Is it possible that a civilized person should

think that it is morally bad to marry a person of different race or ethnic-national belonging? Should Jews have only, or for the most part, Jewish friends and avoid "Gentiles" if possible, even if these are their colleagues with whom they share professional interests, artistic tastes, and so on? Well, no decent intellectual would claim this nowadays; so what does our nationalist really mean with his view that loyalty to the unchosen identity should prevail? Under what circumstances? What should it be allowed to dictate? Let me then charitably assume that our nationalist does not literally mean to advise you to avoid friends of other races or ethnic belonging; he restricts the prevailing only to special circumstances, which he does not care to specify.

(a) Nationality and Numerical Identity

First, consider the most dramatic form of the view, rarely stated explicitly, but present implicitly in remarks like the one by G. Himmelfarb quoted above: that national or some other cultural identity of a given person is essential to her literal, numerical identity. Let us first ask the question about the bare factual ethnic-national belonging: is a definite such belonging essential to the literal identity of a person? Obviously not. Little Kai, a Scandinavian, can move to Canada and become, culturally and politically a Quebecker; thereby he has not ceased to be the person he is. If you want a more extended story, picture a character, call him John Cheng, from a mixed Anglo-Chinese family, raised in France as a monolingual French speaker. His factual ethno-national belonging is extremely problematic. Does this make his literal identity problematic? Are we unsure about who John is, whether he is *this particular person*? The very question sounds eccentric: of course, he is the person that he is. Is he, by the fact of his origin necessarily a "divided self" (to use M. Walzer's expression)? Not at all: he might be quite happy with the indeterminacy of his factual ethno-national belonging, as long as he is a rich and successful citizen of the French state.

Let us next ask the question about endorsed national identity (still considering the first equation of cultural-national and numerical identity). Consider two possible scenarios: in the first scenario, Cheng endorses French national identity, thinks of himself as a Frenchman albeit a bit unusual, teaches French literature, finally begins to call himself Jean, marries a Frenchwoman and dies happily to be buried at Pere Lacheze cemetery in Paris. In the second scenario, the adolescent Cheng discovers his Chinese Han roots, goes to China, learns the language, and becomes a Chinese (Han) nationalist, living under the name of Cheng only. Shall we say that these are two possible carriers of the same person, or that such a

possibility is completely excluded, that in fact the names "Jean" and "Cheng" in our story *necessarily* stand for *two* distinct persons? Intuitively, the John Cheng child has *both possibilities* open to *him*, not to some distinct person who is going to replace him. He will be John Cheng, this very same individual, no matter what career he takes. (Of course, metaphorically, we describe a dramatic change by saying, "He is a different person now," but this we often say when somebody loses thirty pounds, or changes his hairstyle; the metaphor tells really very little about the literal sameness of the person in question.) But then, the intuitive answer is that endorsing a definite national belonging and identifying with it does not change one's numerical identity: it is not like being body-snatched by extraterrestrials.

Let me illustrate the point with the parallel example of religious identity and St. Paul's conversion. He starts his life as Saul, a Jew and a Roman citizen, then becomes a fervent Christian, and dies as an established figure in the early Christian community. By standards employed in the debates about social and religious identity, his conversion is a *change of relevant identity,* from a Jewish-Roman to a Christian one. On the other hand, it is extremely important that Paul is the *same person (numerically same)* before and after conversion: his memories of Jewish-Roman culture are of central impact for his Christian writings. And of course, the conversion is not anything like a numerical change of person: it is not that a mind of another person snatches Saul's body and comes to inhabit it.

In short, pro-nationalist authors and communitarians in general sometimes confuse cultural identity and actual sameness of the person, deriving from this confusion the idea that cultural identity is sacred and untouchable. In short, they allege that national identity is part of personal numerical identity. The later is untouchable; so is the former. The postmodernists are prone to the opposite error. Deleuze and Guattari, for instance, seem to accept that cultural identity is part of personal identity. Noticing that cultural identity can be pluralistic and changing, they conclude that one should become literally a multiple personality. The error of both extremes lies in confusing the literal sameness of the person or the self (which is in this banal sense numerically one) and the pluralism of cultural identifications, resulting in a plural and changing cultural identity (in a nonliteral, metaphoric sense).

(b) Nationality and Rich Personal Identity

Let us now move to the second, more moderate and reasonable version of the no-personality-without-nationality view, prominent in Nielsen and Sandel: a strong sense of national identity, that is, a strong national

identification is a precondition of developing a sense of personal identity since it is unchosen and involuntary. The personal identity in the requisite sense is not mere numerical identity, but a stable configuration of a rich and flourishing self. Again, we consider first the mere factual belonging, and then the endorsed national identity.

Well, is a determinate, merely factual, national belonging indeed necessary for a stable and happy life? Can someone with uncertain factual national belonging lead a happy life? Of course one can. Most happy people before the eighteenth century did. Many do now. Can someone completely unaware of her factual national belonging—our Serbian orphan raised as a Croat—lead a happy life? Yes, of course. Notice an important ethical consequence: mere factual belonging does not carry any high moral value. To see this, consider the clearest case, the one in which a person factually belongs to some nationality N without being aware of it (our Serbian orphan). Does such mere belonging create *any ethical ties at all?* Apparently not. The person in question does nothing wrong by ignoring her original factual belonging.

A sophisticated defender of the no-personality-without-nationality view usually has the endorsed national identity in mind. A moderate such defender will opt for a weaker claim than strict necessity: maybe some rare, exceptionally lucky individuals can live happily without an endorsed national identity. However, as a rule, such an endorsed national identity is the best, and typically the only means for a normal, average individual to live a full life, and achieve a full identity, claims the moderate defender of the view. The crucial reason why national identity is better than other endorsed identities is that it rests upon a belonging that is involuntary, firm, stable, and thereby less exposed to the whims of individuals.

Unfortunately, the rationale fails doubly. First, the endorsed national identity rests upon ties that are not blindly involuntary. Of course, caring for one's nationality is, like every form of love, partly involuntary, but not in the requisite sense. For starters, nothing in our analysis demands that endorsed nationality always retains it priority, and that experience and reflection cannot give pride of place to some other loyalty. Further, endorsing one's national belonging and building it into one's identification is a process encompassing many cognitive and affective steps, some of them completely open to decision, some sufficiently so. It is in principle not less voluntary than identification to a social class, and maybe only slightly less voluntary than a deep traditional loyalty to a stable political party (which is the paradigmatic example of noncommunitarian belonging). This has not been sufficiently appreciated in the literature, due to a nonselective use of the terminology of identity: once a closer look is taken, the apparently monolithic nature of national identity shows its internal diversity.

Our analysis points to a startling ethical consequence. The moral significance of the endorsed national identity is certainly vastly greater than that of the mere factual one. But then, the *ground of the moral difference is certainly not in the merely factual belonging*. It can lay only in the *history of actual interactions with the community*, and in *decisions and endorsements made by the individual. But none of the two are special to involuntary or specifically national belongings*. It is precisely the kind of grounds the mainstream liberal tradition counts as relevant.

This brings us to the second round of criticisms of the no-personality-without-nationality view. The starting assumption about the high quality of involuntary belonging is completely ungrounded. For starters, a quick counterexample. One kind of belonging that is certainly dramatically involuntary and normally quite manifest is racial identity; still, no one in one's right mind would today claim that states should be run on racial principles. Why is this so often forgotten in the case of nation?

Further, our nationalist claims that belonging to firm communities and institutions forms stable persons. But neither are military barracks nor *Hitlerjugend* known for building stable and strong persons, although these have been rather firm and stable institutions. In short, there is probably *no positive correlation between the rigidity of the trait and the stability of identification*. Firm and stable institutions can produce feeble and neurotic persons, while flexible traits can support stable identification. The whole idea is just a misplaced analogy, that feeds further misunderstanding. The same holds for the stability of traditions. The misplaced analogy between the stability of the "whole" (nation) and the stability of the "part" (individual) should not mislead us. Stable identity traits are not necessarily connected with the roles determined by a national tradition. More generally, the whole idea that tradition, national or otherwise, constitutes the roles is wrong. Traditions are most often constituted by actions and roles, and not vice versa. Equally, not all causal, teleological, value-related, and normative properties carried by roles are either constitutively determined by tradition or essential to the roles themselves. (Being a full member of a practice is not the only way properly to understand the roles and the properties in question. One can arrive at the understanding by empathy-simulation, rational commonsense reconstruction, theoretical [scientific] reconstruction and the like.)

Finally, we come to a point often discussed in the literature, the present collection included: the crucial and specifically nationalist thesis (ethno) stating that the best candidate for identity-providing community is the (ethno-)nation. A person typically belongs to several, often concentric cultural-geographic domains, for instance micro-regional (say Yorkshire), macro-regional (northern Europe) ones, and global (Europe or Western World) ones. One is a typically member (full or potential) of various

comprehensive communities, which at least to some extent compete with (ethno-)nation for a person's allegiance. It is prima facie unclear why the nation should have such a special role in building an individual's identity in comparison with all kinds of more localistic or more universal or simply incommensurable competitors.

Of course, this is not the end of the discussion. The defender of the view has the option of switching to a different set of claims. It is not mere national belonging, he might then say, but certain underlying traits of the supervenient nationhood, that are the important providers of (wide) identity. The main such trait is obviously language (Taylor, Montefiore), but philosophers also speak about "national forms of life" (Margalit), "ways of feeling" (Margalit), "national value complexes," and the like. Unfortunately, there is no space left to discuss each such candidate. Let me just mention that I would respond by pointing out that none of them coincides in general with nationality (for languages, take Arabic, Spanish, English, and German: none of them defines one and only one national culture). Whatever their individual merits, they simply do not transfer automatically to national identity.

Let me very briefly pass to the moral implications of the stance we have reached. Many people do care about their national belongings, and this should be respected (the nationalist just exaggerates the issue, and makes national belonging the main pillar of an individual's identity). Indeed, at minimum, a citizen should not unjustifiably be put in a position to have to be ashamed of one's objective belonging to a given social category, that is, one should be enabled to carry the trait in question with dignity. This does not concern ethnic belonging only, but most unchosen belongings about which an individual cannot do much. People normally prefer to identify themselves with what they see as positive traits (this is part of the under-standable optimism of our inner make-up); it is a rather tragic fate to have to identify with a trait one finds worthless or despicable. If a certain invol-untary trait obviously and persistently plays a significant role in one's life, it is impossible not to acknowledge it as one's own, not to accept its con-sequences for oneself, and in this sense not to identify with it. Actual belonging to a certain given category (prominently race, gender, ethnic origin) is often involuntary. If such a belonging is at the same time socially devalued and treated as significant negative trait of the person bearing it, the person will most often be forced to identify with it and bear the con-sequences; at worst the person will interiorize the social judgment and her-self find the trait worthless or despicable. The minimal requirement then is the requirement of nondiscrimination that basically has to do with the value of equality. At more than a minimal level, one should be able to cher-ish, care for, and develop the elements of one's belonging if one chooses to, provided the identification does not clash with general moral require-

ments. Equally, one should be free not to identify with such a belonging, to take it as an accidental and limiting trait, without incurring any negative political consequences. This gives us the link with dignity and recognition (categories put forward by Taylor and his followers), that is, with the demand that belonging to a given category should not clash with a person's self-respect. The involuntary belonging should be socially recognized and not devalued

Where the nationalist goes astray is in not recognizing the fact that the plasticity and flexibility of identification is essential for flourishing, moral maturation, and development. People are fallible and have to be given a second chance, an opportunity to correct and modify their cluster of identifications. He equally fails to recognize the richness of human nature and possibilities which seeks expression in the variety of ties considered relevant or important. Now, the actual conditions of developed societies are such as to guarantee these possibility to a considerable degree, thanks to political, cultural, and technological possibilities. There are unfortunate and sometimes unjustified limits, but on the whole, this pluralism is an acquisition to be defended and expanded.

For many people voluntary belonging is the central provider of the identity traits: a membership in a union, a party, or a club can fill one's life with as much meaning as one's membership in a race. Unchosen roles and associated properties are not the most important potential identity traits for each person. Everyday experience shows that people both change their identifications during their lifetime, and that mutually incompatible identifications take turns in dominating one's life at various times: a football fan will have no problem identifying with his home team when it plays against others in the national league, with the nation team when playing against foreigners, and with chosen, close foreigners when they play against distant or particularly disliked ones. These remarks take care of the accusation that multiple identifications make for a "weak self." On the contrary, they make part of the ordinary richness of life and opportunities. The "mixed self" is a rich self.

What then is the political framework for such a pluralist cultural self? The political community should offer opportunities to develop one's identifications in a free and spontaneous manner (both in the positive direction of acceptance of what is given or negative in the sense of the right to exit); this demand derives from the value of liberty. The national identity is *one among many*, and has a right to be protected only to the extent to which its individual bearers actually care about it. Thus the proper framework is the liberal one. (It is compatible with the ultra-moderate pronationalist view, which demands a *prima facie* right—not a duty, at least not a strong one—to the preservation of national traits, and does so on a liberal basis of the actual choice of interested individuals). The opposite

view of identity—centered around uniqueness and around the claim of "no identity without a political entity"—is an important theoretical obstacle to the fulfillment of the task. The view is theoretically wrong and suggests morally dubious practices, so it should be rejected.

IV. Conclusion

To summarize, the no-personality-without-nationality view is false as it stands. National belonging is not essential for the mere literal (numerical) identity of persons. The mere factual national identity-belonging is also not necessary for a happy life. The endorsed national identity, in contrast, can provide one with an important component of one's complex, wide, psychological identity. But such a wide identity gets its moral standing from the classical individualistic sources: the importance it has for the given individual, the history of interactions it bears testimony to, the respect for the decisions that have been built into it in the course of the formation of identificatory ties.

I also hope that the proposed analysis of identification makes sense of plural and multiple belongings without advocating any radical deconstruction of literal numerical personal identity. On the purely descriptive-explanatory side I hope that the account offered might be of some help to those who work on sociological and political theories about nationalism since it meshes well with the exciting issues about acquisition and change of national identities on which standard philosophical accounts mostly remain silent.

NENAD MISCEVIC

University of Maribor and
Central European University

REFERENCES

Anderson, Perry. 1991. "Nation-States and National Identity." *London Review of Books* (9 May).
Bauer, O. 1923. "The Nation." Translated in Balakrishnan. *Mapping the Nation.* London-New York: Verso.
Berlin, I. 1972. "Nationalism, Past Neglect and Present Power." Reprinted in his *Against the Current,* ed. H. Hardy. Oxford: Clarendon Press.
Campbell, J. 1994. *Past, Space and Self.* Cambridge, Mass.: The MIT Press.

Cohen, J., ed. 1996. *Martha Nussbaum and Respondents: For Love of Country.* Boston: Beacon Press.

Dahbour, O. 1996. "Introduction: National Identity as a Philosophical Problem." *The Philosophical Forum* 28, no. 1–2: 1–20.

Flanagan, Owen. 1983. *The Varieties of Moral Personality.* Cambridge, Mass.: Harvard University Press.

Margalit, A. 1997. "The Moral Psychology of Nationalism." In R. McKim and J. McMahan, eds., *The Morality of Nationalism.* Oxford: Oxford University Press.

Nielsen, K. 1993. "Secession: The Case of Quebec." *Journal of Applied Philosophy* 10, no 1, 29–44.

Rorty, R. 1989. *Contingency, Irony and Solidarity.* Cambridge, UK: Cambridge University Press.

Sandel, M. 1992. Selections in S. Avineri and A. de-Shalit, eds., *Communitarianism and Individualism.* Oxford: Oxford University Press.

Smith, A. 1991. *National Identity.* Harmondsworth: Penguin.

PART III

The Compromise with Liberalism

12

Cosmopolitan Democracy and Liberal Nationalism

JOCELYNE COUTURE

Introduction

Democracy is the very rationale for many nationalist movements aspiring to form a state of their own. In their view, political sovereignty is a necessary condition for a people having its own culture, language, and traditions, first, to control its internal affairs and second, to gain a voice in the concert of nations. The latter is increasingly important, so goes the argument, in a context in which the shaping of a new global world order is at issue. The same argument is currently made by citizens of existing liberal countries who urge their state to keep, within new economic or political larger unions, the control of the national economy, culture, and institutions.

The argument is flawed, many think, because it rests on false assumptions concerning the role that states can play in the present context of globalization. First, the objection goes, authoritative transnational organizations increasingly undermine the capacity of states to further the interests of the citizens at the international level. Second, under the pressures, mostly economic, of such organizations, states have proved to be more effective as instruments for the dismantlement of their own civil societies than in being the locus of social solidarities and political life. And third, the very idea of the state system, based on political sovereignty, territoriality and noninterference, provides the ideological blanket for ignoring the undemocratic practices encouraged by many states, as well as for dismissing demands for more democracy in the world.

In short, a "nationalist project" is self-defeating for those committed to democracy. According to the above three objections raised about states and about a state-based system, the nationalist project would suffer from three defects. Were they to succeed in having a state of their own, nations would: (1) directly fall prey to authoritative transnational organizations and

(2) become part of a global order in which peoples have no voice at all and no prospect of survival. Whether they succeed or not in this endeavor, nations would (3) in effect reinforce the divisive ideology of capitalist economic globalization and contribute to the undermining of democracy in the world.

Some cosmopolitans, to which the third argument could be credited, do not hesitate to endorse the first two as well.[1] They have long since claimed that the nation—indeed the nation state—should not be the locus of political life and social commitments. And indeed, the actual progress of economic globalization comes close to turning their normative stance into a practical necessity. Globalization—of culture, solidarities, and political concerns—is, for them, neither a new word nor a recent idea. But it was, until recently, no more than an idea, not sustaining any definite political program and, moreover, not articulating any clear conception of the institutional or organizational set-up which would carry out the cosmopolitan idea of the global society. In the last few years, though, and mainly, I would submit, under the pressing evidence of a rather chaotic process of globalization, the cosmopolitan idea has evolved into an institutional model called "Cosmopolitan Democracy."[2] This model, and not the state model contemplated by nationalists, is claimed to be the model fit to further democracy in a globalized world.

This is the claim I want to examine. If it is true that, in the present context of economic globalization, states are a poor way of furthering democracy, how does Cosmopolitan Democracy fare in the same context, and how does it compete, in terms of its expected democratic achievements, with nation-states? My contention is that, although the defenders of nation-states have to take seriously the three objections listed above, there remains a strong presumption, on democratic matters, in favor of a liberal nationalist project.

Will such a conclusion, assuming it is right, settle the long-lasting struggle between nationalists and cosmopolitans? My answer to this question is: it depends. On one hand, there are forms of nationalism that I don't want to argue for and which cosmopolitans, in my view, rightly oppose as well. The normative issues raised by cosmopolitans against such nationalisms remain untouched by my arguments, and indeed my concern here is not to reopen these issues which, in my view, are already settled. On the other hand, the form of nationalism involved in what I call the nationalist project is *liberal* nationalism and it is, as I shall explain, compatible with the core doctrine and ideals of cosmopolitanism. My hypothesis is that cosmopolitanism and liberal nationalism become incompatible only when cosmopolitanism develops, as does Cosmopolitan Democracy, into an institutional framework specially designed to carry its core doctrine. For liberal nationalism has its own very different conception of the institutional

devices which could best secure democracy. If I am right in so identifying the possible source of incompatibility between cosmopolitanism and liberal nationalism, then a strong presumption in favor of a reasonable nationalist institutional set-up, even if it is just a presumption, is also a presumption in favor of liberal nationalism and against cosmopolitanism.

I shall first explain how liberal nationalism is compatible with the cosmopolitan doctrine and then show how this removes some stress on the third objection to the nationalist project. In the second part of my article I shall discuss the proposed institutions and the claims of Cosmopolitan Democracy. In the third part, I will show that this model is subject to the three objections addressed to the nationalist project. Finally, I shall come back to liberal nationalism, and argue that it offers stronger prospects for the constitution of a democratic global order than does Cosmopolitan Democracy.

1. Liberal Nationalism and Cosmopolitanism

Liberal nationalism (from now on: LN) is liberal in the sense of John Rawls's political liberalism.[3] First, the idea of nation that it articulates refers to a community which is tolerant with respect to the origin, ideology, and religion of its members. The nation, that is, is not based on race or descent or beliefs (religious or ideological) and is open to anybody so committed to tolerance. Second, it sees the nation as forming a society committed to the freedoms and rights characteristically granted in liberal constitutional democracies and affording all its members equal democratic rights and freedoms. What is nationalist in LN is that it sees such a liberal society as a society whose members are sharing—or wanting to share—in a common culture, language, history, self-perception, institutions, and some collective overall projects for their society, *including the project to secure—or to gain—political sovereignty.* LN is exemplified in stateless nationalist movements aspiring to form a liberal state, and in liberal states whether or not they are multinational states.[4]

Some have argued that nationalism—any form of nationalism—leads to the denial of basic rights and freedoms within societies and is conducive to violent enmities between societies. I do not want to deny that this is true of illiberal nationalism. But it is clear that LN, as I have sketched it here, cannot further its nationalist project at the expense of the basic democratic rights and freedoms of some individuals, or groups of individuals, in the society. LN is not totalitarianism. It is also clear that LN cannot further its ideal of a society at the expense of other societies. The interests of a nation, if it is a liberal nation, cannot be so conceived that they involve the destruction, the oppression or forced assimilation of other nations, soci-

eties or peoples. A liberal nation should defend itself against external tentatives aiming at its destruction, oppression, or forced assimilation, but it cannot engage in predation or be expansionist in any sense.[5]

A more subtle objection to LN comes from the cosmopolitan front. Nationalism, even liberal nationalism, some argue, is particularism. As such it need not, cosmopolitans are willing to recognize, be a menace for people within or outside the nation. Nonetheless, it shows a prejudice in favor of one culture and grants privileges to certain people because they belong to—or want to share in—that culture. Indifference, or sometimes even contempt for other peoples and their ways of living, unequal consideration given to peoples of the world, the reinforcing of barriers between populations, being ethnocentric, self-centered, and even selfish are among the things that cosmopolitans fear from even the best of nationalisms. For cosmopolitans are, in a noble sense, citizens of the world, transcending (so they believe) local attachments and paying an equally attentive and understanding consideration to everybody's rights, freedom, language, culture, and ways of living.

It is not hard to see how this suspicion could develop into the rather serious objection which is at the core of the third argument listed at the outset. Nationalists, the critique goes, being confident that they will succeed—while many others eschewed—in forming a state strong enough to control the internal and external affairs of their nation, have to be committed to the idea that peoples, and nobody else, are *de facto* responsible for what happens to them. This, in the context of economic globalization, is plainly ideological, and the fact that nationalists fell prey to that ideology is supposed to count as one more reason to believe that nationalism, like any particularism, is insensitive to the fate and particular circumstances of other peoples. But by entertaining such an ideology, the objection goes, the nationalists in effect reinforce it and are, then, bound to be an obstacle to the only struggle for democracy which, according to cosmopolitans, is likely to be successful in the context of globalization, that is, a *global* struggle for democracy appealing to *global* solidarities. So even LN, in spite of its not being violent or denying in any sense the rights of other people, becomes, some believe, a menace to the world. The menace is less direct than the menace of illiberal nationalism, but it is not less real, and being more subtle it could also be more damaging. This objection, if it has some grounds, could seriously discredit LN. So let us examine the premise on which it is based, namely that nationalism is a form of particularism.

That nationalists show a special interest in a particular nation would be hard to deny. But a special interest is not necessarily an exclusive interest. First, the special interest of the liberal nationalist for her nation appeals not to the idea that it is superior or more civilized than other nations, but to the fact that her nation is the nation where she can share with other peo-

ple a language, a culture, and the various traditions which provide a background for both their common aspirations and their various life-plans. The liberal nationalist can see, and indeed, should see, that other nations have a similar and equal importance for other people and, unless she is inconsistent, it is hard to see why she should think that other nations do not deserve the same consideration that her own nation does. Second, the confidence shown by liberal nationalists that they could sustain a strong democratic state does not appeal to any self-perception of the nation being more able or more deserving than other nations. Rather, it is based on the idea that a successful struggle for democracy should appeal to strong solidarities *of the type one can find between people belonging to the same culture and having certain ideals in common.* Liberal nationalists will not be less—or more—confident that other peoples, being in similar circumstances and counting on that very type of solidarity, can achieve democracy for themselves. Third, the rationale underlying the liberal nationalist struggle for political sovereignty is not the desire to be isolated from other nations. The rationale is instead the will to join the concert of nations, and that means to be heard as an equal by other nations as well as to listen to them. It is hard to imagine how such a demand could go without an active concern for other nations, for the flourishing of both their culture and democratic rights and for their own attempts to gain—or enforce—their political sovereignty. Given the liberal nationalist's demands, instrumental rationality alone could predict that they will indeed pay a very special attention to the general well-being of other nations. But instrumental rationality aside, it is hard to agree with what seems to be the premiss of the objection made by cosmopolitans, that having a special interest in one nation entails having no interest at all in other nations. Why should it be that people committed to democracy will, at the same time, be insensitive to democracy in other countries? Why should it be that being aware of the importance of their local solidarities in securing democracy, people will show no understanding and provide no support to other peoples' attempts to further their own culture and ways of living? It is not instrumental rationality alone which explains the concern of liberal nationalists to further the general well-being of other nations, but coherence, the understanding of the basis of solidarity and the strength of their commitment to the values of liberalism and democracy. So it seems that the idea that LN will undermine the demands for more democracy in the world by reinforcing the ideology of non-interference within the internal affairs of peoples is not likely to be true of LN. Another matter is that LN will have to *fight* that ideology—but that is also true of the cosmopolitan who sees herself as a citizen of the world. I shall come back to that issue later.

Cosmopolitanism is the ideal of "the person whose allegiance is to the world-wide community of human beings."[6] We have seen that having an

allegiance to one's nation does not entail, for a liberal nationalist, not having an allegiance to the "world-wide community of human beings," nor does it prevent him, nor inhibit him, from thinking of himself as a member of the virtual commonwealth, which Kant called "the kingdom of ends." The moral foundation of cosmopolitanism is equality: "If we really do believe that all human beings are created equal and endowed with certain inalienable rights, we are morally required to think about what that conception requires us to do with and for the rest of the world."[7] Then, what morality requires of the cosmopolitan is, as we have seen, part of the very rationale, embedded in LN, for political sovereignty. The only difference so far between cosmopolitans and liberal nationalists, is that the latter, but apparently not the former, do have a definite proposal concerning "what we should do with and for the rest of the world": liberal nationalists want to participate with the other nations of the world in the decisions which affect all the nations of the world. What they want to do for the world is to struggle for the creation of strong political units which will bring less hegemony and more democracy in the world. Is this answer acceptable in view of the cosmopolitan conception of equality according to which "[t]o count people as moral equals is to treat nationality, ethnicity, religion, class, race, and gender as 'morally irrelevant'—as irrelevant to that equal standing."[8] Again, belonging to a particular nation does not entail that one sees other nations as inferior any more than being of a particular gender would entail that one be sexist, or than practicing a religion would entail that one be a fanatic. To treat nationality, ethnicity, religion, class, race, and gender as morally irrelevant to the equal standing of human beings is a central element in our very idea of tolerance. LN would not be liberal, would, that is not be LN, if tolerance were not one of its firmest commitments.

2. Toward Legal Cosmopolitanism: Cosmopolitan Democracy

LN is—and, I believe, any acceptable nationalism has to be—compatible with the core requirements of cosmopolitanism. But many cosmopolitans oppose LN. Why is that so? I submit, as an hypothesis, that what explains the reluctance of cosmopolitans to endorse LN is their reluctance to admit the legitimacy of the type of political organization—the state—that liberal nationalists take to be the *modus operandi* of their claims. Before I look at the cosmopolitan reasons to so oppose the state as a political set-up, I want to clarify the theoretical significance of the hypothesis I am making at this point by way of making a distinction between moral cosmopolitanism and legal cosmopolitanism.[9]

Moral cosmopolitanism is the doctrine that I have just discussed, endorsing the moral values of autonomy and equality, and also the idea that the universal concern of all for all imposes on us, with respect to the defense of these values, the duties of the "citizen of the world." Legal cosmopolitanism, by contrast, is concerned with designing social, political, and legal institutions specially fit to carry out the core requirements of moral cosmopolitanism. Typically, cosmopolitan institutions are deployed in a multilayered system of governance in which nation-states, and even multinational states, have ceased to play a central role. Not all moral cosmopolitans are committed to legal cosmopolitanism; some think that their doctrine only mandates a general attitude in considering equality, justice, and one's relations to the world, while others think that it mandates certain organizational arrangements which are either feasible within a liberal state-based system or requires such a system. Legal cosmopolitans are indeed committed to moral cosmopolitanism; they think that moral cosmopolitanism provides a moral foundation for a concrete political project as well as a moral incentive to oppose a world order centered on the state system. In hypothesizing that cosmopolitans have reasons to oppose LN because they oppose a system of governance based on nation-states I am turning toward legal cosmopolitanism. Since I argued so far that moral cosmopolitanism provides no reasons to oppose LN, it might seem that I am rejecting in advance the validity of the legal cosmopolitans' critique of the nation-state. But this need not be so, for I am fully prepared to admit, as legal cosmopolitans do, that moral cosmopolitanism, by itself, and deprived of a specific institutional set-up, is not fully consistent.

Legal cosmopolitans claim that a system of governance which gives a central role to sovereign nation-states is incompatible with moral cosmopolitanism for four reasons: (1) The state system in effect tends to create *closed societies* in which the citizens are at the same time fenced off from the rest of the world and opposed to it. Cosmopolitans, as we have seen, are prone to think that, from a "being part of x" one can derive a "being opposed to y." As far as traditional states are concerned, their suspicion is not without grounds. Indeed, the body of administrative institutions and devices which constitute a state draws a line between the interior, the civil society, and the exterior, that against which the citizens should be protected. The state system is then seen as an obstacle to the cosmopolitan equal concern of all for all. (2) The state system encourages the *standardization of political life*. If one consistently believes in the autonomy of people, as a consistent cosmopolitan should, then one has also to reject a world order imposing a rigid and uniform framework in which people are not entitled to choose the form and the objects of their political involvements. (3) The state system is incompatible with the cosmopolitan ideal of equality because it is, among other things, *responsible for the inequality of*

condition of peoples. Wealthy and powerful states of the world became wealthy and powerful because other countries were impoverished and exploited through expansionist wars between states, colonialism, control by others of their productive force and state-supported trade. Through such an interconnectedness of the states in the state system, citizens of rich and powerful states have long benefited at the expense of others. That indeed clashes with the spirit of the "the kingdom of ends" and should be firmly rejected by (consistent) cosmopolitans. (4) Finally, now that inter-connectedness is realized through powerful capitalist-oriented economic transnational organizations, all states in fact have become tools for the impoverishment and degradation of their own civil society and *state sovereignty is, as it always was, a pretext, as well as a fig-leaf for undemocratic practices.*

Legal cosmopolitans think that any consistent cosmopolitan has a duty to oppose a world order incompatible with equality, autonomy, and democracy. I said before that any liberal nationalist also has such a duty. Now legal cosmopolitans think that such an incompatibility results from the very features of the state system. For them, that liberal nationalists could count on a state to gain—or to secure—their political autonomy is at best naïve. And that they could not see that a system of sovereign states is incompatible with the enhancement of autonomy and democratic equality in the world is distressing. Since having a state is built into the liberal nationalist project, liberal nationalism is inescapably both naïve and distressing.

I will come back to that "syllogism" in the fourth section where I argue that, although the legal cosmopolitan criticism of the *actual* state system is well taken, evidence and arguments still need to be given to the effect that the best way to alleviate its present defects is to get rid of states. One reason for doing so could, of course, be that a feasible alternative proposal to the state system is available, and that that proposal is more promising, from the point of view of democracy, than the best state system that can be imagined. Cosmopolitan Democracy that I shall now examine, has, according to its defenders, this double advantage.

Cosmopolitan Democracy (from now on, CD) is at the present time the most extensive articulation of legal cosmopolitanism.[10] Given the legal-cosmopolitan's objections to the state system—its disconnecting peoples of the world in their quest for autonomy and equality and its being an instrument (or instigator) of oppression, and unjust inequalities—the institutional set-up of CD pulls in two directions. One direction is the constitution of a global civil society in which citizens, through self-regulating voluntary associations, can participate in decision-making on the issues they choose, and at the level of governance—local, national, or transitional—that fits them. The enhancement of nonstate, nonmarket solutions

in the organization of the civil society presupposes the provisions of permanent—local or specialized—institutions, and the provision of resources to those in the most vulnerable social positions to defend and articulate their interests.[11] The other direction is the creation of a global order through supranational and international institutions. These involve a Global Parliament, a Charter of Rights to be applied in its various domains of jurisdiction, as well as various supranational and international institutions. The issues globally managed by such institutions range from the structuring of economic activities and arbitration of conflicts between states, to the enforcement of human rights and issues of global concern such as environment and the survival of humankind. Effective power at that level would be secured by a set of organizational, procedural, legal, and military resources.

The basic idea of Cosmopolitan Democracy is to create a new vertical distribution of power, first, by integrating, at the global level, some of the traditional functions of states both over their own territories and in international relations and, second, by granting the global civil society a role in decision-making which, again, extends far beyond the one it plays in traditional states. Although, unlike in anarchy, states do not disappear from CD's model, their political role and significance almost completely vanish. An important claim made by CD should also be stressed at this point: the global layer of governance, it is claimed, does not play the role of a global state—a world state—for it has no absolute sovereignty on any particular domain of jurisdiction. Rather, it shares authority with international institutions and what is left of the states, on the one hand, and associations of the civil society, on the other.

The way these various layers of governance interact will result, legal cosmopolitans think, in more democracy within countries, between countries, and at the global level, than we can expect from the traditional state system. From above, the Global Parliament is connected to regions (such as Europe or Latin America), nations, and localities. It has the power to intervene within these units whenever there is a serious violation of civil rights, and to make use of sanctions to enforce those rights. It might also appeal to the citizens of a state that has violated international law to overthrow their government and replace it by one which abides by that law. The associations of the global civil community could also intervene on their own will in the domestic affairs of each individual nation. As for democracy *between* countries and regions, CD grants that management of international issues, under a global Charter of Rights and Duties, guarantees to all countries, whether they are rich or poor, equal representation, fair trade agreements (including a guarantee of compliance with these agreements), fair distribution of natural resources, and equitable arbitration of conflicts. Such measures, it is thought, will contribute to the eco-

nomic growth of poor countries, remove many of the actual incentives for wars between and within countries, and create the conditions favorable to the political emancipation of populations and to the emergence of democratic institutions in various parts of the world. Finally, *global* issues, such as the environment, should also be settled more democratically, without any country, no matter how powerful or wealthy, being able to impose its preferences, or to act as a free-rider.

Democratic participation is thus expected to benefit from both the coordination of decision-making at the supranational level and the decentralization of the public forum in the civil society. Because their authority is undermined both from above and from below, states cannot anymore curtail or discourage democratic participation at the domestic level as they currently do under the pressure—or the appeal—of external interests. And because states are not any longer the locus of the political life, citizens are free to choose, not only the level but also the form and the domain of their political involvement. All this, of course, fits the cosmopolitan concern for autonomy and freedom. But here also lurks the specific stance of legal cosmopolitanism: what is at issue with CD is "the beginning of the creation of a new international democratic culture and spirit—one set off from the partisan claims of the state."[12]

Two questions should be raised. First, what reason do we have to think that CD is feasible in the present context of globalization? And second, what reasons do we have to think that in this context CD, assuming that it is feasible, is especially desirable?

Evidence that that model is feasible is arguably given by the fact that it is, in some fashion, already on its way. On the one hand, centralization at supranational and international levels already shows itself in numerous transnational agencies and conventions for the regulation, integration, and coordination of economic activity. A similar tendency also shows itself in the political domain—with the creation of larger political units, such as the European Union and of international organizations, such as the UN—and in the legal domain, where international law, international courts for war crimes, and the new permanent international criminal court in effect define new levels and new domains of jurisdiction. On the other hand, examples of associations showing the decentralization of civil society are found in numerous nongovernmental organizations (such as Greenpeace or Amnesty International), transnational associations of grassroots participants, and in various organizations or networks of citizens on environmental, political, or economic global issues.

These examples show that, as far as the shape of its institutional set-up is concerned, CD's proposal is, in practice, feasible; interconnection of peoples through institutions, organizations, and associations at every level is already part of our daily life. But the way this is presently realized is also

supposed to show why CD's program is specially desirable. Present global organizations are too weak and too disparate to form a global government, although they are strong enough to impose severe strictures on states, and, as in the case of economic regulative agencies, to harm their civil societies. Meanwhile, present associations of citizens are constantly frustrated in their attempts at effective action either by international law enforcing the states' exclusive jurisdiction on internal matters or by powerful multinationals protecting, with the help of local governments, their own interests. Globalization, as we now experience it, makes the world more interconnected than ever, but leaves it to the governance of supranational but uncoordinated organizations competing for absolute authority over any domain of jurisdiction. CD expects to achieve the interconnectedness of the world through a coherent and democratic pattern of governance.

3. Democracy in the Global Civil Society

One important way in which CD claims to further democracy is by enhancing a global civil society based on free association through which citizens of the world are enabled to participate in decision-making on the issues and at the level they choose. The idea seems to be that, in maximizing people's opportunities for democratic participation, CD would effectively increase the degree and diversity of their participation. That, however, might not be the case. People may be less attracted by distant or complicated issues, less inclined to participate in larger associations, and less involved than before in domestic politics, since this has ceased to be an important level of decision-making.

But suppose that is not so, and that the opportunities for participating afforded to people are real opportunities, that is, opportunities that they enact by actually participating massively at the level and on the issues they choose. Will that result in more democracy? It seems that in order to give an affirmative answer to that question, especially when capitalist economic globalization is taken into an account, the global civil society must be much more structured than it is according to CD. I shall briefly argue for that contention in two interconnected series of observations. The first series (a) points to some untoward effects of democratic participation through the associations of the global civil society. The second series (b) shows that CD's civil society is in many ways vulnerable to some antidemocratic features of capitalist economic globalization.

(a) Given the domains of democratic participation which, according to CD, should be open to citizens of the global civil society, the idea that such participation would occur by means of associations immediately brings in two problems that I shall first illustrate. CD, for instance, explicitly allows

associations to intervene within the domestic affairs of each individual nation. The idea of such interventions works well in the clear cases where there are systematic violations of human rights by local governments. It does not work so well when we imagine the members of an international association massively entering a debate about having religious schools in some remote island where half the population is religious and the other half is not. Democracy would require here that the persons affected by the decision and its consequences be the only ones to decide. For other people to intervene is simply changing the legitimate balance of power within which a democratic decision should be made. To acknowledge that aspect of democracy, it seems that CD would have to make room for some version of collective rights which, at first sight, does not fit a set-up in which individual freedom and autonomy at least seem to play a central role.

An example of the second problem derives from the fact that citizens of the world are allowed, according to CD, to participate in decision-making "on the issues and at the level they choose." It is usually thought that the soundness of democratic processes rests in part on the fact that a majority of those who participate in decision-making have a reasonable grasp of the issues to be decided and of the probable consequences of the options among which they are to choose. It is, indeed, a strong background assumption of democratic policies that all adult citizens must have democratic competency and, on that basis, be allowed to participate. It is this assumption which seems to be put in question when we consider that, according to CD, people should be allowed to intervene as they will in decisions concerning complex or specialized issues, as economic or environmental issues often are. Lack of competence (knowledge about a particular issue), and the practical impossibility of a majority of people acquiring it, should, it seems, constitute a basis for restricting their participation in such decision. And lack of competence (in the sense of sensitivity to a particular issue) would, it seems, be an additional reason to oppose, in certain cases, the interventions of international associations in national affairs.

The first problem concerns the capacity of CD to deal with power relationships within the global civil society and to counter their distorting effects on democratic processes. The second problem raised about CD concerns its capacity to deal with limited competencies and their effects on the coherence of democratic decision-making. Bringing more democracy and coherence to a globalized world is the central claim made by CD. As we shall see now, the weakness of CD on these two points is systematically carried over by the very conception of the global civil society.

These two problems mentioned above relate to the very idea of free associations as articulated in CD. CD claims to further democracy within the global society by allowing, and indeed encouraging, the reconfigura-

tion of solidarities along patterns which are open for people to choose. The reasoning is clear: decision-making is more democratic if it involves strong associations of citizens; associations are stronger when they appeal to the solidarity of citizens committed to similar causes and citizens are more likely to be committed to a cause they have freely chosen—to causes they feel to be their own. But choices, on the one hand, should not be so wide open that they allow associations lacking competence on certain issues to influence decisions which affect part, or the whole of, the civil society. This suggests that some constraints should be put on the participation, in democratic decision-making, of associations which, as in the second example, lack knowledge of the relevant empirical issues. But similar constraints should be put, for similar reasons, on the participation of associations with limited competence about political or moral issues; the choices open to citizens and to their associations should not be so wide open as to allow, for instance, strong associations devoted to the promotion of a white supremacy or religious fanaticism. Such causes lack validity from the point of view of the values that a democratic society wants to reinforce just as much as promoting witchcraft to stop acid rains would lack validity from the point of view of a technologically advanced society. And since validity here is relative to the consistent sets of representations that a society generally entertains about the world, including itself, to allow associations with limited competence to participate in decision-making is not only to allow for undemocratic decisions but also to allow for incoherence in policies and orientations governing that society. On the other hand, the solidarities that CD calls for between people committed to similar causes should not have such a priority as to allow a taking over of some part of the world, or of other associations, by associations or coalitions of associations, committed to the defense of a particular political, religious, or cultural stance, whether these stances are valid or not. Such an hegemony, whether it is political, cultural, or religious, would go against liberal conceptions of pluralism and tolerance and would, moreover, undermine democracy in the global civil society.

The institutional set-up of CD obviously should provide some mechanism to prevent, or to at least effectively deal with, situations involving either limited competencies or power relationships or both. So far, it seems that that could be done only by constraining, in some arbitrary ways, both freedom of participation and freedom of association. How that could be prevented from within CD is not a trivial question.

To see where the problem lies, one just has to reflect on the fact that what CD calls the global civil *society* is, basically, a set of associations. As John Rawls rightly pointed out, associations are distinct from societies in that membership in associations is voluntary.[13] In a constitutional democracy, freedom of association easily derives from that single feature; nobody

can be forced to belong to an association and anybody belonging to an association is free to depart whenever she wants. Since associations are not coercive in that sense, they are not a threat to either freedom, autonomy, or equality of people and there is therefore, no moral basis to oppose freedom of association *in a constitutional democracy*. The soundness of that point of view however, depends on two conditions. First, the citizens of constitutional democracies are granted freedoms and rights which do not depend on their being part of any association at all, and second, that very fact is part of a public and common knowledge. That is to say, the public institutions of constitutional democracies already provide a framework in which freedom of association is safely granted. But CD does not provide—and does not seek to provide—such an institutional framework. The set of permanent institutions specially designed for the global civil "society" are not institutions whose role, as in constitutional democracies, is to shape democratic representation, delineate the political sphere, secure democratic equality, and provide what John Rawls has called a "public reason."[14] The defenders of CD insist that there should be no such institutions for the civil society and they criticize on that point liberal conceptions of political life which for them are too narrow for the free and autonomous citizens of the world. But the result of this is first, that civil society, as conceived by CD, is a set of voluntary associations and, second, that democracy, in the proposed civil society, entirely rests on the existence of such voluntary associations. There are, as we shall see further, many problems about democracy arising from such an utterly individualistic conception of a society.

One might want to respond to these criticisms by saying that the Global Charter of Rights linked, at the upper level, to the Global Parliament will in effect provide the background—actually, a public reason—by virtue of which all the members of the global civil society will be granted democratic equality, equal rights to participate in decision-making and equal consideration. Thanks to that, one might think, the democratic process will be immune from undemocratic power relationship and intolerance. My point here is that, to be effective in the civil society, the Charter should translate into institutional constraints applying to associations of citizens. But, as I have noticed already, there are no institutions in CD's model whose role would be to shape political life. Rather the institutions designed for the global civil society are institutions fit for free associations, and, at best, to record their voices. In that context, whether the aims and claims of associations are faithful to the Charter of Rights entirely rests on the interpretation of it favored by their members and, in the last analysis, on their personal and private convictions in matters of morals and politics.

The defenders of CD generally acknowledge that the idea of the civil society still lacks an accurate articulation. But to say this is one thing, and it is quite another thing to show how the problems raised by CD in its

actual form could be resolved. If, as I have pointed out, one of the problems is that CD lacks the institutions it needs to ensure its own coherence and a democratic representation in the global civil society, then it is clear that any solution to that problem would require limitations on the freedom of association and would therefore upset the whole mechanism, as CD conceives it, of global civil society.

The weakness of such a mechanism also shows up in the fact that it could hardly ensure the stability of the global civil society. Free associations are intended to constitute, according to CD, the locus of *social* solidarities. But as a corollary of membership in associations being voluntary, associations are not required, as liberal societies are, to accommodate those of their members whose beliefs or values diverge on certain points. That is to say, associations, by contrast with liberal societies, could afford being prescriptively homogeneous, and even exclusivist, in the aims, the interests, and the values which form the rationale of their very existence. The result is that solidarities within associations are not solidarities which have to accord with a reasonable pluralism as solidarities within a liberal society do. Since CD's global society is in fact a loose cluster of associations, and since CD provides no rationale for transassociation solidarities, it seems that the citizens of the world, on such conception, need not be committed to either pluralism or tolerance. Indeed the global society could be pluralist in the sense that it could encompass a wide diversity of associations with their various aims, sizes, scopes, and levels. But that would be nothing more than a wide diversity of closed monads more securely fenced from each other than states could be in a traditional state system, and similarly exposed to the clashes that would result from their occasional encounter on a same scene. The limited competence of associations, resulting in struggles for power, seems to be built into the very structure of global civil society as CD conceives of it. If it were ever to exist, such a global civil society would probably explode long before the appearance of "a new international democratic culture and spirit."

(b) In view of these difficulties it appears that CD's global civil society would be very vulnerable in the context, already allergic to democracy, of economic globalization. Even under international control, capitalists' strong interests will obviously continue to fuel attempts to influence public opinion and more so, no doubt, since the civil society, under CD, would count as an effective layer of governance. And attempts at manipulation are more likely to be successful in a "society" of associations. Associations isolated from each other by their respective particularistic aims are easy to neutralize, if it so happens that their goals conflict with strong economic interests. And associations with limited competence—empirical, political, or moral—are easy to deceive. Neutralization of the isolated objectors and manipulation of the weak by economic interests are

things which do, of course, happen without the help of CD; but it seems that multinationals and other capitalist agents could be more successful in doing so, and in upsetting even more the democratic processes, in a global society which allows, indeed encourages, freedom of participation at the expense of democratic representation. In such a society, any small political, religious, cultural, or environmental association can without much difficulty be turned, by generous quasi-anonymous funding, into a powerful international association; it could become, without ever recognizing it, an instrument for global capital to take hold of new markets, to further policies in accordance with some particular economic interest and to better dominate the still discordant voices. Against that, global institutions cannot do anything; these maneuvers and their results first, do not fall in the scope of regulations concerning the economic activity at the global and international level, and second, do not violate the (CD's) democratic principle granting associations of the civil society full participation in decision-making.

Another reason to believe that decision-making in the global society is likely to be subdued by the economic interests involved in economic globalization appeals to the logic of the decision procedure within associations. The contribution of associations in decision-making is guided by the common interests of their members. If we consider, for instance, issues such as wage levels and working conditions, it is clear that different, if not divergent, interests will lead to a division of the working population along the lines of professional corporations, workers associations, workers' nationality and so on. But the division of the workforce in the world, the individualization of the relationship between employers and employees according to the category to which they belong, and the creating of competition between workers of different countries are among the capitalists' most successful strategies for imposing lower working conditions. It is also one of the main reasons for capitalists to extend their economic activities to distant and otherwise unconnected areas of the world. CD predicts a massive emergence of international associations linking people of the world and counts on that to resist capitalist globalization on issues related to human rights, exploitation, wages, and working conditions in general. But associations do not generally obey the solidaristic logic of citizens democratically concerned with the whole of the society in which they live. Associations obey the logic of associations; they defend the interests of their members and in doing so associations in effect espouse, rather than fight, the divisive logic of global capital.

The associative principle is not only divisive; it is also inegalitarian, and being so it serves in an additional way the interests of global capital. It is dreaming to think that workers in each category and in each part of the world can equally use their freedom of association to further their particu-

lar interests. On the contrary, it is likely that the less skilled, less educated, part-time or seasonal workers, and workers from underdeveloped countries will lack the capacity, as well as the opportunities, to organize themselves and to promote their economic interests through international associations. At the scale of the global civil society, there will still be, probably more than ever, categories of workers who have no other choice but to accept unfair working conditions unilaterally fixed by multinationals. Again, capitalist economic globalization is counting on the weakness of such workers.

CD's defenders predict that, through an effective global control of economic and state behaviors, working conditions would never be so bad as to involve violations of basic rights, gross exploitation of workers, and child labor. That would, of course, be a good thing. But that is beside the point. The point at issue here is that CD is claiming that the free associations of the global civil society can counter the antidemocratic effects of capitalist economic globalization. As we have seen, freedom of associations, in that context, plays into the hands of capitalist economic interests, first, because associations can easily be subdued or effectively manipulated by such interests, and second, because mere freedom of association plainly does not guarantee in every case the availability of associations. If it is by means of associations that the citizens of the world acquire a democratic voice in the global civil society, then one can in turn predict that that society will be divided into two halves: on one side, those whose voice is that of capitalist interests and, on the other, those who are without voice because their conditions do not allow them to form associations. With CD and capitalist economic globalization fully in place, it seems that the global civil society will experience a democratic deficit at least as large as the one that we experience now.

4. Cosmopolitan Democracy and the Nation State

CD is an ideal theory competing with other ideal theories in providing aid to the solution of actual problems of justice and democracy. By contrast with ideal theories, such as Rawls's, which assume the familiar framework of the nation state, CD, even in its more elaborated versions, leaves room for a good deal of organizational experimentation, namely in the structuring of the global civil society. But it seems that in order to bring, as they claim, more coherence and better democratic control to the actual world, the partisans of CD will have to relax some individualistic features of their conception of democracy. As we have seen, for the global civil society to be stable and coherent it should call for the allegiance of the citizens to a public reason acknowledging the value of pluralism and tolerance. So it

might not be the case that the free associations of the civil society can be the unique locus of political life and of social solidarities. In accordance with public reason, associations should be constrained so as to make democratic participation consistent with the requirement of democratic representation; so it might very well not be the case that associations could freely intervene within the affairs of each individual nation. Finally, a democratic global civil society should provide an institutional framework suitable for democratic decision-making and it should be able to count on the citizens to support that institutional framework; so it might not be true, in such circumstances, that anyone is entirely free to choose the form and the level of her democratic participation.

If CD wants to satisfy all these requirements, the global civil society will have much more structure than on the blueprint. Better democratic control and more coherence would need to be brought at that level of governance not only through the permanent consultative organization but also through public institutions which can shape democratic participation in accordance with a public reason, and through some organizational and legal devices able to secure individual and collective rights and to enforce the relevant set of correlative obligations. How that layer of institutions will interact with the global layer of governance, such as the Global Parliament and the international organizations, will be of crucial importance; for at that point, CD's model could easily change into a proposal for a global *state*, that is, into a proposal which, by all standards, cosmopolitan or not, is unacceptable. But at any rate, it seems that, in order to avoid both too much decentralization "from below" and too much centralization "from above," CD will have to count much more than it wants to on some middle layer(s) of governance.

That is precisely what LN is counting on. Liberal nationalists are deeply committed to pluralism. The idea of some global public reason, comprehensive enough to bring coherence into the whole domain of public policies, and by which all nations should abide, is for them, as it should be for cosmopolitans, intolerable. But liberal nationalists are also deeply committed to the idea of a society as a common venture. For them, a society is made up of people who share—or want to share—in a common culture, a common language, a common representation of themselves as a nation, common institutions, and some overall collective projects including the project to gain or to secure their political sovereignty. For liberal nationalists, the idea that democratic participation should be just a matter of freely joining associations of people who just happen to have similar interests seems frivolous at best. It does not capture the crucial idea of what it is to be a political community, or even more basically, as Emile Durkheim would surely have argued, for a mere collection of people to be a society.

The relevance of democracy for LN is not that it enables people to just gang together as they will, but that it allows people, whose fate depends on each other's, to decide together what they want their life to be like and to set the agenda in order to realize it. Democracy, for LN, derives from the mutual duties, advantages, and attunements which interconnect people. And that perspective, of course, determines what is an instrument for democracy and what is an obstacle to democracy. For liberal nationalists, the state should be an instrument for democracy. It is not an instrument for *building* and *creating* democracy; it is an instrument for societies which are already democratic to enact the social practices endorsed by their members through appropriate institutional schemes and institutional rules. And the global civil society for liberal nationalists is made up of such societies whose fate in the world is interdependent and who each need self-governance as a means to democratically achieve what they desire. A menace for democracy is a menace which threatens the instruments of democratic societies. For LN, capitalist economic globalization is such a menace.

As we have seen, the normative point of view of legal cosmopolitans is substantially different from that of LN. Free associations, for legal cosmopolitans, are instruments for people who want to create democracy, and a democratic society is a society unencumbered with social practices and the corresponding institutional rules. States, in their view, are obstacles to democracy for, through such institutional schemes reinforcing different sets of social practices, they fence off people from each other. And economic globalization is a threat to democracy only insofar as it has states,— and their mock power over people—as allies. Citizens of the world, freed from the narrow constraining institutional framework of states, are supposed, on CD's conceptions, to gain access to the "real battlefield" where they could defend their interests as they each conceive of them. Here the tides of ideology are running high.

So it seems that the disagreement between LN and CD most essentially turns on this: a very different conception of the basis of democracy. For LN, the basis of democracy is the solidarity between people—and of peoples—whose fate is interdependent; for CD the basis of democracy is the freedom for each to choose the object and the domain of her commitments. We have seen what the chances are for CD to achieve democracy on its own terms. We now can better evaluate the weight of the arguments legal cosmopolitans oppose to liberal nationalists. Legal cosmopolitans claim that nationalists are naive in counting on what in reality are diminishing states to further democracy. But this is, at best, an argument loaded with the complex-question fallacy. For liberal nationalists, it is not a strong state that makes a society democratic, but a democratic society that can make a state strong in ways that democrats would welcome. A liberal nation is more likely to form a strong democratic society because its mem-

bers have a sense of a commitment to each other and because their aspirations are shaped by cultural and historical parameters of which they have a reasonably clear and common understanding. A nation is not counting on a state for it to become democratic, nor will it, if it is a nation with liberal values, support a state—any state—which has become the valet of the multinationals, nor would it be content with a diminishing state as a means to control its internal affairs.

Another complaint of legal cosmopolitans is that LN is distressing because it fails to see that the state-based system, any state-based system, is incompatible with the enhancement of autonomy and democratic equality. This complaint, substantiated as it is by legal cosmopolitans by examples of some features of the *actual* state system, is a clear case of a "naturalistic fallacy." That the actual state system has fallen prey to capitalist economic globalization is not a reason to reject LN's proposal—or, for that matter, any other proposal—for a better, stronger, and more democratic state-based system. Neither is the fact that economic globalization is part of the actual context a reason to adhere to the ideal of a "new international democratic culture and spirit" which *de facto* paves the way for more capitalist economic globalization. Capitalist globalization is not a law of nature; it is a political and socioeconomic project aiming at cutting the politics from its democratic basis. Facing such a project, democracy mandates efforts to strengthen the democratic basis of politics rather than replacing it by the invisible hand of free associations.

LN would be an unrealistic utopia if it was counting on isolated states, as strong as they could be, to resist an increasingly authoritarian economic order. Like CD, LN recognizes the crucial importance of a coherent set of policies on global and international issues and, to enforce these policies, the need for global organizations with the effective relevant powers. LN also recognizes the crucial importance of global institutions subjecting economic interests to the interests of peoples. For that to be more than politics from above, however, a democratic basis should be constructed. LN is committed to the creation of a strong democratic basis through supporting and encouraging local solidarities and emancipatory movements in all parts of the world. Increased interconnectedness of people in the world—and the solidarities that can spring from it—is then another aspect of the cosmopolitan ideal that LN espouses. But LN also claims that, in order for such interconnectedness to result in a democratic and coherent global civil society, it should be based on a mutual understanding and acceptance of the value of self-governing societies: that is, of democratic sovereign nations.

Epilogue

There is cosmopolitanism and cosmopolitanism. Some have argued in what seems to me a convincing way that, when nations are struggling for recognition or are insecure, LN is compatible with, and even required by, a reasonable cosmopolitanism.[15] The present paper endorses that contention and spells out some reasons to think that it is sound, as far as cosmopolitanism *as a moral doctrine* is concerned.

My point of departure has been that a reasonable disagreement could still arise between cosmopolitanism and LN when the former develops into *legal* cosmopolitanism. For then each supports a different conception of the institutional devices which could best secure democracy in a globalized world. My conclusion is that, although the defenders of LN have to take very seriously the objections against state systems, there remains a strong presumption, on democratic matters, in favor of LN and against CD.

From the fact that neither moral cosmopolitanism nor CD refute LN, one should certainly not infer that no objections to LN can possibly come from the cosmopolitan front. Although CD is presently, to my knowledge, the most articulated example of legal cosmopolitanism, other versions, less individualistic, more socially oriented and more sensitive to the solidaristic basis of democracy, could be developed. My hunch, though, is that an institutional scheme able to convey these intuitions about democracy will have to make room for something approximating at least the institutional scheme involved in the central conceptions of LN.

JOCELYNE COUTURE

*Université du Québec
à Montréal*

NOTES

1. As it will soon become clear, the present article is concerned with cosmopolitans who reject liberal nationalism and not all cosmopolitans do (see for instance Kai Nielsen in the present volume, and Mitchell Cohen: "Rooted Cosmopolitanism" in Michael Walzer, ed., *Toward a Global Civil Society* (Providence, RI: Bergham Books), pp. 223–33.

2. The main defenders of that model are: David Held, *Democracy and the Global Order: From the Modern State to Cosmopolitan Governance* (Cambridge, MA: Polity Press, 1995); Richard Falk, "Revisioning Cosmopolitanism" in: Joshua Cohen, ed., *For Love of Country* (Boston, MA: Beacon Press, 1996), pp. 53–60; Mary Kaldor, "Cosmopolitanism versus Nationalism: The New Divide?" in

Richard Caplan and John Feffer, eds., *Europe's New Nationalism* (New York; Oxford University Press, 1996), pp. 42–58; Thomas Pogge, "Cosmopolitanism and Sovereignty" in C. Brown, ed., *Political Restructuring in Europe: Ethical Perspectives* (London: Routledge, 1994), pp. 89–122.

3. John Rawls, *Political Liberalism* (New York: Columbia University Press, 1993). A detailed account of how Political Liberalism allows for a liberal nationalist agenda can be found in Jocelyne Couture: "Pourquoi devrait-il y avoir un conflit entre le nationalisme et le libéralisme politique?," in F. Blais, G. Laforest and D. Lamoureux, eds., *Libéralismes et nationalismes* (Québec: Les Presses de l'Université Laval, 1995), pp. 51–75.

4. Although most modern states encompass several nations (e.g., Canada includes the Québécois nation, the Acadian nation, and the Aboriginal nations), I call somewhat stipulatively "multinational" only those states which grant self-governance and equal standing to their component nations. Canada is therefore not a multinational state but Switzerland comes close to being a genuine one.

5. LN is in this respect very different from the patriotism of powerful nations seeking to use their influence in the world to impose their culture and ways of living.

6. Martha Nussbaum, "Patriotism and Cosmopolitanism," in J. Cohen, op. cit., p. 4.

7. Ibid., p. 13.

8. Martha Nussbaum, "Reply," in J. Cohen, op. cit., p. 133.

9. Thomas Pogge, op. cit, uses this distinction in a different sense.

10. See in particular David Held, 1995, op. cit.

11. David Held, "Democracy: From City-states to a Cosmopolitan Order?," in Robert E. Goodin and Philip Pettit, eds., *Contemporary Political Philosophy* (Oxford: Blackwell, 1997) 78–101.

12. Ibid., 95.

13. John Rawls, 1993, op. cit., pp. 40–43.

14. "Public reason—citizens' reasoning in the public forum about constitutional essentials and basic questions of justice—is now best guided by a political conception the principles and values of which all citizens can endorse [. . .] such a conception is [. . .] worked out for a specific kind of subject, namely for political, social and economic institutions [which form] the basic structure of society" John Rawls, 1993, op. cit., pp. 10–11. See also pp. 212–54.

13

Liberally Limited Nationalism

ROBERT E. GOODIN

This paper has its roots in three connected observations. First, there is a crisis of confidence in our collective approach to the contemporary world order. Second, that has its roots in turn in a crisis of confidence in—and of—liberal internationalism. Third, the roots of that crisis, in turn, lay in liberalism itself.

The problem, at root, is just that liberalism is ordinarily seen to be such a wishy-washy, noncommittal, milquetoast sort of ideology. Tolerant to a fault, it is constitutionally averse to intervention of any sort into the affairs of others. 'Live and let live' is its undying motto and its besetting sin. This makes liberalism an inauspicious basis upon which to ground any activist, interventionist internationalism. The fundamental problem with liberal internationalism is that its very liberalism leaves the world's policemen holding no writ to enforce—or anyway no authority with which to enforce it—against the miscreants of the world. Flacid liberalism is incapable of inspiring the sort of confidence we need in order to enforce universal standards in a world of palpable (or anyway noisily purported) difference, whether ethnic, religious, racial, or whatever.

My thesis will be that liberalism has many more resources than we tend to suppose for containing the mischief of fractious factions. There is a good liberal reason for coming down hard on anyone who tries to 'play the race (etc.) card' in domestic politics. And that reason extends perfectly well from domestic institutions to international ones. I am left reassured that liberalism has plenty of resources intellectually—if perhaps not, just yet, politically—to rein in international troublemakers on more or less the same basis Hobbes long ago taught us liberals to justify reining in domestic miscreants.

I

A telling question with which we should begin is just this: How does it happen that ethnic differences, which long existed without having any social consequences, have suddenly come to have the force of real social divisions of enormous consequence?[1]

That way of stating the problem is implicitly a riposte to the standard irrendentist account, which sees ethno-nationalism as just a primordial sentiments bubbling to the surface.[2] There are some places, and some circumstances, in which that is plainly the most plausible account. That was presumably the case in the first wave of postcolonial upwellings of previously suppressed ethnic, religious, and nationalist sentiments. And the 'return of the repressed' may well be the most plausible story to be told about the fracturing of old Soviet-bloc countries along long-suppressed ethnic, national, or religious lines.[3]

But in a great many countries of the world, there is no such plausible story to tell. Without having been particularly suppressed in the immediate past, ethnic sentiments nonetheless swell suddenly and come to dominate the political landscape quite inexplicably in fairly short order. What on earth is going on, there?

A.

There are essentially two models we might employ in analyzing that phenomenon. One sees it as analogous what urban sociologists describe as 'neighborhood tipping'. The basic scenario is straightforward: a neighborhood which has been racially mixed for some time suddenly flips: several whites sell their houses; housing prices drop; more whites panic into putting their houses on the market, selling them for whatever they will fetch; and suddenly what had long been a stable, middle-income, racially-mixed neighborhood becomes a poor black ghetto.

Notice that this dynamic can get going perfectly well without anyone being particularly racist in their own personal sentiments. All it takes is a certain amount of anxiety about the racial sensitivities of others. The first whites to sell up might have just been moving to better jobs; and it might have just been a pure coincidence that several of them were selling their houses at the same time. The second round of whites to sell might have done so, not because they themselves minded living in a marginally 'blacker' neighborhood, but merely because they supposed that others probably would regard the neighborhood as less desirable the larger the fraction of blacks within it. They find themselves confirmed in this view by the falling prices their houses are now fetching, a fall which is of course

fuelled by the very fact that lots of panicky whites put their houses on the market at the first sign of a fall in prices. Market signals here are simply feeding on themselves. The point is just that all this can easily happen, with 'neighborhood tipping' as the consequence, without anyone meaning it to or themselves being particularly worried in any personal way by the racial composition of their neighborhood. All that is required is some diffuse sense that others might worry, even if we ourselves do not.[4]

Thomas Schelling has done much to show how tipping phenomena of this sort might be modelled as sheer 'coordination problems'.[5] The point of calling it a 'coordination problem' is to emphasize that the natural outcome of the ordinary workings of the processes, absent some central coordination, is an outcome which will be worse from the point of view of all concerned that would have been some other outcome which was available to them, and which could have been obtained by them through some coordinated efforts. To call 'tipping' a coordination game is to assimilate it to the case of two friends trying to meet up without having specified in advance a particular place for meeting, or to two drivers trying to use the same roads without crashing into one another. Neither of the friends cares where they go: both just want to go to the same place so they will succeed in meeting. Neither of the drivers cares which side of the road she drives on: both just want to drive on the opposite side from the other to avoid a crash. Nor, to anticipate, would either of them mind in the least which site was officially specified as the 'meeting place' or on which side of the road the state said to drive. All that matters is that everyone go to the same place to meet or that everyone going in the same direction drive on the same side of the street.

B.

The 'tipping' model represents one way of making sense of the sudden politicization of ethnicity upon which Greenfeld remarks. A second builds on old sociological notions of 'mobilization-and-counter-mobilization'.

As political sociologists have long noticed, certain corners of the social world seem virtually Newtonian in character, in that sense that for every action there seems inevitably to be an equal and opposite reaction. The political logic of mass mobilization, in particular, seems to behave according to some such rule.[6] Once capital gets organized, labor must organize or be left behind in the wage game. Once crafts get organized into unions, the lumpen trades must similarly unionize or be left behind. Once Ulster Catholics organize themselves politically along religious lines, Protestants must likewise organize along sectarian lines. Once whites in the American South or native Fijians mobilize politically along self-consciously racial

lines, southern blacks or Fijian Indians must do likewise just in order to protect themselves.

Without some such story about how every mobilization begets an equal and opposite counter-mobilization, we would be at a loss to understand much of this century's politics. We would continue to be mystified by the absence of class-based politics in Ulster or the American South.[7] We would be puzzled by the the rise and fall of the Equal Rights Amendment and of rights to abortion, and so on.[8]

Political sociologists have usefully commented on the existence of the phenomenon. What I want to do here is to take a tentative first step toward modelling it slightly more formally, with that in turn serving as a tentative first step toward framing a liberal proposal for the proper state response to the phenomenon.

In more formal terms, the mobilization and counter-mobilization phenomenon might be regarded as an instance of a self-defeating 'game of status'. A game of status is a game of 'relative power'.[9] Such games have a zero-sum game feel about them, in the sense that what one side gains the other loses and vice versa. But, of course, what each side is pursuing, in these games of status, is some strategic resource ('firepower', generically) which will put it at an advantage vis-à-vis its opponent. And in games of relative power, of which games of status are a subspecies, the benefit to each party is represented as the difference between its firepower and the other's firepower. Thus, the two sides involved in such a game can and often do expend vast energies and other resources in a pointless arms race, vastly increasing their absolute firepower but leaving them in exactly the same relative position as before they undertook those fruitless expenditures.

The sudden ethnicization of politics often has broadly this feel about it. One side 'plays the race (etc.) card', mobilizing people on its side along racial or ethnic or religious lines—and in explicit opposition to some other racial or ethnic or religious group in the community. Confronted with this aggressive mobilization of political firepower against them, members of that 'other' group have little choice but to counter-mobilize in self-defense along parallel lines themselves. Aggressive mobilization is met by defensive counter-mobilization in quick succession. The initial mobilization determines, almost structurally, the lines of cleavage along which the rest of the community will be forced to counter-mobilize. Latecomers to the process must simply fill the 'holes' left for them, take the places assigned to them, by those whose initial moves have structured the basic shape of available political spaces.[10]

The point about games of status is that they usually end up being self-defeating. One side might of course gain a temporary advantage over the the other and cash in on it in a big way. But more typically, the arms race

proceeds apace on both sides, with both sides running hard to stay in essentially the same (relative) place vis-à-vis one another. In some narrow sense, the resources devoted to the process cannot be said to be wasted— for if either unilaterally withdrew from the race the other would have it at its mercy. But in some larger sense, the resources both devote to the process are collectively wasted. If both could somehow manage to stop simultaneously (and be sure the other had really stopped, and would not start again without warning), both would be better off spending their money on something more productive.

Arms racing is perhaps the most standard example of this 'game of status' phenomenon. But another more purely domestic example of it might be the 'lawyer game'. To some extent, the more lawyers there are in the community the better the cause of justice is served: more people know their rights and pursue them more effectively against the world at large, and so on. But to some extent (or rather beyond a certain point) an increase in the number of lawyers does not increase the quality of justice in any such straightforward sense. In an excessively litigious culture like that of the United States, you need lawyers principally just to defend yourself against other people's lawyers. It is a case of 'defensive counter-mobilization' of just the sort described above. We all spend a lot of money hiring legal firepower designed merely to cancel the effects of others' legal firepower, ending up at considerable cost with the same outcome we could have achieved at much lower cost had all of us desisted from upping the legal ante. Just as in the arms-racing game so too in the lawyer game, we would all have been a lot better off if there had been some way to ensure that none of us sets off down what was always bound to be a mutually self-defeating track.[11]

Let me reemphasize that there is more going on in the rise of ethnic politics than either of these two basic models can quite capture. The 'tipping' model represents ethnicity as something that matters hardly at all, from each person's point of view (though each presumes it to matter more to others than himself). The second 'relative power' model represents ethnicity as a purely political ploy, valued purely for the strategic advantage it might confer in relative power games within the community.

Obviously, people sometimes set much greater store by their ethnic identities than either of those two accounts would suggest. Equally obviously, though, people sometimes 'discover' potent ethnic identities much more suddenly than any of those other models of deep, enduring values would suggest. These two models of ethnic politics I have been advancing, then, seem to capture something even if they do not capture everything that is going on in the upsurgence of ethnic identity politics in today's world.

II

My aim in setting out those two slightly more formal models of ethnic (etc.) politics is to recall what resources liberalism as a political theory has for dealing with such phenomenon. Seeing the situation in those more starkly formal terms, I think, helps us recall what exactly the liberal theory of the state is—and, by extension, how it might bear on these most perplexing problems plaguing the new liberal international order.

Schematically, the liberal theory of the state is broadly as sketched by Hobbes (modified only at the margins by shifting to the gentler assumptions of Locke). The state is a response to the prospect of a 'war of all against all', represented in modern game theory as an iterated Prisoner's Dilemma. In the state of nature, no one can trust any other. The strictly dominant strategy, the best each can do whatever anyone else does in every single round of the game, is to double-cross one's opponent. Each one of them would be better off if each of them had not double-crossed one another. But absent some way of ensuring that agreements are kept, the more likely you think the other is to not double-cross you, the more certain your advantage in double-crossing him.

The central function of the state, in this account, is simply to provide some external agency (outside the game itself) with the interest and ability to enforce agreements, and thereby make each player better off than any of they could realistically have been in the absence of central state authority. Each might have been better off yet again by double-crossing others, in a world where no one double-crossed him. But that world is *ex hypothesi* unattainable, anyway not in the long term.

How hard it is for the state to impose this mutually beneficial settlement on everyone depends principally upon how great is each one's temptation to defect. Where the temptation is low, it is much more just a 'coordination game' like choosing which clock tower to serve as our meeting point: one might be marginally more convenient for me, another for you, but our shared interest in meeting under the same clock vastly outweighs any marginal differences we might have over which it should be. Where the temptation to defect is high, it is much more like a classically 'Prisoner's Dilemma' or 'status' game, with the more certain each is that others will keep the bargain giving each all the more incentive to defect from the bargain himself.

Hobbes thought it was more the latter case, Locke more the former. But however much or little you think heavy-handed enforcement mechanisms might be needed to enforce the edicts of the liberal state, thus conceived, the central fact you need to hold onto is just this. What we are enforcing, when enforcing a liberal political settlement, are arrangements that make everyone better off than they would otherwise be.[12]

The fact that some of them seek, for strategic advantage, to defect from that settlement—the fact that there are some people who seek to break the law for private advantage—ought not necessarily be counted as evidence against this interpretation. If the basic liberal story about the state is right, defection from the shared legal code is not so much a matter of deep 'treachery' as it is of pure cheating, taking advantage of others adhering to rules which you flout simply in order to secure a competitive advantage over them.[13]

We feel perfectly comfortable in allowing the liberal state to do all sorts of things for us along these lines. We allow—indeed, expect—it to provide public goods, like clean air and water, national defense and air traffic control systems. The details of any particular policy are, of course, politically contested: everyone wants the details of the law to favor them, as much as possible consistent with living together at all. Everyone would likewise prefer to let others pay all the costs of programs from which they would inevitably be able to benefit, whether or not they paid.[14]

The first job of the liberal state to broker compromises among people who want everything but who would, most realistically, otherwise end up getting nothing. The second and potentially harder job of the liberal state is then to enforce that settlement upon upon people each of whom has an incentive for defecting from it (just so long as his own defection does not cause the whole deal to unravel).

This way of framing the problem helps us understand the multitude of political challenges that the liberal state inevitably faces, as everyone seeks an exemption for himself from the general rules that bind all the rest. That way of framing the problem, however, also bolsters our faith in the moral authority of the liberal state to resist such fundamentally unprincipled demands.

III

Let us now return to the alternative ways of understanding ethnic conflict I sketched above. On the irredentist account—where all the members of each group really do want to kill all the members of the other, and where all the members of each group are perfectly prepared to accept the risk of being killed themselves in the process—there is little in liberal theory that would justify anyone else in trying to stop them. But on both of the other accounts I offered, ethnic unrest would indeed fall very much within the general sort of things which liberal states rightly regulate.

First suppose the problem of ethnic unrest is akin to the pure coordination problem represented by the 'tipping game' which characterizes residential segregation. Everyone knows that his first preference is for an

ethnically mixed community. But everyone assumes that everyone else's preference is for a much less mixed community. Those expectations of each about the behavior of the other feed on themselves, causing everyone to realign themselves completely along purely ethnic lines, at the first hint of any shift whatsoever in the ethnic balance.[15] While everyone (mistakenly) supposes this was inevitable from the structure of (other people's) preferences, everyone knows fully well that it was a worse outcome from his own point of view than continuing the older traditions of harmony and balance within an ethnically diverse community.

What each is then facing is essentially an 'Assurance Game'.[16] Each positively prefers to opt for ethnic diversity, so long as enough others so opt. But each requires positive assurance that enough others will opt that way as well: and absent that assurance, each will be forced to opt for what each regards as the second-best of an mono-ethnic community.

The role of the state lies in providing precisely that assurance. In part, it can do that simply by disseminating information about what people's real first-best preferences are. Everyone knowing that everyone would prefer a mixed community, just so long as everyone else has the same preference, is in itself powerfully reassuring in crucial respects.[17]

Beyond merely disseminating information, though, the state might also legitimately play a rather more interventionist role. In the residential segregation example, the state might prohibit people from putting their houses up for sale if, say, more than ten percent of houses within a three-block radius are already for sale.[18] Or the state might undertake to purchase all excess houses on the market in such circumstances, at a price which reflected the 'fair market price' before the stampede of sellers artificially deflated prices, thus ending the spiral of ever declining prices making people ever more desperate to escape the neighborhood.

Both sorts of state intervention—both the positive and negative ones —interfere with the 'free play of market forces'. Both thus interfere with people's unfettered freedom of action in these matters. But both sorts of intervention—both negative as well as positive ones—would be welcomed by people in the circumstances of an Assurance Game. Even if coercive, the state's interventions would be welcomed by everyone as a crucial means whereby everyone manages to achieve his own first-best preference, which is 'living in an ethnically mixed community'. Furthermore, if it really is an instance of an Assurance Game, then no one would have any reason to want to defect from, undermine or 'cheat on' the overall outcome which the state is striving to bring about. *Ex hypothesi* in an Assurance Game that really is everyone's first-best preference, anyway.

The second model, of mobilization and counter-mobilization as a game of relative power akin to an arms race, complicates matters principally just in that latter respect. The essential dynamic at work here is one of a Prisoner's Dilemma.[19] It still is the case that everyone would be better off,

in his own terms, if everyone (himself included) were prevented from mobilizing in ways that would ultimately inevitably just prove counterproductive. State intervention to prevent that—to limit the weaponry available to street gangs, or the legal firepower available to disputants in civil suits, or the ability of any side to stir up ethnic animosity through 'hate speech'—makes everyone better off.

But of course each party's primary interest, in this case, is in the others' being disarmed. They agree to be disarmed themselves only as the cost of that. But it would be better still, from each party's point of view, if he himself could remain armed while his opponents were being disarmed. Of course, since having everyone else disarmed is the price that each would demand for agreeing to be disarmed himself, the only arrangement which can command universal asset is a policy of universal disarmament; and that is the regime which the state is charged with enforcing. But the task of enforcing that regime is complicated by the fact that each thus has an incentive unilaterally to break the rules.

We are ordinarily perfectly capable of recognizing special pleading for what it is, however. Those who seek exemption from the general rules for themselves, while insisting that those rules continue to bind others, are *prima facie* violating the most obvious principles of fairness and reciprocity.[20] Sometimes that *prima facie* indictment will ultimately fail in the face of 'difference': in Shaw's gloss on the Golden Rule, 'Do not do unto others as you would that they should do unto you. Their tastes may not be the same'.[21] Often, however, the plea of 'different tastes' will be a transparent sham, an excuse for cheating of a perfectly flagrant sort.

Prohibitions on activities which would stir up ethnic hatreds are characteristically of that more robust sort. They are universally beneficial, and transparently so. Much though any one group might benefit from mobilizing its members against some other group, it would in the long term lose even more from having other groups mobilize against it. Thus, even the most committed liberals have little hesitation in enforcing laws against 'hate speech', 'racial villification', incendiary marches (of Nazis in Skokie or Orangemen in the Falls Road), and so on. And the reason that liberals are so comfortable with prohibitions on speech and actions with which they would ordinarily hesitate to interfere is that those interventions are warranted by people's own preferences and permissions implicit, if not explicit, within them.

IV

In transposing these lessons from domestic to international settings, let us start by recalling that liberalism is of a cloth, domestically and internationally. Whatever the liberal state is legitimately authorized to do by its basic

liberal logic domestically, the liberal state's international analogue may by the same basic logic do internationally. In the same way, and for the same reason, that the liberal state may legitimately intervene to limit ethnic strife domestically, so too may the liberal state's international analogue legitimately intervene to limit ethnic strife in the world community.

In some larger sense, that is of course contentious. But dealing just in terms of arguments internal to liberalism, it is not. Liberalism infamously ignores community; it is insistently universalizing; it issues precepts which are completely cosmopolitan in scope. Some say that that is a problem with liberalism, and maybe it is. But for the purposes of my present discussion, asking what resources liberalism offers for curbing ethno-nationalist excesses, we can rest assured that we are not violating anything in the internal logic of liberalism itself by extending its domestic teachings into the international sphere.

The basic principle of liberal order, internationally as well as domestically, is the principle of non-interference. Just as the liberal state is supposed to allow each citizen maximum liberty consistent with like liberty for all, so too is the liberal international order supposed to allow each state maximum liberty consistent with like liberty for all. The non-interventionism that characterizes liberalism internationally is a perfect echo of Mill's precepts *On Liberty,* domestically.

The principal tasks of liberal authorities, thus conceived, are to prevent unwanted interference among members on the one hand, and to facilitate mutually beneficial interactions among them on the other. The former amounts to enforcing criminal and tort law domestically and the UN Charter's prohibition on the use of force internationally. The latter amounts to enforcing contract law domestically and treaties internationally.

Liberal internationalists have historically been much more comfortable with the latter than the former. Treaties embody mutual consent. Liberals are perfectly comfortable enforcing them, because in so doing they are not really forcing anyone to do anything that they have not themselves agreed to do. They are not really interfering, not really imposing their own will. In enforcing treaties, like contracts, liberals are just helping the parties themselves give effect to their own wills. Stopping people from fighting, when one or both clearly want to fight, seems on its face harder to square with liberals'commitments to noninterference.

But of course the fundamental liberal justification (*à la* Hobbes et al.) for stopping people from fighting is essentially a contractual one. *Ex hypothesi,* most people would usually want to stop fighting, at least so long as others stop fighting as well. Or they want others to stop fighting them, and are prepared to stop fighting themselves as the necessary price to pay for that. Whether their consent is explicit or merely implicit, the fundamental liberal warrant for stopping people from killing one another is just

that everyone would agree that they are better off having these rules enforced against all.

That premise is what grounds liberal peacekeeping operations internationally. We are helping people to do something that each wills for himself (even if, in Prisoner's Dilemma-like situations, each also has a private motive for defecting from the rule each wills for all). And insofar as liberal principles are impervious to state boundaries, the same logic would for liberals justify peacekeeping operations within states. The liberal international community is every bit as justified in stepping in, if necessary, to stop or prevent civil wars as it is in stepping in to stop or prevent wars between states.[22]

Just as the liberal state might legitimately intervene to stop its citizens from stirring up ethnic strife, so too might the liberal international community legitimately stop states or groups within states from stirring up ethnic strife. Internationally as well as domestically, the liberal legitimacy of such interventions would of course depend upon assimilating the ethnic strife to the 'tipping' or 'relative power' games described above. But much ethnic strife can indeed be assimilated to such models, and in such cases restraining the excesses of faction can be seen as just a matter of 'mutual coercion mutually agreed upon' of a sort with which liberals should be perfectly comfortable.

Domestically, it is clear what a liberal state dedicated to stopping ethnic strife should do. It should ban hate speech, ban racial villification and group slander, ban marches and displays designed to offend the known sensitivities of other groups, and so on. Internationally, it is perhaps less clear what the the 'liberal world order' might do to stem ethnic strife. While none of those domestic dampers have strict international equivalents, most have loose analogues. We can ban hate speech, racial villification and group slander—at least in the UN General Assembly and other international forums. We denounce those who incite ethnic hatreds, and we can make it clear that anyone inciting genocide will be held to book in international tribunals. Provocative marches and demonstrations which threaten world peace can be prevented, if necessary with the assistance of international peacekeeping forces. In short, everything the liberal state is supposed to do domestically to stem the tide of ethnic hatred could in principle be done internationally, as well.

But inevitably it will be more awkward internationally, precisely because of the way in which liberalism subcontracts authority to states which it is broadly prepared to regard as sovereign for policing their own internal affairs. We can 'send in the troops' in the blue helmets, but we do so only reluctantly and as a last resort. So what measures, short of calling in the international police, might we consider?

We might simply inform each state what we collectively expect *it* to do, by way of stemming ethnic strife. Tell each state that we expect it to ban hate speech, offensive insignia, intimidating assemblies. Tell each state that we expect it to institute suitable arrangements (of a federal or other appropriate sort) allowing groups to govern their own affairs without threatening any other groups. And so on.

The force of clear norms and standards, clear expectations and benchmarks, ought not be underestimated. Therein, I would argue, lies much of the impact of ILO standards and of human rights monitoring regimes. Many times, these things work perfectly well even without any formal enforcement mechanism.[23]

But if some enforcement mechanism is required, here is one suggestion. The Tobin tax is an attractive proposition, on several grounds. In the form proposed by Tobin, we would simply impose a tax on international currency transactions, designed purely to suppress international currency speculation.[24] That aim would be achieved simply by collecting the tax, regardless of how (or whether) the monies thus collected were actually spent. But of course the Tobin tax would generate a sizeable pot of money which might as well be put to some good use—'social development' or environmental protection or whatever. In short, it is a win-win proposition.

What I would now like to propose, as a wrinkle on the standard Tobin tax proposal, is that we institute a global 'surcharge' within this Tobin tax regime on currencies of countries which make inadequate efforts to curb ethnic violence within their own countries. If unchecked, ethnic strife is likely eventually to require international intervention. A Tobin tax surcharge for countries failing to discourage ethnic strife would amount to making them pay in advance for the international assistance they are likely eventually to require. At the same time, that Tobin tax surcharge would have desirable incentive effects, encouraging countries to try harder to curb ethnic strife in its early stages.

V

Such a Tobin tax surcharge is just one practical (or possibly impractical) suggestion, to counter ordinary complaints about excessively abstract philosophers never having anything practical to suggest. My larger point is indeed the more theoretical one, which is simply that liberal internationalists need not feel unduly squeamish about intervention to stamp out at least certain sorts of ethno-nationalism. At least certain forms of that phenomenon can be easily assimilated to just the sort of strategic dynamic which legitimates the liberal state domestically, and just the same liberal

logic serves to legitimate analogous intervention into what liberals might otherwise regard as 'other people's affairs' internationally.[25]

ROBERT E. GOODIN

Australian National University

NOTES

1. A theme powerfully developed by Greenfeld 1997.
2. The locus classicus being Geertz 1963; cf. 1977.
3. Elster, Offe, and Preuss 1998.
4. O'Gorman 1975.
5. Schelling 1978, ch. 4; see further 1971. In his model, the assumption is just that no one wants to be completely surrounded on all four sides by members of the opposite race; Schelling shows just how astonishingly quickly that minimal racial reticence leads to complete segregation.
6. Lipset and Rokkan 1967; Tarrow 1994.
7. Rose 1971.
8. Luker 1984; Mansbridge 1986.
9. Shubik 1971. Less formally, see Hirsch's (1976) description of self-defeating competition for status goods.
10. Goodin 1995.
11. Goodin 1990.
12. It is, in the phrase of Schelling (1971), a case of 'mutual coercion mutually agreed upon' — or rather mutual coercion which (counterfactually) would have been mutually agreed upon by everyone simply attending to their own interests in the matter.
13. That is to say, no 'thick' (deeply contextualized) moral understanding is required to operate this code: the thinnest of understandings is quite sufficient (cf. Walzer 1994).
14. Such is the character of a 'public good', and thence the classic public finance case for coercive governmental provision of goods with that character (Samuelson 1954; Baumol 1965).
15. Hence the reluctance to allow any new census in Lebanon, postindependence, for fear its findings would upset fragile power-sharing arrangements predicated on the ethnic mix found in the last colonial census (Hudson 1969).
16. Sen 1966; 1967.
17. Therein lies the social psychologists' points about 'pluralistic ignorance'and its solution (O'Gorman 1975).
18. Or, more realistically, it might set stringent criteria for anyone wanting to put his house on the market in those circumstances, like a dramatic change in family or employment circumstances.
19. Luce and Raiffa 1957, ch. 5.

20. Hart 1955, p. 185; Rawls 1958, p. 178; 1971,pp. 111–14, 342–50.

21. Shaw 1901, p. 188.

22. Some may say that this relative indifference to state boundaries marks a deficiency in liberalism, and maybe it does. But be that as it may, remember that here I am just exploring what resources there are within liberalism to justify intervention to stem ethnic strife: and in those terms, at least, that ostensible deficiency once again actually proves quite convenient.

23. Judging from domestic US environmental protection regimes anyway (Taylor 1984).

24. Haq, Kaul, and Grunberg 1996.

25. An earlier version of this paper was read to the Nobel Symposium on 'Nationalism and Internationalism' at the University of Stockholm, September 1997. I am grateful for comments, then and later, from Rainer Baübock, Kjell Goldmann, Liah Greenfeld, Stanley Hoffman, Bob Keohane, and Yael Tamir.

REFERENCES

Baumol, William J. 1965. *Welfare Economics and the Theory of the State*. London: George Bell & Sons.

Elster, Jon; Claus Offe; and Ulrich Preuss. 1998. *Institutional Design in Post-Communist Societies: Rebuilding the Ship at Sea*. Cambridge: Cambridge University Press.

Geertz, Clifford. 1963. "The Integrative Revolution: Primordial Sentiments and Civil Politics in New States." Pp. 105–57 in Old Societies & New States: *The Quest for Modernity in Asia & Africa,* ed. C.Geertz. New York: Free Press.

———. 1977. "The Judging of Nations." *Archives Européenes de Sociologie* 18: 245–61.

Goodin, Robert E. 1990. "Relative Needs." Pp. 12–33 in *Needs and Welfare,* ed. Alan Ware and R. E. Goodin. London: SAGE. Reprinted in Goodin, *Utilitarianism as a Public Philosophy* (New York: CambridgeUniversity Press, 1995), pp. 244–63.

———. 1995. "Conjectures on the Nation-State." *Government & Opposition* 20: 26–34.

Greenfeld, Liah. 1997. "Democracy, Ethnic Diversity & Nationalism." Paper presented to the Nobel Symposium, "Nationalism and Internationalism," Stockholm.

Hart, H. L. A. 1955. "Are There Any Natural Rights?" *Philosophical Review* 64: 175–91.

Haq, Mahub ul; Inge Kaul; and Isabelle Grunberg, eds. 1996. *The Tobin Tax: Coping with Financial Volatility*. New York: Oxford University Press.

Hirsch, Fred. 1976. *Social Limits to Growth*. Cambridge, Mass.: Harvard University Press.

Hudson, Michael C. 1969. "Democracy and Social Mobilization in Lebanese Politics." *Comparative Politics* 1: 245–61.

Lipset, Seymour Martin and Stein Rokkan, eds. 1967. *Party Systems and Voter Alignments*. New York: Free Press.

Luce, R. Duncan and Howard Raiffa. 1957. *Games and Decisions*. NewYork: Wiley.

Luker, Kristin. 1984. *Abortion and the Politics of Motherhood.* Berkeley, Calif.: University of California Press.

Mansbridge, Jane J. 1986. *Why We Lost the ERA.* Chicago:University of Chicago Press.

O'Gorman, Hubert J. 1975. "Pluralistic Ignorance and White Estimates of White Support for Racial Segregation." *Public Opinion Quarterly* 39:312–30.

Rawls, John. 1958. "Justice as Fairness." *Philosophical Review,* 67:164–94.

———. 1971. *A Theory of Justice.* Cambridge, Mass.: Harvard University Press.

Rose, Richard. 1971. *Governing without Consensus.* London: Faber &Faber.

Samuelson, Paul A. 1954. "The Pure Theory of Public Expenditure." *Review of Economics & Statistics* 36: 387–89.

Schelling, Thomas C. 1971. "On the Ecology of Micromotives." *Public Interest* 25: 61–98.

———. 1978. *Micromotives and Macrobehavior.* NewYork: Norton.

Sen, Amartya. 1966. "Labour Allocation in a Cooperative Enterprise." *Review of Economic Studies* 33: 361–71.

———. 1967. "Isolation, Assurance and the Social Rate of Discount." *Quarterly Journal of Economics* 81: 112–24.

Shaw, George Bernard. 1901. "Maxims for Revolutionists" (preface to Man & Superman. Pp. 180–95 in *The Complete Prefaces of Bernard Shaw.* London: Odhams Press, 1938.

Shubik, Martin. 1971. "Games of Status." *Behavioral Science* 16:117–29.

Tarrow, Sidney G. 1994. *Power in Movement: Social Movements, Collective Action, and Politics.* New York: Cambridge University Press.

Taylor, Serge. 1984. *Making Bureaucracies Think: The Environmental Impact Statement Strategy of Administrative Reform.* Stanford, Calif.: Stanford University Press.

Walzer, Michael. 1994. *Thick and Thin: Moral Argument at Home and Abroad.* Notre Dame, Ind.: University of Notre Dame Press.

14

Cosmopolitan Nationalism

KAI NIELSEN

I

I want, some might say, to have my cake and eat it too for I want to be both a cosmopolitan and a nationalist, and, congruently with that, I think liberals and socialists, depending on the societies in which they live, should be either cosmopolitan nationalists or people in sympathy with liberal nationalist projects where these projects have a legitimate point. This includes people like myself who are liberal socialists committed, as all socialists are, to socialist internationalism and the international solidarity that goes with it (Nielsen 1998b). How can—or can?—these things consistently go together? Beyond that—consistency being necessary but hardly a sufficient condition for adequacy—why go for cosmopolitan *nationalism*? Why not instead just go straight-out for cosmopolitanism and its internationalist outlook without the dangler 'nationalism'?

In facing these questions let me first say what I take desirable—or at least putatively desirable—forms of cosmopolitanism and nationalism to be. It is sometimes said that to be a cosmopolitan is to be a citizen of the world (Nussbaum 1996). However, absent a world state, "citizen of the world" must be a metaphor, but it is, as I think Martha Nussbaum evidences, a useful and important metaphor. Still it needs to be said what it is a metaphor of. To be a cosmopolitan—"a citizen of the world"—is to identify with and have a commitment to and a concern for all of humankind and not just for some subunit of it, *and* it is, as well, to have some reasonable understanding of, to prize and to take pleasure in, humankind's vast, and sometimes creative, diversity. It is not just that a cosmopolitan will grudgingly accept, as an intractable fact, the great variety of forms of life, practices, art-forms, languages, religions, cuisines, and the like that the world has on offer, but she will take pleasure in the very

existence of them, feel at home with a goodly number of them and wish to see them prevail where their prevailing does not harm others. Above all she will take an active interest in them, be reasonably knowledgeable about many of them, and wish to see all of them flourish that are respectful of the rights of others, including, of course, alien others.

Someone who was simply an Enlightenment humanist, without also being a cosmopolitan, would identify with, be committed to, and show concern for humankind, but it would be on an *assimilationist* model. She would be a One Worlder advocating a one-world culture—a single globally encompassing culture, including ideally a single language, for all humanity. In contrast with the cosmopolitan, she would wish to see humankind become as much alike as possible with some preferred model in mind as some French and some English Enlightenment figures wished to see the whole world modeled, as the case may be, on enlightened Frenchmen or enlightened Englishmen—to carry the "white man's burden" from one end of the globe to the other. The ideal of such an Enlightenment humanist was to have a world of either Frenchmen, Englishmen, or Americans or the closest approximation attainable thereto of one or another, depending on which was their preferred ideal model for a proper humanity.

By contrast a cosmopolitan is not so ethnocentric (ideally is not ethnocentric at all) and is a *nonassimilationist* Enlightenment humanist. She is a humanist prizing humankind in and for its diversity without denying that in this diversity there is some commonness as well (Berlin 1980, 333–55, Appiah 1996, and Nussbaum 1996). Moreover, this diversity is not seen as something to be regretted (accepted with a sigh), but is seen as a source of human richness, a richness that enhances our world.

To be a nationalist is to regard nationality as being of deep and desirable human significance and to regard group identity, which (or so at least some nationalists believe) takes the form (in conditions of modernity) of a national identity, as something to be sustained as being necessary for human flourishing and for there to be a good and just polity. This requires not only the protection of individuals, but the protection of nations as well, and the guarantee, where this can be had, that they will have some form of self-governance. This self-governance will in the best case take the form of a nation having either a nation-state of its own or being a secure and equal partner in a multination-state with a considerable amount of autonomy of its own, the exact extent of which is to be negotiated between the component nations of the multination-state in conditions of fairness as equals (Rawls 1993, 15–22).

However, for nationalism to make match with cosmopolitanism it must be a liberal nationalism. By "liberal" here I do not mean the neo-liberalism of *laissez-faire* economics and the economic ordering of the world characteristic of capitalist globalization with its associated, severely individ-

ualistic libertarian or neo-Hobbesian social philosophies, but a social liberalism with its political exemplifications in social democracy or in genuinely democratic socialist societies (for example, Chile during the time of Allende) and theoretically articulated now (though, of course, variously) by political philosophers such as Isaiah Berlin, Brian Barry, G. A. Cohen, Joshua Cohen, Ronald Dworkin, Jürgen Habermas, Stuart Hampshire, Thomas Nagel, John Rawls, and Amartya Sen and, to reach back into recent history, by John Stuart Mill, T. H. Green, R. H. Tawney, and John Dewey. There is a stress in such liberalism on the virtues of tolerance, on autonomy, on equality, on the protection of human rights and on the societal nonprivileging of any comprehensive conception of the good. Such liberals will emphasize the importance of there being a recognition and a nonruling out in the public domain of all conceptions of the good that respect human rights and are in accordance with the political principles of justice of such a liberal society. These are principles that, in a broad sense, are egalitarian: prescribing that the life of everyone is to count and to count equally. To give this moral equality substance, there is also the stress that there be a *roughly* equal sharing of resources (though making allowances for incapacities) and a commitment to attaining an equality of the life conditions that would as fully as possible, produce, and for everyone, to the extent that is possible, conditions of human flourishing for each person, taking into considerations their different capacities and capabilities, at the highest level for each person that they as individuals can attain. The idea is to produce conditions of life for everyone that would enable them to have the best life they are capable of having. It is the stress on these substantively egalitarian features that highlights the *social* nature of this liberalism in contrast with the *individualistic* liberalism of Friedrich Hayek, Milton Friedman, Robert Nozick, and David Gauthier.[1]

Such a social liberalism meshes (as does an individualistic liberalism) with cosmopolitanism. The crucial question is whether cosmopolitanism is compatible with a *liberal* nationalism. There are paradigmatic social liberals (Brian Barry, for example) who are robust substantive egalitarians but strong antinationalists, and there are cosmopolitans who are social liberals but not nationalists (Martha Nussbaum, for example) (Barry 1987 and Nussbaum 1996). I shall argue, by contrast, that the most adequate forms of cosmopolitanism and social liberalism will also be liberal nationalisms or accept liberal nationalisms as legitimate where there is a need for nationalist movements. I shall further argue that the most adequate nationalisms (and thus the most adequate liberal nationalisms) will be both social liberalisms and cosmopolitan.[2]

To argue this I first must specify what liberal nationalism is in line with my characterization of social liberalism. A liberal nationalist will *reiterate* (if you will, recursively define) her nationalism, taking it that, since group

identity and cultural membership are key goods for all human beings (arguably, in Rawls's sense, a primary good), then it is something that, morally speaking, must not be recognized (acknowledged and accepted) *only* for her group but for all human beings. In that respect human beings (the whole bloody lot) are not relevantly different. And if national identity is the form that group identity takes under conditions of modernity, then sustaining or attaining, as the case may be, a secure national identity for the members of a nation should not only obtain for her nation but for all nations in such conditions. This reiteration only assumes the minimal and unproblematic conception of universalizability that if x is good for A then x is good for anyone relevantly like A in situations relevantly like those of A.

A liberal nationalism will not only be reiteratable. It will, as well, be tolerant of all other nationalisms that themselves accept reiteratability and are similarly tolerant. As a social liberalism it will have substantively egalitarian principles of justice that acknowledge the equal human standing of all human beings, the importance of coming to have the necessary means actually to have that equal standing, the necessity of designing programs and policies aimed at achieving that, and to recognize as well the deep value of a commitment to equal respect for all human beings, keeping firmly in mind the considered conviction, deeply embedded in liberal belief, that the life of everyone matters and matters equally (Nagel 1979, 105–27). So that that will not become a hollow human mockery, I will also argue for the necessity of there being material conditions for its realization actually in place so that this ideal can become a reality and not simply remain an ideal. Here we do well to follow Rosa Luxemburg.

Keeping that firmly in mind, along with a recognition that cultural membership is a primary good, it should also be stressed that this primary good must (morally speaking "must") be available to everyone. Not making it so available would be arbitrary, for it is something we all need, for, as a primary good, it is something necessary for the meeting of whatever ends or aims we—that is anyone—happen to have.[3] As different as people are in some important respects they do not differ here. Some income and wealth, health, at least a minimal intelligence, some recognition and acceptance as well as cultural membership are all-purpose means—I did not say that is all they are—necessary for the realization of the various ends that we have and the life plans (whatever they may be) that are ours. Primary goods, in fine, are something we all need. We will not, and morally speaking cannot, privilege (whoever we are) our own people with respect to them, but must argue that this egalitarian treatment should obtain for everyone, recognizing that the people of our nation are not relevantly different from anyone else in this respect.

Being inescapably persons living in a certain place at a certain time, with certain attunements, within a certain culture, we should, and proba-

bly will, in this domain, direct much of our attention to sustaining conditions favorable (particularly where they are fragile) to the flourishing of our own society, to making continued cultural membership in the nation a secure possibility, without attempting or wishing to lock people into such a membership. We must have a conception of cultural integrity that seeks, within the confines of reiteratability, the flourishing of our particular nation. But that is not because we regard our nation as more important—as our being God's chosen people or the people with the one truly human way of ordering things—but we seek to further the flourishing of our nation, as we hope others will do as well for their nations, because that is where we happen to be and that is where some (though not all) of our very deep attunements are and where many of our commitments lie. And again this is clearly reiteratable and should be reiterated. Nationalists should be reiterative—they should be recursive—about nationalism and this is exactly what the very idea of a liberal nationalism commits the liberal nationalist to be. Their position is closely analogous to the position of parents vis-à-vis their children. Parents have special obligations toward them and they should lovingly care for them without (absurdly and counterproductively) trying lovingly to care for all—or even many—other children and without their having the same obligations to them that they have to their own children. But in acknowledging this and acting on it, they need not—and indeed plainly ought not—to regard their own children as more valuable, more deserving, or being owed (except by them and others close to them) special protection that is not similarly owed to all other children. In both cases, without needing to, or indeed being justified in, narrowing their moral vision, they are acting there on the ground where they are. Morality, as Hegel taught us, must have this concreteness and contextuality. Without it, moral life would be impossible. But this does not mean that morality should be against universalism and by doing so turn itself into tribalism (O'Neill 1996 and Nielsen 1998–99).

Similarly, a liberal nationalist will stress the importance of self-governance for her nation, but not (pace Barry's portrayal of nationalism) at the expense of running roughshod over other nations or violating human rights (Barry 1987). Just as self-governance is a very central good for her nation, so it is for every other nation as well. All nations, she will recognize, have—the members of the different nations not differing in their needs here—an equal claim to this good. Only if she thought, and *with very good grounds,* that they were, even with the aid of a little "affirmative action," *incapable* of self-governance, would she be justified in rejecting this claim to an equal right of all nations to self-governance. But for that not to be an ideological mystification or a rationalization for hanging onto privileges, it must be the case that there really is an incapability there that is not rooted in remediable poverty, ignorance, and exploitation (past or

present). "Ought" indeed implies "can," but we have to be careful that the incapacity is not rooted in remediable contingencies. But it is necessary clearly to recognize that it is very unlikely that it could be rooted in anything else.

Tragically, where two nations have a valid claim to the same land—say, the Israelis and the Palestinians—this will lead, as we well know, to very difficult situations where there may be no ideal solution. But for liberal nationalists—and remember my kind of liberal nationalists are *social* liberals—there must be, respecting human rights and reasoning in accordance with substantively egalitarian principles of justice, a resolution by a fair compromise respecting equally the interests of everyone involved and discounting any bargaining from positions of superior strength (Rawls 1993, 16–17).

Certainly, in practice, that is not how most nationalists have acted. They have not only sought (reasonably and correctly) to protect their nations' interests, but to see that they prevail over the interests of other nations and not infrequently at whatever costs to others. But that, by definition, is not how a liberal nationalist can behave. A liberal nationalist must recognize that all nations are in the same boat here; they all want to protect their own nationhood and see it flourish. But they will also acknowledge, if they are liberal nationalists, that from the moral point of view equal consideration must be given to the interests of every nation and that no nation's interests can be privileged. However rare such a taking of the moral point of view is in real-life politics, however far it is from the dirty world of *realpolitik*, such liberal nationalist behavior (such a taking of the moral point of view) is compatible with a robust, but reiteratable, nationalism. It is, that is, compatible with the firm valuing of nationality, with each nation seeking (though within the limits of fairness and certainly not at all costs) to protect the integrity of its own nation and to the sustaining of (where it is in place) or the seeking of (where it isn't) some form of self-governance for one's nation. But it is not, of course, compatible with the drive for my nation *über alles*: the running roughshod over other nations, the taking of one's own nation to have a manifest destiny. Hitler was a populist and a nationalist with, at least in his early days, a lot of popular support in Germany and Austria, and even to a certain extent beyond, but he was, to repeat a commonplace (and to very much understate the matter), a nationalist of the wrong sort (Craig 1997 and Luckas 1997). If we wish to attain any moral and intellectual clarity, we must not, however, let this unforgettable paradigm, with its many downscaled present-day barbarous incarnations, block our understanding of the possibilities of a liberal nationalism and a recognition of the occasional reality of their actual exemplifications (Couture and Nielsen 1996, 579–62, Kymlicka 1995b, and Nielsen 1996–97).

II

Why should a social liberal and a cosmopolitan be a liberal nationalist? I shall argue that, in conditions of modernity, or (if you will) "post modernity," liberal nationalism (where nationalism has some point) better anchors: (1) self-identity and, with that, increasing the possibilities of human flourishing and (2) more adequately than the other alternatives, giving democratic empowerment to people, thus contributing to their democratic life, all this understood within the bounds of justice as fairness or justice as impartiality, or some improvements on these egalitarian and social liberal conceptions of justice (Rawls 1971 and Barry 1995). I now turn to explicating and defending these claims.

I first turn to self-identity (the having a sense of oneself as being a certain kind of person). We human beings have a deeply embedded and ubiquitous interest in something that gets called, perhaps rather pretentiously, self-identification or self-definition (Berlin 1991, 238–61, G. A. Cohen 1988, 132–54, and Nielsen 1998b). We have a very strong need to retain a sense of who we are and, in the doing of this, we need to see ourselves as a we. And, important as this is, it will not suffice just to affirm that we are human beings. It will not do to try to root our self-identification just to our humanness—what we have in common with all other human beings. In trying to gain some adequate sense of who we are we need a more local identity as well. We need—and this is the cosmopolitan and humanist impulse—to see ourselves as members of the party of humanity, but we also need to have a sense of our particular bonding (Barber 1996). Without that, we are, humanly speaking, at sea. Anthony Appiah has well argued that we need, if we are to flourish, to have a keen sense of our local identities (Appiah 1996). We need, along with whatever cosmopolitan identities we aspire to and, perhaps to some extent attain, also to locate ourselves as members of a particular human community with its distinctive ways of being and doing. We need to know who we are and how our identity connects us with certain particular others, since, after all, we are not Hobbesian atoms. The very idea of such "cultureless human atoms" is incoherent (Berlin 1976). Cultural membership and group identity is a fundamental need of all human beings. It fits, as Kymlicka has well argued, Rawls's conception of a primary good (Kymlicka 1989, 166–69).

In the complex societies of contemporary life, where the state form is either that of the nation-state or some form of the multination-state, our group identity takes the form (though that does not exhaust it) of a national identity. It is a central and inescapable element of our self-definition, of our sense of who we are, even though it sometimes, perhaps often, will play a rather minimal role in our actual conceptualizations of who we are, or in our sense of our moral identity (Rawls 1993, 30–31). We may

care very much more about our relations with very particular others (our being a father, a spouse, a colleague, a friend) or about our work, our particular political commitments and identities, or about our religion or lack thereof, than we do about our nationality. For me, for example, my political identity, my being a socialist and a social liberal, is much deeper than my sense of nationality as is, as well, my sense of my being (as part of a deep sense of vocation) a critical intellectual (to be pleonastic). But such things, however true they are, do not undermine the nationalist project or show that we do not need, in the societies in which we live, or could plausibly be expected to come to live, a sense of national identity.[4]

However, this certainly does need an explanation. The liberal nationalist is not saying, or even suggesting, that we should reverse our priorities here and see our sense of nationality as the central thing: the thing that should be most important to us in coming to understand who we are or in setting our life priorities. But to say this is not at all to deny that national identity is not important. Moreover, the weight we should give to considerations of nationality will vary with the security of our nation.[5] The situation is very different for a Basque or a Kurd than it is for a member of a German-speaking or French-speaking Swiss canton (where their cantons as they are are perfectly secure). Similarly, it is very different for the First Nations in Australia, Canada, New Zealand, and the United States than it is for the dominant nations (the settler nations) that surround and dominate these First Nations. It is the elites of the latter and not the First Nations that have a grip on the state apparatus—the state in which the First Nations are embedded. But nothing of what I said above gainsays what I said about nationality and self-identification in modern societies. In such societies—as in all modern societies—national identity is a primary good, but in some circumstances it is secure, and in others it is not.

What liberal nationalists are reminding us of is that, in a world of nations embedded in nation-states or multi-nation states, the nation of which we are a part provides the framework in which these other sides of our identities are formed, sustained, conceptualized, and realized. Nations are encompassing cultures, that, in being encompassing, are political communities (though not in Rawls's strong sense of "community") which are almost invariably associated with a homeland (perhaps only an imagined homeland) and which aspire to some form of self-government, though not necessarily to independent statehood (Rawls 1993, 42, 146, and 201). The people in a nation (where they are not in a condition of very deep alienation) recognize themselves as belonging to the same community, as sharing a common history, typically speaking a common language and having a common public culture. These are things which, taken together, differentiate them from their neighbors. Moreover, this is a common culture which structures the way in which their other relations are formed and real-

ized in the nation. How one is a mother, a colleague, a friend, an artist, a nurse, a businessman, a priest, a painter, a postal worker, or whatnot is significantly (sometimes deeply) affected by this comprehensive (organizational) culture. Globalization has not wiped that away. Or perhaps we should say, with a shudder, "At least not yet."

In modern societies such a comprehensive culture is very much in the background of the beings and doings of their members. It provides their cultural context of choice without which they could not make sense of their lives or, to put it more actively, we could not make sense of our lives. For us, situated in the context of modernity, there would be no cultural membership, no group identity, without a sense of nationality structuring it, providing the organizational comprehensive culture framing and sustaining our other identities. Our situation is very different from that of the people living in the stateless societies of medieval Iceland as they are depicted in the Sagas. Without our distinctive national identities we would be lost: there is no standing outside these comprehensive cultures and living a life (Berlin 1976). The very idea of doing this makes no sense at all (Wittgenstein 1969, Davidson 1984, 183–98, and Rorty 1991, 93–172).

We have, as I have argued, a need—a very deep need—for self-identification and self-definition. In the context of our particular, distinctively historically situated lives—something that is inescapable for everyone in our societies—national identity will be a nonnegligible part of that, even though it is not a part that in most circumstances we are adverting to, but its import for us will be felt when it is threatened or thought to be threatened. It is something which, at least strategically and instrumentally, is central in the lives of people in modern societies. Nations are not about to wither away, and a postnational identity is not just around the corner.[6] Having a sense of national identity is a key element, but surely not the sole element, in our retaining a sense of who we are.

Most of us do not change our identities or at least we only change them in superficial ways. Even where we are the exception and not the rule, and we do over time gradually (most of us are not like Saul on the road to Damascus) in good Parfitian style change our identities rather deeply—become rather different persons with different priorities, commitments, different ways of reacting and responding to the world—still, for all of that, we do not, *individualistic* liberalism to the contrary notwithstanding, just *choose* our identities. The identities that we have are normally not even experienced as being matters of choice. Rather, where they change, though typically to some extent marked by our own endeavors, that change is deeply affected by our circumstances—often conflicting circumstances—and our change is not something chosen out of the blue.[7] And even in the case in which individuals change some bits of their ways of being and doing, it is misleading to say that they choose a new identity,

that what comes into place is just chosen. Rather, what happens is that an individual in extensively altering her life is responding to a host of things in her culture and environment that affect her, and typically in conflicting ways. In responding to all of these pressures and considerations, she changes some ways in which she lives and how she views herself. But she hardly "chooses herself" or chooses a new identity. As a deeply culturally embedded person (something we all are) she makes, working with what she has, some renovations.

In the standard case the comprehensive culture of which we are a part, along with (in many instances) even more localized cultural effects, such as our religion (or lack thereof), our ethnic group (if any), our class, our sexual orientation, our more specific political orientation (being a Communist, a Libertarian, a Green) provide the cultural context in which we make our choices. But among the choices we make there is no choice of our identities, though we may deliberately, and sometimes reasonably successfully, seek to alter them. But this change will always be within limits, limits hardly specifiable in advance and certainly not rigid. Still, our identities pretty much come with our distinctive socialization. We grow into the world speaking a certain language and, with that language or languages, absorbing a certain culture. In some rare instances, like the two main characters in Andrei Makine's *Le testament français,* people are split between two conflicting comprehensive cultures (in this instance Russian and French) and the people involved are tugged in different directions and develop various blind spots and ambivalences, but still, as in the above instance, these conflicting national identities are both deeply there, though probably for most such people one is more deeply there than the other. But it is not that such people are without a national identity, have (pace Omar Dahbour) their basic identity in some subunit more local than a nation (Dahbour 1996, but see Couture and Nielsen 1996, 592–612). But in these rather rare cases their national identity is to some extent a polynational identity. They have, that is, cultural membership in two nations, sometimes with senses of nationality that are at war with each other within their own breasts. Still, they have national identities, though not a single one. It isn't that they have gone *überhaupt* to a "postnational identity."

The crucial thing to see here is that they have not transcended these national identities into some "postnational identity." Moreover, these are unusual cases; in the more standard case as our socialization proceeds—as the comprehensive culture becomes more firmly a part of us as we grow into adolescence—we come, usually, without thinking about such matters very much, to have ("adopt" would make it too voluntaristic) certain customs, ways of looking at things and characteristic attunements. In Makine-like cases socialization, of course, also goes on, but it comes from two

conflicting sources, producing a keen awareness (sometimes mixed with self-deception) of these disparate national identities. In, for example, the case of the narrator in *Le testament français,* his Russianness is much more dominant than he realizes (Tolstoya 1997). But my central point is that, both in the typical case and the nontypical case, the national identities are there and deeply embedded. And it is a Nussbaumian cosmopolitan prejudice to think they must be hostile or even enfeebling to cosmopolitanism. These identities, though not as iron bonds, are prime generators of our reflective sense of self, our sense of who we are. We cosmopolitans cannot set aside our local identities as we change our clothes, for they are crucial to our lives—as they are to the life of any person—and hardly voluntary. Part of our identity, and as something which is inescapable, is particular and local. It can change, and sometimes deeply, but it is still, in one form or another, something which is powerfully there and a locality (a habitation and a home) remains though it may in time come to be a very transformed one. But in certain ways local it will remain. We cannot become *just* citizens of the world. We cannot simply be, though it is, normatively speaking, also vitally important that we be, of the party of humanity.

The point is that we—or at the very least most of us—have this need for having a particular culturally determinate identity. It is not enough for us to think we are members of the biological species *Homo sapiens* or that we just identify (more accurately attempt to identify) with humanity at large without at the same time identifying with some particular subunit of that humanity. It is not enough because we need, as well, whatever our universalistic commitments, to have a sense of who we are. To have this sense is to have some more particular identification, an identification which is, and must be, historically and culturally rooted. We should, of course, be cosmopolitans, but *rooted* cosmopolitans—the only kind that it is in fact possible to be (Mitchell Cohen 1995, Appiah, 1996 and Barber 1996).

To attain clarity and some reasonable moral adequacy, we must firmly recognize that our self-identifications can be, and often are, illusory and ideologically distorted and that either religion or nationalism, or both working together, have been, and not infrequently, the source of such distortion: the source of what Marxists call "false consciousness." But that does not gainsay the Herderian point that we cannot (extreme circumstances apart, and then only in a particular context) just relate to our fellow human beings as members of the same biological species. If we are socialists and (to be redundant) cosmopolitans (Stalin's campaign against cosmopolitanism notwithstanding), we may try to be something like that. However, if we are tolerably clear-headed, it will not be exactly that, for that is impossible. We will, and rightly, be egalitarians and egalitarians of a robustly substantive sort, and we will take an interest in, and be in

solidarity with, the struggles of the various peoples around the world (Nielsen 1985). We will not, in a fundamental sense, put our compatriots first (Pogge 1996). We must be like that—by definition, if you will, must be like that—if we are to be social liberals or socialist cosmopolitans. (The 'or' here is, of course, not exclusive.) But, if in doing this, we try to set aside local attachments, we will impoverish our lives and have as well an impoverished view of the world. We should, of course, struggle to escape ethnocentricity. But ethnocentricity is one thing, local attachments another. If we would be socialists, or more generally social liberals, we need to align our local attachments with cosmopolitan ideals. We need coherently to integrate our local attachments with a universalistic moral point of view that is committed to moral equality (O'Neill 1996). That is to say, to a moral point of view which takes it as settled that the life of everyone matters and matters equally (Nagel 1979, 106–27). So, at least in this way, even to be persons, we must have our local attachments as well. Without them we will have no sense of who we are and we will be unable to have any attachments, including, of course, larger more universalistic attachments.

III

I turn now from arguing for the importance of national identity as providing grounds for claiming that liberal nationalism (where there is a need for it) is the best carrier of cosmopolitanism, to arguing for it as furthering democracy more fully than the cosmopolitan alternatives which are not liberal nationalisms.[8] (I speak here of those contexts where there is a need for liberal nationalism. As we have seen, where a nation is secure there is no need for a nationalist movement. But there is still a need on the part of its members to have a good sense of national identity, to be aware of its importance, and it is as well important for the people in such secure nations to recognize the validity of liberal nationalist movements where a nation is insecure.)

There is an impediment to so considering things which I must first discuss. It is both tempting and easy for us, particularly if we live in the rich capitalist democracies, to be cynical about democracy. We will not, if we are reasonable, wish for the abandonment of universal suffrage (or tolerate its abandonment when we can do anything about it) or the abandonment of representative democracy, no matter how much we would wish to see some more participatory elements come on stream. But while so responding, and here we respond as the vast majority of our fellow citizens do, we can still readily, and consistently with this, come to think of our actually existing democracies as farcical, standing at a very great distance from the attractive conceptions of democracy articulated—and variously articu-

lated—by John Stuart Mill, John Dewey, Joshua Cohen, Frank Cunningham, Andrew Levine, Jürgen Habermas, John Rawls, Claus Offe, and Michael Walzer. Actually existing democracy largely consists in spending a few seconds marking a ballot or operating (as in the United States) its mechanical equivalent. The democracy that we live with and which controls our political lives consists, for the most part, in doing that and in passively listening to "political discourse" as brief, usually silly, sound-bites on radio or television, of our viewing negotiated and managed unspontaneous "debates" between our major political candidates, of our viewing, hearing, or reading undetailed, unnuanced and for the most part unreflective media discussion of what gets selected out as "the issues" with little attention to input from the grass roots. There is in our mass democracies, with their staged political events, little concern for actual citizen participation. Indeed it is exactly that that is not wanted. What is desired is just the opposite: a passive and ignorant electorate. Candidates are selected by elites largely, but not entirely, from elites. It is necessary for a candidate with any real chance of winning to have massive campaign funding. And the sources from which much of this money comes is not even remotely democratically determined, though some of the rich capitalist democracies (for example, the United States) are worse here than others (for example, Sweden). But generally wealth calls the tune. This, and other things cut from the same cloth, is what democracy is for most citizens of such societies. And things are usually even worse—sometimes much worse—elsewhere. Moreover, things of this sort are reasonably evident to most of the educated population of the rich capitalist democracies. And rather more inarticulately to many others as well, notwithstanding their lousy media sources. But still such knowledge causes no great stir. "So what else is new?" is a not unlikely reaction.

All that notwithstanding, we would still struggle very hard to keep "the vote," thinking with horror of countries without it or effectively without it, like the old South Africa, the former Soviet Union or present-day Burma, Kuwait, Saudi Arabia, and Iraq. We are likely to repeat to ourselves, when feeling the force of such considerations, some version of the old saw that democracy is the worst system imaginable except for all the others. Still, if not in its details, at least in its general thrust, something like Noam Chomsky's view of political life in the rich capitalist democracies, and most particularly in the United States, is very compelling.

So the prospects for democracy are bleak and may well be getting bleaker (Nielsen 1995). But, as Antonio Gramsci will not let us forget, we are participants in our world and not just spectators. However cynical we are about democracy, still, if we could have it, or even something which approximates it, we would want something very like what John Dewey persistently portrayed and what John Rawls models with his conception of

political liberalism (though we would pay much more attention than he to workplace democracy and to issues concerning power). There are vast structural differences of power in all our liberal societies. If they are inescapable, there will be little equality in other domains as well, or autonomy either. What anguishes us, and prods us to rethink what is to be done, is our recognition of the great distance our actual democracies are from such conceptions as we find in Dewey and Rawls.

My contention is that in modern industrial ("postindustrial," if you will) societies, cosmopolitan liberal nationalisms can achieve, where nations are insecure, if their projects for society are successful, more adequately some little something of democracy than their alternatives in such situations. All of our societies are badly off and their democratic prospects are bleak. They may even be getting bleaker, though that is not so sure. But the prospects are a little less bleak for social democratically oriented liberal nationalisms as well as for societies such as Norway and Finland, which are secure nation-states (secure in their nationhood and comprehensive culture), and thus in no need of a nationalist agenda and movement.

Democracy is essentially about popular self-governance: about the governance of "we the people."[9] Nation-states and multi-nation states, having nations as component parts, are for us the most likely democratic options. Both are made up of either a nation or of nations. When we speak of a nation we are, as we have seen, speaking of a people organized as a political community (Kymlicka 1995b). Popular self-governance and sovereignty is, of course, talk about you and me and the rest of us having control over our lives, including very centrally control over, as far as that is humanly possible, what our society is to be like and how it will develop. But, while remaining individuals—what else?—with all the value that accrues to individual autonomy, we are also members of a nation (in some instances nations) and, as we have seen, our very identity is tied up with that. It is as *a people* (a nation) that we primarily exercise *political* self-governance. And it is nations that can claim sovereignty and sometimes have it. In wishing to be *maître chez nous*, it is centrally for us as a people (as members of this "we") that we wish to have it, though, as well, we wish to have it (or at least many of us do) for ourselves as individuals. Many of us despair of getting anything like this. We tend to think belief in it is an ideological illusion. But for most of us, if we could have something in that neighborhood, we would grab it with both hands. It would be of crucial significance for us without at all being the whole of our lives. But while utopia is certainly not around the corner, it is not clear that nothing can be done that would yield a little bit more by way of self-governance than what we now have. And, where nations are at risk, a robust and intelligently designed and carried-out liberal nationalism will further democratic aspirations without at all undermining individual rights.

I will flesh this out a little. Given the strategic importance of nations, democracy is best attained by a liberal nationalism or by a people, generally with social liberal commitments, organized in a nation-state or multination state, which would be nationalistic if their nations were threatened. Both realize democracy more adequately than the other forms of political liberalism, including its antinationalist cosmopolitan forms. People are, though, of course, variously, *a people;* they always have a group identity and, under conditions of modernity, this takes the form of a national identity. With their distinctive interests and an understanding of their own culture, when they can freely act politically individually and as a people, they are more in control of their lives than they otherwise would be. This being so, they can better govern themselves than if they are governed by others (alien others). The same thing obtains where, as a smaller unit in a much larger political unit, they end up, concerning the bargaining and compromises that go on between the bigger and smaller units, having less say than their bigger brothers. This obtains where there are two or more nations of unequal size and strength in a single state which is not a genuinely multination-state. This can be overcome, or at least ameliorated, where these nations split into independent nation-states or organize themselves as a genuinely multination-state with equal status for each component nation and with significant self-governance for each nation regardless of size as an equal sovereign nation in a multinational federation. Here we should also recognize, particularly in our interdependent world, that there is nothing like "absolute sovereignty" (Pogge 1994).

So, with all of democracy's discontents, nations remain crucial to democracy under conditions of modernity—under, that is, foreseeable conditions for us. Where a nation lacks self-governance, where people cannot be *maître chez nous,* to that very important extent, democracy is undermined. Where we have a *pseudo*-multination-state—Canada is arguably an example—where some of the component nations lack such self-governance and equal status, then, to that extent, democracy is weakened.[10] It is in bad shape anyway, but without, where nations are endangered, the effective ethos of liberal nationalism, it is in even worse shape. A pseudo-multination-state cannot help but be a very imperfect democracy in a very imperfectly democratic world—imperfect, for among other reasons, the reasons to which I have just adverted.

To translate into the concrete what I mean by the very imperfectly democratic world faced by nation-states, genuine multination-states and pseudo-multination-states alike, consider the present situation of Quebec. It is as thoroughly a liberal democratic society as most societies in the rich capitalist democracies and more so than some. Still, to suggest how imperfect as democracies our rich capitalist democracies are, consider the fact that Quebec may gain its independence while still continuing to be ruled

by elites (though now by its own governing elites). Moreover, without democracy coming to the workplace, Quebec (like all the other rich capitalist democracies, though some more so than others) will still continue to be dominated by a capitalist class. And democracy may not (most probably will not) be extended to smaller units of people, so urgently argued for by socialist anarchists and "greens," smaller units that would have, where they become active elements in the civil society, the solidarity so essential for democratic life, and which would give us something on which we can build, so that with them we would come to have effective units—or so the belief goes—to resist neo-liberal capitalist globalization (Dahbour 1996). Quebec might gain independence without gaining any of those things. Put more bluntly, Quebec sovereignty, if it becomes a reality in a few years, is not likely to bear any of *those* democratic fruits.

Some think I am being too pessimistic here and that with the somewhat social democratic orientation of some of the key players on the sovereignist side and, more importantly, the actual civil society of Quebec, there might be more resistance to capitalist globalization and the like than I believe is likely. I remain skeptical here, but it is something that we can hope will obtain. However, even if my pessimism is a telling it like it is, it does not at all mean that sovereignty would not inch democracy along in Quebec. Just that, given that it is liberal nationalism that is at issue—as it is—would justify Quebec's secession (Nielsen 1996–67 and Nielsen 1998a).

Still, liberal nationalism is not, nor is anything else, a magic wand that will solve all our—that is Quebec's—political ills, yielding the full component of democratic life so essential for human flourishing. If in the next few years Quebec gains its independence, it will not carry with it these wonderfully democratic things—things that surely would enhance human flourishing. The most that can be hoped for is that it will move its citizens an inch or so closer to being able to achieve them. But, even without such an inching, it will to some extent advance democracy. If sovereignty is gained in Quebec (and this can and should be generalized to other nations similarly situated), if, that is, its liberal nationalist agenda pays off, it will give a people—and that is what Quebeckers are—a little more control over their lives than they would otherwise have. And that certainly is not nothing.

It is essential to remember here that we have been speaking of a liberal nationalism construed as a social liberal nationalism and not of nationalism *sans phrase*. As a social liberalism, it will, fitting the model of political liberalism profoundly articulated by Joshua Cohen and John Rawls, have a political conception of justice with its determinate principles of justice for our basic institutions and social practices (Joshua Cohen 1989 and 1994 and Rawls 1993). There are here principles which are designed to protect equal basic liberties for all and, with them, the civil and human rights of

individuals. It will, while seeking solidarity as well (something underplayed in our societies), seek a proper balance of equality and liberty while protecting both and seeking to extend them. This model will make us see how very deeply equality and liberty depend on each other. We cannot have one without the other. (This is the central thrust of the work of John Rawls and of central portions of the work of Ronald Dworkin, G. A. Cohen, and Amartya Sen.) This means that the liberties of the ethnic and national minorities in a sovereign nation (sovereign in either their own nation-state or in a genuine multination state) will be fully respected. They will either actually have full citizenship or have available to them (as immigrants) the unencumbered right, once they have met certain clearly specified conditions, to attain full citizenship. It will also be the case that their civil liberties will be protected, their distinctive ways of life as ethnic minorities respected, their historical rights as national minorities protected and neither group will in any way be excluded from the life of the nation. This is, if you will, analytic of liberal nationalism. Nationalism cannot be liberal without having all these features. To the extent that it lacks any of them, then, to that very extent, it will not be a liberal nationalism. Such things are built into the very idea of liberal nationalism.[11] Moreover, liberal nationalism is not just an idea in the heads of some intellectuals, but has exemplifications (imperfect though they be) in some liberal societies. Scotland, Belgium, Quebec, Catalonia, and Wales come to mind. And Norway, Iceland, and Finland were exemplifications in the past when there was the need for a nationalist agenda in those societies.

I have argued not only for the compatibility of cosmopolitanism and liberal nationalism, I have argued as well that liberal nationalism—as a social and political liberalism—more fully realizes the ideals of cosmopolitanism (where nations are insecure or reasonably believed to be insecure) than a nonnationalist, to say nothing of an antinationalist, cosmopolitanism. Here the idea of a political liberalism, as opposed to neo-liberalism, is important and was stressed. In articulating this liberal nationalism, the role and import of both national identity and the democratic self-governance of nations in enhancing human flourishing was argued for. Cosmopolitan liberal nationalism is not an oxymoron. Quite to the contrary, "a cosmopolitan liberal nationalism" is a pleonasm.[12]

KAI NIELSEN

Concordia University
Montreal

NOTES

1. Sometimes these individualistic liberals are also libertarians, but not all individualistic liberals would feel comfortable with the label 'libertarian', so I use the more inclusive designation.

2. What I intend by 'adequate' here will become clear, I hope, as my argument unfolds. I am generally here speaking of forms that will be adequate from a reflective and informed political and moral point of view: forms that we would, as moral agents, reflectively endorse when we are well informed and being impartial.

3. That is the sense that the idea of a primary good has in Rawls's thought. See John Rawls (1971, 62 and 92–93) "primary goods . . . are things which it is supposed a rational man wants whatever else he wants. Regardless of what an individual's rational plans are in detail it is assumed that there are various things which he would prefer more of rather than less. With more of these goods men can generally be assured of greater success in carrying out their intentions and in advancing their ends, whatever these ends may be" (92). A page later Rawls adds "Now the assumption is that, though men's rational plans do have different final ends, they nevertheless all require for their execution certain primary goods, natural and social. Plans differ since individual abilities, circumstances and wants differ; rational plans are adjusted to these contingencies. But whatever one's system of ends, primary goods are necessary means" (93). As he puts it in Political Liberalism, primary goods are "general all-purpose means" (188). They are things that we need for whatever it is that we may want to do.

4. National identity is a central form of group identity in conditions of modernity. But it might be responded that claims about group identity being a primary good sit badly with the above argument in my text. However, I think not, for a primary good is a strategic good. It is something that is necessary for our achieving our aims, but it does not follow from that that it is what we value the most highly, but rather it is something that we, if we are thinking at all clearly, will recognize is necessary (causally necessary) for us to have in order to attain our ends, whatever they are. A primary good is, that is, as I have quoted Rawls saying, a general all-purpose means. But it need not be the case that we see our nationality (our comprehensive cultural membership) as being the most important thing in our lives. Indeed its being so would be very strange. What is strategically central may also be an inherent or intrinsic good, but it need not be. I take no position about whether a primary good (any primary good) is also an inherent or intrinsic good. Moreover, it could be an inherent or intrinsic good without being the highest good, if indeed there is such a thing. What it is vital to recognize is that there would be little in the way of securely realizing our life plans, whatever they are, without cultural membership, without a secure national identity.

5. It is important to keep firmly in mind the difference between (1) the importance that we give (consciously and deliberately) to our national identity and (2) the strategic importance, often unnoticed by people, of national identity in the formation and the sustaining of their personal identities. In speaking of the importance of national identity and of how it is a primary good, we are concerned with (2). That is compatible with people not giving it a high priority in their lives and

its not being much of a factor in their sense of self. They may well only come to recognize how important it is to them when they are threatened with its loss. I owe this, or something rather like it, to Jocelyne Couture.

6. It is not crystal clear what is meant by "postnational identity," though I do not think it is bandied about as loosely as "postmodernity." I think "postnational identity" is something like the idea of people coming to have a sense of their being Europeans as distinct from being French, German, Italian, and the like or being Latin Americans (Bolívar's dream) as distinct from being Argentinians, Brazilians, Colombians, Chileans, Cubans, and the like. The idea is that their being (for example) good Europeans is far more important to them than their being good Germans. To have such a sense of identity is to have a postnational identity. The idea seems to me to rest on a false contrast, for why should there be a conflict, for example, between being Dutch and being European? Only if our sense of nationality was nonliberal or the nation-state of which we are members is illiberal would there be a necessary or even a presumptive conflict.

7. This might be thought to conflict with my Rawlsian stress on autonomy. People, and as something of their own doing, have their own life-plans, goals, and ideals. And these things are important to them and to their sense of who they are. All of this is true, and importantly so, but it does not contradict or even stand in tension with my claim that we do not choose our identities and that what we are grows out of our circumstances. We are not prisoners of our circumstances, but they provide us with the context of cultural choice. Human beings, Marx well said, make their own history, but not in circumstances of their own choosing. Situated selves and autonomous selves are not alternatives. There is no anti-Rawlsian commitment to communitarianism in what I am saying here.

8. One reader has responded in the following way to my argument in II. "Your argument," this reader remarked, "principally shows that even cosmopolitans need local identities, but that we would be better cosmopolitans if we are also liberal nationalists (or will stand in solidarity with liberal nationalists where our own nation is secure and their nation is insecure) is another matter altogether and has not been established by your argument." But, *au contraire*, if my argument is sound that in conditions of modernity, group identity, and with that, local identity, requires national identity, then to show, as the objection accepts, that cosmopolitans need local identities is to show that they need national identities in the circumstances of contemporary industrial or "postindustrial" societies. The only way to have a local identity, or at least a secure one, in such circumstances is to have a national identity.

9. Though we must add as well, as Rawls stresses, the need for a firm constitutional basis with what he calls "constitutional essentials" in place (Rawls 1993, 165–67).

10. It may be that they have a de jure equal status, but not a *de facto* equal status, but for the multination-state to be a genuine one the component nations must have both de jure and de facto equal status. Otherwise talk of equal status is a fraud.

11. It is a blemish on the democracy of the United States that no immigrant can become President of the United States. This means that full citizenship is

denied immigrants and so there are legally sanctioned grades of citizenship, some full and some not. This hardly becomes any democratic nation and most particularly not a settler nation.

12. I am grateful to Jocelyne Couture for her perceptive criticism of earlier versions of this essay.

BIBLIOGRAPHY

Appiah, Kwame Anthony. 1996. "Cosmopolitan Patriots." In *For Love of Country,* ed. Joshua Cohen. Boston, MA: Beacon Press, 21–29.

Barber, Benjamin R. 1996. "Constitutional Faith." In *For Love of Country,* ed. Joshua Cohen. Boston, MA: Beacon Press, 30–37.

Barry, Brian. 1987. "Nationalism." In *The Blackwell Encyclopaedia of Political Thought,* ed. David Miller. Oxford: Basil Blackwell, 352–54.

———. 1995. *Justice as Impartiality.* Oxford: Clarendon Press.

Berlin, Isaiah. 1976. *Vico and Herder: Two Studies in the History of Ideas.* London: Hogarth Press.

———. 1980. *Against the Current.* New York: The Viking Press.

———. 1991. *The Crooked Timber of Humanity.* New York: Alfred A. Knopf.

Cohen, G. A. 1988. *History Labour and Freedom: Themes from Marx.* Oxford: Clarendon Press.

Cohen, Joshua. 1989. "Democratic Equality." *Ethics* 99, no. 1: 727–51.

———. 1994. "A More Democratic Liberalism." *The Michigan Law Review* 92: 1506–43.

Cohen, Mitchell. 1995. "Rooted Cosmopolitanism." In *Toward a Global Civil Society,* ed. Michael Walzer. Providence, RI: Berghahn Books, 223–33.

Couture, Jocelyne. 1998–99. "Liberals and Cosmopolitans." *Imprints* 3, no. 3: 156–67.

———. 1999. "Cosmopolitan Democracy and Liberal Nationalism." *The Monist* 82, no. 3: 491–515.

Couture, Jocelyne, and Kai Nielsen. 1996. "Liberal Nationalism both Cosmopolitan and Rooted." In *Rethinking Nationalism,* ed. Jocelyne Couture et al. Calgary, Alberta: The University of Calgary Press, 579–663.

Craig, Gordon. 1997. "Hitler the Populist." *The New York Review of Books* IV, no. 1: 20–23.

Dahbour, Omar. 1996. 'The Nation-State as a Political Community." In *Rethinking Nationalism,* ed. Jocelyne Couture *et al.* Calgary, Alberta: The University of Calgary Press, 311–44.

Davidson, Donald. 1984. *Inquiries into Truth and Interpretation.* Oxford, Clarendon Press.

Kymlicka, Will. 1989. *Liberalism, Community, and Culture.* Oxford: Clarendon Press.

———. 1995a. *Multicultural Citizenship.* Oxford: Clarendon Press.

———. 1995b. "Misunderstanding Nationalism." *Dissent,* 130–37.

Luckacs, John. 1997. *The Hitler of History.* New York: Alfred J. Knopf.

Nagel, Thomas. 1979. *Mortal Questions.* Cambridge: Cambridge University Press.

Nielsen, Kai. 1985. *Equality and Liberty: A Defence of Radical Egalitarianism.* Totowa, NJ: Rowman Allanheld.

———. 1995. "Reconceptualizing Civil Society for Now: Some Somewhat Gramscian Turnings." In *Toward a Global Civil Society,* ed. Michael Walzer. Providence, RI: Berghahn Books, 41–67.

———. 1996–97. "Cultural Nationalism, Neither Ethnic Nor Civic." *The Philosophical Forum* 28, no. 1–2, 42–52.

———. 1998a. "Liberal Nationalism, Liberal Democracies and Secession." *University of Toronto Law Journal* 48, 253–95.

———. 1998b. "Socialism and Nationalism." *Imprints* 2, no. 3: 208–22.

———. 1998–99. "Cosmopolitanism, Universalism and Particularism in an Age of Nationalism and Multiculturalism." *Philosophic Exchange,* no. 29: 3-34.

Nussbaum, Martha. 1996. "Patriotism and Cosmopolitanism" and "Reply." In *For Love of Country,* ed. Joshua Cohen. Boston, MA: Beacon Press, 2–20 and 131–44.

O'Neill, Onora. 1996. *Towards Justice and Virtue.* Cambridge: Cambridge University Press.

Pogge, Thomas W. 1994. "Cosmopolitanism and Sovereignty." In *Political Restructuring in Europe: Ethical Perspectives,* ed. C. Brown. London: Routledge, 9–122.

———. 1996. 'The Bounds of Nationalism." In *Rethinking Nationalism,* ed. Jocelyne Couture et al. Calgary, Alberta: The University of Calgary Press, 463–504.

Rawls, John. 1971. *A Theory of Justice.* Cambridge; Harvard University Press.

———. 1993. *Political Liberalism.* New York: Columbia University Press.

Rorty, Richard. 1991. *Objectivity, Relativism and Truth.* Cambridge: Cambridge University Press.

Tolstoya, Tatyana. 1997. "Dreams of My Russian Summers." The New York Review of Books XLIV, no. 18: 4–6.

Wittgenstein, Ludwig. 1969. *Über Gewissheit.* Oxford: Basil Blackwell.

Contributors

ELIAS BAUMGARTEN, Associate Professor of Philosophy at the University of Michigan at Dearborn, is also a Research Associate for Middle Eastern and North African Studies at the University of Michigan at Ann Arbor.

GILLIAN BROCK is a Senior Lecturer in Philosophy at the University of Auckland, New Zealand. She has written on various topics in ethics, applied ethics, and political philosophy. Much of her work has focused on human needs and the work they can do in moral and political philosophy. She is the editor of *Necessary Goods: Our Responsibilities to Meet Others' Needs* (Rowman and Littlefield, 1998). Her articles have appeared in journals such as *Ethics, Analysis, Public Affairs Quarterly, Philosophia, The Southern Journal of Philosophy, The Monist, Dialogue: Canadian Philosophical Review, The Journal of Business Ethics*, and *Business Ethics Quarterly*.

JOCELYNE COUTURE has her doctorate in philosophy (Logic and Philosophy of Science) from the University of Aix-Marseille I. She is Professor of Philosophy (Ethics and Political Philosophy) at the department of philosophy of the Université du Québec à Montréal. She is editor of *Ethique et rationalité* (1992) and co-editor of *Ethique sociale et justice distributive* (1991), *Meta-philosophie/Reconstructing Philosophy?* (1993), *The Relevance of Metaethics* (1996) and *Rethinking Nationalism* (1998). She has published papers in ethics, political philosophy, methodology of social sciences, decision theory, logic, and philosophy of mathematics.

ROBERT E. GOODIN is Professor of Social & Political Theory and Professor of Philosophy in the Research School of Social Sciences, Australian National University. He is the founding editor of the *Journal of Public Policy* and coauthor of, most recently, *The Real Worlds of Welfare Capitalism* (Cambridge University Press, 1999).

FRIDERIK KLAMPFER is Lecturer at the University of Maribor, Slovenia. He has written on various topics in applied ethics, political philosophy, and theoretical ethics. His work has centered on issues of war, nationalism, and moral motivation. He was the editor of the first collection on contemporary ethics ever published in Slovenia. He is currently working on ethical intuitionism and related topics in moral epistemology.

OLLI LAGERSPETZ is Docent at the Department of Philosophy at Åbo Academy, Finland. Dr. Lagerspetz has studied at Åbo and at Urbana-Champaign, Illinois. In 1992–1998, he was a lecturer of philosophy at the University of Wales at Swansea. He is the author of *Trust: The Tacit Demand* (Kluwer, 1998).

NENAD MISCEVIC is Professor of Philosophy at the University of Maribor and Director of the Doctoral Philosophy Program at Central European University in Budapest. He has been active in creating and developing four analytic philosophy departments, in Zadar and Rijeka (Croatia), Maribor (Slovenia), and CEU Budapest. Having published several books in Croatian and Slovenian, his first monograph in English, *Rationality and Cognition*, is forthcoming from University of Toronto Press. He has published articles in philosophy journals such as *Philosophical Studies, Proceedings of the Aristotelian Society, The Monist*, and *Pacific Philosophical Quarterly*.

KAI NIELSEN is Emeritus Professor of Philosophy at the University of Calgary and Adjunct Professor of Philosophy at Concordia University. He previously taught at Amherst College, New York University, and the City University of New York. Two recent books are *On Transforming Philosophy* (1995) and *Naturalism without Foundations* (1996). His *Naturalism and Religion* will be published in the winter of 2000.

ALAN PATTEN is Assistant Professor of Political Science at McGill University and author of *Hegel's Idea of Freedom* (Oxford University Press, 1999). His current research explores the relationship between equality and cultural protection, recognition, and self-determination.

IGOR PRIMORATZ is Associate Professor of Philosophy at Hebrew University, Jerusalem. He is the author of *Banquos Geist, Hegels Theorie der Strafe* (Bouvier Verlag, 1986), *Justifying Legal Punishment* (Humanities Press, 1989, 1997), *Ethics and Sex* (Routledge, 1999), and papers in moral, political, and legal philosophy. He is also the editor of *Human Sexuality* (The International Research Library of Philosophy, Ashgate Publishing, 1997).

MICHEL SEYMOUR is Professor in the philosophy department at Université de Montréal. He recently published a second book, *La nation en question* (Montréal: l'Hexagone, 1999). He has edited three collections of articles on nationalism, including (as co-editor), *Rethinking Nationalism*, which was published in 1996 as a Supplementary Volume of the *Canadian Journal of Philosophy*. He has published many articles in international journals, such as the *Journal of Philosophy, Philosophical Studies, The Monist*, the *Canadian Journal of Philosophy* and *Nations and Nationalism*.

CHRISTOPHER HEATH WELLMAN directs the Jean Beer Blumenfeld Center for Ethics and teaches in the department of philosophy at Georgia State University. He works in ethics, specializing in political and legal philosophy. His articles have appeared in *Ethics, Philosophy & Public Affairs, Law and Philosophy, Social Theory and Practice, The Good Society*, and *Pacific Philosophical Quarterly*.

DANIEL WEINSTOCK teaches philosophy at the Université de Montréal. He has published extensively in political philosophy, mainly on questions to do with the impact of normative and cultural pluralism on standard liberal accounts of justice. He is presently working on the problem of unity in multination states.

Index

Allende, Salvador, 301
Anderson, Benedict, 5, 6, 65
Anderson, Perry, 239
Appiah, Anthony, 305
Associative Thesis, 169–70
Assurance Game, 290

Baier, A., 245
"banal nationalism," 67
Barber, B., 19
Baron, Marcia, 103, 105
Barry, Brian, 301, 303
Bauer, Otto, 245
Berlin, Isaiah, 16, 239, 301
Buchanan, A., 221, 229
Brubaker, Rogers, 178

Campbell, John, 245
Canovan, Margaret, 50
Carens, Joseph H., 80, 81
Chirac, President, 11
Chomsky, Noam, 311
citizenship, and shared issues, 60
civic nation. *See* nation: civic
civic nationalism. *See* nationalism:
 civic
Cohen, G. A., 240, 301, 315
Cohen, Joshua, 301, 311, 314
communitarianism, 6
community
 language in, 65
 liberal, 128
 political
 and democratic legitimacy, 58
 and legitimate authority, 60
 shared issues in, 60
 shared space of, 59–61
 in social–contract tradition, 61
 political value of, 158

revisionist liberals on, 181
in social-contract tradition, 61
Connor, Walker, 189, 192
Cosmopolitan Democracy, 262,
 268–69, 281
 feasibility of, 270
 and globalization, 270, 271–75,
 277–78
 and liberal nationalism, differences
 between, 279
 and nation-state, 277–80
 and participation, 271–75
 problems for, 271–75
 and the state, 269, 270
 vertical distribution of power in,
 269
cosmopolitan-nationalist compromise,
 18–20
 limitations of, 19–20
cosmopolitan patriotism/nationalism,
 18, 19
cosmopolitan view, 6–7
 on ethnic conflicts, 8
 and nationalism, contrast between,
 6–8
 on voluntary belonging, 7
cosmopolitanism, 240, 265–66,
 299–300
 legal, 266, 267–68, 279–81
 and democracy, 269–70
 on the state, 268, 280
 and liberal nationalism, 168,
 262–66, 281, 301
 moral, 266, 267
 and nationalism, 300
 as nonassimilationist, 300
 and social liberalism, 301
 on the state, 266–68
Coulanges, Fustel de, 19
cultural nationalism. *See* nationalism:
 cultural

culture and freedom, relation
 between, 204–14
 and meaning-providing reason,
 205–8
 and option-providing reason,
 208–11
Cunningham, Frank, 311

Dahbour, O., 243
Davis, Nancy, 93
Dayan, Moshe, 88
Dayton Treaty, 51
democracy
 and capitalism, 313–14
 citizens in, 59
 community in, 58–59
 and cosmopolitanism, 269–70
 cynicism about, 310–11
 in global civic society, 271–77
 as imperfect, 313–14
 legitimacy in, 57–58
 liberal, and noncitizens, 137–38
 and liberal nationalism, 279,
 312–14
 and national identity, 310
 and nationalism, 186, 261
 and nations, 262, 312–13
 and nation-states, 312–13
 Quebec as example, 313–14
 and self-governance, 312–13
 and states, 262
de Sousa, Ronald, 245
Dewey, John, 301, 311, 312
divine right, 61
Doctors Without Borders, 111
Durkheim, Emile, 278
Dworkin, Ronald, 208, 301, 315
 and laissez faire, 202
 liberal egalitarianism of, 201,
 202

Erikson, E., 244
ethnic-civic dichotomy
 problems of, 26
 overcoming, 25–26, 27–28, 32, 33,
 52
ethnic nation. *See* nation: ethnic
ethnic (ethno-) nationalism. *See*
 nationalism: ethnic

ethnic politics, rise of, 284
 as mobilization and counter-
 mobilization, 285–87
 as tipping phenomenon, 284–85,
 287

Flanagan, O., 244, 248
Friedman, Milton, 301

Galston, William
 Liberal Purposes, 181–82
Gauthier, David, 301
Gellner, E., 4
German nationalism, 26
Gilbert, Paul, 179
globalization, 262
 and cosmopolitanism, 270, 271–75
 and state roles, 261
Godwin, William, 103
Goffman, E., 244
Gomberg, P., 220
Goodin, Robert, 77
Gramsci, Antonio, 311
Green, T. H., 301
Greenfeld, Liah, 50, 285

Habermas, Jürgen, 301, 311
Hampshire, Stuart, 301
Hardin, Russell, 164, 166, 172, 173
 *One for All: The Logic of Group
 Conflict*, 165
Hayek, Friedrich, 301
Hegel, G. W. F., 240, 303
Herder, Johann, 16, 26
Himmelfarb, Gertrude, 240, 250
Hitler, Adolf, 67, 304
Hobbes, Thomas, 283, 288, 292
Hobsbawm, Eric, 229
Horowitz, Donald, 187
Horton, John, 106, 108, 109
Hurka, Thomas, 151, 179, 180, 221,
 227
 on nations as intrinsically valuable,
 179–80

identification
 cognitive and affective, distinction

between, 244–49
 and endorsed identity, link
between, 244
 feature-clusters in, 248
identities, as nonchosen, 307–8
institutions, effect of, on judgment,
 136–37, 139
intuitions and emotions, problem of
 appeal to, 143–48

Jewish nationalism, 75, 76
 as "closed," 83
 criticisms of, 82–86
 as defensible, 86
 as exclusive, 85
 moral claim to Palestine, 91–92
 and realistic morality, 82
Jews, as a people, 82–83
Jones, J. R., 65, 69

Kant, Immanuel, 266
 on imperfect obligations, 142
Khalidi, Muhammed Ali, 77, 78
Klampfer, Friderik, 106
Kylicka, Will, 157, 177, 178, 189,
 305
 on culture
 and freedom, relation between,
 204–14
 value of, 188
 on laissez faire, 200
 liberal egalitarianism of, 198–99,
 200–203, 211
 *Liberalism, Community, and
 Culture,* 209
 and meaning-providing reason,
 205–8
 on minority cultures/rights,
 202–3, 209–11, 214
 and option-providing reasons, 209

Lagerspetz, Mikko, 67
legitimate authority
 community as requirement for, 58,
 60
 and divine right, 60–61
 and institutional concerns, 60–61
 modern ideas of, 57, 60

Lenin, V. I., 67
Levine, Andrew, 311
liberal egalitarian principles
 and argument from linguistic
 incapability, 211–14
 limitations of, 214–15
 debate over, 197–98, 199
 and expensive-tastes objection,
 209–11
 as interventionist, 197, 199–200,
 211
 justification for, 213–14
 as laissez faire, 197, 199–200
 and linguistic capability, 213
 and minority cultures, 199–200,
 213–14
 and option-providing reasons, 209,
 211
liberal internationalism
 crisis of, 283
 interventionist role of, 292–94
 and noninterference, 292
liberal nationalism. *See* nationalism:
 liberal
Liberal State, 61
liberalism
 and community, 292
 crisis of, 283
 as egalitarian, 301
 and ethical individualism, difference
 between, 50
 individualistic, 301
 and nationalism, 50
 and noninterference, 292
 resources of, for regulating ethnic
 conflict, 283, 288–93
 and self-determination, 122
 social, 301, 314
 and cosmopolitanism, 310
 as egalitarian, 302
 and tolerance, 283
 virtues of, 301
Lichtenberg, J., 229
Lijphart, Arend, 187
limitations, value of, 116–19
linguistic capability, 212
Locke, John, 288
Luxemburg, Rosa, 302

MacIntyre, Alasdair, 12, 103, 220,
225

Makine, Andrei
 Le testament français, 308–9
Margalit, Avishai, 16, 177, 230, 240, 254
Mason, A., 221, 228
McMahan, Jeff, 157, 221, 229
Mill, John Stuart, 189, 301, 311
 On Liberty, 292
 "On Nationality," 186
Miller, David, 5, 135, 144, 157, 171, 172, 177, 180, 229, 230, 231
 on culture, value of, 188
 on moral judgments, 136, 137, 139
 on nation
 as intrinsically valuable, 182–83
 shared culture in, 160
 on national identity, 167
 On Nationality, 179
 on obligations
 to nonmembers, 167–68
 special, 140, 146–47, 157, 170
minority cultures (*see also* nation: minorities in; nationalism: and minorities)
 debate over, 200
mobilization and countermobilization, 285–87
modern life
 features of, 120
 luxury of, 120–21
 as social, 120–21
Montefiore, A., 254
Montesquieu, Charles de Secondat, 13
moral egalitarianism, 219
moral impartialism, 219
moral intuitions, effect on, of institutions, 136–37, 139
moral virtues, and obligation, 111
morality
 idealistic vs. realistic, 80–81
 and public policy, 81
Mother Theresa, 111
multination states, 27, 32, 33, 34, 40, 44

Nagel, Thomas, 301
Nathanson, Stephen, 103, 105, 220, 229

national belonging
 endorsed/conscious, 243
 factual, 243
 and identity, 254–56
national consciousness, 41
national identity, 239–40, 241, 302, 313
 claims for, 249
 and cosmopolitanism, 309
 and democracy, 185–87, 310
 endorsed/conscious, 243, 44, 248, 253, 256
 and numerical identity, 250–51
 familiarity in, 165–66
 and flourishing, 251–56
 framework for, 255
 of a group (community), 242–43
 importance of, 305–9
 of an individual, 243
 liberal, 255
 and liberalism, 167
 and minorities, 189–90
 and myth, 167
 as oppositional, 167
 origins of, 164–67
 and personal identity, connection between, 249–56
 and social justice, 183–84
national liberation movements, and territory, 85–86
national majorities, concept of, 40–41
national minorities, 40–41
 and nations, difference between, 47–49
national partiality, 219 (*see also* nationalism: partiality in)
 demanding, 222
 internalist justifications for, 221, 222–24, 232–33
 intrinsic-value argument, 226–32
 universalist, 224–26
 permissive, 222
 principle of, 219
national self-determination (*see also* nation[s]: and self-determination)
 and personal identity, 80
nationalism
 academic bias regarding, 68
 administrative, 77–78, 85

and appeal to intuitions and
emotions, problem of, 143–48
arguments for, 12–16
and attachment to land, 84–85
attitude in, 3
and autonomy, 10
behavior in, 2–3
civic, 27, 44, 68
as exclusive, 27
problems of, 44
collective amnesia in, 93
as collective rights, 52
as communitarianism, 16
cosmopolitan, 299
and cosmopolitan view, contrast
between, 6–8
cosmopolitans on, 262
and creativity, 10
criticisms of, 16–17, 158–59
cultural, 4–5, 14, 76–77, 85
defense of, 78–82
and diversity, 80
minority protection in, 79
and oppression, 79
partialism in, 78, 79, 80
positive features of, 79–80
and racism, difference between,
78–79
cultural proximity in, 14–15
debate over, 1, 5, 9
defensibility screen for, 159
definition of, 66, 198, 219, 239,
300
as demanding, 11
and democracy, 186, 261
and diversity, 11, 15–16, 30–31
doctrine in, 3
and egalitarianism, 13, 17, 219
ethics of, 81
ethnic, 3, 11, 27, 44, 68
as exclusive, 26
problems of, 44
on ethnic conflicts, 8
and flourishing, 15
fundamental claims of, 8–9, 12
and globalization, 261
as a good, 13–14
and identity, 15 (*see also* national
identity)
and individual rights, 10
and inequality, 17

insensitivity in, 17
institutional context of, 66–69
liberal, 18, 19, 28, 163–64, 300–302,
214
and Cosmopolitan Democracy,
differences between, 279–80
and cosmopolitanism, 168–69,
262–66, 281, 300, 305, 310,
315
cultural argument for, 177,
188–90
definition of, 26
and democracy, 279, 312–14
as egalitarian, 304, 305
and flourishing, 305
and globalization, 279
institutional argument for, 177,
181–88, 190
intrinsic-value argument for,
177, 178–81, 190
and minorities, 177–78, 190–91
on national identity, 306
and nation-building, 190–91
normative arguments for, 178
and pluralism, 278
problems of, 157–59
as reiterative, 302, 303
and self-determination, 190–91
on self-governance, 303
and self-identity, 305
and shared culture, 278
and the state, 268, 279
tolerance in, 266, 302
and liberal egalitarian principles,
198
and liberal-democratic society, 9
and liberal theory, 50, 134
liberals on, 115, 121, 122
and loyalty to unchosen identities,
249–50
and minorities, 177
misery from, 157
and modernity, 50
and moral egalitarianism, 219
moral intuitions in, 135
moral issue of, 220–21
moral justification for, 219
moral requirements for, 164–65
and moral understanding, 15
morally acceptable form of, 171
mythologies in, 18

and nation-state, 27
negative connotation of, 102
noninstrumental value of, 13–14
and obligation to nonmembers,
 167–68
organic metaphors for, 239
partiality in, 10, 76–77, 219–20
 justifications for, 151–52
and patriotism, contrast between,
 101–2
and personal identity, 80
philosophical, 2, 5
 universalism in, 2, 3, 9
pluralistic, 163
as political, 3–4
and principle of tolerance, 30–32,
 52
psychological argument for,
 172–73
racial, 79
as reiterative, 303
on right to self-defense, 12–13
and rights, 263
and self-determination, 9–10, 186
 group, 12
 individual, 122–23
special-obligations thesis of,
 133–34, 140–41, 143–44
 ambiguities in, 148–50, 152
 justifications of, 150–51
and the state, 4, 5, 198
statist thesis of, 9
and universalism, 133–34, 143–44
value of
 identity argument for, 161–62
 instrumental argument for,
 162–63
 moral, 157
weaker varieties of, 4
nationalist tensions, sources of, 31
nationality
 ambiguous nature of, 146
nation-building and national self-
 determination, resolving
 ambivalence between, 190–93
nation(s)
 aboriginal, 43
 belonging to, meaning of, 57,
 63–64
 citizenship in, 38
 civic, 26, 28, 29, 38, 63

as exclusive, 31–32
 problems of, 31–32
common language and culture in,
 37
common values in, 123–125
as community, 61
cosmopolitans on, 262
and culture, 28, 29, 43, 44, 116,
 159–60, 162, 166
 problems of, 46–47
definition of, 115, 159, 160, 178,
 186, 229, 306, 312
 difficulties for, 160
and democracy, 262, 312–13
diaspora, 28, 37, 39, 43, 44
effect of, on nonmembers, 123–24,
 125–26
ethnic, 26, 28, 63
 dangers of, 31
 instability of, 46
and globalization, 307
historicity of, 64–66
as imagined community, 5
inegalitarian, 123
as irreplaceable, 127–28
language in, role of, 68–69
and liberal political philosophy,
 49–50
liberals on, 127
as limiting options, 116, 119,
 120–21, 126
loyalty to, issue of, 62–63
majority in, 37, 38–39, 46
membership in, 229
minimizing evils of, 128–30
minorities in, 37, 38, 46, 47–48
in modern life, 121
as necessary, 127, 128, 129
as nonvoluntary community, 6, 62
objective features of, 5, 34, 45
obligation in, 5–6
 to members, 169–71
 to nonmembers, 167–68
partiality of, 140
 moral issue of, 221–22 as
 pluralistic, 26, 28, 29, 30–31,
 37, 44
pluri-cultural, 29, 38, 44, 46
as political, 37–38, 61–69
redefining, 25, 32, 35–39
 constraints on, 32–36, 43–52

and liberal political philosophy,
49–50
and nation-state, 44
and rights, 44
and religion, 121, 127–28
representative authority in, 62,
69
responsibility in, 160
and secession, right to, 46–47,
48–49
and self-determination, 35, 46, 47,
48, 49, 116, 158, 160, 172
self-representation in/of, 30–31,
41, 45–46
as shared space, 64
sociopolitical, 28–29, 32, 37, 39,
40, 41, 43, 44, 47, 48,
49–50, 51
and context of choice, 49–50
and culture, 49–50
features of, 49
and language, 49
and liberal political philosophy,
49–50
as multinational, 51
and national minorities,
difference between, 49
and pluralism, 49–50
and Quebec, 42, 51
tolerance in, 52
special obligation in, 140
and stability, 46
and state, 33, 44
difference between, 38
state-based problems for, 261–62
subjective features of, 5, 30,
34–35, 45, 116
and territory, 41–43
and tolerance, 46
and Utopian community,
difference between, 62
value of, 116, 119, 120–21
values in, as arbitrary, 125
nation-state(s), 44, 50
and Cosmopolitan Democracy,
262
and democracy, 312–13
emergence of, 138
moral intuition in, 140
partiality in, 138
'neighborhood tipping,' 284–85

New Nationalists, 157–58, 159, 161,
163, 166, 167, 168, 169,
170, 172
on self-determination, 171
Nielsen, Kai, 240
Nietzsche, Friedrich, 129
no-personality-without-nationality
view, 240–42, 249, 250, 253
consequences of, 240–41
criticisms of, 252–53, 256
and endorsed national identity, 252
Nozick, Robert, 301
Nussbaum, Martha, 67, 220, 299,
301

obligations, 142 (*see also* special-
obligations thesis)
distributive, 142
imperfect, 142–43
Oedipus, 243
Offe, Claus, 311
Oldenquist, Andrew, 8, 10
O'Neill, Onora, 142
Orwell, George, 102

Palestinian nationalism, 81, 83–84
attachment to land in, 83–85
moral claim to Palestine, 91–92
and realistic morality, 82
particular national partialist (PNP),
222
patriotism
definition of, 102
duty of, 105–6, 108
extreme, 104
in moral philosophy, 101, 102
defense of, 103
objections to, 103
moderate, 103–4, 105
as morally acceptable, 104, 108,
110, 112
as morally required, 108, 110
as morally valuable, 111–12
and nationalism, contrast between,
101–2
as political, 102
and positional obligations,
106–110
positive connotation of, 102

renewed interest in, 101
rule-utilitarian view of, 105–6
and universalizability, 103
"Peace Now" movement, 75
a "people," 312, 313
 criteria for, 83
 and self-determination, 83
philosophical pro-nationalism, 5
 dangers of, 17–18
 universalism in, 2, 9
political representation, 57
political self-determination, as state-
 hood, 76
political community. *See* community:
 political
positional obligations, 106–8
 in family, 107, 108–110
postnational identity, 307, 309
Primoratz, I., 220, 221
Prisoner's Dilemma, 288, 290, 293
public policy, ethics of, 81
Putnam, Hilary, 19

Quasimodo, 244, 246
Quixote, Don, 247

Rawls, John, 30, 41, 151, 201, 208,
 263, 273, 277, 301, 302, 305,
 306, 311, 312, 314, 315
 on considered judgments, 135–36,
 139
 Law of Peoples, 50
 Political Liberalism, 182
 A Theory of Justice, 136
Raz, Joseph, 177, 230
Renan, Ernest, 6, 26, 66, 93, 94,
 182, 186
representative government, commun-
 ity as requirement for,
 59
Republic, 119
republicanism, 6
rights
 infringements of, 93
 as not absolute, 88, 92–93
Rorty, Richard, 240, 248
Rousseau, Jean Jacques, 59, 60
 Social Contract, 58
Russell, Bertrand, 1

Sandel, M., 240, 241, 251
Sartre, Jean-Paul, 125
Saul (biblical), 251, 307
Schelling, Thomas, 285
secession and partition, difference
 between, 47–48
Sen, Amartya, 301, 315
Shakespeare, William, 246
Shaw, George Bernard, 291
Smith, Anthony
 National Identity, 243
sociopolitical nation. *See* nation:
 sociopolitical
Socrates, 119, 126
special-obligations thesis, 140
 strong version, 140–41, 142–43
 weak version, 140, 141–43,
 148
Stalin, Joseph, 67, 309
state
 assurance role of, 290
 compatriotoncompatriot distinction
 in, 139
 considered judgments in, 139
 and democracy, 262
 and globalization, 260
 interventionist role of, 290–91
 liberal theory of, 288
 modern function of, 138

Tamir, Yael, 77, 78, 80, 140, 162,
 166, 171, 177
 Associative Thesis of, 169
 on nation, 159
 culture in, 159–60
 on nationalism
 liberal, 163
 pluralistic, 163
 value of, 157, 158
 on obligations to nonmembers,
 168
Tawney, R. H., 301
Taylor, Charles, 15, 19, 248, 254,
 255
Thomas, R. S., 68
Thomson, Judith Jarvis, 93
Tobin tax, 294
totality of cultures, as basic value,
 16

universalist national partialist (UNP), 222

viable linguistic community, 212

Walzer, Michael, 6, 78, 80, 311
Weber, M., 6
Weinstock, Daniel, 6
Wellman, C. H., 229
Wolf, S., 220

Zangwill, Israel, 87
Zidane, E., 11
Zionism
 concept of, 75

criticisms of, 76, 85, 86–87
and cultural nationalism, 76–82
debate over, 75
as defensible, 86, 88, 92–93
historical reality of, 75
and Jewish self-determination, 75
and moral rights, 92–93
morally acceptable form of, 91–92
principles of, 75
and realistic morality, 81
rights involved in, 88–89
 impartialist version, 89
 partialist version, 90
and territory, 85–86
as violation of Palestinian rights, 86–90, 93, 94